Painting Below Zero

Painting Below Zero

NOTES ON A LIFE IN ART

James Rosenquist

WITH DAVID DALTON

ALFRED A. KNOPF · NEW YORK · 2009

THIS IS A BORZOI BOOK PUBLISHED BY ALFRED A. KNOPF

Copyright © 2009 by James Rosenquist

All rights reserved. Published in the United States by Alfred A. Knopf, a division of Random House, Inc., New York, and in Canada by Random House of Canada Limited, Toronto.

www.aaknopf.com

Knopf, Borzoi Books, and the colophon are registered trademarks of Random House, Inc.

Library of Congress Cataloging-in-Publication Data
Rosenquist, James, [date]
Painting below zero : notes on a life in art / by James Rosenquist with David Dalton.—1st ed.
p. cm.
Includes bibliographical references and index.
ISBN 978-0-307-26342-1 (alk. paper)
1. Rosenquist, James, [date] 2. Artists—United States—Biography. I. Title.
N6537.R58A2 2009
759.13—dc22 2009021218

Manufactured in the United States of America

FIRST EDITION

TO RUTH AND LOUIS ROSENQUIST
AND TO CAMERON BOOTH

Contents

ACKNOWLEDGMENTS

There are many people who make what I do possible. I wouldn't be able to build my canvases without the ingenious mechanical help of my amazing crew: Dan Campbell and Kevin Hemstreet.

At the nerve center of my studio in Aripeka are Beverly Coe, my secretary of twenty-three years who keeps everything afloat (including our spirits), and the radiant Charlotte Lee, who presides over truant documents and files. I am grateful to my resourceful archivist, Michael Harrigan, for his meticulous organizational skills and—on this manuscript—his corrections and suggestions; to Mary Lou Rosenquist and Susan Hall for sharing their memories; to Sarah Bancroft for her invaluable assistance; to Hannah Williams for transcribing tapes made under trying conditions, and to Coco Pekelis Dalton for casting her eagle eye over the manuscript.

I owe enormous thanks to my brilliant dealer, Bill Acquavella, for his astute eye and great care, and also to his children at the gallery—Nick, Alex, and Eleanor—and Michael Findlay, whom I've known for years and who sees to my every need, and Bill's wife, Donna. I'd also like to thank my old friends and colleagues Don Saff and Billy Goldston, and especially my son, John, for all his love and support. And a special thanks to Bob Adelman and Gianfranco Gorgoni for their amazing photographs that have documented so much of my life.

This book would never have happened without the vision, taste, and care of my editor at Knopf, Shelley Wanger. Many thanks to

David Dalton, who helped me every step of the way and without whom this book would never have gotten started or finished.

And last but not least, this book is for my saintly wife, Mimi, and my lovely, very grown-up daughter, Lily.

Painting Below Zero

The Empty Canvas

Painting has everything to do with memory. Images of the unexpected, the surreal, well up unbidden in your mind—as do things you haven't resolved. A bizarre scene from your childhood that seemed unfathomable to you at the time will linger in your memory for years.

The Midwest is a strange place. On the one hand it's very basic, down-to-earth; on the other it's a great generator of illusions. I grew up in North Dakota where the land is totally flat, like a screen on which you can project whatever you imagine. We had no electricity, and when a kerosene lamp was lit or put out in a house half a mile away, you would know that Siever Svenson had just woken up or gone to bed.

Living on the plains, you often see mirages. One evening I was sitting on the front porch at sunset with the sun in back of me, and I seemed to see a giant Trojan horse walking across the horizon.

"What's *that*?" I said, running into the house. "Look! Look at the big horse!" Turned out it was the neighbor's stallion that had gotten loose and, caught against the setting sun, it loomed as a giant that looked four stories high. But then again, odd things seemed to happen all the time. In 1938, when we were living in Minnesota, a meteor landed on a neighbor's house a few miles away and struck a woman on her hip while she was in bed—and she lived.

There's no scale in the brain. An image of the most colossal monument and the tiniest ant can rest side by side in your mind. The mundane and the bizarre can fuse into a language of images that float to the surface when you least expect it.

I was named James Albert, for my dashing uncle Albert, and was born at the Deaconess Hospital in Grand Forks, North Dakota, on November 29, 1933, the only child of Ruth Hendrickson Rosenquist and Louis Rosenquist.

Perhaps because the land is so flat—there were no mountains to climb—in North Dakota people wanted to go up in the air. My mom and dad wanted to fly, and they both became pioneering pilots. One of my earliest recollections of planes is of my father taking me to the airport and putting me in one of these beautiful little biplanes, like the Travelaire that my parents flew, but they also flew Curtiss Robins and Monocoupes. My mom and dad and Uncle Albert were planning an international airline with a mail route from North Dakota to Winnipeg when the Depression hit. Their plans were further dashed when Albert crashed and died in a rainstorm in 1931.

I tell people that I was born in the Happy Dragon Chinese restaurant. I've always thought it fitting that the hospital I was born in turned into a Chinese restaurant later on.

Even my first memory now seems to me mysterious and evanescent: the smell of coal smoke and the look of the small squares of the sidewalk. This was near the train depot in Grand Forks, North Dakota, an old station from the 1920s.

Perhaps being born in a future Chinese restaurant brought me luck because I barely survived infancy. When I was little we lived in an old rooming house in Grand Forks that had an open atrium in the center. One day I was in a baby stroller; my mother and godmother were standing talking at the top of two flights of stairs

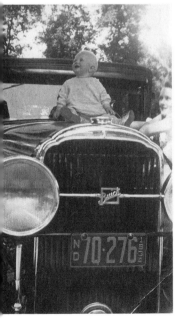

At age one on our neighbor's Buick.

when somehow the stroller rolled away from them and began crashing down the stairs. I went head over heels down two flights. My head just missed the floor and I ended up hitting the glass door at the bottom. I vividly remember my mother screaming in horror as she watched me tumble down the stairs.

In Grand Forks my babysitter was a gangly teenage girl who we thought was the sister of my mother's best friend—but really she was her illegitimate daughter. Her mother worked at a dairy, and she often took me there. I remember her reaching into a big churn they had there to give me a huge chunk of vanilla ice cream.

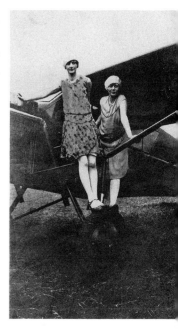

My mother, on the right, with a friend on a Curtiss Robin that she flew, ca. 1931. It was probably owned by her instructor.

We were a nomadic family, living in a half-dozen places in North Dakota, Minnesota, and Ohio. I attended seven schools by the time I was twelve. When I was in first grade we left Grand Forks and moved to Atwater, Minnesota, a small town a hundred miles west of Minneapolis. That's where my father's parents had a farm. I stayed with them for a time while my parents were trying to find a place to live.

Grandfather Rosenquist had a quarter section, which was something like five hundred acres, on which he grew wheat, corn, and soybeans. He also had twenty dairy cows. He'd get up before dawn, take a nap at noon, and then go work until suppertime. He'd stay up until ten, listen to the news on the radio, and go to bed. Even after I moved back with my parents I went out to the farm and fed the pigs. I used to make them pig cocktails. You would take a big barrel of water and put in so many shovels of wheat, and then add barleycorn to make it a little sweeter. My grandfather lived to age ninety-two—he could have lived longer but he got gangrene in his heel; they wanted to cut it out but he wouldn't let them. "Well, I came into this world with two feet," he told them, "and I'm going out with two feet."

My father ran a Mobil gasoline station off the highway. It was during the Depression, and the big treat for me was being able to drink the bottom half of my father's five-cent Coca-Cola. The Depression started in 1929, but it hit the Midwest in the 1930s and lasted until 1940. There was work on the farm and enough food, but the towns had a hard time of it.

Money was in short supply. A dollar was as rare as frog hair, but we lived in a communal society where sharing food, clothing, and

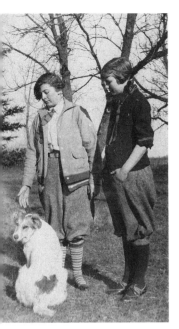

My mother is on the right, in her flying jodhpurs with a friend, ca. 1931.

so on was a way of life that went way back in those old Swedish and Norwegian communities. During the Depression the Chamber of Commerce came up with a clever idea: they would write big food companies to ask if they could have a Pancake Day or a Coffee Day; these companies would send food, and we would have these little festivals sponsored by the different companies. I used to pull a wagon in these parades wearing a clown suit, saying, "My dad sells Mobil gas"; or I would be dressed in some other kind of costume advertising a different product. There were contests and raffles. I remember one pancake-eating contest when they gave the guy who won first prize a giant pancake. He was not pleased, and he punched the judge in the jaw.

Money was so scarce that I began to have dreams about it. One night, I dreamed that in the backyard I saw this great big turtle. I got a washtub, put it over the turtle, and then went into the house and called out to my mom, "Momma, Momma, look what I got." I lifted up the washtub and underneath it was a hundred-dollar bill.

My mother was a great cook, and occasionally when she'd put an apple pie out on the windowsill to cool, a bum would smell it from the railroad track, come over and knock on the door, and say, "Ma'am, do you have any work?" She'd say, "Yes. Would you chop some firewood?" And then she'd give him a chicken dinner and a piece of apple pie as payment.

There were no rival factions in the towns where I grew up. We didn't live in neighborhoods where the Catholics fought the Jews or the blacks fought the Italians. To be honest, we lived in a mono-culture of Swedish and Norwegian immigrants so there were few people around to be bigoted about. In these little towns out West, you'd have the Jewish peddler coming down the railroad track sell-ing his wares. He was simply "the peddler." No one hated him or called him names. Individuals were called Bicycle Charlie, Snoose Victor, or Lame John—everybody had his attribute and nickname. My grandfather was always Louis Senior. A guy with a great big warty nose was called Spoonbill. My grandpa was very outgoing. He'd strike up conversations with strangers, ask who they were, where they came from, what they thought about this and that.

In the late 1930s, around '36 or '37, I was taken by my mother to see Franklin Roosevelt in Wilmar, Minnesota, which was about half an hour from where we lived in Atwater. That image is still so

vivid to me I can replay it in my mind like a film clip. Roosevelt was in a 1936 Ford Phaeton four-door convertible, sitting in the back-seat smiling and waving, with his trademark cigarette holder sticking out of his mouth at a rakish angle and a blanket covering his knees. No one in the world imagined he couldn't walk. We loved FDR; we were all Democrats out there.

Not that long ago I got an honorary degree from North Dakota State University in Fargo, and while I was there I went back to visit Mekinock, a little town where we used to go for our groceries and gas. When I lived there it had a train station, a bar, a general store, dirt streets, and wooden sidewalks just like a set for a Western. Now the general store and the bar had disappeared. They tore down the grain elevator. There had been a nice brick train station; that was gone, and the train tracks were pulled up, and no houses were left. They had had no fire department, so when the houses burned down, they let them burn. That was the end of it. There was no place left to reminisce about. They'd wiped it out, and in its place there were only a few mobile homes. A ghost town.

In 1940, when I was seven, my dad opened up a motel for tourists in Perham, in northern Minnesota. The town was named after Josiah Perham, the first president of the Northern Pacific Railroad. East Otter Tail County was very beautiful, with rolling hills and woods and over a hundred lakes.

It was while we were living there that I was sent out with a lumberjack as my babysitter. I went with him into the woods, and when we got to a clearing, he told me to stay put. He began chopping down a huge tree. As it came crashing to the ground I got so scared I shat my pants. There was no toilet paper so the lumberjack used white wood chips to clean me up. He just laughed and went right on chopping down trees like Paul Bunyan. I remember those wood chips and that odd feeling.

In Perham I made pocket money by collecting old newspapers, which I'd sell to the local florist. I'd get thirty-five cents per hundred pounds of newspaper. The florist was an interesting character. He was building an aluminum inboard speedboat from plans he got out of *Popular Mechanics.* To us it looked like a rocket ship. No one in Perham had even heard of aluminum.

Throughout my childhood the strangeness of things made a

great impression on me. When I was eight years old, walking in the woods in Canada, I came across a carousel with painted horses and unicorns in the middle of a clearing. Trees and bushes had grown up through it, vines wound around the poles and the horses, covering their flanks in leaves and turning the whole thing into a fantastic creation—part machine, part exotic plant.

And then came the war. It was 1941, and one day I was walking along the railroad tracks in the rain, using an Underwood typewriter cover as an umbrella, when I heard that the Japanese had bombed Pearl Harbor. And soon after, the United States entered the war. My dad had two boys who worked for him: one had a Harley and the other had an Indian motorcycle. They would give me rides when I was little. Those two boys went into the army, got shipped over to the South Pacific, and never came back.

The war changed everything and our fortunes changed along with it. When war broke out gas rationing came in, and that was the end of tourism. My dad was unlucky that way. He always had bad timing. We left Perham in 1942 and moved to 2528 Third Avenue in South Minneapolis, where my dad got a job for a short time in a munitions factory. Today Perham is a big tourist resort with two golf courses and many fancy shops.

The rationing meant there were no toys, little ice cream, and few candy bars. All the metal that would have gone into making toys was put in the scrap drive to be melted down for weapons. As a boy, I made model airplanes and cars out of wooden orange crates—cars with no wheels, of course, because you couldn't get wheels for them. Everything was rationed; sometimes I had no idea why. We were supposed to save our bacon fat, for instance. We were told they needed the animal fat in munitions manufacturing for rocket shells, but while we understood that scrap iron was clearly a necessity, the bacon fat business we never could figure out. We always wondered if it was just to make people feel patriotic.

Cars were scarce. If you were lucky enough to get a ride in a car, you only went thirty-five miles an hour. Hundred-mile trips were like a slow boat to China. A decent car was impossible to come by. My father's 1934 Chevrolet was a piece of junk. He cut oak pieces to rebuild the body and the sides. There was a worn-out armrest in the back. You couldn't get cloth to fix it, so my mother upholstered

it with a piece of flowery material used for making drapes. We ended up with a mouse-colored car with this bright flowery armrest in one corner.

During the war I was out of school a lot because we moved so much, since my father was working on planes at different bases; my mother used to take me to movies—for twelve cents you could see a movie and a stage show. When I was little, I had listened to Gene Autry, *Superman*, and all that stuff on the radio, so I was thrilled when I heard that we were going to see Gene Autry in person. Gene Autry was going to do his radio show, plus we'd get to see Kay Kyser and his Kollege of Musical Knowledge and Horace Heidt with his Musical Knights. Onstage! Live!

We watched the bands play and then it was time for Gene Autry. But instead of the cacti and sagebrush I had imagined, the stage was covered with big thick black cables. And instead of Gene Autry galloping in on Champion, there was a middle-aged man in a big cowboy hat sitting at a desk reading from a script and a soundman going *clip-clop, clip-hop, heeeeeeeeeee*, and whinnying. I was very disappointed. This wasn't at all the way I'd imagined it from the radio. Where had the magic of gulches and sidewinders and desperadoes and injuns and lariat-twirling galoots gone? It had a big effect on me. I was disenchanted by the discrepancy between what I'd imagined and the shoddy scene onstage, and I began to think about the gap between illusion and reality.

My first encounters with art as a child left me with strange ideas about what it was. When I was nine we were living right near the Minneapolis Institute of Art, and my mother, who was an amateur painter, often took me there. In the Egyptian Room they had mummies on display and to my childish mind it looked as if they were exhibiting corpses. I ran to my mother.

"Mommy," I said, "there's bodies in there that haven't been buried, just like Grandpa on the porch." My great-grandfather had died in the winter when the ground in North Dakota was too hard to bury him. They kept him in his coffin on the porch, and every day as I would go to school I'd say, "Bye-bye, Grandpa, see you later!"

In 1943 my dad went to work servicing B-24 bombers for Northwest Airlines and we had to move to Vandalia, Ohio, where Northwest subcontracted for the government at Wright-Patterson

Field. His salary was very low—he was making about $380 a month—and though things were very cheap, a family could just about scrape by on it. We lived in army housing barracks.

The government was testing planes there and we saw all kinds of experimental aircraft, like the pusher planes with the propeller in the back, and we also watched a lot of them crash. You could see the parachutes coming down after a plane had taken a nosedive. Every day I played war with my friends—that's what the grownups were doing, and we copied them as best we could by throwing rocks at each other's heads, digging trenches, and staging maneuvers. I was covered in cuts and bruises all the time from these games. One was called catapult; you'd put a rock or a big clump of dirt on one end of a big piece of wood and catapult it over to the other side by jumping on the opposite end of the board. Once I put a rock on one end of the catapult and jumped with all my might on the other end. Instead of flying over to the other side, the rock went right up and hit me in the eye—I got a huge shiner from that. The next day was my first day at school but no one beat me up—the black eye was a plus—because they thought I was some kind of a toughie.

While we were living in Ohio, my mother took me to a museum in Dayton, where I first encountered the enigma of collage, something I would spend my life trying to unravel. There, all on the same wall, was a painting, a shrunken head, and a little flower: three completely different things that seemed to have nothing to do with one another.

People always mention Kurt Schwitters when they think of collage, but it goes much further back than that, way back to the Japanese tea ceremony. When you look at a collage by Schwitters, with disparate things stuck side by side and laid on top of each other—a newspaper, a train ticket, paper money, a torn piece of blue paper, a fashion illustration, an envelope with a stamp on it—you involuntarily make connections. With collage you are free to create your own narrative. That and an element of mystery is what originally attracted me to the process.

During the war my parents continued to move around a lot and I was often sent by train to stay on my grandfather Ole Hendrickson's wheat farm in North Dakota, twelve miles from Grand Forks.

It was in a valley with woods around it and the Turtle River running through it—very quiet, pastoral, and picturesque. I had a great time there despite the fact that we had none of the things people today would consider basic necessities. It was a very rustic living, no electricity, no telephone, no running water. You'd go to bed with lanterns and get up with the birds. There was no washing machine; you washed your clothes in a cast-iron pot heated up over a fire (the water came out of a hand pump in the kitchen). I'd jump in before it got too boiling hot and take a bath. It was called the cannibal pot. Breakfast was hot chocolate and peanut butter on homemade bread heated on a huge wood kitchen range with burning wood. I don't remember eating any eggs in those days. I don't think we kept chickens. We didn't have any cows either and only a couple of horses.

As an only child, I had no brother or sisters to play with, but I did have a pet skunk (not deodorized) and my aunt Dolores who was only a few years older than me. I adored her and she provided all the entertainment. Dolores was a bit of a tomboy and, like me, enjoyed building model airplanes, making marionettes, and rough-housing. When Dolores became a teenager, she took a big old hayrack on wheels and had a barn dance for all her friends on the hay wagon to the old-time records of Ernest Tubb and other country-and-western stars, with everybody singing along.

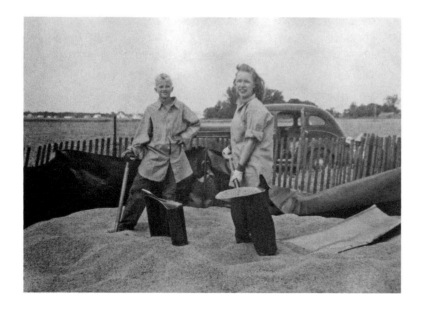

I am thirteen and in the middle of shoveling a record wheat harvest with Aunt Dolores, at my grandfather's farm in Mekinock, North Dakota, 1946.

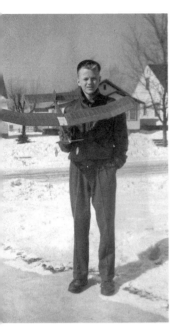

I am holding a model airplane I made, age thirteen, 1946.

My grandfather Hendrickson was Norwegian but born in America. He'd only speak Norwegian to say something he didn't want us children to understand. He was a wonderful guy, an inventor—and a very funny man. He made ice skates out of files welded onto braces attached to a pair of old shoes. He'd skate on them on the pond in the winter. He invented the first power lawn mower, a scary contraption with a whirling blade mounted on a Briggs & Stratton motor but with no guard. It was a terrifying machine.

After the war I went back there occasionally to pick potatoes with Mexican migrant workers. I worked in the fields with my uncle Clarence Hendrickson who'd just come back from fighting the Japanese. The poor guy was shell-shocked and ended up shooting himself.

Periodically, when my parents got settled, I'd go back and stay with them. One day when I was eleven my mother said, "Jimmy, come in the house, I want you to hear this. They're going to have the voice of General George S. Patton on the radio." It was 4:10 in the afternoon when Patton's voice came on: "We kicked the fucking sons of bitches' asses down the fucking Rhine and we're going to kick them all the way back to Berlin." "*Cut!*" someone shouted, and then an announcer came on and said, "You've just heard the voice of General George S. Patton somewhere in the European theater of war." "Momma," I said, "he talks just like Grandpa."

I remember the end of the war very clearly, and celebrating VJ Day in 1945. I liked that period just after the war, but material goods were still very scarce; 1945 to 1950 turned out to still be hard times. Getting a refrigerator or a car was a problem. If people could get them, they would buy them immediately, but mostly they just were not available.

The war produced its own surreal touches. In an old *Life* magazine I discovered this item from *Stars and Stripes*, the military newspaper. At the end of World War II, somewhere in the south of France a reporter found Gertrude Stein and interviewed her. The reporter asked, "Miss Stein, how do you feel on this great day of liberation?" And she said something to the effect of, "Today is like yesterday was like today is like tomorrow will be tomorrow is like today will be like yesterday." To which the reporter commented, "We think she may have been shell-shocked."

It was during the war that I began drawing. I was often alone in hotel rooms while my parents were traveling or at work, and I would spend the entire day creating elaborate battle scenarios. Paper was scarce and expensive, but my mother found me long rolls of discarded wallpaper to draw on. I could draw huge narrative scenes on the back of these sheets, beginning with soldiers creating gun emplacements, digging trenches, and then moving on to the next giant battle scene involving catastrophic explosions, air-bombing raids, crashes, mines detonating, and soldiers flying through the air from grenade attacks.

In 1945 we moved back to Minneapolis, to 2541 Third Avenue, right across the street from where we used to live. My mother was working as an accountant and my father was still with Northwest Airlines. In 1946 my father built a house in South Minneapolis for $7,000. It looked like a Cape Cod cottage.

On the farm, money had been irrelevant, but in Minneapolis I was a kid from a family without any money. I had always worked. Sometimes I was embarrassed by it. When I first went to high school, someone had asked, "Does anyone here want a job?" I said, "I do." What was the job? It was selling ice cream right across the street from the school. My classmates would come up to me and ask me what I was doing there. I told them it was my job. They thought it was kind of stupid.

Where we lived in Minneapolis was on the edge of the crime area. The kids on the other side of Fifty-fourth Street were juvenile delinquents, so you had to watch out for yourself. I remember Joe Digidio, who wasn't that much older than I was, driving up alongside me in a car. "Hi. Come in," he said, "I'll give you a ride." I got in. "Wow," I said. "Where did you get this car?" "Oh, I just picked it up a few blocks away." I asked him to pull over and let me out. "My mother sent me to get a loaf of bread," I said. "I have to get out here." The guys driving stolen cars would rob a golf course or steal cases of soda pop. The cops got them—and the kids who'd gone along for the ride. They all got charged as accessories. Little kids who didn't know any better ended up in reform school, too.

At age fifteen I got my driver's license and began driving a truck after school, sometimes until after eleven at night, making deliveries for a drugstore. I worked like hell all year round, right through

the winter, too. My grades suffered as a result. I had some very strange experiences; I delivered drugs to the oddest people, to crippled people living alone in attics, crazy old women—weird stuff. One time I had to bring thirty pounds of tobacco to a house in Minneapolis. I knocked on the door. Inside was a large family of hillbillies in bib overalls. The big wooden table was piled with great mounds of tobacco and rows of cigarettes. Everybody was smoking like a chimney. There was so much smoke in the room the air had turned blue.

In South Minneapolis the best part about the new house was the garage. It was there that I built model airplanes, and eventually a speedboat using plans I got from *Popular Mechanics*. The ad said: "Build the Merry Maid yourself in your basement or garage!" You sent away for the plans, which gave you step-by-step instructions. I got some sawhorses and a piece of red oak from my grandfather's farm, cut it up, made the keel and part of the stem from it, and covered it with plywood—it wasn't that different from building a model airplane. You first build the frames and hang them on the keel and then put the stem in front of it. We didn't have electric drills then, so it was all done with hand tools. The only motor available was a four-cylinder Johnson attack motor made for the army. It was a very crude thing with a pulled starter. There was no reverse—you just flipped the motor to make it go backward. But I couldn't even afford one of those, so now I had a speedboat with no motor.

In Atwater, Minnesota, the Holm Brothers hardware store said a company was coming out with a new twenty-five horsepower Johnson that had a shift on it. It cost $275 wholesale, and they gave it to me for $300, because the owner of the hardware store wanted me to have it. Everybody had done without for so long, they just wanted people to get the things they needed. I got that Johnson motor, put it on my boat, and I'd go out on Lake Minnetonka and pull two water-skiers behind.

After the war I spent my summers on my grandfather Louis Rosenquist's farm with my uncle Frans. My first day and night seemed endless, with frequent pauses for massive amounts of food. It was the longest day I'd ever known—from predawn till ten at night. My first morning, I was awakened at five o'clock and came down to a

breakfast of four cups of coffee and cookies. My uncle, who was an alcoholic, supplemented his breakfast with a gulp of whiskey.

It wasn't yet light when we went out to weld up the plowshares, gas up the tractors, and get the rigs ready. By the time we'd gotten that done—it took almost three hours—it was eight o'clock and we'd worked up a healthy appetite, so we had our second breakfast. This consisted of ham, three or four eggs, stacks of buttered toast, and steaming hot cups of coffee—and more whiskey for my uncle. Back out we went, bucking and bouncing across the fields on the tractors as we ripped furrows. At noon we packed it in for lunch. After lunch, we gassed up the tractors again, checked the rigs, and went out into the fields again. We stayed out there until around six o'clock. I was exhausted, but, after another big meal, we were out in the fields plowing again.

That night the moon came up just as the sun went down, and, for a few minutes, the furrows were lit up from both sides by the sinking sun on one side and the rising moon on the other. The noise from the tractors was deafening, and they rattled and bounced across that field, but it was a beautiful sight. Later that night, the stars came out. Then a storm came up, and huge clouds piled up in the sky to hide the stars. It rained and we had to go home. The next day we were at it again. I could never understand before how people could bear the terrible monotony of being on a farm, of working the land. But I think I learned that night why people do it and why they love the life.

Uncle Frans was a very colorful character. Unfortunately, he died at thirty-nine from a drunk-driving accident. When he was younger, my grandfather had given him a brand-new 1940 Ford for graduating from the sixth grade. He was already a crazy, wild nut, and that year he was in a car wreck. His head went through the back window of the car, he had to have about fifty stitches in his face, and they had to sew his ear back on. He did so many wacky things. He'd go into a beer parlor with a knife and cut the straps off the farmers' bib overalls so their pants would fall down. Then they would beat the hell out of him. He dried out for two years, and then someone slipped him a drink in a soda pop and he went off the deep end again. After a day spent plowing on the farm, I'd go to sleep and he'd wake me up in the middle of the night. "Come on, Jim," he'd say. "We're going to have a tug-of-war across the coulee and

we got the fat Swendson twins on our side." Just a bunch of drunken farmers trying to pull one another into the water.

I had a lot of fun on the farm with my cousin Archie. He'd been in the batallion that liberated Buchenwald and he told me they had used one room there as a latrine. He said he mistook a moonbeam for a piece of toilet paper on the latrine floor and tried to pick it up. "Damn, have you ever tried to wipe your ass with a moonbeam?" I later made a print based on this image titled *Moon Beam Mistaken for the News.*

Archie would take me flying with him in a Piper Cub, something I couldn't tell my parents about. When Archie came back from the war he had this idea that everyone was entitled to a house, a car— and an airplane. He took his GI Bill in flying. He'd buzz the farm, and one day he flew out to the farm and landed in a field. He told my uncle Frans he'd take him up for a spin. They got in the Piper Cub. Next thing we knew, this plane was coming over our heads about fifty feet off the ground, going *nnngggwwwwrrrrmmm*! And there was my uncle, terrified, trying to climb out of the plane. He was leaning out on the wing, thinking that Archie was dangerous and was going to get him killed, and that if Archie flew lower than a telephone pole, he *was* going to jump. (He was drunk, or he'd have thought about that twice.)

Archie never said anything more about Buchenwald. That's the way it was with World War II vets. I saw firsthand the psychological damage the war had done to the soldiers returning home. My grandfather would hire these guys and they were in terrible shape. Unlike today, when soldiers are flown into these places and flown back, the troops from World War II returned slowly on a ship, but they still had a hard time adjusting. When my grandfather hired them, they'd show up on the farm with their medals and uniforms and so forth; some were pretty strange. They'd work for my grandfather for a month or two and then go home. They knew they were out of sync and were trying to get back into normal civilian life again by working on a farm in the Midwest before they went back to their families in other parts of the country.

One fellow who came back from the war and worked on my grandfather's farm got dirtier and dirtier plowing, but he had a phobia about bathing. He'd come into the farmhouse where there'd be a big spread of roast beef or turkey, four kinds of beans,

salad, and apple pie, stinking to high heaven, and my grandmother, in her singsongy Swedish, would say, "Dat dirty ting, he can't stay in my house unless he take a bath." But the guy just wouldn't bathe. She refused to let him sleep in the house, so what did he do? He took newspapers and put them in his 1936 Ford coupe. The next day he got up in the morning, ate breakfast and lunch in the house, and went to work. He left a month later. Then there was a paranoid vet who always carried a big knife with him wherever he went. My uncle would bait him. He'd say, "I'm gonna get you, you son of a bitch." And the guy who was disturbed would pull out his big knife and say, "Don't you come near me," in his strange, slow delivery. While he was sleeping my uncle took the blade off his knife and welded a bolt and a nut to the knife handle in its place. This was very disturbing for the poor fellow.

Swedish farmers are not all that talkative to begin with, but in Minnesota they were the most taciturn people on earth. They rarely spoke. They'd stand on a street corner and entire conversations would go like this:

"Yah, are you in town today?"

"Yah, yah, yah."

"The fields, ya know."

"Oh yah, yah, yah, the fields" (meaning it was too wet to plow).

"Maybe two weeks."

"Yah, yah, maybe two weeks, yah."

If someone started going on and on about something he was going to do, they'd say, "Yah, beer farts and bullshit wishes." They were very no-nonsense, practical people.

In the winter the farmers would go to the Lyric Theater to see a Betty Grable musical straight from cleaning their barns, with cow manure on their overshoes. You had this incongruous combination of Betty Grable, Hollywood glamour, and the acrid stench of ripe manure.

Then there were the jokes about Lena and Ole—a Swedish couple of stupefying earnestness. Lena hears a noise downstairs. "Ole, wake up," she says, "I think I hear a burglar." Ole goes downstairs and says to the guy, "Our money is in the buffet cabinet, our jewelry is in the bureau drawer." "But I'm not a burglar," the intruder tells him, "I'm a rapist." So Ole yells upstairs, "Lena, it's for you."

•

Aside from the few interesting people in my family—my grandfather, my uncles Frans and Albert, and my cousin Archie—most of my other relatives are normal and have nice families. They raise their families and their families raise families. I wanted to get out of that mold. I wanted to get out, period. I wanted to take the long way home.

By the time I was a teenager I'd found my way out by picking up pieces here and there, like clues to a puzzle. I'd found a way of looking at the world as disconnected images brought together for an unknown purpose. Without realizing it, I deliberately sought out the incongruities that would match my memories.

Fuel Tanks and Egg Tempera

GRAIN SILO PAINTER

PRE-REVOLUTIONARY CUBA

ART STUDENTS LEAGUE

My mother always encouraged my interest in art. She was very talented: she played the piano and her paintings were pretty good despite the fact that she'd never studied painting. Like many amateur artists, her subject matter was limited and predictable. She did the kind of kitsch paintings of waterfalls and autumn leaves that you'd find in dime-store reproductions.

I had a natural aptitude for drawing, for seeing things in perspective and setting them in the right scale, but my range of subjects—cars, planes, boats, and battle scenes—was not all that much broader than my mother's. When I was fourteen, I painted a watercolor of a sunset and won a scholarship to study art for four Saturdays at the Minneapolis School of Art. I knew I was involved in serious business here, because they gave us erasers that cost twenty-

five cents and paper that cost thirty-five cents a sheet. I drew and painted gouaches.

One day my teacher asked me, "Have you ever heard of French nonobjective painting?"

"No," I said. "What's that?"

"Well, let me put it this way: Have you ever painted abstractly?"

"No," I said, "I paint things as real as I can."

He asked if I had ever heard of Jack the Dripper. I think that's what they called Jackson Pollock. Like most people, I knew a little about modern European art, about Picasso and Salvador Dalí, but this was the first time I heard about the new American postwar art.

I had seen very few books on painting and most of those were in black-and-white. Up to that point I was much more familiar with magazine illustration, the kind you'd see in adventure magazines, pulp fiction, and girlie magazines. A well-known painter who did watercolors for the covers of these magazines was John Pike. Another illustrator whose work I noticed was Hardie Gramatky. I used to examine *The Saturday Evening Post* covers and I became curious about who these artists were. I found two books about two of those artists: Stephen Dohanos and Norman Rockwell.

I read about how in back of their mansions they had small studios where they took photos of models knifing each other and embracing, or singing the national anthem, and they would use these to compose their illustrations for the covers. *The Saturday Evening Post* paid a couple of grand for a cover, a serious amount of money at that time. Norman Rockwell was the most famous of these artists.

The *Saturday Evening Post* artists would do all this prep—models, black-and-white photographs, renderings in pencil—then they'd paint their covers in an old-master-like way. I was about seventeen or eighteen when I first saw these pictures. They seemed fantastic to me. At that time I was looking for sources of inspiration in fine art, but I couldn't find the kind of revelation I was seeking, so realist illustration was my first encounter with art.

There were few examples of modern art at the Art Institute and, in any case, modern art meant something different back then. It didn't mean contemporary; it meant Picasso, Matisse, Braque. Pollock was the first modern, abstract American artist who people argued about. There were articles in *Life* magazine about American

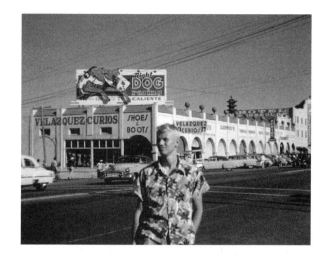

In Tijuana, where my father and I drove in 1951.

artists before Pollock, but they were all figurative painters. They'd have a few spreads in the magazine of paintings by World War II artists like Eugene Speicher and Gandy Brodie, who was in the Marine Corps—and that was modern art. According to *Life* magazine it had just about gone as far as it should go.

I was beginning to think about what I was going to do in life. In 1951 I flew to Los Angeles on a Lockheed TWA Constellation with my father. I was seventeen, and California was a big wide screen with the ocean and the Sierras. I saw all these Brit motorcycles. I'll come out here, customize a car, and go surfing, I thought as I looked around. This is incredible! This town is going to grow. It was the idea of "go west, young man" and having fun. For a while I considered becoming a cattle rancher out there, but I decided to return to Minneapolis and think about it.

In 1952 I graduated from Roosevelt High School in Minneapolis, and all I wanted to do was go back to California. I just wanted to buy a motorcycle and *go*. "I want to drive to California and live there," I told my mom.

"Jim, you should go to the university," she said.

"No, I know what I want and it's out in California," I argued with her.

"Why don't you register anyway?" she said in her wisdom.

The University of Minnesota was a state school, so I registered even though I had no intention of going. I ended up attending the university; I studied humanities and art and found it a lot easier than high school. In high school all I did was goof off. I worked

nights driving a truck and had no time for homework, so I neglected my studies—everything except art, which I always had a feeling for. When I began college I was surprised that I was getting such good marks.

So, from 1952 through the spring of 1954, I attended the University of Minnesota, where Cameron Booth became my mentor. He was an incredible painter. He drew realistically, he was an unbelievable colorist and, later on, a colorful abstractionist. After serving in World War I he'd studied in Munich with Hans Hofmann and later, in the 1940s, taught at the Art Students League. From him I learned oil painting, egg tempera, and Renaissance-style underpainting. I studied perspective, color theory, and figure drawing with him. My first encounter with modernism came when I went with him to the Art Institute of Chicago (where Cameron had taught) when he was trying to get a student, Mel Geary, a scholarship.

With Cameron we went to see the old master paintings, the impressionists, and Matisse at the Art Institute. I was overwhelmed by the art I saw there. Living in Minneapolis, I'd looked at some art books; I'd seen paintings by European modernists and old masters—but only in photographs. You can't tell about the texture of a painting, the brushstrokes, and the drips from a reproduction. I was just blown away by how sloppy these paintings were up close. They were made by hand, done with a paintbrush, painted with thick buttery slabs of color. Oh, I thought, so *this* is modernism.

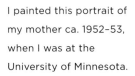

I painted this portrait of my mother ca. 1952–53, when I was at the University of Minnesota.

Cameron Booth was tall, with a mustache—distinguished looking and very British in manner, though he was American, and like the old-time artists he wore a smock when he painted. He was one of those 1950s abstractionists, and his paintings glowed with an inner light. He had been out West in the 1930s helping the American Indians, and in New York he became a famous teacher who had attracted a lot of protégés—Wing Dong, Seong Moy, and Joe Stefanelli studied with him. He was just gaining a reputation for himself as a painter when he fell in love. His friend Will Barnet tried to persuade him to stay in New York and follow his heart. "Why don't you divorce your wife and marry this girl?" he asked. But Cameron's father had been a man of the cloth, so Cameron couldn't bring himself to do that, and he ended up going back to his wife. That was his downfall. If he had stayed in New York, he would have had shows, because he was that good; he would have become known and his work would have evolved. Instead he went back and became a secluded teacher at the University of Minnesota—it was as if he'd fallen off the face of the earth. Unfortunately Cameron had no children, and when he died, I don't know what became of most of his work. He did some beautiful paintings. I only have a couple of them, but I would have liked to have owned more. I heard that a few of his paintings got swallowed up by a little gallery in Red Wing, Minnesota.

I wanted to learn composition, how to create dynamism in the picture plane. With Cameron I studied composition by focusing the way a Hollywood cinematographer frames an image. I drew six portraits a day. After you know how to draw, the question becomes what do you do with it. At that point you don't know whether or not you're any good, and, as a student, you're generally herded into doing things.

When I was seventeen I answered an ad in the *Minneapolis Star-Tribune:* WANTED ARTIST/SIGN PAINTER APPLY W. G. FISCHER. I went to see this W. G. Fischer, who had a paint-contracting business. He was a gruff guy, still dressed in his army clothes. He wanted me to paint Phillips 66 emblems on gas tanks and refinery equipment in South Dakota, North Dakota, Iowa, Wisconsin, and Minnesota. He offered $1.60 an hour. Mr. Fischer was very democratic. He hired anybody. He hired people straight out of jail.

I began working on my own out of a truck in Iowa painting signs;

then they said, "Well, Jim, meet up with us in Black River Falls, Wisconsin." During those summers, I got my first taste of the wild side: traveling with the crew of the W. G. Fischer Company across the Midwest. It was a crazy bunch: some were Fischer's relatives, but more were jailbirds. There were sleepless nights in hotels with this hard-drinking group, sometimes sleeping rough on tarps out in the fields.

I was seventeen, and they were at least ten years older than I was, so they figured that because I was just a kid, they didn't have to beat me up. We'd go in a bar, they'd bellow: "Give the kid a whiskey sour!" "Nah, he's too young. Give him a malted milk!" "Nah, give him a gin and tonic!" They'd make me drink all these drinks and get rowdy. It now seems like a dream—if you strung these scenes together in a film, it would make a very strange movie.

We got to the next location, a little one-horse town—nothing there but these huge gas tanks we were to paint. Nothing to do at night: no bars, no movies, no hotel rooms, no nothing; not a soul in sight. At one point we got in a truck and went to the oil fields in the western part of North Dakota. We arrived all covered with dust and there were no rooms in any of the hotels, so we went to sleep on a tarp under the stars. Six people sleeping on dirty paint tarps. It was like an *On the Road* type of adventure.

And then in the morning we discovered something really strange. We were sleeping on the grass, and all of a sudden we hear a lot of noise. It turned out, in the middle of the night circus people had appeared and started setting up. We woke to find an entire circus—animals, tents, a Ferris wheel—in an adjacent field. Soon people began coming from all the towns around, with the men saying, "Watch out for them guys, watch out for your daughters." I picked up this nice country girl, Florence Erlenbusch. I wonder where she is now.

Next day we got a hotel room and the guys got ahold of a bottle of Everclear, 180-proof alcohol. They had a few shots of that and they got seriously unruly. A couple of snorts of Everclear was enough to set Wally off; he then tried to rape the girl who worked at the drugstore. He was so drunk and out of control that several times we had to grab him and let him have it and drag him back to the hotel. This farmers' hotel had big clean rooms with three or four beds in them. We'd be fast asleep when in the middle of the

night Wally would start peeing up in the air. "Oh shit," one of the other guys would say. "We gotta get out of here. Man, this is so embarrassing we gotta leave town."

The following day we worked like hell. Next night we were all beat-up tired and trying to avoid going back to that place, but when we went to the other old hotels in town we were told there was no room. We had no choice but to go back to the same hotel. The hotel said nothing and put us back in the same room.

I continued to travel around with this bunch of guys, who all lived in Minneapolis. When I finally got back home I thought, I'm going to go over and say hello to Wally. I go to his house and he looks through the shade. He'd been in the slammer—and had that convict mentality of being suspicious. His best friend, Red, had come back from Korea, and he had a big fat sister he wanted Wally to marry. But Wally didn't want to marry Red's sister, so what does he do? That night he walked down the street and robbed every gas station he encountered. They're closed by that time of night, so he broke in and took the money. After about the fifth gas station he found a gun in the drawer, put it in his pocket. Just then the cops arrived, put a gun in his back, and got him for armed robbery. He went to the slammer. Now he was happy. He doesn't have to marry his best friend's sister and, consequently, doesn't lose face. That's the way it was with these guys.

The Korean War began in the summer of 1950 and went on until the summer of '53. Two buddies of mine were put in the army; one came back dead and the other with a broken collarbone. The Korean War was the first war where you couldn't be a conscientious objector. You'd get eighteen months in the clink for resisting the draft. I failed the draft because I had a stiff left wrist from an infection I had in 1948.

My parents were very supportive of everything I did. They had no money, but whenever I said I wanted to do something they'd say, "Why not?" When I told them I wanted to hitchhike to Florida, they said, "Do it!" I went to Florida, and to Cuba. Our family had always been nomadic so they understood my wanderlust. I didn't realize it at the time, but their attitude saved my life.

In the summer of 1953 I hitchhiked to the motorcycle races in Daytona Beach; in '54 I hitchhiked to Florida again and then on to Key West. When I was first in Florida it was extremely rustic: no

superhighways, not many paved roads. There were palm fronds and oranges on the highways—and no air-conditioning, except in supermarkets. In houses all people had was ceiling fans.

I was hitchhiking down the road by myself. I'd gotten a pretty bad sunburn waiting for a car to come along. Around seven o'clock at night, just as it was getting dark on some lonely highway, I heard a voice coming from a bush saying, "Boy, you gonna *die* out there! Why dontcha come on in and have some chicken dinner with us." So I went inside this nice wooden house and there was a family with their kids who'd just come back from college. It was a big old-fashioned house with ceiling fans. They'd just finished eating, and they fixed me up with a chicken dinner and a glass of lemonade. "We got a gator in the backyard, too," the father said, just as casually as, "Have you seen our Pomeranian?" I went to take a look at their alligator, said, "Well, thank you very much," and walked around to the front of the house, got back on the highway, and started hitchhiking again, heading south to Miami.

I traveled about the state as an itinerant painter. I'd brought my watercolor kit with me, and I painted watercolors of the marinas, the old black shantytowns, the palm trees. But nobody cared about art in those days; nobody went to museums. Everyone was out on their boats except for the old guys sitting in their chairs in front of their fifty-foot cruisers. They'd never take them out—too danger-ous. They'd have parties on them, sleep on them, but they'd never leave the harbor. Florida was strictly an outdoor place until the New Yorkers moved down there, and when they came they wanted culture. They wanted something other than the marinas and minia-ture golf and Fort Lauderdale.

When I got to Key West I was at the end of my rope. I thought, Hell, I might as well go to Cuba. It was only ninety miles away and I figured if I didn't go now, I might never get to go there again—which turned out to be true.

The travel agent was a big, fat lady. "How can I get to Cuba?" I asked her.

"Well, easy, you can fly there for twenty-six dollars round-trip."

"Okay," I said. "I'll go."

So I went out to the airport. They had an old army C-46 plane with no upholstery in it, and I got on, and in a few minutes I was down in Havana. On the plane I met a sailor: "Ah, how're ya doin',

how're ya doin'?" he said. He was very garrulous, and after talking for a few minutes, he mentioned the name of someone I went to grade school with who was now in the navy—Dick Malchesedic. "No kidding," I said. There aren't many Dick Malchesedics around, so this was quite a coincidence. We hung around Havana together, and then went to a bar to get something to eat. You had to be careful what you ate there, because you'd get a really killer stomach problem. I ordered a Bacardi ginger, *jamón y queso*. "That'll be seventy-five cents," the guy said. I took some wrapping paper, and drew the guy's portrait with his mustache and beard. He said, "Arrrr! *Mira!*" and put it up on the wall. Then the cost came down to the real price: thirty-five cents.

The sailor had about fifteen rums, he was what they call a *borracho* in Cuba. Totally drunk, he stumbled against the bar, breaking all their glasses. He tried to pay for it, but they said, "No, señor!" We soon realized we were paying too much at our hotel, too—$4 a night. "God, this place is expensive!" I said. "We've got to get out of here." So the sailor and I tried to sneak out, but we got caught. The next day I found a room for a dollar a night at another hotel across from El Capitolio.

In Cuba schools and colleges were free, but poverty was so pervasive that some of the students I met couldn't scrape together enough money to *get* to school. Life was hard, nobody had any

I went to Havana in 1954, the year I graduated from the University of Minnesota.

money. I hired a guy in a zoot suit for fifty cents to take me around all day. He showed me all over Havana: the prostitutes on the street, the beautiful girls up in balconies, and the daughters of the bourgeoisie who were never allowed to go into the street unchaperoned.

The architecture was beautiful, but people were sleeping in doorways or on the roofs in tents on these great old buildings. There were rumblings that the revolution was coming. This was under the old Batista government—Fidel Castro was in jail after the assault on the Moncada Barracks the previous summer. Batista had set up machine guns on the lawn of El Capitolio in anticipation of a coup. I had a room overlooking the front lawn of the capitol. In the entrance of the capitol building they had mounted a huge Cuban diamond. I don't know whether it was a real diamond or just glass, but it was Cuba's most heavily guarded treasure. I stayed in Cuba about a week, and then came back home.

In 1954 I graduated from the University of Minnesota with a two-year Associate in Arts degree. At Cameron Booth's suggestion, the summer after I graduated I got a job painting billboards for General Outdoor Advertising in Minneapolis. I went to see the foreman, Henry Bevins, who was an amazing draftsman. He could draw a straight line from here to the equator—*ziiiiiiiiiip*—like that. In the warehouse there was an old guy painting a huge macaroni salad for Kraft Foods, a real juicy salad with dressing and big round macaroni pieces. I was very cocky, and I said, "I can do that."

"We can always use a good man around here," Henry said. "But we don't let anyone do that until they been here at least twenty years."

"Well, I'm telling you right now that I can do that."

"Oh yeah?" he says. "You think you can do that, do you? Okay, here"—and he hands me a photo of a boy and a girl drinking Coca-Cola—"take this and paint those two heads eight feet high."

So I ran around, found some paints, and mixed up my colors. I worked like crazy on that thing for eight hours; I'd been told that Coca-Cola was very fussy about their artwork. Then Henry came out, took a look at it, and said, "Sorry, kid, you don't have the swing." I was around twenty years old at the time. I came back about six months later; I don't know if he even remembered me. Anyway, same thing again. He said, "Yeah, we could use a good

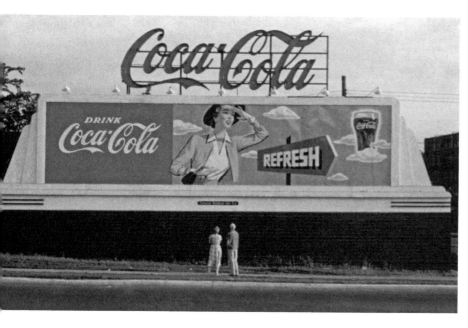

With my mom in front of a sign I painted in Minneapolis in 1954.

man around here." And there were the two heads for Coca-Cola again. I said, "*Now* I can do that."

An old painter there gave me some valuable advice: "Listen, kid, first you start with your paint—before you do anything, you gotta get that right. It takes you half a day to mix up all the right colors ahead of time, but once you've got them mixed you'll be able to paint that very quickly."

So I took care tinting, getting the exactly right color. I painted the two heads, a young boy and a young girl. One of them was drinking a big bottle of Coke. They had green eyebrows, green eyes, green hair, and pink skin—this was all done because from a distance, dark green eyebrows look black. You learn these tricks minute by minute, quick—or you're dead. The boss came around: "Not bad, not bad. Now move the nose over one inch and it'll be good." So I did what he asked and he says, "Okay, kid, you got the job." I was so pleased with my first big billboard that I got my mom to come and see it. She was very proud of me and happy that I had made a success—at that point I was making more money than my dad.

After that I painted eight big fur hats for *Davy Crockett, King of the Wild Frontier.* Just the hats. Then I painted a big bird on the side

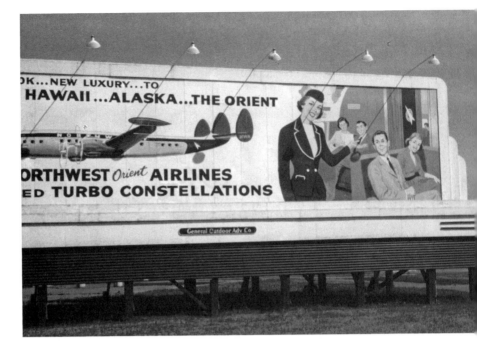

A Northwest Airlines billboard I painted in Minneapolis, 1954.

of a Corby's whiskey bottle from a tiny image of a bird. Next I painted a little boy two stories high plus a tuba with all the valves on the tuba gleaming and sparkling. The boss said, "That looks good, James, now paint another one." I painted another one. "Looks good, James, now next week you can paint another one." I painted five of them; I was so tired of that boy and the tuba I started painting it left to right, upside down. I made good. I got one hell of a lot of experience doing that. I also painted ads for Northwest Airlines.

Working in commercial art sharpened my drawing and painting skills—I learned how to mix colors and how to interact with people from every walk of life. Later I got laid off, but by then I'd saved some money. Now I knew I could always make a living. I'd never starve because I could always get a little paintbrush kit and hitchhike down the highway like the old-time painters who traveled around the country painting tobacco signs, stock signs, signs on trucks or barns. I could paint anything anywhere in the country and make a dollar. I felt like a bird, totally free.

At the Sign Painters Union in Minneapolis, I met the union rep. First thing he said: "Where'd ya learn how to handle a brush, kid? You're gonna haveta join the union, ya know." He was ninety-nine

years old. He'd been a boy piano player in a medicine show in Jackson Hole, Wyoming, in the 1880s. He told me stories about the real wild frontier. He was a kind of repository of the old ways; he carried pieces of the nineteenth century around with him, and it was through him I realized I was only a couple of generations away from the legendary West—it was still so close you could almost touch it. A fascinating old guy. He said in the days of the Wild West, he'd go into a saloon with a big long wooden bar, and in the corner there would be a desperado eating a chicken with two guns lying beside the plate and nobody bothered him. He said one time he'd seen two cowboys arguing at the bar. In the middle of the argument one of the guys says, "I don't argue, I kill," and he shot the guy right on the spot. The other fellow just crumpled up like a rag and then the guy who shot him walked to the front of the bar, out the swinging doors, got on his horse, and rode away. Nobody followed him.

I saw a bit of wild life right in Minneapolis as it happened. I used to go to these things called Mau-Mau parties with my friend Melvin. I'd to go to this jazz club in North Minneapolis, up on the Olsen Highway. The bass player Edmond Thigpen came from there. At one of these parties, a muscle-bound guy named James Grimes pulled a gun on Melvin. There were some twenty-five people at this party, all black. I was the only white person there. Melvin says, "You got your gun out now. You better shoot me." The guy couldn't shoot, because of all the witnesses, so he just put his gun back in his pocket, embarrassed.

I was doing well at Outdoor Advertising, but unfortunately the boss had a son who was an absolute jerk. One day, he sent his son out with me as my helper. We went to work on a billboard in St. Paul. We were standing on the top of a building and from there we could see secretaries in offices across the street and they could see us. This kid would shout down to them, "Hey baby, how about a date?" I said, "Listen, Jack, if you don't stop that you're going to get us all fired." He was a pain in the ass, but you couldn't exactly squeal on him to the owner—I didn't feel it would do me much good to tell him his son was a jerk.

One morning in the summer of 1955, we were all at this plant ready to go to work when this kid starts screwing around with me. I got so pissed off I went for him. Just by luck, I'd seen this neck hold

on a wrestling show on TV the night before. I got the guy up around my neck and above me and I started spinning him around. I was about to drop him on the cement when his father walked down the stairs and into the room. I gently put the boss's kid down. "Thank you very much," I said, "but we can't work together anymore."

What was I going to do? Where was I going to go? Here I was in the middle of the United States, and being smack in the center of the country the big decision was whether to go west to California or head for the East Coast. In 1973 I did a painting called *Slipping Off the Continental Divide*, which was, in part, about my dilemma. The Continental Divide runs down the Rockies from Summit Lake in Wyoming to Antelope Wells on the Mexico border, and if you're standing there and you pee toward the east, your pee goes to the East Coast; if you pee in the direction of California, your pee goes west. I left home when I was twenty-one years old. That was it. I never went back. One way or another, you leave your home; I slipped off the Continental Divide.

I used to listen to New York radio stations at night. I liked the hipness, the sound of a city that never slept. So I thought, Whatever I do, I'll go east to do it, because the East is more literate, more European, more educated—it was just smarter to go that route. After settling my affairs I'd saved about $350, which I thought was a lot of money.

Cameron Booth was also encouraging me to go to New York City and study. "There's nothing for you here in Minneapolis," he told me. "Why don't you do what I did and study with Hans Hofmann?" But Hofmann had quit teaching at his Eighth Street school and relocated to Provincetown. "So, what do I do now?" Cameron suggested I try to get a scholarship to the Art Students League. I tried for an out-of-town scholarship at the League and won it. But the scholarship covered only tuition. I arrived in New York City in September 1955 on the night flight from Minneapolis, with less than $300 and a list of restaurants where you could eat cheaply.

I went straight to the William J. Sloan YMCA on Thirty-fourth Street. Just the week before, somebody had been pushed out the window there and killed, but I didn't know about that until I'd been there a few days. I paid $1.79 a night and made my own bed. The first morning I went down to the cafeteria to have breakfast and

then walked outside. I took a look at the Empire State Building and went right back in and had another cup of coffee. The place was so big I had to sit down and think it over for a while. I walked up Seventh Avenue to Fifty-seventh Street, looked at the Art Students League, and walked in. The secretary, Rosina Florio, claims I jumped up on one of the desks and said, "Hi! I'm here now. I made it, I finally made it!" She later became director of the League, after Stewart Klonis died. I used to have drinks with Klonis at the Russian Tea Room when I was a student. I once asked him, "What was Jackson Pollock like?"

Stewart was straight off the shoulder; he told you exactly what he thought. "You know, he's about a sixth-rate Benton student," he told me. "I used to see him in Vincent's Clam Bar down in Chinatown and he was always drinking wine. He asked me for a job, and I said, 'How can I hire anyone who drinks wine all the time?' But look what happened later!"

There were two Klonis brothers. One lived a very bourgeois lifestyle; they were classy people. In those days artists who did commercial work lived well; you could have a great apartment for $300 a month. One had some money, but at that time fine art was a private thing. They would have cocktail parties and show each other their work, but not in galleries.

The Art Students League had produced painters from the Ashcan school of painting like George Bellows, Robert Henri, John Sloan, and Thomas Eakins, among others. There I got a chance to study under a group of artists with very different styles and techniques: Will Barnet, Edwin Dickinson, Sidney E. Dickinson, George Grosz, Robert Beverly Hale, Morris Kantor, and Vaclav Vytlacil. Later I met Hans Hofmann, who was my teacher's teacher—he was a real schmear painter. I saw some of his drawings from Germany. Amazing sketches of trees and houses.

George Grosz is known today as the artist who drew devastating caricatures of greedy businessmen, lecherous army officers, and grotesque prostitutes, but he was actually a very accomplished painter in the traditional style. For me he made a drawing of light shining through figures with cross illumination and shadows, abstract and very old-fashioned at the same time. He knew a lot about painting and had a very delicate touch. Unfortunately, I can't find those drawings now.

Grosz was very quiet, very German, but also a very social person. He gave me a cigar once. He loved to go to parties and he'd invite me to ones with fancy older women who liked him. Grosz was a real ladies' man. He liked women of all shapes and sizes. Occasionally I'd go with him to these parties. I was so poor and all I had to wear was an old pair of dirty khakis and a sweatshirt. I was always amazed at these beautiful penthouse apartments he'd take me to. I thought these people were incredibly rich, but maybe they weren't.

Edwin Dickinson was a very different kind of painter from Grosz. He made very subtle, almost ethereal paintings. Dickinson would do a painting of an air shaft in a tenement with the light coming through. There would be an imaginary plane, like on the surface of the pond in a Monet painting where the sky is reflected on the surface with fish swimming in the water below. They were very soft and mystical.

Robert Beverly Hale was a strictly figurative painter; his focus was the makeup of the body. He had a skeleton hanging in his studio and in his class. He knew all the muscular systems in the human body. Anatomy is like a vocabulary—you forget it sometimes and then you brush up on it when you have to draw some exotic character. You know underneath there is the skull, cartilage, and the bones. All noses are made of the same cartilage. Some are fat and some are skinny. But given that variance, all human structure consists of the same matter with the armature of the skeleton underneath it all, and to know that is extremely helpful. With that knowledge you can draw figures in action without needing to have a model in front of you, but simply project all the tendons, muscles, and masses in your mind. George B. Bridgman had been my teacher's teacher, and was the classic anatomy teacher before my time.

That kind of teacher isn't around anymore, there's nobody even near that caliber. All the people I studied with were true artists of the old school who had mastered composition and fine art. At the same time there were commercial artists teaching there, too. People like Robert Brackman, who painted covers for *The Saturday Evening Post*. I admired them, but that wasn't my interest at all.

I could already draw well when I got to the Art Students League. Sometimes people say to me, "I can't draw a thing to save my life."

"Wait a minute," I say. "Have you ever drawn a map to your house so someone could get there?"

"Yeah, that I can do, but . . ."

"There you go," I tell them. "Start there and you might be able to use your skill to draw something else. Do whatever you can do and just go on from there."

There are a lot of methods for training your eye and your arm based on the idea of accuracy—like Marine Corp pistol practice, for example, or the concept behind *Zen in the Art of Archery*, where you're supposed to hit the bull's-eye with your mind. *Zing!* It's a psychological kind of accuracy. Between mind and pointer, there is a muscle that lets you draw things.

Before the League, I'd developed that muscle myself. I could already paint pictures—movie stars, soup, salads, macaroni and cheese, beer, Coca-Cola, and Davy Crockett coonskin caps— because I had worked on billboards in Minneapolis.

I could draw a figure with his feet planted on the ground. What I wanted to know was how to do something dynamic. I wanted to learn the "golden mean" rectangle. I wanted to learn about cubism. That was Cameron Booth's thing: plasticity in making an exciting picture plane. That, for him, was the most important thing, not becoming a social realist or a commercial artist.

At the Art Students League I did abstract paintings and a few realistic drawings of models. In those days—and I'm talking fifty years or so ago—painters, even abstract artists, would paint out-doors. When I was a student I went into Central Park and painted scenes—this sharpens your natural color sense and your drawing. Understanding color and how to mix color is critical: making black out of red and green, for instance, or black from ultramarine blue and orange.

I went to the League hoping to learn how to paint murals. I had already painted billboards back in Minnesota, but I didn't know how to scale images up very well. At the Art Students League, I looked in vain for mural painters, but the people who said that they had painted murals had only painted large canvases, something like six by seventeen feet. That was a mural to those artists.

So, I was still faced with the question, where could I learn mural painting. I looked at billboard painting again, and I thought, That's

where the tradition lies, right there. That's where these old men mix up gallons and gallons of paint. They cover huge areas with imagery by scaling images up from sketches. They create something large using the grid method. Sometimes the grids would go from a quarter inch or an inch to three feet, so a pencil line in a sketch would be almost a foot wide up on these big buildings. How does one deal with that. That was my question. I was not fascinated with the subject; I was fascinated with the technique.

When I got to New York I hit the streets right away. I walked everywhere. I never took buses or subways. My legs got tired from the cement. I walked to the League and back to wherever I was living. After four months in New York, these two girls asked me, "Would you like to go out to the racetrack?" I remember getting in the car and thinking, Hmm, these are nice, nice seats! My experience in New York created a total transformation in my thinking about material things. It got to be so I didn't care about cars or bikes or anything like that.

New York in 1956 was an entirely different place. The elevated subway tracks were still up as far downtown as Chinatown. The city seemed abandoned, almost gone—dismantled and taken away. Manhattan itself was fairly empty of people. The Upper West Side was virtually empty. Hoboken was empty. You could get a huge place for $40 a month. Why? Because when the army vets came back, they moved out to Long Island or New Jersey. They left the city and the neighborhoods for the suburbs. Down in what is now Soho you had Hell's Hundred Acres, which had been the heart of the war economy: they manufactured gun parts down there. But by 1955 that was all gone. All the small factories that made machine parts and tools were closed.

Money was scarce then, too. It was hard to make a buck, but you could live well on very little because rent, food, and everything was very cheap. You could get bags and bags of food in Chinatown for $15. Artists I knew would buy big gunnysacks of pasta and rice and live on that for a month. You could survive on nickels and dimes. To live in such a cosmopolitan place for next to nothing was great. You could go to the Met for free and see Egyptian and Greek sculpture and Italian and French masterpieces.

I stayed at the Y a week and a half and then I got a room on West Fifty-seventh Street, west of Ninth Avenue, for $8.50 a week. Just a room with a sink and a toilet. I wasn't there for long. Then I got a room on Columbus Circle for $8 a week—a savings of fifty cents. My landlady was very eccentric. She showed me every room in her building—these small, cubicle-like rooms—and in every room there would be a dog standing on the bed. She was a wild old lady. She knew I had no money and would invite me down for spaghetti dinners. The apartment building was right across the street from where the Coliseum would go up, and that whole area was being torn down. I remember once sitting on my front stoop eating a sandwich. The demolition across the street was going on at a furious pace, and the air was full of dust. As I sat there, I watched the sandwich in my hand change from white to dull gray as the dust settled.

At the Art Students League they didn't give you a degree—no diploma, no graduation certificate, nothing on paper. When you left, all you got was the experience of having been there. You learned what you needed to learn and you left. My year was up. I didn't have much money from home. My parents sent me $25 a week for a while, but they didn't really have any money. I got out of art school and was pretty much starving.

My apartment was unheated, and so cold that it was better to just hit the streets. To stay warm, I used to go to the theaters where they taped shows with live audiences—you could get into them free. One evening in January 1956, I was walking on Broadway and I looked up at the CBS Theatre marquee, which read, TONIGHT— ELVIS PRESLEY! What the hell is an Elvis Presley? I thought. I stood in line. I was right at the end and after a number of people had gone in, the usher came out and said, "Sorry folks, no more seats." A few minutes later the usher came back and put me and this other guy right in the front row.

Elvis came out holding a guitar with his name embossed on it. His band was just two guys: Bill Black on bass and Scotty Moore on guitar. Elvis was dressed in a pink shirt with a skinny tie, black pants, a speckled jacket, and white bucks. His hair was a slick, jet-black wave. He wore it long and greasy in a pompadour that looked like the plastic hair on a doll. He stood still, but his whole body

vibrated with pent-up energy like some manic machine idling. Tommy Dorsey came to the front of the stage and announced, "Ladies and gentlemen, *Elvis Presley!*"

Elvis went *braaaaaam* on his guitar and right away cut his finger from the force of his strum. He was bleeding all over his guitar, but you wouldn't have been able to see it on a black-and-white TV. As soon as the music started, Elvis lurched forward, his knees buckled, his feet splayed. He grabbed the microphone as if it were some skinny stick figure of a girl, and launched into a frenzied version of "Shake, Rattle and Roll." When Elvis had finished, a couple of people in the audience clapped out of politeness. He sang one more song, a novelty number as if to say, "Hey, I was only kiddin', folks!" When Elvis was done, Dorsey came out and said, "Let's have a big hand for Elvis Presley!" But only about three people clapped. I was one of them.

The following Saturday, I was walking on Broadway and there was Elvis up on the marquee again. Same thing. I went in. This time fifteen people clapped.

The next week, once again I saw Elvis's name on the marquee. Now I was curious. I got in the same way. The audience this time was considerably younger, louder, and more restless, and when Elvis came out a few of the girls squealed. When he went into "Heartbreak Hotel," the girls screamed. He mumbled the words like a man in a trance, sleepwalking through this spooky hotel. On his last song, "I Got a Woman," he rocked out like some mechanical marionette under electric shock. His mouth contorted, his eyes looked one way, his head turned another, his hair shook, he went down on his knees. The audience found Elvis, and the waves of excitement flowed back and forth between him and the frantic crowd of girls in a state of religious ecstasy. He brought the house *down*. Everybody was clapping; the whole audience went rushing out onto Forty-fifth Street. After the show Elvis appeared on the fire escape and waved to everybody, and all the kids were going crazy. In three weeks his reputation had taken off like a brush fire. A week later I heard "Heartbreak Hotel" on the radio—it was number one on the charts.

When I was at the League I wasn't eating enough, and I got weak and caught a cold that turned into pneumonia. I ended up in the

welfare ward of Roosevelt Hospital. I wrote my parents a postcard from the hospital saying, "Hi mom and dad. I'm just fine, but I'm in the hospital with pneumonia." My dad worked for the airlines, so they got a free airline pass. They came to New York for five bucks apiece. I was amazed when they showed up. I got over the pneumonia in two weeks. The doctor told me, "James, I want you to buy breakfast every morning. The rest of the day you might get invited by someone, or someone will give you a sandwich or something, but always have breakfast." I followed his advice and I've never had pneumonia since.

While I was studying at the League I was only interested in art—and in staying alive. Then, in the summer of 1956, my life changed. Through my friend Ray Donarski I got a job as a chauffeur, babysitter, and bartender to the heirs of the Stern's department stores.

Ray and I went out to their place in Irvington, New York, on the Hudson—it was a castle they'd built for themselves overlooking the river. This girl, Joyce Stearns, came out in Bermuda shorts and asked Ray and me to jump into her Buick Wildcat. "C'mon, I'll show you the castle," she said. She took us to the castle, and then to lunch. After we'd eaten this huge meal, she said, "Well, boys, you want the job?"

"We'll have to think this over," I said.

We went outside and had a huddle in the driveway. Within two minutes we turned around and said, "Yeah, we'll take it." Of course we would: we were hungry. I went straight from being tired and hungry on the streets to living in great luxury. All of a sudden I was eating fantastic meals with the family. They had a 1956 Lincoln convertible, which I drove. They had a huge apple orchard but never took care of it. So we would go collect bushels and bushels of apples, and Ray and I would take them into New York and give them to all of our artist friends. I was doing a little abstract painting out there, but I was on call a lot. They asked me to take them everywhere in the car.

Roland Stearns was an heir both to the Stern's department stores and to the Bear Stearns brokerage house; his father had added the *a* to the name. Roland was a war vet and a mechanic and I liked him. "Good morning, old fellow, old sport," he'd say to me when I came down for breakfast.

I am doing a headstand on Roland and Joyce Stearns's Lincoln Premium convertible at their house in Irvington, New York, 1956.

I did both of these when I was living in the Stearnses' house. I had a great octagon-shaped space on the third floor with views over the Hudson that I turned into a studio. Untitled, 1956. India ink on paper. 25⅜ x 38⅛ in. (64.5 x 96.8 cm). Collection of the artist.

Roland was twenty-nine years old when I first worked there. Later that year he had a party for his thirtieth birthday. Superman came (old George Reeves), and John Heller the art dealer, the painter Romare Bearden, and a bunch of good-looking girls. At this birthday party I carved his head out of a big block of ice for the punch bowl. He got $16 million as part of his inheritance for his birthday, which would be like $400 million today.

Shortly after we'd started working there, Ray got $250 from his uncle to go make lace designs in Florence, so he left for Italy. The deal was that when he came back, he would take over both our jobs. In the year I was there, I lived high on the hog. Then, at the end of that year, I said to myself, This isn't my house. This isn't my television. I'm just a worker here. I don't own anything. And just about that time, Ray came back from Italy to take over the job. When I quit the Stearnses' I went back to my grimy, grubby life. Work was tough; I was homeless, broke, and everything else. Suddenly I had no job, nowhere to live, and I began thinking about trying to get work through the Billboard Painters Union.

In the spring of 1957 I was truly down and out. I'd lived really well at the Stearnses'; I'd made $50 a week and that was great, but now I had nothing. So I headed back to Manhattan where my fellow students at the Art Students League Takeshi Asada, Jo Warner,

and Alice Forman shared a loft with Chuck Hinman. They said, "Well, Jim, you could sleep there at night because we only paint there in the daytime." They had a sink and that was it—a toilet and a sink—but I slept there. One day, I went and got a quart of milk; I was standing on the street drinking it like a bum, and a real bum comes up and says, "Give me some of that!" And I said, "Fuck you! Get away from me!" I thought, Jeez, this is down and out! This is *really* low. It went on like that for a couple of months, and then the Stearnses said, "Well, there's a little more work up here if you want to do some work along with Ray." So I went back there and I worked doing some gardening and things like that.

I'd work at the Stearnses' and go back to New York on the train to sleep in this bare loft. One day I was sitting next to a guy on the train. "Hi," I said. "How ya doin'?" "Fine, and yourself?" "What do you do?" I asked. "Oh, my dad has a trucking company called Reale Trucking. And you?" "I'm a sign painter." "Oh, yeah? My dad really needs his trucks painted." So I went over and looked at his red trucks, and I did Little Orphan Annie lettering (I knew how to do lettering by then) with a crown like royalty on top of the *R.* I did it for fifty bucks a truck, and all of a sudden I had $150 in my pocket. Then Reale Trucking told the Burnham Boiler Company on the Hudson River about me; they made big boilers (I have one

in New York in my building). "Well, as a matter of fact, we have these trucks to paint with tons of lettering." And then my mother flew out to New York on a $6 pass. I was painting these trucks in a parking lot by the Hudson River with my mom sitting on a rock crocheting, watching me work. I took her out to dinner. Then, shortly after that, A. H. Villepigue Company in Brooklyn hired me.

Life is very peculiar. I've experienced many ups and downs, but for me the amazing thing has been the kindness of people that you encounter. At one point I had an apartment where Lincoln Center is now, for $50 a month. I didn't know what I was going to do, I didn't know how I was going to pay the rent, and one Sunday morning I remember sitting on the front step with no money in my pocket. I was hungry, and this fat guy came out all dressed up; his mother was the landlord of the building where I was living. "How ya doin' today?" he asked. "Not so good. I'm a little short," I said. He goes, "Here's ten bucks. Get something to eat." Then he said, "My mother is making dinner"—they were lace-curtain Irish with 25-watt lightbulbs, a lot of furniture—"will you join us?" And they gave me a nice dinner, you know, and that was just so unexpected. Then, I guess, shortly after that I got a job in Brooklyn and was able to pay my rent, but it was all touch-and-go. It was always touch-and-go.

Four Things You Need to Know to Paint the Sistine Chapel

SIGN PAINTING

ARTKRAFT-STRAUSS
AND BROADWAY

I'd been trying for some time to get into the Sign, Pictorial and Display Painters Union, Local 230, in New York City, but it wasn't easy. They kept postponing my appointments. I finally got a meeting with the old gorillas there on the board. Tough old Italian and Jewish guys. The union office was on Twenty-eighth and Lexington. When I walked in, they all stopped whatever they were doing and turned around to look me over. I told them I was hoping for work painting billboards.

"What do you want to join this union for, anyway? There ain't no work for you, kid," they said. "There ain't nothin' for you to paint."

I got up and made a speech: "I respect the rights of all the older

gentlemen here in the union," I said, "and I'm willing to await my turn."

"Haw, haw, haw!" this gruff old Italian said. "Awright. Bring two hundred and seventy-five dollars on Thursday." Fortunately I had saved enough money, and the minute I paid my union dues, they had jobs for me—jobs I didn't want to do.

"James, do you want to paint yellow lines on the highway?" the secretary asked me.

"Nope, I don't do that."

"James, you wanna paint numbers on the seats at the Polo Grounds?"

"No, I don't want to do that either. I paint pictures. I *only* paint pictures."

"Well, come back tomorrow."

Finally, they called me and told me there was something opening in Brooklyn at the A. H. Villepigue Company. The head painter there was very good. He was a guy with skin cancer, named Al White, from Tampa, Florida.

I got a job working on top of Stauch's Baths, where all these fat ladies would come up on the roof and take their clothes off. My helper Red Smith, from Red Hook, Brooklyn, and I were up on a metal scaffold painting a Seagram's whiskey sign, and when we looked down there they were in their birthday suits. I said, "Red, we better say something or we'll get arrested for being Peeping Toms."

"Yeah, maybe you're right," he said. "You say something."

"Good morning, girls," I called down to them.

The ladies were lying on their tummies, naked. One of them turned to the other and said, "Don't worry, Sadie, they don't look anyway."

Shortly afterward, Red threw his cigarette down; it landed on a paint tarp, which caught on fire. All these ladies grabbed their towels and ran naked off the roof. It was like a happening.

Then they gave me the job of painting the Hebrew National salami sign on the Flatbush extension. The script for Hebrew National was a little like the Superman logo, and it was very hard to duplicate. I could paint any picture you'd show me, but at that time I didn't know how to letter on a big scale very well, so within a month I was fired.

Right after that I got a job with General Outdoor Advertising in Brooklyn. I started to practice lettering again on a rooftop where Lincoln Center is now. They called me to go to work. At eight in the morning I went out to the offices of General Outdoor Advertising on Atlantic Avenue. None of the painters was there. They asked who I was. I said, "I'm the new man." They said, "Oh, the crew already left. You better take the subway out to the job." It was way out at the end of Brooklyn. Every day either you were taken out in a truck to the site or you went out and home again by subway.

After a while I got to know my way around Brooklyn pretty well. I worked in every single neighborhood. I painted signs all over the place. They would take me in a truck and dump me somewhere in Brooklyn with a helper, and I'd paint the sign. Then I'd take the subway back to Manhattan. I knew every subway, where it went and what it connected to.

I painted billboards above every candy store in Brooklyn. It was there that I really started to pick up the tricks of the trade. I got so I could paint a Schenley whiskey bottle in my sleep. I often was repairing messed-up signs that the old, drunken sign painters had screwed up.

One time a guy working on the other side of me was trying to paint the Canadian Club subscript—it's an elegant script—but he was so drunk he started to wobble, and the script went all over the place. The boss told me, "James, go out and clear that up, but don't say nothing, you don't want to embarrass the older painter." "Okay, boss." So, I went and fixed it. "Good job, kid, now keep your mouth shut." He was something else. They would tell me, "Jim, go out and fix that cross-eyed Schaefer beer drinker sign on the Williamsburg Bridge and don't say nothin'. We don't want to embarrass the old-timers, understand? You're a good kid. Now get outta here."

When they were ready to retire, my old sign painters would get a little crazy. They wouldn't give a damn. They were going to retire, so they would do weird stuff like tying a huge paint bucket that weighed almost seventy-five pounds on a thin little string; halfway down six stories, of course it would break on an empty lot and smash.

The first people I worked with painting signboards were old New York Communists from the 1930s. I went to my first union meeting on the corner of Union Square. I walked into a big room

and this guy says, "Hey, Jimmy, come over here, have a beer with us. Hey, Jimmy, sit down." So I sat down to have a beer with those guys. When I got up to go to the toilet, the head of the union came up to me—he's a tough little Italian guy—and says, "James, see that side of the room over there? It's all red. You get a little red on you, it don't wipe off." I said, "John, those are my fellow workers." "I told ya," he says, one time. "I told ya." That's all he said.

The Communists used to raise hell with the Catholics. One of them, a tough but gentle guy named Harold, looked like Mr. Clean.

"Harold," I said, "how come you keep talking about communism to these Catholics? You're driving them crazy."

"I do it 'cause I like to get a rise outta them," he'd say, and then he'd laugh.

One day during work, someone who, I was told, was connected to the Mafia showed me a picture of a pretty red-haired girl.

"She's my niece, ain't she beautiful?"

"Yes, she's beautiful," I said.

"You should take her out," he said. When one of these guys suggested something like that, you knew it was either a threat or a promise—but more likely a threat.

"But you can't fuck her and leave her," he said.

Hey, that much I knew. I knew if you went out with a Mafia girl and left her, they'd break your nose. Nothing more than that—one smack, that's it. I knew people it had happened to.

"I'm really sorry, but I'm already engaged," I quickly added.

"Aw, that's too bad," he said.

Billboard painting was very rigorous work. I was twenty-three and I didn't have a lot of muscles when I started, but I developed them pretty quickly. Pulling the scaffolding loaded with heavy stuff all the time was a real workout.

From everything that I knew about art, I knew what I was doing wasn't art, but I sure was moving a lot of paint around and painting a lot of different things.

For a while I tried to get into the Scenic Artists Union, but you couldn't get in there with a crowbar because it was a family affair, and you had to design a whole series of sets for an opera. If you

At Forty-seventh Street and Broadway—I'm on the lower right, my helpers are on the left. I did the figures, they did the background. The billboard took three weeks to do.

could get in there, you made a lot of money—it was really a passport to work, but the work was very demanding.

At Nolan Scenic Studios in Brooklyn, the boss would come in with a champagne bottle and tell the two artists who were there: "Look, see this champagne bottle? I want it four feet long, I want it this scale, I want it this big, and I want it to look exactly like this champagne bottle." "Right away, boss!" They'd go into the wood shop, cut down a huge piece of wood, put it on the lathe, carve the shape of the champagne bottle, sand it down, spray it with dark green paint, then hand letter the label *exactly* (everything was hand-painted, not printed; every little digit was done exactly) and they'd glue it on the champagne bottle, put some foil on there for a cork, and it would look just like the real champagne bottle. These guys were so incredibly talented they could do anything, plus the big stuff: painting clouds, painting hundred-foot-wide backdrops that went from the floor on a curve up to the ceiling. One of the last times I went to Nolan's, I saw two girls with sprayers painting clouds and I asked the boss, "When did you hire the skirts?" He laughed and said, "Aw, yeah, we had to do that, you know, we had to

I painted this Cadillac on the outside of an auto shop in Minneapolis, 1958.

let some ladies come in here." It was finally time for women's lib employment.

In 1957 I was laid off. I decided to go back to Minneapolis for a while. I didn't know what was going to happen; I left my phone number with Henry Pearson and told him to call me if I got any job offers. After I bought my bus ticket, I was broke and starving. I asked two sailors if they could spare a quarter; you could get a peanut butter and jelly sandwich for a quarter at that time. They gave me fifty cents and I got a peanut butter sandwich and a drink. I made it all the way to Minneapolis on that one sandwich. I picked up a little cash there painting promotional signs—automobiles on garages. It was hard outdoor work.

The union called Henry Pearson, but he never called me. Eventually I called him and asked if anybody from the union had ever tried to contact me.

"Oh yeah. They called you about two weeks ago."

"Man, why didn't you call me? I'm stuck out here in Minneapolis waiting for that call."

I jumped on the red-eye, which was a propeller plane (and cheap), and got back to New York. When I arrived at the union they told me my job had been taken. I went back to my loft to wait, and about a week later they called me and said a position might be open at Artkraft-Strauss; I had to go audition. For my audition I

painted this big head of Kirk Douglas—I came back thinking, Boy, am I going to show them. I did an eight-foot painting of Kirk from the movie *The Vikings*. I put tears in his eyes, saliva on his lips, and #5 makeup on his face. He looked *good*. Shiny blond hair, light glinting on his lips, a tear in his eye.

When old Mr. Strauss saw my painting of Kirk, he said, "Hire that young fellow. Hire him."

Finally I had a steady job with the Artkraft-Strauss Sign Corporation, painting billboards. Billboard painters use techniques like the Mexican muralists', but by the 1950s few people were interested in investigating mural painting. It was a kind of art associated with the WPA projects, post offices, and Marxists, but I had always loved the huge scale of Diego Rivera's and David Alfaro Siqueiros's murals. When I saw photographs of Rivera and his assistants working on a monumental mural celebrating peasants and factory workers, I liked the look of it—practical, craftsmenlike painters walking around in their coveralls, making no fuss about their art, just doing their work. I felt as if the craft of traditional painting had gotten mislaid; you no longer learned your trade from a master painter, but from books and classes, and it occurred to me that looking for art in art schools was like looking for your wallet under a streetlamp when you hadn't lost it there.

Billboard painting was really like an old master's school of painting. Training like that doesn't exist anywhere now. These people were journeymen artists, in a tradition that went back to the painters' guilds of the Middle Ages. The nearest thing to it would be for a kid to be mixing colors in an ink manufacturing plant. You would get to know color pretty well doing that. Of course, there are still the scenic artists who work on Broadway shows. That's quite a complicated business because they use water-based paints that dry darker and differently than when you are working with them wet. They have to use water paint so it won't catch on fire so easily. That would be the nearest thing to getting an education painting billboards.

Artkraft-Strauss was an old business with union workers. The old painters would say, "Hey, kid, come ovah heah. I wanna show you something." And they'd only offer once. If you said, "I'm doing something; don't bother me," they'd never try to show you how to do anything again.

My Astor Victoria billboard for the movie *The Fugitive Kind*, 1958; it was 395 feet wide and took up the whole block between Forty-fifth and Forty-sixth Streets.

Everybody I worked with was at least twenty to fifty years older than me. They were old guys; they needed money. Once when they thought I was in trouble, one of them offered me a gun with no numbers on it.

But I had fun, too. I used to slide down the outside of the Astor Victoria Theatre on two ropes—seven stories down—like Super-boy! When I made it to the ground, I felt great. You wear deerskin leather gloves, tape up your pants, put the rope between your legs and around one leg, break it with the toe of your other leg, and go all the way down without burning your hands.

They used to send me out to start the jobs. I painted the Astor Victoria Theatre sign, which was 58 feet high and 395 feet wide, seven times. I once painted an autumn leaf twice as big as a large living room, with a can of beer in the middle of it, and finished it in one day, something other workers would take a week to paint and all the boss had to say was, "You've got a run there, you've made a mistake, take care of that."

One day my boss paired me up with Pete Murray, one of the World War I vets. Pete took one look at me and went, "Whew, I ain't going out with that cocksucker." To which I said, "Oh, thank you." Murray had an open morphine prescription from World War I. We'd be working in Brooklyn and he'd start relapsing, let go

of the rope and go "*Woooooh!*" sliding down, and the rig would slip down along with him. It got very hairy and eventually I had to get rid of him.

Then there was Jimmy, who was sixty-one and a thief who would steal anything. We were painting a Kleenex sign on Forty-third and Broadway, and he kept walking back and forth, back and forth on the scaffold, which is a dangerous thing to do. The whole rig was jumping and swaying, bumping into the wall. So I said, "Hey, man, what in hell do you think you're doing? You're gonna get us both killed."

He just glowered at me. I went down for a cup of coffee, and as I was coming back up the rope, I looked up and I saw Jimmy standing on the scaffold with a two-by-four, waiting to bean me. I climbed on the scaffold; he kept following me around. "If you so much as touch me, you son of a bitch," I told him, "you'll be over." He put down the two-by-four. Later I called Jake Behrman, the foreman and my boss, and told him that I didn't want to work with Jimmy. "Jeez," he said, "I can't separate you two yet. I don't have enough guys." So I had to go on working with crazy Jimmy, never knowing when he was going to go nuts on me.

I used to go to work at eight in the morning. On the desk in the office would be a whole lot of images, some large, some small. The boss would be sitting there.

"What's up?" I'd ask.

Behrman (groany, creaky voice): "We gotta paint the Mayfair billboard today, and here's the stuff that goes on the sign."

Sometimes, when they wanted you to paint something, they'd just rip a picture of a piece of cake or a rose out of a magazine. Sometimes they wouldn't give you a picture at all. Once Jake Behrman told me to paint some bagels on the side of a building. "What bagels?" I asked. "Do you have a photo?" "Here," he says and hands me a package of bagels. "Go paint these as high as the ceiling."

A typical day: someone has made a pencil drawing of a big flower that is to go up one side of the billboard; in the corner are two movie stars, and on the bottom the CinemaScope logo. The first thing I do is take the photos of the different objects and scale them up to the size they were in the pencil drawing. The technique used for this is called the Brooklyn Bridge—for what reason I have no

idea. Using a one-foot ruler, you draw a series of squares on top of your sketch and then make diagonals all the way down, like a fan. I still use this technique to scale up images—I square off using boxed squares and just scale up the image from that. Because the boxed squares are all the same size, you can enlarge an image that's a few inches across to that's one foot or ten feet across.

I learned a few optical tricks at Artkraft-Strauss, like how to indicate that something came from a different kind of media. Behrman would hand me some black-and-white photographs and say, "James, here's some stills from the movie. Now go make them look like they're on a film clip. Put some blue in; it'll make it seem like you are looking at a strip of film."

Artkraft-Strauss became my painting laboratory. I studied the refraction of light on outdoor signs, different colors, the effect of paint on various surfaces, the special qualities color took on under certain circumstances, the juxtaposition of colors—which ones were complementary and which ones weren't. I experimented with scale, fragmentation, and collage. Working on billboards immersed me in the act of painting. It was a place to learn, and I had an opportunity to use—and spill—a lot of paint.

I learned about color and form while I was working for Artkraft-Strauss, and I soon began experimenting with ideas. I realized that what I was doing was working on vast canvases. One day our job was to paint a huge loaf of bread on the side of a bakery. I was the crew leader, working with three guys in their fifties and sixties. We had to prep the background, using a light gray, to get ready for painting the image on Monday. Each man mixed up his own batch of gray paint to match the sample we'd been given to copy from. Then, when the others went to lunch, I took a half cup of red paint and poured it into one guy's container, put a half cup of yellow into another, and green into a third, mixing them all so well that you couldn't tell. I wasn't being a smart-ass; I just wanted to try something.

After lunch the four of us got to work, each painting our sections of the wall. Then we all went down to examine the job. Only when we walked some distance away could we see—to my delight and their mortification—the painted-in squares in different tints of gray. What appeared close-up as a uniform expanse, at a distance transformed itself into a wonderful collage of grays. It looked like a patchwork of gray swatches, like a future Jasper Johns.

My sign for *The Visit,* on the side of the Morosco Theatre on Forty-fifth Street. The theater was torn down in 1982.

"Jeez, what happened?" the guys asked. I told them it must've been something in the chemicals. I remembered the four grays from the loaf-of-bread sign when I began doing my first paintings, using only gray tones. At first I would use a grisaille palette—blacks, whites, and grays—only occasionally adding a color, because I didn't want my paintings to look gorgeous.

All the tools you need to paint a billboard are paint, brushes, a two-foot ruler, and a blue-chalk string to snap the line. That's it. Extremely simple. I thought that if I could learn that technique, using these four things I could paint anything. I could paint the Sistine Chapel using just those four things. I might not have the content—but I *could* paint it.

I brought my Art Students League experience to sign painting. I had studied anatomy with Robert Beverly Hale, so I knew how to draw cheekbones, muscles, cartilage, and bones in the face. When I painted Hollywood stars—Kirk Douglas, Jean Simmons, Gregory Peck, all with faces twenty feet high, noses ten feet tall, and eyes a yard wide—I made them look good, not like the cardboard movie portraits you often saw on billboards. I painted Joanne Woodward

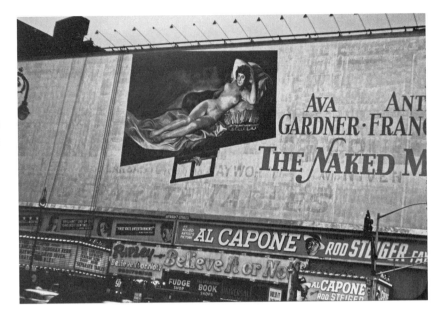

Another Astor Victoria sign, from 1958. I was told to make her private parts smaller before the canvas was dropped. This was for the film *The Naked Maja*, with Ava Gardner and Anthony Franciosa.

and Marlon Brando in *The Fugitive Kind*. I painted parts of *The Naked Maja*. The public complained about it, so they dropped an enormous canvas from the top of the sign to cover Ava Gardner's crotch. It had to be repainted.

The first inklings of what I wanted to do as an artist came through painting hair. When I had to paint the heads of movie stars twenty-five feet high on billboards, I'd start at the top. In the morning I'd paint the face down to the forehead, laying in these big arabesque curls and deep chiaroscuro swirls of hair in shades of blond, brown, or black. Painting a few inches away from it, the hair took on an abstract quality. It *swirled* into mystical locks and tresses and I began to ask, What does hair do? It covers the brain. All the thoughts that must be going on in that brain under this strange wavy substance. And ideas began stirring in *my* brain, too. I'd paint the eyes before lunch and from there down the cheeks, which would be painted in a big cosmetic blend shaded from skin tone to face powder and back again. These huge cheeks, twenty-five feet across, looked like the Sahara while I was painting them. Then, when that was done, I'd work down from the lip line to the chin and neck to finish up the head. It didn't take much brainpower, so your mind would be free to think, to look down into Times Square from way the hell up in the air.

One time I was putting green eyelashes on a face and the brush

slipped out of my hand. A guy was walking along on the street below wearing a camel's hair coat and the brush, as it fell, went right down his back and left a dark green stripe on it. He didn't seem to notice, just kept going. Once at noon off the Mayfair Theatre, at Forty-seventh Street and Seventh Avenue, one of the painters dropped a gallon of purple paint. It just exploded in the street. Ladders, paint cans—all kinds of things—used to fall off the scaffolding. Coming from that height, they could have easily seriously injured or killed people, but luckily nobody ever got hurt.

Another time I was on top of the Latin Quarter, painting a JOIN THE NAVY sign, when down below I heard someone shouting at me.

"Hey, you!" he called, so I made my way down the building to the ground. It was a navy ensign.

"Hi, I'm at the naval station on Staten Island," he said, "and I'm authorized to have you to paint this little Wave here." He handed me one of those tiny photo-booth pictures of a girl in uniform. It was the size of a postage stamp, a *small* postage stamp. "See that JOIN THE NAVY sign?" He pointed to a picture featuring two sailors and a Wave wearing hats. "This little girl just won the Miss Wave contest, so I want you to paint out the Wave who's up there and paint her picture instead."

"What color is she?" I asked. The picture was black-and-white and small, so it was hard to tell. "She's a little Georgia peach with blond hair," he told me.

So I drew two lines across this tiny Fotomat-like snap and scaled it up to fifteen feet tall. I made her a little blonde with rosy cheeks. I had no idea whether the painting actually looked like her or not. I didn't get any complaints about it, but then again, Miss Wave might have seen this cute, blond girl fifteen feet tall and not recognized herself.

While I was working on top of the Latin Quarter roof in Times Square painting that JOIN THE NAVY sign, five or more stories above me in the ironwork were electricians repairing lightbulbs in the Canadian Club sign. I was up on the scaffold and I saw a girl down below the roof of the Brill Building sunbathing in the nude. I was leaning over the edge to watch her when the two workmen five stories up dumped a couple of hundred lightbulbs on my head. As they hit me on the head, they made loud popping sounds all over me that were so loud I thought they were bullets going off.

Sometimes odd things that happened while I was working on billboards led me to intuitions about color and form. When they cut the movie stars' photos out of magazines for us to copy, each cutout piece of paper itself would have a shape. I was asked to paint Rossano Brazzi and Mitzi Gaynor from *South Pacific* on a big piece of Masonite that would be nailed onto a billboard. The carpenters had cut the bottom of her sailor suit with a jigsaw, and her foot looked like a whale or a sea otter—some sort of fish. I yelled at the carpenters, "You really fucked up my image." But that gave me an idea, because if you take an existing image and cut it out in contour it could end up looking like something else entirely. In other words, what you think is a face could turn out to be a whale—something totally the opposite just because of its shape, like a piece of a jigsaw puzzle. Kids, for instance, who haven't had the same experience as an adult, will ask, "What is the reason for that image being there?" Younger artists see things and just copy them but without knowing what the original idea was.

Painting billboards was nervy work, but I never had a fear of heights. When I was painting signs, I always had my hand on something so that in case I slipped I would have something to grab on to. When you work twenty-two stories up in the air, in all kinds of weather, one false step and you're dead. So you become like a spider. I got sprained ankles, backaches, sunstroke, and frostbite from working on billboards. When I got into the Sign Painters Union I was essentially a laborer again. I knew I didn't want to stay with billboard painting, but in the process I learned a lot and met a lot of very interesting people. I worked with Marty Napoleon's father. Marty Napoleon was a jazz pianist at the Old Metropole Club on Forty-seventh Street and Eighth Avenue. They had Woody Herman's band in there. It was fun to hang out with these guys, but the longer I stayed in billboard painting, the more deadened I became and thought I should get out as soon as I could. When I was sliding down the ropes outside the Astor Victoria Theatre, seven stories to the ground, I was getting bone scrapes and dents that were permanent, the kind of injuries football players get. But it wasn't so much about the physical aspects of the job—that period was a time of big mental change for me.

In 1958 I had to pull a rope to save a guy. He was a German

painter, an ex-paratrooper named Heinz. He would just paint until he dropped. He was trying to make a life for himself, but he would push things to the edge—literally.

"I must go on, Jim, we must finish," he'd say with the grim determination of a paratrooper at the Russian front—which he had been. One time I was working with him and I looked down and saw he was going over, leaning off the scaffold and about to fall, so I grabbed hold of his rope. It saved his life, but I ended up with a hernia, which is what comes of working twenty stories up.

One day Heinz and I were working across the street from where Madison Square Garden is now. I was painting a six-pack of Budweiser, a big two-story six-pack. At noon we broke for lunch. Heinz wanted to get a suntan so he put aluminum foil over his eyes and he took off his clothes. His body was covered in scars from bullet holes.

"What the fuck happened to you?" I asked.

"Zer vas a Russian front—da shrapnel hit me here and here."

And then he pointed across the street to the old Madison Square Garden.

"See that building over there?" he said. "There's a building just like that in Hamburg where I'm from, and during the war a British bomber hit the building *mit* a blockbuster. Six thousand people, they were all bomb-blasted out to hell. *Alles kaput*—all dead. I hate war. My mother was killed in a war. My father was killed in war. I never want to see war again."

After lunch, he got up to put on his clothes and he said, "You know what I think? I think dem West Germans are gonna go and clean out dem East Germans."

"You son of a bitch!" I said. "You're still fighting the war!"

"Yeah, yeah," he says, "I know."

Later on I would get some experience in the craft of painting things to be seen at a distance. At the Mayfair Theatre at Forty-seventh Street and Seventh Avenue, there was a big corner billboard for a movie, *The Roots of Heaven*. The *oo*s in *Roots* were forty feet high. I was on the scaffold trying to draw a perfect big oval *o*. It was black and yellow. I got down and the *o* looked like it was broken in the middle. This is a lesson in hard-edge painting. I went back up and blended the black and yellow until it turned this sort of greenish

yellow on the edges, but oddly enough from a distance the *o* now looked perfect.

One of the hardest things to paint was a photographic image on plastic. You couldn't paint the image directly on the plastic because it would just end up smudgy. What you had to do was put an area of color down with a brush—at first it's this really crummy-looking image—and then you spread the paint around with a pounce bag made out of cheesecloth and cotton. You stipple it until it looks photographic. It's a very tedious process using smeary oil paint on Plexiglas. I once painted Elizabeth Taylor in a bathing suit using this technique, and when I was done it did look just like a photograph.

At one point, I started the Castro Convertibles sign, the Mayfair sign, and the Astor Victoria sign—all at the same time. The Astor Victoria was the biggest sign in the world. It was on top of two movie theaters, the Astor and the Victoria. Three hundred and ninety-five feet wide, it took up almost the whole block between Forty-fifth and Forty-sixth streets. I would go up on the scaffolding and begin laying out images to paint. Start one and go on to another one and so on. They'd send other painters along to finish them up. I would come back later and touch up the images. In the meantime, the letterers, the background painters, and the filler-inners would come along and do the other areas. I think I can say that at that time I was the best painter in Times Square. Some of my fellow workers, like Heinz, didn't even know how to draw. His movie stars looked like cardboard cutouts.

I worked at Artkraft-Strauss until the end of 1959. I was quick, I was doing well; eventually I became head painter. One of my helpers was Marty's son Joey. More than thirty years after I'd left billboard painting I used to invite him over for Christmas from time to time. When his father died he became the labor union steward in the area. Remembering that little building on top of the Kleenex sign on Forty-third Street where we used to change our clothes, I asked him, "Joey is that little building still up there?"

"Yeah, it's still there," he said, "but it's been turned into a Mafia whorehouse now."

And then he told me this story: "I had to go up to the roof of the Kleenex sign and as soon as I get up there, this little Mafia guy

I am working on the Castro Convertibles sign on the Latin Quarter building at Forty-seventh Street and Broadway, 1959.

grabs me, and I shove him away. I say, 'Don't touch me!' He had two big black guys as guards. So I told him, 'If any of you guys shove me against the wall again, so help me God, I'll let you have it.' What else could I do? I broke my knuckle on the back of his head."

I asked him, "What happened then, Joey? Did they—"

"Nah," he said, "the black guys didn't like him either. They didn't make a move to stop me."

"But didn't the Mob come after you?"

"No," he told me, "the union settled it."

The union was tough, too, because they were Italian, so if we'd get into any kind of confrontations with mobsters or anybody, the union took care of it.

Times Square was still very seedy in those days. A lot of petty crime, prostitution, and drug dealing went on. I had a helper, Marty Parillo, Joey's dad; he was a short Italian guy, and we'd sit there having coffee in some place on Forty-second Street and watch the passing scene. These naïve kids would come in from the tunnel, small-time hoods, and they'd go, "Hiya, I got this knife here, what do you got?" "Do you have a gun?" "You wanna trade?" This and that. It was all done under table. And sitting right

there was a plainclothes cop that we knew—we knew everybody, we knew all of the cops, the undercover guys, the vice squad. The cop would sit there and watch these kids trading knives and guns; then as soon as they'd walk out the door, *pow*, he'd put them under arrest. We could see what was coming, everyone had his role—it was just like watching a movie unfold before your eyes.

One day I was standing in Times Square looking at the Astor Victoria Theatre. A reporter from the United Press came by and asked, "What are you doing here?"

"Man," I told him, "these are snake-oil ads. I'm really an artist, but I don't have any money. I'm making little sketches, and someday I'll have enough paint to make them bigger."

The headline in United Press International read: BILLBOARD PAINTER, LOCAL 230, IS BROADWAY'S BIGGEST ARTIST.

I was getting a lot of attention for my billboards, so I went into the office at Artkraft-Strauss and asked for a raise. I told them I wanted another $30 a week or I would quit. This was stepping way outside the union. If you're in the union, you can't negotiate or talk to management. I left that day. I went to the union and there was Dante Morandi, head of the union sitting there in his Al Capone hat. He asked me what was the matter. When I explained what had happened, he said, "Sorry, kid, but I can't do nothin' for you. You stepped outside the union." These guys liked me; I was a young kid—these veteran sign painters used to call me Baby Jimmy—and they wanted to help me. So they sent me to go to work at Seaboard for a couple of weeks. "I'll keep putting you on the bottom of the unemployment compensation list," Morandi told me. I went to work there for two weeks and then I quit. I collected unemployment for a long time after that. This was in 1959. At the beginning of 1960 I did a bit of billboard painting; I worked for Seaboard for two weeks, and then in the spring I quit for good.

In New York strange opportunities came up all the time. You'd run into people, and out of the blue someone would ask you if you wanted to do some crazy thing. You'd get offered unbelievable jobs, things so nutty your mind would freeze up. "You want me to do *what*?"

I was at a cocktail party once in the late 1950s with Howard Fast, the author of *Spartacus*. A producer came up to me and said, "The

This was very exciting for me.

tree got sick in *Winnie the Pooh* on Broadway. Do you want to be a tree?"

"I don't think so," I said. "I wouldn't make a very good tree." That was the weirdest job offer I ever got; it wasn't all that tempting.

A painter friend of mine met the producer of *The Andersonville Trial* at a party. "Would you like to be a stand-in?" the guy asked him. He ended up in that play for two years. Another artist I knew used to go to Stillman's Gym to draw the boxers. The manager asked him, "Hey, kid, the sparring partner got sick, can you box?" "I dunno," said the artist, and promptly became a boxer. Never heard from him again, either. It was easy to get sidetracked and end up a boxer or a tree on Broadway.

I had an apartment in New York for $60 a month, and I collected things off the streets for that apartment. Just stuff. Later on the only things in my apartment were a refrigerator, a kitchen table, and a mattress on the floor. No chairs and no stove.

One time, around Thanksgiving, before I had quit sign painting, I found myself on top of the Astor Victoria sign, seven stories up, painting a small MERRY CHRISTMAS sign. It was snowing. The two previous Thanksgivings I'd had my dinner in the Automat. I wasn't going to do that again.

When I got home, I went straight out to the supermarket. The luxury of seeing all that food was overwhelming. I didn't have a stove so I couldn't cook any of it, but I got a big frozen turkey anyway and took it home. I put it in my refrigerator, and I called three girls I knew from Atlanta who had a one-room apartment. "Look," I said, "I've got a frozen turkey. Do you have a stove?"

"Yeah," they said, "we have a stove, but we don't have a pan to cook the turkey in." So I called my friend Wing Dong, who said, "Got pan. I come over and cook turkey for you, but I don't make stuffing, and I don't stay for dinner."

"No," I said. "If you cook the turkey, you gotta stay for dinner."

Two of the girls and their boyfriends got some great French ninety-nine-cent wine and some vegetables. We had this big turkey dinner on the floor of their one-room apartment.

My upbringing in the Midwest was, you'd say, a typical lower-middle-class way of life. There I lived like any kid in the suburbs of Minneapolis. I'd never heard of *Howl* or *Naked Lunch*. People like Jack Kerouac, Allen Ginsberg, and William Burroughs were so far from my original life in Minneapolis, they might have been living on another planet. But once I moved to New York, I met underground people—the Beats, bohemians—people who lived the kind of life I'd only read about in magazines. My first art dealer, Dick Bellamy, was totally Beat. I met Larry Rivers and the poets Ginsberg, Frank O'Hara, Oscar Williams, and Amiri Baraka—or LeRoi Jones, as he was then called.

Everyone at that time was interested in French existentialism, bebop, and Beat writers. Bellamy, Miles Forst, Ginsberg,

Kerouac—they were peculiar people, a bit nostalgic, doomy. They were nihilists, really. Their mantra was "Nothing means nothing means nothing." They were funny, too—a whole group of wandering fellows who put value on the strangest things. They drove around in old cars, wore old clothes, and smoked French cigarettes and pot. The threat of the bomb hung over them and they spun negative ideas—Jean-Paul Sartre and Albert Camus were all the rage at the time. Life had no meaning, and it was all coming to an end anyway, so you might as well have a good time while it lasted. The end-of-the-world party had begun. But despite all the theatrical gloom, there was a lot of optimism and a sense of freedom when *On the Road* came out in 1957. Soon after that, the Beats began to get a lot of attention from the media and mainstream society. People were fascinated by these guys and at the same time, horrified. Beats made provocative guests on TV, but they were an utterly unpredictable quantity. After all, the Beat philosophy was totally opposed to the whole consumerist, capitalist, philistine, appliance-worshipping society of the 1950s.

While I was sitting in the audience at *The Steve Allen Show*—probably just to stay warm—I saw Kerouac's first appearance on TV. Steve Allen introduced him, saying, "Ladies and gentlemen, tonight we're going to have the So-and-So dancers and the So-and-So jugglers and—Jack Kerouac of the Beat generation. Ladies and gentlemen! Jack Kerouac." Jack came out in a long overcoat, hunched over, looking like a doomed character out of Dostoyevsky, and Steve Allen said, "Tell us, Jack, what *is* the Beat generation?"

Jack just sat there staring at him for a few seconds.

"*Nothing*," he said and promptly walked off the set, never to return.

So cool.

One day while I was still painting billboards, I ran into a girl I used to go to school with, a pretty, dark-haired woman named Virginia Chase, granddaughter of the painter William Merritt Chase. She invited me over for dinner, and there was Mary Lou Adams. She was Irish Catholic and had gone to Marymount. I liked Mary Lou immediately but we didn't make any plans to see each other. Then one afternoon I ran into her again at the Metropolitan Museum. I

used to sit behind the door of the twentieth-century wing. It was very relaxing just to be there; you didn't have to talk to anybody and the museum was practically empty.

I was sitting there in my paint-splattered clothes when this pretty girl in a flowery dress came in—it was her.

"Oh, it's you," she said.

I walked around the museum with her for a while, then I asked her, "Would you maybe like to have dinner tonight?"

"No," she said. "No, I can't. I have to go back to my mother's house and have dinner there. Would you like to come?"

I went to dinner and met her parents. Her mother was lovely, a big Canadian lady who was president of the Daughters of the British Empire and used to wear a feather in her hat. But her father was another story, a cranky old guy from Boston. He was eighty-some years old. He'd lost his printing business, Charles Adams and Sons, because he was too proud and too ornery. He could have sold it for a lot of money, but he closed it down rather than sell his name to another company.

Mary Lou was working as a commercial artist designing shirt plaids for a textile company. From one spot on the scaffold where I worked I could see her in a window across the street. I kept thinking about her and arranged it so I'd run into her on my lunch hour. The next time I saw her, she was standing outside the building where she worked in Times Square. Since I was working at the Astor Victoria Theatre and she was working only a couple of blocks away, we started seeing each other and having lunch together in Times Square.

New York City before Kennedy was assassinated was like living in another era entirely. Foreign dignitaries, even heads of state, wandered around without bodyguards. I was on 125th Street painting a Knickerbocker Beer sign when I looked across the block and saw cops with shotguns on the roof of the Hotel Theresa. What the hell was that? I climbed down and noticed Cuban soldiers standing around the entrance to the hotel in their beards and revolutionary outfits. Castro was moving into the Hotel Theresa. In his army fatigues and smoking a cigar, Fidel looked like he'd just come down from the Sierra Maestre and taken over the Havana Hilton. I saw him a few days later walking around Times Square.

Then, a little while after that, I was painting a bank sign above a deli at Thirty-fourth Street and Second Avenue, and four stories down was Nikita Khrushchev in an open car with three big, chunky Russian guys in boxy blue suits. No police escort, no nothing.

"I saw Khrushchev today," I told Mary Lou. "I threw a paint-brush at him."

"Oh no!" she said. "You didn't."

"Well, of course I didn't," I said. "But I *could* have."

One day when I was working in Brooklyn for General Outdoor Advertising, they said, "James, go out to this candy store and paint a two-story tall Schenley whiskey bottle on the side of the building." So I did.

"Okay, that's good, James. Now go paint another one." Well, I painted that same dopey bottle some 140 times, and by the time I'd painted my hundredth Schenley whiskey bottle I was beginning to get a little crazy. I was so bored; all that repetition was making me delirious. The label on the bottle said, THIS SPIRIT IS MADE FROM THE FINEST CANADIAN GRAINS, blah blah blah blah, in script. I got so sick of painting this damn thing that I began painting MARY HAD A LITTLE LAMB, ITS FLEECE WAS WHITE AS SNOW.

Now you couldn't tell that from the street, but the riggers who were helping could see what I'd done and they started to say, "What is he doing? Is this guy nuts?" They became afraid they were going to lose their jobs because I'd screwed up. I'd always known that advertising was ridiculous, but it would take me a little while longer to find myself as an artist.

From 1957 to 1959, while I was working on billboards, I was doing abstract paintings in my spare time, often using india ink. The variety of form that one can get from just india ink and water is incredible. Paul Klee was a master at conjuring spiky, nonobjective imagery out of a few lines in an ink drawing. The pieces I was doing were abstract, but in retrospect I think those early abstract paintings were subliminal collages. Some of these paintings from the late 1950s had imagery in them, although they were elements in abstractions; to me they now seem to be prototypes for the collages I would make in 1960 using actual objects.

I didn't have any money, so I occasionally collaged together

pieces of paper, ideas in pure color, as abstractions that had nothing to do with pop art. I would include a photograph of a girdle, throw in a photo of a bunch of pencils—things like that. When you don't have anything to work with, you try to make dynamic, nonobjective pictures out of what's at hand. I did tons of ink paintings. I would pour india ink into a ketchup bottle, put a pinhole in the lid, and make drawings by squirting the ink onto the paper. I could draw like crazy that way; I could draw like Pollock. It made the lines very dynamic, and they streamed with squiggly energy. Unfortunately, many of these early abstractions have disintegrated. I bought what I thought was good Swiss art paper, but over time it crumbled.

All the art students then, myself included, liked abstract expressionism; many aspired to be action painters themselves. It was a very vigorous and heroic style—you made epic canvases by splashing your psyche on the canvas. I loved the abstract expressionists as much as anybody. I worshipped Willem de Kooning and Pollock and Franz Kline, but I never wanted to look as if I were copying someone else's style. I wanted to do something *new*.

Zone

BEGINNINGS OF PAINTING IDEAS

When I think of it now, there were parts of my life that were very strange, particularly those periods when I didn't know what to do. The time I thought of raising cattle in California, the year I worked as a chauffeur and a bartender for the Stearnses, the last few years of working on billboards. At the Stearnses' I had that octagonal studio upstairs, but I didn't know what to do when I got there. Whenever I come to a mental standstill now, I go back to those periods.

I've done a lot of paintings in my life but there were times when I was utterly at a loss for what to do next. When I look back I'm incredulous; I get mad at these former selves of mine and ask, "What was the matter with you? You didn't know what to do? Could you have started painting in, say, 1956?" The thing is, I lacked the abstract turn of mind necessary to transform the raw materials into art. Also, I guess I was too interested in trying to do well at whatever I was doing at the time.

By the late 1950s I'd begun to lead a double life. In the daytime I

painted billboards and designed display windows for Bonwit Teller, Tiffany, and Bloomingdale's; at night and on the weekends I hung out with artists and painted. At first, I painted small abstractions. I idolized the great abstract expressionists and jazz musicians. They were my heroes, they were mythic people, and by the mid-1950s American art was in full bloom. Abstract expressionism had made New York the art center of the world, and this transformation had all happened in ten years. Just think: Pollock's career was from 1944 to 1956.

I had a lot of copies of *Life* magazine from the 1930s and early 1940s with articles about American and European painters in them. The prevailing taste even among art critics was very conservative. We were so far away from "getting" modern art back then that at the 1937 Pittsburgh International Fair, Leon Kroll, a conventional, figurative painter, won first prize. Pierre Bonnard, painter of sublime, humid colors and jewel-like tiles, came in second! That always gives me an uplifting feeling whenever I think of it. One's contemporaries generally have it all wrong. That was the state of American art before it found its native soul. Europe had gone through fauvism, futurism, Dada, surrealism, Wassily Kandinsky, and *Les Demoiselles d'Avignon*, but as far as art went, you'd have thought Americans were still sleepwalking through the nineteenth century.

I met Leon Kroll once. His paintings were traditional—nicely done portraits and figures. That kind of art won prizes up until the beginning of the 1940s. There was a big transition from 1939 to 1946. During the war European artists had come here—Max Ernst, Roberto Matta, George Grosz, Hans Hofmann, Arshile Gorky—and with them came the transmission of new art from Europe to America. The idea of what art was shifted radically. You could see a new sophistication coming in—the energy of the picture plane. Pollock, de Kooning, Kline, Mark Rothko . . . It was as if the American spirit had revealed itself at last as a kind of howl in paint.

I came to New York to study art, and to meet artists. And where do you find artists? In bars, especially in the 1950s. Drinks were cheap in those days. White Rose bar whiskey was twenty-five cents a shot; if you had $3 you could get twelve shots—that would do it. Among the artists' bars was the old Cedar Tavern on University Place and Eighth Street, not to be confused with the Cedar Bar, which was also on University Place and came later.

The Cedar Tavern had been a workingman's bar and therefore cheap. It was just a long, narrow space with a room in the back. It was where Pollock had kicked the bathroom door off its hinges and they left it that way. The fluorescent lights looked green. They had Audubon and horse prints on the walls. I can just picture the bartender right now—he had a funny eye, and because of that he looked at you strangely. For dinner you could go to Nedicks around the corner and get a fifteen-cent hot dog. I began hanging out at the Cedar Tavern, where I went with the sole purpose of meeting the grand masters of abstract expressionism.

There was another place we used to go: the Waldorf Cafeteria on the Lower East Side; that place was really grim. Nothing but tables and bright fluorescent lights. People would just go in there and talk. Then there was another funny joint on the Bowery. A bar. I remember drinking beer there with de Kooning and Milton Resnick. A clean, well-lit bar with no toilet. The law was that you could go pee on the curb under the El, the elevated subway line that used to run above Third Avenue. That was the old-time law. You wouldn't think the Health Department would have permitted it, but it did, because it was dark under those elevated tracks. Then they tore down the El and you couldn't do that anymore.

There was a fierce amount of drinking in those days. I remember once being at Al Leslie's studio and drinking a whole bottle of cheap scotch *myself*. Somebody else there must've had quite a few because I dimly recall carrying him drunk down the stairs over my shoulder. That day I'd bought my first car in Manhattan, an old VW convertible, and I had it parked by the Flatiron Building. I told myself that if I could walk around the Flatiron Building, I could drive home. I couldn't. I had to lean against the building to hold myself up. Luckily, I took the subway home and left the car there.

Eventually, from hanging around the Cedar Tavern I got to meet Franz Kline. He was about fifty years old at the time, and like all the abstract expressionists he dressed scruffily, in a pair of jeans or khakis with a stained, laundered T-shirt and penny loafers. Beer in one hand, cigarette in the other. I didn't know much about him. I heard he had a wife who was sickly but I never saw them together. He was a womanizer, always hitting on girls at parties; he often had a young beauty cornered against the wall. According to Walter

Hopps, he packed a lunch and went to work in the evening and worked all night long. He would have his lunch about one or two in the morning.

You could find de Kooning in the Cedar Tavern pretty much every night in those days. He was a heavy drinker, and like most drinkers he had intense mood swings, from belligerent to amiable. De Kooning *looked* like a painter—rumpled, paint-splattered overalls, a work shirt, careless of his appearance, smoking like a chimney. He was a very tender individual, outspoken and generous. He always had a lot of girlfriends. The stories of him getting in bar fights are, I'd say, greatly exaggerated. Okay, he might have hit Ivan Karp in the face with a beer can once at a party up near Nyack, but Bill wasn't the crazy, pugnacious character of legend. He was a happy-go-lucky guy who liked to drink. And when he went on a bender, his assistant Carlos Anduzia would stay with him.

John McMahon, another of Bill's assistants, knew de Kooning well by this point, and he told me a funny story about how he first met him. "One day I was walking down the street," he said, "and there was Bill de Kooning. I saw him at the Cedar Tavern but I'd never talked to him, so I crossed the street and said, 'Mr. de Kooning, I'd like to talk to you about painting.'

" 'Talk about *painting*?' de Kooning said irritably, as if I'd brought up a thoroughly unpleasant subject. 'I *hate* goddamned painting. Are you that son of a bitch from Yale that's been leaving notes under my door?'

" 'No, no,' I said, 'that wasn't me.'

" 'Aw, to hell with it then,' he said. 'Good-bye!' And he walked away."

A few days later John was again walking down the street early one morning, and there was de Kooning on the other side of the street. De Kooning yelled, "Hey, come over here. Aren't you the one from Yale leaving notes under my door?"

"No, not me."

"Well, hell, then," he said. "Come on in and have a drink."

So at eight-thirty in the morning they went into a bar. "What are you having?" Bill asked. John said, "A Coke."

"A *Coke*?" said de Kooning. "Hell, that's no drink. Have a beer." He ordered John a beer while downing two or three gins.

"That was his drink," John tells me. "Gin, *ginebra*."

After this, John went to work for Bill for the next fifteen years. Eventually I got to know de Kooning well. Once I went to see him out in East Hampton, and we had a few drinks. After a while he said, "Who the hell asked you to come here? Get out, you son of a bitch!"

I got up, said good-bye, and left.

In a second he ran out, put his arm through the window of my car, and said, "Don't leave me, you bastard! Come in and have another drink."

De Kooning was always trying to think of ways to slow down the time it took for paint to dry. He tried mixing his paint with cooking oil—anything to retard the paint-drying process so he could keep working on his painting. At the time this seemed a bit nutty, but now I'm beginning to have similar thoughts.

In 1957 I was going out with a girl named Peggy Smith, who was a reporter for a local paper. She'd take me to different events. "I have to cover this story out in Yonkers," she'd say. "Would you like to go to W. C. Handy's birthday party?" "Oh yeah," I said. We went and there he was, the famous old composer who'd written "The St. Louis Blues." He'd practically invented the blues; now he was blind and in a wheelchair, but beaming like Buddha and surrounded by family and friends. After an hour or so, Nat "King" Cole got up and sang "Happy Birthday," and then his daughter sang "The St. Louis Blues."

Through Peggy I met the eccentric painter, collagist, and Dada correspondence-school artist Ray Johnson. A film about him was made not all that long ago called *How to Draw a Bunny*. Ray was very social and knew everybody. He asked me, "Would you like to go to a party at the Stevensons', friends of Jack Youngerman?" I already knew Youngerman a little bit. I saw these two young guys leaning against a wall who were good friends of Youngerman's: a kind of nervous Bob Rauschenberg and a stone-faced Jasper Johns. I just said hello in passing; I didn't get to know them till later on— again, through Ray. Ray also introduced me to Lenore Tawney, Agnes Martin, Bob Indiana (or Bob Clark, as he was then known), and Ellsworth Kelly. Claes Oldenburg, Henry Pearson, and I ended up attending drawing classes organized by Indiana and Youngerman, with Jack's wife, the actress Delphine Seyrig, as the model.

I was out of work, and one day I was walking by the Art Students

League and I went in. They had a bulletin board with different categories: Jobs, Looking for Work, Apartments, et cetera. I saw a notice that said: "Wanted: Sign Painter/Artist." The job was up in Yorkville, the German part of town. I thought, Well, yeah, maybe I can get some work out of this, so I went up to the address in Yorkville, a candy store owned by this old German guy. A bunch of teenagers were in the back, and who comes in there but George Lincoln Rockwell, the American Nazi. He leans on the counter and says to a group of guys, "Well, how did you do last week? Did you throw rocks on the synagogue sidewalk? Did you mess them up?" And they answered him very enthusiastically, "Yeah, yeah, yeah, yeah. We really messed 'em up." So I thought, George Lincoln Rockwell? Here was this white supremacist in a nest of fledgling neo-Nazis. I beat it out of there.

A few weeks later I was walking around looking for a loft down on Fulton Street. I was in a restaurant and asked the owner, "Do you know of any lofts around here?" "Yeah," he said. "There's two artists living upstairs. Why don't you ask them?" So I went upstairs and knocked on the door. The door opened up. There's a bed on the floor and next to the bed a big flower planter and there's Jasper Johns standing in front of a white American flag, and I thought, God, is this another Nazi place?

As I was standing there in shock, Jasper who was very cool, invited me in. I had only been there a minute when in walked Rauschenberg, a skinny guy wearing granny glasses.

"Hi," I said, "I'm a painter and I'm looking for a loft."

"Well, follow me," Bob said, "and I'll show you where to look." And he walked me downstairs. Bob was very shy back then, a completely different personality from the outgoing character he became.

"Go in that store there," Bob said, "and you tell 'em you want a loft."

And then he left. I told the store owner I was looking for a loft. "I got one for fourteen dollars a month," he said. "Is that too much for ya?" You know, like a joke. It was just a room with a toilet and a sink, like an office.

"Nah, nah, that's too small for me," I said.

"Well, I got one four times as big for thirty-five dollars a month."

It was a larger room with a toilet and a sink, but I was looking for something bigger, a place where I could live and take a shower.

I didn't run into Bob and Jasper again until I moved to Coenties Slip.

When I was painting billboards, the bosses would say, "That Arrow shirt collar looks dirty," or "The color of the beer in that Schaefer ad is wrong. It looks like it has too much hops in it," or "I don't like the blue you painted on that Chrysler." So I'd remix the color and take the rejected colors home with me.

I painted my first paintings using that rejected paint from my billboard jobs. I called them the rerun paintings. That wasn't so unusual at the time: Pollock used house paint, and so did Rothko—he used poor-quality paint even in his later paintings. But aside from these early days, I've always used good quality paint: Winsor & Newton oils.

Up until 1959 or 1960, I was still making abstract paintings. Abstract painting is like jazz—it's going *be-bitty-bop, woo-ba-dado*. The melody is great, but what is the statement? Great tunes, but not connected to the real world where roses are red and the sky is blue, Tide is orange, and 7-Up is green.

But by the late 1950s, abstract expressionism had pretty much exhausted itself. The second generation of action painters wasn't able to maintain the heroic impetus of Pollock, de Kooning, and Kline. When you look at catalogs of later American abstract artists, they were very good painters but their work didn't surprise you. It was beautiful and intelligent but there was no shock, no bolt from the blue. Philip Guston made beautiful abstract paintings. Then, at the end of his life, he did these crazy paintings: a drunk with a big eye, somebody sleeping with a bottle of whiskey on top of him. It was nutty.

The painter Nicholas Krushenick and his brother John had a place on Tenth Street called the Brata Gallery, and when I was in the neighborhood painting signs I would stop by there.

One day I ran into John Krushenick and he said, "Jim, you've got to see these paintings. We've got some new artists now, and they even have *ideas*!" That was revolutionary stuff—artists having ideas. It was groundbreaking for the time because, for some two decades,

art had been about subjectivity: emotion, spontaneity, *action* in painting, or as we rudely referred to it, *schmearing*, meaning daubing, dripping, splattering paint. That's what the Krushenick brothers had meant: that Jasper and Bob were not just schmearers.

Jasper and Bob were at the forefront of the new movement. They are often thought of as the originators of pop art, even if their intentions were quite different from the art that Andy Warhol, Roy Lichtenstein, and I later made. Their paintings, influenced by Marcel Duchamp and the philosopher Ludwig Wittgenstein, are only tangentially related to pop art. Still, they changed the way people thought about art.

Jasper is an intimate painter who works with ideograms, idea pictures. His painting modulated between abstraction and imagery. But the mind-set in which Jasper worked gave rise to some paradoxical questions. For instance, if you had an assistant who was also an artist and you asked him to paint the storm windows on your house, would those storm windows be art or would they just be storm windows?

I see something similar in Jasper's maps, targets, and flags. What I think is that he started with a flag as a takeoff point in his mind and began painting, and as he went through the act of painting—just applying encaustic paint in a random, painterly fashion—he unconsciously arrived back at a flag again. For him, it was as if painting were the equivalent of doing some type of mindless work—like, say, sweeping grain off a sidewalk—during which he could let his mind soar. In a kind of Zen way, by freeing his mind through simple, physical work, he arrived at illumination. I think he was in some kind of trance while painting in a messy, abstract manner, and spontaneously the image of a flag emerged from the process. His painting was the result of a journey. He painted "things the mind already knows" to free his hand to paint in those luminous, encaustic colors. As an artist Jasper is intuitive, but as a person he's very analytical. Even in a bar where everybody, including Jasper, was getting drunk, he was still capable of intellectualizing the physics of arm wrestling.

One time I was in Dillon's—the bar where everybody went after the old Cedar Tavern closed—and ran into John Chamberlain, the sculptor, who is something of a fun maniac. I was watching Jasper

play shuffleboard when John put me in a neck hold and started choking me. I was in good shape then from all the rope work I did as a billboard painter, so I figured I'd heave him up and drop him to release his arms from my neck. I got him up off the ground, but as I dropped him on the table, it smashed and collapsed on the floor. Even that wasn't enough action for John. He wanted to arm wrestle, so we did and I beat him.

"That's no fair," John cried. "Jim's holding on to the chair." Jasper leaned over and said dryly, "His arm is attached to his body, isn't it?"

Soon after Jasper appeared on the cover of *ARTnews*, his paintings began selling, and he started making money. One winter morning I walked out of my building, and along came this white four-door Jaguar sedan. At the wheel was Jasper, wearing a white overcoat. White on white. With his first money he'd bought a coat and a Jaguar. When he saw me, he stopped the car and said, "Would you like a ride?" He drove me to the Brooklyn Bridge subway station. I was happy to see a down-and-out artist finally make his first buck.

There were several reasons that I stopped billboard painting in 1959. Most important, two of the guys I worked with got killed. Abbie Marco got knocked off Klein's Department Store. Another guy fell off a Budweiser sign in Kearny, New Jersey. I thought, You know, this is a dangerous business. That was a life-changing moment, but also I realized I just didn't want to work for anybody anymore. I wanted to step into space, to take a leap into nothing— to get a painting studio just to wonder who I was.

One day I ran into Ellsworth Kelly, who knew I was looking for a space. "I know of a studio on Coenties Slip for forty-five dollars a month," he told me. "It used to be Agnes Martin's old studio. Why don't you take it?"

In the early 1960s there were all these loft buildings that had originally housed light industry and were now empty, and artists began to move into them. In those days there was no such thing as artists living in lofts—that was totally illegal. When you got a loft that had formerly been a business you called it "breaking in." An artist would go to the landlord and say, "I have a small business and

I'd like to rent a floor." If you asked him, "Would you mind if I sleep there overnight?" The owner would say, "What you do there is your business, don't bother me, just pay your rent, keep your mouth shut." By and by the artist meets a girl, the girl lives with him. She gets pregnant, has a baby, and then starts to complain: "I'm gonna call the city. The lights aren't working, there's a leak in the bathroom, and there's no heat." And that's where the trouble started.

It became a big fight to get AIRs, artist-in-residence lofts, which were sanctioned by the fire department. I remember a meeting between a bunch of artists and the fire department at the Washington Irving High School. On stage was de Kooning, the fire department guys with their dog, and Larry Rivers. It was freezing. Artists came in wearing serapes, stockings over their tennis shoes. Bill gets up and says, "What's a matter here? Can't we get together and have beers no more? Why you kicking us out? We not doing nothing." The meeting had been held to convince the fire department that the artists in Hell's Hundred Acres were safe and sane residents and not firebugs. Just then some kid in the audience set off an M-80 firecracker, and that was the end of that meeting.

I shared a loft at 3–5 Coenties Slip opposite the Seaman's Institute with another painter, Chuck Hinman. When I stopped painting billboards I thought I was being so hip. I'd quit being a commercial painter and was now devoting myself to a life of art. It took me a long time to realize that this was the way it had always been. The abstract expressionists, and all the artists who'd come before them, had always been poor and thought of art with a capital *A*. They were uncontaminated artists. They would get up and say, "This is Art! This splashing and this schmear we do—this is *Art*! We are creators, in the company of Michelangelo, Goya, van Gogh, and Kandinsky."

Now I was joining them. I went on unemployment, collecting Kennedy's twenty-two extra weeks in 1960. You could go to Chinatown and six people, six *hungry* people, could go to Hong Fat and have a big meal with rice and tea. The bill would be $5.75!

In June 1960 I married Mary Lou in a very traditional wedding at the Forest Hills Tennis Club. No one in his right mind quits his job and gets married, but that's what I did. We lived in a cold-water flat on the Upper East Side; the rent was about $35 a month. We stayed

Opposite: In my Coenties Slip studio dressed to apply for a job, ca. 1960. I used to go to all my billboard jobs dressed like this and change into work clothes to paint. Then, when I was finished, I'd put on the other clothes so I could interview for the next job.

in this tenement in an old, decent building a long time. We were still living there when my paintings started to sell.

Every day I'd go down to my studio on Coenties Slip. Once I'd get there, I wouldn't know what to do. I would walk around Manhattan and drop in on artists. I used to drop in on Kelly before I got my own loft. I wanted to be an artist but I didn't have any idea what I wanted to do as an artist. At first, all I had was a strong feeling of what I *didn't* want to do. I knew I wanted to create a new kind of painting.

I wanted to do something totally different from anything being done by everyone around me. All the artists I knew had been taught to use paint expressively, to splash paint on a big canvas, look at the big blob you'd created and to have it suggest something back to you. It seemed to me too simple to put a mark on a canvas and have that be it. Once you've put that mark on the canvas you have the responsibility of cleaning up the mess, of making something unexpected out of it because you started out with a white canvas that was beautiful to begin with.

My question was, what do you do with that mark? There's a difference between trying to achieve a predetermined idea and letting your random action dictate what it may or may not suggest. Now, I like the first idea better for many, many reasons. If you tackle a huge canvas, unless your idea is planned out, as in mural painting, everything can, may—and usually does—go awry.

What was being taught in art school at that time was to splash, but for young artists in New York after Pollock the aesthetic of the drip became old-fashioned. By the early 1960s anti-splash was in the air—not only from pop artists but from op art, too. Around that time there was a big op art show at MoMA. Most of the painters I knew were hard edge—Indiana, Kelly, Frank Stella—and that meant no drips.

I remember Frank coming over to my studio one time. He saw a painting I was working on, and with some concern said, "Jim, did you know you've got a drip there?"

"I know, I know," I said, "it's not finished, I'm taking that out."

The drip was like death in those days, because that was a defunct aesthetic, it was old hat. You may not have known where you were going to go with your paintings, but the one thing you knew you weren't going to do was splash.

It wasn't as if I just woke up one day and started doing pop art. It took a long time to germinate. I had studied composition for years. I constantly thought about the notion of how imagery could be used in an abstract way, but how was I to achieve this? It seemed an almost absurd idea to use objects as abstractions, but that was what I was beginning to think about.

When I first got my loft I still didn't know what I was going to paint. I didn't have an idea yet. Nothing. So what I'd do was look out the window. There were long stretches when I just sat there and thought without any interruptions. Sometimes I sat there from nine in the morning until four in the afternoon watching people go to and from their jobs. I never felt that I was wasting time. It felt great to be free of a routine job, and I thought, Well, at least I don't have to do *that*. I was collecting unemployment at the time. I would stand there in that empty space and think, What the hell am I all about? What is this? I wasn't thinking about other people's art or what other painters were doing. In any case, nobody was making money from their art. To sell a painting for $7,000 was a really big deal back then.

Sometimes ideas come through the window, floating in from somewhere. That sounds like a poetic way of describing it, but I mean it quite literally. For all I know it might be electromagnetic signals or extraterrestrial rays or, as they used to say in the old days, a visit from your muse. All I had to do was snatch them out of the air and begin painting. Once that idea came to me, everything seemed to fall into place—the idea, the composition, the imagery, the colors, everything began to work.

When a zingy idea enters your head that little initial blip so consumes you it seems like a thread unraveling your belly button. You get up and your ass falls off. It's just this little hint you've found: "Oh, what is *this*?" It's like a sudden flash of enlightenment. It always seems to start very small and then grows. Where does that come from? That little juxtaposition of thought and intuition. An illumination. People walk by it, ignore it; but I have a feeling that the most incredible things are around us all the time, and we just don't have the ability to see them.

One time the photographer Mel Sokolsky took me into his studio, which was a railroad apartment, and held up an antenna and said, "Look at this!" It gave off such a blinding amount of energy

Drawing and cutout for *Zone*, 1960. Pencil on paper; magazine clipping. 11⅛ x 18⅝ in. (28.3 x 47.3 cm). Collection of the artist.

that it could shoot your balls off—so we tried to avoid standing in its path. I think it was the RCA signal being beamed from the Empire State Building to Europe and it went right through that apartment.

John Cage seems to have intuited this phenomenon in a piece he did in 1958 called *Fontana Mix—Feed*. When I first heard it I thought, What the hell is that? It starts off very quietly and gradually develops into a cacophony: a swoosh, a *cccracchhhhhhhh* of sound; then it gets quieter again. One afternoon I was driving on the Long Island Expressway and all of a sudden exactly the same noise came on my radio: *shhhhh cccracchhhhhhhh*. Apparently at a certain point on the LIE, you pass through the same beam that sends signals over to Europe from the RCA building.

The idea of using images from the recent past came to me while I was in Coenties Slip. On a hunch I started looking for old *Life* magazines and avidly collecting them. I was cutting pages out of *Life*, and as I was looking at them I began to say to myself, This stuff is *ridiculous*. Even the cigarette ads were bizarre. I'd see the Camel T-zone ad with its surreal cutout around the smoker's mouth and throat and wonder, What is that about? It had an endorsement that said, "More doctors say Camels have less tar than any other cigarette." This was long before the connection had been made between smoking and cancer, but anybody could see how stupid

this was—you already knew that cigarette smoke wasn't any good for you. You just had to laugh at all this magazine advertising. It was so strange. What was Madison Avenue doing? It was on another planet. Most advertising is based on getting your attention by juxtaposing things that don't belong together. Advertising uses a crude form of surrealism to get your attention.

I started by writing things on the wall, jotting down notes, clipping things out of magazines and stapling them to the walls. The pictures I clipped out of magazines weren't intellectual concepts—they weren't ideas in that sense—but images that I chose for their mental texture, which came from the billboard close-ups.

As soon as my contemporaries moved into their lofts, they would paint the walls with three coats of perfect stark white paint to create a pristine environment in which to make a painting, as if out of that blankness an idea would magically appear. And then . . . they never painted. Too antiseptic. I said, "Screw that," didn't bother cleaning mine. I never painted it, never fixed the place up. Left the broken plaster walls, left the cracked ceiling with debris falling through the lath. I felt it was more fertile that way. Some people might have thought that my studio floor was part of me, part of my painting method, because that's the way I intended it, with things strewn all over the floor. But I hadn't arranged it at all. It was accidental, and in that way it was like nature, a kind of flora of images.

Often you start out with an idea or a notion and you don't know whether it's going to come off. You hope that by the time you actually get it down, there is something to it, but when things come out of thin air you don't know what they are. Ideas come unbidden, and you don't understand their meaning or know what they're going to become and that's the best thing about them. You just do it—and then try to figure it out.

Many years later I was at Rauschenberg's studio in Captiva; it was three in the morning and we'd both had a lot to drink.

"I want to show you my new work," he said. It was six bamboo poles leaning against the wall with strings and tin cans hanging from them.

"Bobby," I said, "I've been looking at this piece for an hour and I don't get it."

Zone, 1960–61. Oil on canvas. 7 ft. 11 in. x 7 ft. 11½ in. (241.3 x 242.6 cm). Philadelphia Museum of Art.

"Well," he said, "I know you put things on the wall before you know what they are, too."

The idea of going for a zero nonobjective painting of pure color and pure form obsessed me. How does one get deeper? Beyond abstraction, beyond *that*. I began to think of color itself as a form of abstraction. What if I were to push the limits of that idea by randomly choosing objects solely in terms of color and shape regardless of meaning? In this way I would be able to create a form of abstraction through other means. I could see it in my mind's eye, but you can't always count on that.

I thought I might find an answer by fragmenting images in some way. Cubism, for instance, which has always had an influence on my painting, suggested one possible solution. I'd studied its "sum of destruction," as practiced by Picasso and Braque in the early 1900s. Cubism has everything to do with using the rectangular edges of the canvas as the dynamic. With cubism the composition exploded on the canvas; I was trying to take that thrust and blow it out of the canvas altogether.

All previous painting is like looking out a window. Even with the

epic paintings of Delacroix, the panoramic battle scenes in the Louvre, you are still looking out onto a vista. My painting is more like smashing images in your face. They fall out the front of the picture plane. I wanted to subvert the point of view in art, the way the viewer looks at a painting.

The big issue at that time was violating the picture plane—that had always been sacred. Bob Rauschenberg did a lot of crazy things to the picture plane. *Bed*, for instance, in which he painted directly on his quilt, pillow, and mattress; *Monogram*, where he put a tire around a stuffed goat; and *Odalisk*, which incorporated a chicken on a box. It was clear he thought there was no such thing as an inappropriate image in art. Bob could make art out of anything— he was a big influence on me. Now that I was able to make my own paintings I could do whatever I damn pleased. Then it became a question of, do you dare to do that? From Bob's fearless art coups I gathered an important message: the bigger the risk you take, the more accurate your vision has to be.

Then it occurred to me that another way of disrupting the picture plane might be to create images so large they would *overwhelm* the viewer. I was thinking, of course, of my billboard experience; in my mind, I saw imagery breaking open the picture plane, spilling off it, bursting out of it. This way the painting would no longer be a window you peer into, but something that pushes outward into the space of the person looking at it.

As I was stapling the pages of magazines to the wall, I did not know exactly why I was doing it. What attracted me in ads was the mystery, the strangeness of these bits of commercial propaganda— they were enigmas. I began thinking, What if I used generic fragments from ads and photos in *Life* magazine and juxtaposed them in different scales? And what if I made one of the images so large that close-up it would initially be difficult to recognize? Wouldn't I then have created an abstract effect using recognizable images? The images would be painted realistically, but made so big and collaged together so apparently arbitrarily that you wouldn't understand it at first. In this way I could make a mysterious painting using the most banal materials. That was my initial idea about the dislocation of scale. I still think about that and use that idea when I start a painting. If I were to paint something so large it became, in essence, an arabesque to the eye, it would have a subliminal meaning—but

one that you at first wouldn't be able to identify. It was a surrealist impulse, but the crucial difference between my paintings and those of the surrealists was that their paintings were small, and, like all art before them, they were painted as if you were looking out a window.

Around this time there was an article on the art world in *Esquire* that said Coenties Slip was the in place to live, which was pretty funny because you couldn't live there—it was illegal. It went on to say Fifty-seventh Street was the Street of Culture, where all the established galleries were; Tenth Street was the new place showing the new art. But the mysterious hive of creation was the artists living near the waterfront on Coenties Slip, their art and lifestyles quite apart from the uptown art scene and virtually unknown. At that point, a lot of artists down there had underground reputations, but none of us had done much of anything at all. Kelly had a career, but the rest of us didn't. He owned a Volkswagen, and to us that was wealth. He'd shown with Betty Parsons. He, Agnes Martin, Johns, Newman, Rauschenberg, Randy Mullerman (who later killed himself), Indiana (who was still known as Bob Clark), Steve Durkee, Youngerman and his wife, Delphine, Ann Wilson, Jessie Wilkinson, the poet Oscar Williams, John Kloss, the dress designer Rolf Nelson, and I were all struggling artists of one stripe or another, usually making ends meet doing things other than art.

Bob Rauschenberg had had shows—at Stable Gallery, Betty Parsons—but he still wasn't very well known. Bob was probably the least career-minded of anybody. In any case, at that time having a career in the art world was like looking for a ghost. Essentially, there was no art world and no market, especially for the kind of art we were making. How could you have a career in that environment? It would be like grabbing air.

The lofts we worked in weren't huge spaces, most of them no more than twenty by one hundred feet. My loft was on the third floor of 3–5 Coenties Slip. Across the hall from me was a gay songwriter, Jay Taylor. He used to have parties where he'd invite whole soccer teams and one beautiful blonde. He'd be playing Chopin and Gershwin, and there would be Bulgarian soccer players, Paraguayan soccer players—and the only other people there would be Frank Stella, me, and this blonde. One of the Bulgarian soccer

players saw the big holes Frank had in his socks and asked him, "What is that with holes in socks? He is proletarian man, no?"

Rolf Nelson, who became for a time a dealer in LA, used to live above me. In 1961, a few weeks after Christmas, he invited me up to his loft to show me the environment he'd created. He opened the door and there were five hundred Christmas trees he'd collected. He'd set up in his loft all the old Christmas trees that people had thrown away. "Come along," he said, and I went down this path between the trees and there was a little settee at the end with two gay guys sitting there having tea. I walked a little farther into the kitchen and into another area—it was like walking through a wood. "How do you like this?" he asked. "It looks a little dangerous," I said, "but not everybody has woods in their house."

I'm in front of the 3–5 Coenties Slip studio, which was on the third-floor corner, 1960.

I used to have parties down on Coenties Slip, and all kinds of people would show up. I threw a party for Joanna Laurenson, a tall girl who later was Abbie Hoffman's girlfriend. I put road flares on the floor, and people danced in the dark between them. It was quite magical until, after a while, these flares made big soot stains on the faces of the girls dancing, black streaks coming from their nostrils. They looked like witches at a coven.

There was a fire escape that went onto the street and during this party a bum pulled it down, came up, climbed in the window, went to the bar, and poured himself a drink. "Hey, look at that crazy bum!" somebody said. "Who the hell are you?" I asked him. "Sir, I just dropped in to fortify myself," he said very grandly. "Have a drink and fortify yourself and then get outta here!" "Oh, oh, *allll* right, you don't have to act like that." He left, but two hours later he came up again for another drink.

In 1961 there was a famous blizzard in New York. The snow was four feet deep. That day I saw Rosalind Russell in a one-horse open sleigh going up Fifth Avenue right near Tiffany. Living on the top floor of Coenties Slip was Jessie Wilkinson, a big, good-looking older woman, from down South somewhere. She was a friend of Oscar Williams, the poet who had compiled an anthology of contemporary poets. It was the first loft I ever saw fixed up—all white with nice furniture in it and a potbellied stove. Jessie had left

because of the cold and after she'd gone her hot-water heater broke and caused water to run down through all the floors. It turned the fourth floor into a rain forest, and then it came pouring through my ceiling and splashed over a couple of new paintings. From there it poured down through my floor all the way to Jim Screen's, the old Irish bar on the first floor. I remember sitting there with Ellsworth and having coffee in the middle of the night during the blizzard while this rainstorm was going through the building. It didn't damage much.

Strange things seemed to happen around Coenties Slip. One day I went over to see Bob Indiana. I'd just walked in the door when he said, "Jim, would you like a nice drawing board? You know, one of those big, tilted drawing tables." "Sure!" I said. "Well, follow me, but, whatever happens, don't say anything." We went up into this building, Bob knocked on the door—it was freezing cold in the building, and who comes to the door but a man wearing only a loincloth, like a Yogi from India. I think he was a foreign sailor; his bed was a sleeping mat on the floor, and there was a freestanding sink in the middle of the room with no plumbing connections to it. "Jim, come over here and give me a hand—we'll take this drawing board," Bob said without addressing the man in the loincloth. And so we took the drawing board, without my knowing whose it was or what was going on.

Another time when I went up to see Bob something else strange happened. As I entered his building there was an overwhelming smell. At first I thought it was from the harbor water that flowed underneath the building. But it wasn't sewage; it was the stench of something rotting. We thought it might be a dead cat, but it turned out someone had died on the third floor. No one knew him and he'd been rotting there for weeks. It was a guy named Hoffman from LA. They found a briefcase in his loft with ninety grand in cash—the cops took it for evidence. When my friend Melvin heard about it, he said, "Man, if only I'd found that . . . damn!" There were a lot of transient people down there in that neighborhood, sailors and drifters and guys involved in shady stuff.

Right across the hall from me was Ellsworth Kelly, who was starting to sell his paintings to English collectors for $5,000 to $7,000 apiece, which was huge, because at that time prices were

running around a thousand bucks. If you sold anything for more than that, you were really making it.

I learned a few things from Ellsworth—practical *and* conceptual—like how to stretch a canvas. He stretched and primed his own canvases. He was very precise. I've always thought of Ellsworth as the first pop artist and I'll tell you why.

One day he showed me three little diamond-shaped paintings with one small shape in the corner.

"What is that?" I asked.

"That's the James Dean road sign going backward at a hundred and ten miles an hour," he said.

"Oh, really?"

Then he showed me a big painting with some black shapes going across it. I think it's called *Wall Street.*

"What's that one about?" I asked.

"That's clothes on a line hanging across Wall Street."

And in this way he explained to me how he made his paintings. He'd made a drawing for my wife that looked like a pair of bib overalls, and he told me the idea for it came out of a combination of images: the view of a Knickerbocker Beer sign out the window and Bob Indiana putting his pants on—the fusion of those shapes had been the source of this painting. So I thought, You know, that's very oblique, very simple, and clear. I really liked that attitude. He was very direct. It was all about shapes that he would see in the city or reproduce from nature.

Jack Youngerman was also painting shapes at that time. I remember one called *Cuba Si* about Fidel Castro—Castro was his hero; he was everybody's hero until he started shooting people by the thousands. *Cuba Si* consisted of one big shape, but where Ellsworth's were painted in flat colors, Jack's were done in a thick impasto, which had a very different effect.

One day in late 1960 I stretched up four canvases approximately six by eight feet—two panels. I felt the abstract expressionist canvases I'd painted up to that point were jammed with stuff I no longer wanted.

In my mind abstract painting was about trying to make nothing, but I noticed when I was painting abstractions that I was piling up a lot of stuff in order to prove *nothing.* The idea occurred to me that

maybe by using imagery from my billboard painting days I could go below zero, because if I chose images not for their content but for their form and color, what was on the canvas would be only what I had chosen to put there. No one would be able to see—as they might have in an arabesque in one of my previous abstract paintings—a bird, a plane, Superman, a crucifixion, or anything else if I hadn't intended it. If you paint Franco-American spaghetti, no one can make a crucifixion out of it—and who can be nostalgic about spaghetti? They'll bring their own reactions to it, but, probably, they won't have as many irrelevant ones.

The nonobjective painters Alfred Manessier, Antoni Tàpies, and Jean-Paul Riopelle had aimed for their own zero association—no images, no references. But I wanted to get to a zero below that of French nonobjective painting whose content was nothing but color and form. The idea of a zero below abstraction came to me when I recalled how numb I became from painting these damn things up close day in and day out on billboards. I thought maybe I could make an aesthetic numbness out of these images, a numb painting where you don't really care about the images—they're only there to develop space.

So I decided to dive into the common pool of popular images, anonymous images from advertising. I'd heard the story about the painter John Marin and the photographer Alfred Stieglitz. Trying to create the most fantastic show possible, they had an exhibition at a gallery on Madison Avenue in the 1930s; then one of them glanced out the window and said, "Look at those horses. Damn if it isn't more exciting out there on the street than it is in here!" There was more energy, more action in the street—and this was when there were only horses and carriages on Fifth Avenue, nothing compared to the frenetic movement we have today. In the same way, I began to think there was more power in advertising than in paintings made in artists' studios.

When I began using advertising imagery in my paintings it was never a question of beating advertisers at their own game. It was simply the idea of doing something that had the same *force* as advertising, using their techniques and bizarre imagery. I never used a brand name. The closest I ever came to displaying a product was when I painted a big dish of Campbell's tomato soup with parts of male and female images floating in it. This was long before Andy

Warhol's soup cans. It was called *In the Red*, meaning broke—the average bourgeois family that is always broke.

I wasn't in love with advertising images at all; I was in love with the techniques used in commercial art. As a young artist you react to what's going on around you. I certainly hadn't chosen these things because I liked them. If anything, I was trying to make a statement about things I *didn't* like. It was more a matter of being able to say what I wanted to say with power, to be able to paint these images as effectively as art as they were in ads. I thought, Why can't I use the force of what I had been doing commercially as a billboard painter to say something of my own?

There's an obvious connection between my work and my background: the fact that I was born in the United States subjected me to media flak my whole life. In America from an early age you are bombarded with images trying to sell you something. Billboards with big juicy hamburgers and laundry detergent, and posters of movie stars. Later, when supermarkets came along, I remember being blown away by all the color. As you walked into a supermarket, you'd see all these items for sale, each marked with its own bright colors. The windows of supermarkets were plastered with proto-pop images: sales signs depicting giant cans, huge cereal boxes, monster-size carrots, all in neon colors. It was the look of those colors that I remember best. I don't think this kind of thing existed anywhere else. This jumble of color was unique to America.

I was living in a society where advertising had a huge impact through its compelling imagery. It generated excitement. It occurred to me that if painting were to compete with advertising, it would need to be at least as exciting—so why shouldn't it be done with the power and gusto of ads, with that impact? I was interested in contemporary vision: the flicker of chrome, reflections, quick flashes of light. *Bing-bang! Bing-bang!*

Billboard painting was a very aggressive type of painting: its sole purpose was to sell *stuff*, to sell products. I didn't like that aggressive approach, but it was an ideal vehicle with which to produce an emptiness, a numbness on canvas.

Images from my midwestern childhood began to float through my mind, change shape, and rearrange themselves. That was the way I learned to interpret the world: as loose, unstable images whose meaning was enigmatic, and that became the template

for my juxtaposition of disparate images. They are at the core of my interest in collage—an unconscious attempt to make aesthetic sense out of the nonsense I saw around me. Collage is a very odd thing. Incongruous images pushed up against one another for some reason shock the psyche. A juxtaposition of opposites disturbs you: if the elements don't connect, it sets your mind off. It remains such a relevant art form because it interprets the fragmentary nature of urban life. It's still shocking to set two things that don't belong together side by side. Montage remains such an effective device because it so exactly mirrors the fragmentary nature of urban life.

The daily newspaper is one huge sprawling collage of juxtaposed stories that have no preexisting relationship. The front page of *The New York Times* is inspiring. It will have as many as eight different articles, some featuring photographs or diagrams or illustrations that have nothing to do with the pieces next to them, aside from the fact that they happened on the same day. The brain itself is a collage machine. All day long you unknowingly take pictures in your mind of the things you see; in your sleep you try to sort these juxtapositions through dreams. And that's what I'm trying to do in my paintings.

On Coenties Slip I stopped thinking of doing abstract paintings and began to think about how to paint things. With this in mind, I started work on *Zone*, my first painting in a new style using pieces of pop imagery. The painting kept changing as I worked on it. It changed and changed and changed again as I painted the images over and over and over. I was experimenting, trying out various forms, techniques, and images. I started out painting in grisaille—gray. The early paintings are all black-and-white; there's a complete absence of color. To paint in grisaille is to deal with the void—a void of color.

One day I began juxtaposing a combination of images on a painting. I was testing things out. I had a little gray man committing suicide like in a painting Warhol was to do later on. The man was going headfirst out the window—he was only about as big as a cat on the scale of the canvas. I eliminated him. I had a huge shirtfront with a big saltshaker sprinkling on the lapel, the way you're supposed to sprinkle salt on a dove's tail in order to catch it. There

were bullet holes in the shirt out of which flowed blood that turned into the American flag. Then there were some cows with their noses out of the water swimming across the top of the painting, and a mother's head dissected by a baby's face. I put all sorts of surrealistic things in the painting, but it wasn't working. The guy committing suicide was too small in a painting where everything should be big. The first version of *Zone* was neither surrealism nor the thing I saw in my mind. I wasn't, in any case, trying to become a surrealist, or anything else that already had a label. And anyway, the scale was too large for what I imagined surrealism was.

I'd describe *Zone* as a place in the mind where, like archaeology, things are covered up. I started painting images, and I was filtering them out because they didn't fit the concept I had. Eventually I painted out everything. Underneath the finished painting are many, many strange images. It was a process—something I was going through to get to my art. After I'd painted out everything, I painted a blown-up image of a black tomato and part of a lady's face in gray. That's all. That was *Zone*. That was the first painting. I tried to develop a kind of painting that was so new people wouldn't be able to call me old-fashioned, where I could set these images in the picture plane in scale, almost like cubism. But they would be large, so big that the image closest to you would be *smack!* in your face; you wouldn't be able to get it until the last minute. You'd say, "Oh, now I see it, it's spaghetti, or it's a shirt"—or whatever the largest fragment was.

When *Zone* was finished, I wasn't that surprised by it. It had taken a while to bake and it was just the first step. I was trying to expand the universe. I'm always trying to get out of myself or out of *it*; that is why those two images were huge. I started painting fragments larger and larger.

In 1959 I was doing window displays for Bonwit Teller and Tiffany to make a little extra money. For Bonwit Teller I made a big painting of a nineteenth-century Gay Nineties girl as a background. For another set of window displays I painted famous high places like the Eiffel Tower and the Statue of Liberty. One lunchtime I had just finished installing a painting showing the hand and torch of the Statue of Liberty, and I went out on the sidewalk to look at my

The Statue of Liberty torch was one of the backdrops in the famous high places and towers series I was painting for Bonwit Teller's windows, ca. 1959.

work. There was a guy standing behind me twirling his mustache and muttering to himself in a foreign language. Salvador Dalí. He was checking it out, too. He didn't know me from Adam, but three days later he invited me to lunch.

I went into the St. Regis with paint on my hands, funky clothes, and very tired. Dalí had a corner table at the restaurant. All around us were beautiful girls with suntans in décolleté dresses. As I sat down I accidentally put my elbow into a dish of nuts, and all the peanuts flew up into the air. Dalí stood up and applauded as if I had just performed some sort of magic trick. He banged on the table with his cane and said, "*Voilà!*" He asked me what I wanted to drink. "I'll have a screwdriver," I said. He looked at me astounded, as if I had made a brilliant remark. "*Sacre bleu!* I invite him to order drink and he ask for *un destornillador* [Spanish for a screwdriver]!" He'd never heard of the drink with that name and thought I was saying something surrealistic. Next he opened a book he had with him and said, "Use ze color green, Jim. Zis is your green." He showed me a book of presurreal fantastic painting with pictures of nuns and bats running up stairs and other weird things.

"Ze River Styx, ze river of ze dead, you know it?" he asked me.

I found a trunk on the street with a lot of old photos, which was the inspiration for my Bonwit Teller displays, including this one with a Gay Nineties girl.

"We don't know if on ze raft zey are playing with themselves or zey are dead." Nothing made sense.

He invited me to his birthday party a week later. It was in an old folks' home where he and his wife, Gala, were judging a watercolor contest. He gave first prize to somebody who had made a painting of low tide. After he had presented the award he got up and made a speech. "Today, I did finish painting the portrait of the dollar bill," he said solemnly, and then, without pausing, he launched into an idiosyncratic lecture on twentieth-century painting. "Modern art, it started in España, which is first fact to know; Juan Gris, Picasso, Salvador Dalí—they begin the modern art. *Multo pomposo gratiososo rhinoceroso y fantastico . . .*" He went on and on.

Dalí liked to hang around the fashion photographer Mel Sokolsky's studio, because he had a thing for models.

Later on he saw some of my work, but when I first met him I wasn't exhibiting. He was curious about pop art; its audaciousness fascinated him. At one point he took a George Segal sculpture, put it in a taxicab, and drove around New York with this white plaster cast. Everything was an exclamation point with Dalí.

I didn't see him again for a long time. Then one night he was on

TV, in a wheelchair with an oxygen mask and tubes coming out of his nose. He announced, "Today I just finished tube-in-the-nose painting." He remained true to form.

Many of the concepts I later used in painting related to things I worked on in commercial art. The idea of using fragments and shifts in scale, for instance. If there were different elements to be included on the billboard, they'd hand you a bunch of images in an envelope of, say, a rose, a glass, a horse, a house, a car, a hand. The pictures they gave you would be in different sizes, and this disparity of scale between the different images was, in a way, the basis for the beginning of my painting. I'd be given a blueprint and they'd tell me, "The rose for that Melrose whiskey ad has to be this size and the glass has to be that size, et cetera." The idea of playing with scale and form got me going, and in my early sketches of my own work, I'd start off with a couple of ideas, a couple of images juxtaposed to each other in different scales.

From making rescalings for billboard paintings I had learned how to enlarge images to any size I wanted. In my early paintings I used imagery in all different sizes, the fragments often opposite in size to the way I'd found them in old magazines or in photos I took myself. I now have a color copier and with it I can change the scale of an image to any size I want, but back then you didn't have any mechanism to blow up or change an image's size; it was all done by hand. This was very laborious and took a lot of time. My earlier collages (with the images still in their original size) often look like a scattering of junk, because the maquettes were just the starting point—the end result, with the images scaled to different sizes, was the painting itself.

Another idea that had occurred to me while doing commercial art was the relationship between colors and objects. As I painted huge swaths of color on billboards—my nose a few inches from a sea of green or orange—I began to develop my own idiosyncratic vocabulary of color; like Rimbaud's "Alchemy of the Word," where he says, "I invented the color of vowels! *A*, black, *E*, white, *I*, red, *O*, blue, *U*, green." Except that my chromatic alphabet came from Franco-American spaghetti and Kentucky bourbon. Green became the eyebrows of a kid drinking Coca-Cola; blue was a Chrysler sedan; orange was orange soda and the color of Early Times whis-

key. How can one orange be both these things? I wondered. Both oranges came out of the same can, but applied to different objects, they took on different meanings. In my mind, I associated colors with real objects: brown was a dirty bacon color, blue was a Chevrolet blue, cadmium yellow was a Man-Tan orange. The imagery itself was dispensable to me—it was the color and texture that I was interested in. If I felt like painting red I might paint a great big tomato.

My aesthetic may have come from being too close to what I was painting to know what it was. I didn't give a damn about the images themselves as I was painting them. One billboard would replace another, and then I'd paint over it and another one on top of that one. All that interested me was their color and form. In any case, the images were usually so large that all I could see were their textures and forms: the crumbly texture of a piece of cake, baroque curls rolling down a movie star's face, the chrome on the side of a car, the white creases on an Arrow shirt that looked like the face of Mont Blanc.

I would become deeply involved in using color and form when I was painting the side of a big piece of juicy chocolate cake. Rendering the succulent chocolate brown texture of that slice, I became infatuated by the softness, the closeness of this imagery.

My work differed from any other painter's work at the time in part because of this concept of objects seen in extreme close-up. When I was painting huge images I often felt disoriented, as if I were suspended in front of a big, shiny chrome ball. From that experience, there was a certain mystical quality about some types of imagery that I was then and am still attracted to. That closeness to the image and fading around the peripheral space fascinated me.

So, in an almost old-fashioned optical manner, I began thinking of the numbness that comes from the brutality of an enlarged image. Also, by using imagery I could set up a time sequence in the painting: a certain image would be recognized at a certain rate of speed. I would always make the object that was most difficult to recognize the largest. I used very banal things to make sure people would recognize what they were, such as a hot dog or a typewriter. In other words, I wasn't, despite what people may have thought, glorifying popular imagery; I was attempting to deconstruct it, to dismantle it, and convert it into an aesthetic of my own.

Part of a collage for *I Love You with My Ford*, 1961. Magazine clipping and mixed media on paper. 7¼ x 9¹³/₁₆ in. (18.4 x 24.9 cm). Collection of the artist.

What I was setting out to do was to create a palimpsest of images, where there are many layers of vision in the same picture. At first glimpse you see one image; then, as you look a little further, you say, "Oh, there's something else there, too." Subliminal values and colors that seep out slowly. Like memory. That was the way I thought of it: as a visual corollary to memory.

The memory of something is often more interesting than the real thing. That goes back to when they asked Cocteau what he would save if his house burned down. He said, "The memory of the fire." For me there's an odd overlapping of memory, movies, and art. I remember sometime in 1960 seeing Delphine Seyrig wearing a beautiful housedress and pushing her son, Duncan, down the street in a stroller. And then one year later she was in *Last Year at Marienbad* and had become an international movie star. I thought, That's strange! I just saw her last year in Coenties Slip and now she's in a big movie. I found it strange that the movie had the same tone as my memory and the movie itself was about memory and coincidence.

In memory you can recall your childhood and the present, but four or five years ago is a little dim. The anonymity of recent history was always striking to me. In 1961 I painted the front of a Ford in a painting called *I Love You with My Ford*. People would ask, "Why are you painting a '50 Ford in 1961, why not paint a '61 Ford?" Because I felt that in 1961, a '50s Ford was devoid of emotional connotations. I wasn't excited about the look of a 1950s Ford, and I wasn't sentimental about it, either. It was just an image. If it had been the front end of a new car, people might've got passionate about it, and the front end of an old car might make some people nostalgic. But this was just an anonymous image of a car from ads I found in old copies of *Life* magazine. When I say old, I mean 1945 to 1955—a time that by the early 1960s we hadn't started to regard as history yet. It was a blind spot in time. The images I used were empty images, drained of associations—they are like no-images. If it were abstract, people might read something into it. There is a freedom there.

I Love You with My Ford is an abstract painting using the front grille of a car, two people whispering, and a field of spaghetti.

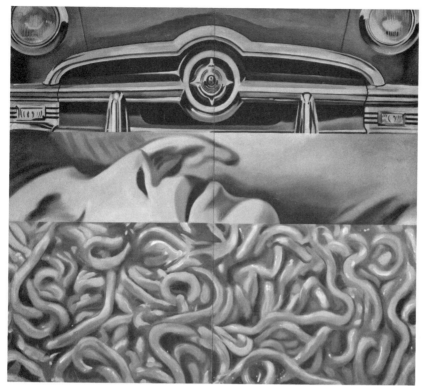

I Love You with My Ford,
1961. Oil on canvas.
6 ft. 10 in. x 7 ft. 9½ in.
(210.2 x 237.5 cm).
Modena Museet,
Stockholm.

When I copied a 1940s spaghetti illustration, I had to ask myself, why am I doing this? I didn't honestly know. It was just an instinct about images as pure form. I'm not in love with spaghetti per se; the spaghetti is there simply as a visceral color field. I think of it in terms of form and color. In a sense the spaghetti is like an abstract expressionist painting. De Kooning loved it. He said it was sexy.

The idea of substituting the banal for the beautiful doesn't have anything to do with it—that's not relevant to my painting at all. But I have to admit I am somewhat poetically involved in these images. Part of my reality has been dented by being taught to appreciate objects, material things: blue socialism, I call it. It's like U-Rent-It, an analogy of everyone's being filed into a vast giveaway contest, saying, "Now, which one of these things do you want?" It's marked on the ledger and you have a sense of owning that object, but you never use it.

It's funny how people have gotten into pop art *because* it's so accessible, part of the floating world of media imagery. Now you have pop art underwear at the Gap. Anything "pop" used to be

transient, not worth anything. What's truly unbelievable is how long pop art has lasted, and not only lasted but become a part of the culture.

I wanted the fragments that I juxtaposed in my paintings to be corrosive—and the titles of those paintings to be antidotes to that corrosiveness. The titles of my paintings are frequently ironic: the opposite of what you see, or a pun.

Sometimes a title will set off an idea. The images themselves are expendable; therefore the painting itself is also expendable. In my paintings I only hope to create a colorful shoehorn for someone who sees it, to make that person reflect on his or her own feelings.

Enigma of the Object

EMERGENCE OF POP ART

EARLY PAINTINGS

METAPHYSICAL DISGUST
AND THE NEW VULGARIANS

PARIS

PRESIDENT ELECT

Pop art. I've never cared for the term, but after half a century of being described as a pop artist I'm resigned to it. Still, I don't know what pop art means, to tell you the truth. It sounds like instant gratification—something that goes off with a bang and then fizzles, which is the way people thought about pop art at the time and for a few decades thereafter. Pop art was considered the novelty song in American art and sooner or later, they said, the novelty would wear off. But now that pop art paintings are

going for millions of dollars, it doesn't look like its going away any-time soon. Instead of going away, it's become the granddaddy of a lot of art, some of which I'd just as soon not claim the paternity of.

Andy Warhol, Roy Lichtenstein, and I are so often mentioned in the same breath you'd have thought we all lived together in some abandoned amusement park. The truth is, we didn't meet until 1964, years after we had started painting what became pop art. My first reaction to the early works of Warhol, Oldenburg, Lichten-stein, and Tom Wesselmann was, You mean there's *other people* doing this stuff? What united us, you might say, was dread of the drip, the splash, the schmear, combined with an ironic attitude toward the banalities of American consumer culture. If anything, you might say we were *anti*pop artists.

The progression of pop art in the galleries went like this: in the fall of 1961, Wesselmann had a show of very colorful little collages, American Nudes, on Tenth Street. Then in late 1961 and early 1962, Oldenburg showed his Store Days in a storefront on Second Street that also went by the name of the Ray Gun Theater, where he presented a series of happenings.

These, you might say, were the first pop art shows. There was Sam Wiener's anti-atomic exhibit, Lois Dodd showed her cow paintings on Tenth Street, and I think the Brata Gallery also exhib-ited the Japanese artist Yayoi Kusama, who is one of my favorites. When I was in Tokyo a few years ago I went to the Fuji TV Gallery and they said, "Mr. Jim, do you know, Yayoi Kusama's in our gallery!" They called her up and she came right over. "Hi, Jim-o!" she said. "Hi! How's the Donald Judd-a?" She wanted to know about Donald Judd. She tells me, "I number one artist in Japan now." I said, "Okay, I'll be number two then."

My show at Dick Bellamy's Green Gallery was in February 1962; in May, Lichtenstein had a show of his comic-strip paintings. Then Warhol had his first one-man show in New York at the Stable Gallery where he showed his *Marilyn Diptych, 100 Soup Cans, 100 Coke Bottles*, and *100 Dollar Bills*.

With the galleries, dealers, and collectors it was all very new and up in the air. Dick Bellamy wasn't quite decided about whether to take on Wesselmann as an artist at the Green Gallery, but as soon as he sold a piece of Wesselmann's for over $1,000 he went straight to Wesselmann's apartment, knocked on the door, and when Tom

opened it threw a wad of twenty-dollar bills on the floor and said, "Can I come in?"

I'm resigned to being lumped together with Andy, Roy, Claes, and Tom because I use similar imagery, but there's a considerable difference in the way we each use that imagery. I was never concerned with logos or brand names or movie stars, like Andy, for instance. Unlike Roy, I wasn't interested in ironic simulations of pop media; I wanted to make mysterious pictures. I've never included commercial imagery in a painting for its own sake, for its "popness" alone. In my paintings there's always a reason for an image being there.

Pop artists were a disparate group to begin with: ex-abstract expressionists (Lichtenstein), ex-cartoonists (Oldenburg), ex–commercial artists (Warhol), ex-chicken farmers (Segal), and ex–billboard painters (me) all working independently toward our own vision. We were products of the big, booming 1950s. The media constantly reminded us that we lived in a material utopia. We had electric can openers, dishwashers, two-tone cars, television sets—there was all this *stuff*. The idea being promoted was that everybody should be peppy and happy and could have everything they wanted: two and a half cars, three and a half children, and instant everything. People clung to the idea of their own personal utopia, which had been fused in the American imagination onto commercial products. Every ad in every magazine and TV commercial was telling you that you could buy happiness on the installment plan.

Popular culture isn't a freeze-frame; it is images zapping by in rapid-fire succession, which is why collage is such an effective way of representing contemporary life. The blur between images creates a kind of motion in the mind. With collage there is a glint, a reflection of modern life. If, for example, you take a walk through midtown Manhattan, you might in quick succession see a street vendor, the back of a girl's legs, and then out of the corner of your eye catch a glimpse of a taxi as it comes close to hitting you. You see parts of things—the vendor, the legs, the cab—and you rationalize them into a scenario. It all happens very quickly; the experience is almost subliminal.

From early on I developed an attraction for the incongruous. I had no wish to try to resolve visual contradictions. I felt that aesthetic disparities were actually questions, questions that I did not

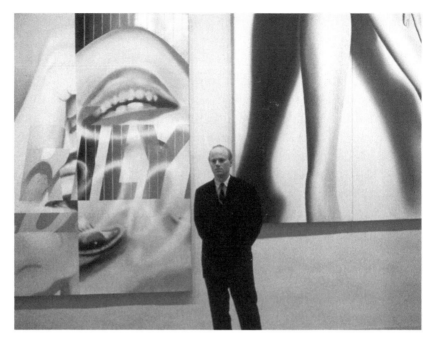

Standing in front of *Marilyn Monroe I* and *Above the Square* at the opening of Americans 1963 at the Museum of Modern Art, New York, May 22–August 18, 1963.

need to answer. By leaving the meaning up in the air I could provoke responses in the viewer that would trigger further questioning. What are these things I'm looking at and what do they mean? Each person seeing the painting will come away with a different idea.

Starting with *Zone* I had begun to develop an idiosyncratic visual vocabulary. Painting in black-and-white tonalities was similar to working with the snapshots from which I'd painted billboard images. In 1961 I continued to experiment with the discoveries I'd made while working on my first pop art paintings: *Zone* and *1947–1948–1950*.

With paintings like *Flower Garden* and *Pushbutton* from early 1961, I made my first attempt at trying to duplicate the sensation I had when painting billboards: of being so close to the image while painting it that I was no longer thinking about what it was. These shapes fascinated me. They were provocative, enigmatic, unresolved. In *Flower Garden* I painted the left side of Roger Bannister (the man who ran the first four-minute mile) in his running gear, as if it were a photo torn from a newspaper, and juxtaposed him with gloved ladies' hands with different-colored fingertips

Collage for *Flower Garden*, 1961. Magazine clippings and mixed media on paper. 5⁷⁄₈ x 8½ in. (17.5 x 21.6 cm). Collection of the artist.

from some unknown ad—the pink, rose, and yellow of the fingertips being a metaphor for flowers.

It's not always easy to explain what these paintings mean. It's elusive. Looking at it, you say, "Oh, that looks like a glimpse of . . . *something*. . . ." It may not always make literal sense—or, to put it another way, it makes sense only if you *can't* translate it into words. I was trying for that. In a visual work you try for some kind of magic, something that is readable in another part of the mind.

I have a lot of odd paintings from this period—I could put them together for a very strange show, but showing them might turn out to be a horrible idea. These paintings have never been in any of my retrospectives. People might look at them and say, "God, they're awful!" or they might find them ingenious, but in the end, it's their inability to be explained that makes them so indigestible. They're odd and enigmatic; they didn't sell, and yet I think they're some of my best work. One of these paintings, *Mayfair* (1962), had a big windshield with a red horse's head in the front seat of a convertible car, a rearview mirror with paint on it, and there was also some silver object in there. I used the horse in a couple of other paintings, too. It's about our inability to communicate with other species; the mysterious quality of being right beside a big, powerful animal like an elephant or a porpoise in the water—some very large creature

Collage for *Pushbutton*, 1961. Magazine clippings and mixed media on paper. 8¼ x 11³/₁₆ in. (21 x 28.4 cm). Collection of the artist.

with another kind of brain. An animal that comes from an entirely different mental space than our own, like the whale with its underwater clickings. What do they mean? They are thinking, even communicating with each other in their own animal languages, but we can't understand them. I wanted to convey that strange, disturbing feeling of being next to a huge creature whose thinking is quite alien to our own.

Another one was called *Trophies of an Old Soldier*. It consists of drapery with handprints and other images on it and three hooks stuck into the canvas—two hooks with twine going down and a third hook from which the twine goes up over the top of the canvas. The idea of this painting is the enigma of memory: the private trophies people save to remind themselves of events in their lives. You may not be able to decipher the meaning of someone else's old trophies. Everyone has their own special objects that are important mementos; to someone else they may not mean a thing. After World War II my grandfather hired a war veteran named Floyd Strom, who was mentally disabled. He'd been in the South Pacific fighting the Japanese and had gone a bit nuts. He kept all his possessions in one of those wooden army boxes where soldiers put their private stuff. He kept this box upstairs in his room. People would ask him, "Well, what's in it, Floyd?" "Don't you dare go near that," he'd say, "or I will hurt you." He was damaged. This was the

same fellow who had threatened my uncle Frans with a knife, and Uncle Frans had broken off the blade and substituted a nut and a bolt. One day while he was working in the fields I went up to his room and opened up his box. In it was a stone and some photos of nude island girls with their legs wide open and other odds and ends. Why was he so protective of this stuff? I wondered. *Trophies* is an oblique idea, suggesting perhaps torture—a mystical idea of personal mementos and their hidden meanings.

Another of these strange paintings was called *The Space That Won't Fail*. Paula Cooper bought it at auction all broken up; I put it back together for her. It has an extruded plastic box sticking out in front of it with fingerprints in paint showing through from the inside. There was a lady's face, a guy smoking a cigarette, and a painted can of beans. To activate the painting you would blow smoke through a little tube until it fills the box and says SMOKE inside the box. That would really puzzle people—it would puzzle me. They would say, "What the hell is this?" I don't think I could explain any part of it.

Lisa and Richard Perry own a painting of mine that for a long time I'd lost track of. It's called *Fix* and consists of two parallel lines representing ropes and a girl's hands holding on to the rope—and that's all. There is no bottom to it, no swing, and no human body. The idea is holding on to something in order to survive. Sometimes exploring these enigmatic paintings makes them sound simplistic, but visually I think they carry their own weight.

Some of these images came from that early period when I was first in Coenties Slip, with just a pile of old *Life* magazines and a pencil, writing ideas on the wall. The title or the idea would sometimes precede the painting. A title comes along and you search for a painting. The title of *The Light That Won't Fail I* was about daily routine, in which the teeth of the comb in the painting become the bars of a prison. When I had my first show, in 1962, Paul Berg from the *St. Louis Post-Dispatch* put *The Light That Won't Fail I* on the cover of its Sunday magazine section.

Fragmented images from the movies have been a big influence on my paintings. I used to go to drive-in movies back in Minnesota when I was seventeen or eighteen. I'd block out the upper part of the screen, framing the lower left-hand corner with my hands, and watch what kind of dynamism would develop in that little section.

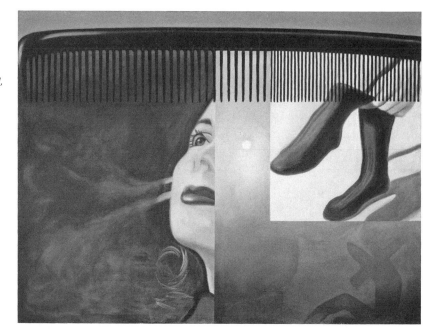

The Light That Won't Fail I,
1961. Oil on canvas.
5 ft. 11³⁄₄ in. x 8 ft. ¹⁄₄ in.
(182.2 x 244.5 cm).
Hirshhorn Museum and
Sculpture Garden,
Smithsonian Institution,
Washington, D.C. Gift of
the Joseph H. Hirshhorn
Foundation, 1966.

The wiggle that was going in one corner, the movement of some-one's bow tie when it came into focus or a woman's stockinged leg climbing a staircase. It was a fascinating experiment, because by doing that you disregarded the content of the film. By selecting a corner of the screen and watching the action that was happening there you created a surreal movie of your own. I was thinking in terms of the unexplained fragment, fragments as self-contained concepts.

It's been said that the epic size of abstract expressionist paintings was influenced by the CinemaScope screen, which it well may have been. A Pollock painting may look like it is way out in space, but actually it's on the picture plane. Clement Greenberg called them flat, but that was just Greenberg's obsession with mystical flatness. Still, for all their mammoth size, none of the imagery in abstract expressionist paintings spills out of the frame. They are flat on the picture plane or a thousand miles out—and that's where Pollock was.

In 1961 I did a painting called *Balcony* that had a mirror attached to it and a little box upholstered into it, cutting the sacred warp and woof of the canvas. Some of my early paintings came from the feeling you get being in a certain place. *Balcony*, for instance, is about the sensation of being at a cocktail party on the terrace of a pent-

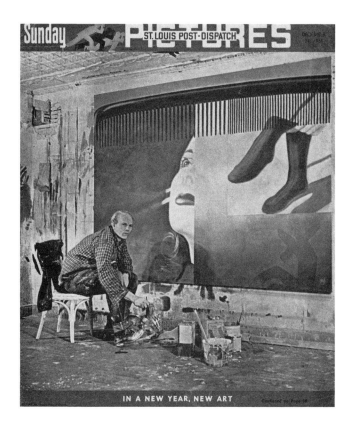

The *Post-Dispatch* on me painting *The Light That Won't Fail I.*

house in Manhattan—space described in terms of the sky, a lump of lady's hair, a man's cuff in the mirror reflecting the sky. I put the little box there to show part of his cuff.

The idea behind *Tube* is that of floating around in a bubble, the bubble of traveling—as in the vacuum tubes in a department store where you put an invoice in a container and it goes shooting up a tube to another department. Just that: an idea about floating and traveling. I imagined a car without wheels traveling everywhere.

A painting like *Look Alive* (*Blue Feet, Look Alive*) plays with the idea of the viewer's involvement in the picture by using a mirror. When you look into the mirror you see your own feet reflected— they are now incorporated into the painting. I tried to take this idea further by pushing the images out at the viewer. In *Hey! Let's Go for a Ride*, the girl's face and the soda bottle burst out of the frame right in your face. You're in the picture. It's coming at you as if you're a couple of inches from the girl holding the soda bottle. You almost have to back off.

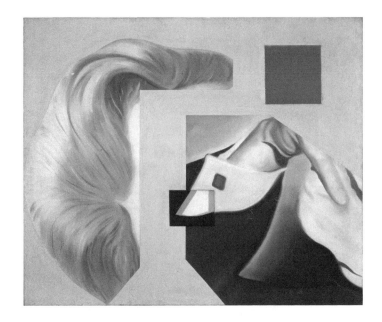

Balcony, 1961. Oil on canvas and Plexiglas, with mirror. 5 ft. x 6 ft. 1 in. (152.4 x 185.4 cm). Courtesy of Sonnabend Gallery, New York.

Not all artists have ideas when they begin their paintings. Thinking ahead and planning out a painting was anathema to the abstract expressionists with their credo of spontaneity and impulse. Rauschenberg always said he never entered his studio with an idea.

There is always the impulse to express things one has experienced. If you've had an unusual experience, you want to try to describe it in some sort of abstract way to someone else. From my experience in painting billboards, for example, I wanted to communicate that sensation of working on giant images outdoors, the exhilaration of being way up in the air with color and paint, and bring all that down into an art gallery. I had worked on a big billboard on top of the Latin Quarter; I had walked across all this glowing neon with flashing noises and I tried to duplicate that sensation in a piece of sculpture called *Untitled* (*Catwalk*). I took a big piece of plastic, painted it, and put it on a little footbridge off the floor with flashing lights underneath it. I could never quite capture that feeling or experience even in a small way and eventually I destroyed the piece.

In the early paintings I made following *Zone,* I didn't set out to follow my original intentions too religiously. I still used huge images but they were put together in such a way that they didn't mean too

Tube, 1961. Oil on canvas. 60 in. (152.4 cm) in diameter. Collection of Jean Todt, Paris.

Look Alive (Blue Feet, Look Alive), 1961. Oil on canvas, with mirror. 67 x 58½ in. (170.2 x 148.6 cm). Private collection.

Hey! Let's Go for a Ride,
1961. Oil on canvas.
34⅛ x 35⅞ in. (86.7 x
91.1 cm). Collection of
Samuel and Ronnie
Heyman, New York.

much except in terms of color and form. The images themselves
were dispensable.

In *1947–1948–1950* I wanted to create a nonobjective existential
painting using representational imagery. It was based on a photo-
graph of a series of neckties in *Life* magazine. The article was about
how men's necktie fashions never change. Women's fashions change
all over the place, but men's neckties stay the same. It goes on and
on. This nothingness again. That was what this was about: banality,
repetition, conformity.

I discovered I could exaggerate the banality of the images I
found in a magazine by erasing and obscuring the subjects' faces
and placing them in grids and quadrants. I used this idea again in
Up from the Ranks, depicting eight grim telephone executives I'd
seen in a *Life* magazine article. This was somewhat tautological,
since I was erasing the faces of men who were in effect faceless to
begin with. In a sense I was transforming one type of anonymity
into another. I thought of the erased executives' faces as a sort of
corporate autobiography of men who spent their lives doing the
same thing over and over again.

I decided to take this idea a little further in *4 Young Revolutionaries*
and *4-1949 Guys.* The identities of the four young revolutionaries
are concealed behind objects that represent their attributes—and
the image is seen through glass cracked by bullet holes. The idea

was that these are the radicals who get sacrificed in any revolution. Whenever there's a revolution, the original revolutionaries are killed by the new government, because once the revolution has succeeded they don't want those guys around any longer to disrupt things. As they move out of their frames they fade from our short-term historical memory.

In *4-1949 Guys* objects are substituted for faces: an ice-cream cone that looks like it's made of metal, a double-barreled shotgun, fragments of black-and-white photos. They're anonymous people, just guys from 1949. The idea came from the realization that people can remember their childhood and the recent past, but what fogs over is that nebulous in-between period. It becomes a kind of a gray area—hence the gray images over their faces.

The ideas of the Beat generation had a big effect on me. The Beats were utopians and a bit nostalgic, but they weren't materialistic. The conformist culture in America at the time was soul-destroying, and that is what I was trying to say with those pictures.

By obscuring the features of the faces in these paintings, I removed an essential part of representational imagery: the face. If anything, I've always thought of myself as an abstract painter,

4 Young Revolutionaries, 1962. Oil on wood and glass. 24 x 32 in. (61 x 81.3 cm). Private collection.

4-1949 Guys, 1962. Oil on canvas. 60 x 48 in. (152.4 x 121.9 cm). Hara Museum of Contemporary Art, Tokyo.

and what could be more nonobjective than something you can't remember?

The flip side of anonymity and banality is the cult of personality. The odd thing about many of these famous people was their wish to turn themselves into commodities—into things. I painted Kennedy, Joan Crawford, and bluesman Big Bo McGhee just like I saw them in ads. I called them self-portraits, because by employing the same slick, glossy techniques they used in their own advertising and public relations I could mirror their self-inflation. *Big Bo* was a blind Texas rock-and-roll singer. He advertised himself in pink tones, just like I painted him.

When I started the Kennedy painting, *President Elect*, at the end of 1960, I didn't have any money. I painted it on the back of Masonite—a material I'd used in many of my billboard paintings. The image of Kennedy comes from a 1960 presidential campaign poster. I took the picture and juxtaposed JFK with images of middle-class consumerism to pose the question: "Here is this new guy who wants to be President of the United States during the Eisenhower era; what is he offering us?" He wasn't president yet. His campaign

promise was the usual: a chicken in every pot. He already looked like an ad. I was interested in the idea that he was a sort of living advertisement for himself. He was like an ad come to life. I was curious as to how and why people wanted to project themselves like that.

The idea of using fragments in *President Elect* was economy of means. I was trying to get the greatest amount of information in a picture using only snippets of images to suggest the whole. I'd seen Kennedy on Broad Street sitting up on the back of a convertible whizzing by with a bright orange face and a baby blue suit and sort of reddish silver hair—his skin looked yellow, like he had jaundice, with big splotches of rouge on his cheeks. The picture of him I worked from was actually in black-and-white. I didn't have a color photo of him to work with so I invented my own tones for his face and hair, something I'd been doing for years. I knew how to make up a face, tint it. I changed the scale and the color of each object in the painting. Took the color out of the cake so it would look stale, and put it into Kennedy's face.

When I was living in East Hampton in the mid-1960s I had put this painting on the truck at one time to go to the dump because it was in such bad shape from being moved from studio to studio so much—it had gotten very scratched up. The next day I told the guys who worked for me to unload it because we had to buy lumber and I needed the truck emptied. I put it back in the studio. It hung

Collage for *President Elect,* 1960–61. Cropped poster, magazine clippings, and mixed media. 14½ x 23¹³⁄₁₆ in. (36.8 x 60.5 cm). Private collection.

around there and finally I took it out one Sunday and repaired it. I filled in the scratches and fixed it. James Mayor and Ann Uribe, gallery owners from London, came out to my East Hampton studio in 1967 and saw it and said they'd like to buy it. "I say, what is your wicket?" Ann asked. I didn't know what to tell her, so we went to dinner and then came back to the studio. "What do you want?" she asked again. Purely as a joke, I said, "How about thirty-five thousand dollars." At that time abstract expressionist paintings were selling for $17,000. She said, "I'm pleased." I couldn't believe it. They in turn sold it to the Centre Pompidou in Paris, where it still resides.

In *Marilyn Monroe I*, the face is cut up, and the letters of her name—some of them in skywriting script—are superimposed over her image. I got the idea of painting Marilyn when I saw her buy a *New York Times* from a newsstand in Irvington, New York, tipping over a stack of papers in the process. Some pieces of her face are upside down, but she is such a recognizable icon you can tell it's her just from that small portion of her face.

In *Candidate* I did a huge painting of a woman's face with a plastic letter *T* and a chair in front of it with a flower sitting on it. Then I painted out the face and called the new version of the painting *Silo*. I wish I hadn't done that. It's now owned by the Tate; I don't think they ever show it. I'd like to get it back someday. In 1950 de Kooning had done *Woman*, an oil on paper collage using the mouth from a Camel T-zone ad. Everyone was copying de Kooning, trying to imitate his energy. Critics and art historians may try to connect the dots, but I wasn't aware of de Kooning's T-zone image when I did *Silo*. I did another painting with women's mouths in different colors called *Woman I*. Everyone who owned it died; it was like a jinx, the bad-luck painting.

Later I did a Joan Crawford painting, *Untitled (Joan Crawford says . . .)*. In an old *Life* magazine there was a Camel ad from 1951 that showed a picture of a woman's face with a T-shaped frame around her mouth and neck. I thought Joan Crawford's self-promotion was especially weird because it was so blatant and grotesque. She used her studio-marketed movie-star persona to make herself into a brand name that was now applied to selling products. I knew Joan Crawford was married to Alfred Steele, president of the Pepsi-Cola company from 1950 to 1955. What I'd

heard about her was that she wouldn't appear in a movie unless there was a Pepsi-Cola in at least one scene. She was constantly trying to slip bottles of Pepsi into her movies. The director would say, "Get that mouthwash outta here."

At one point Joan Crawford decided to latch on to pop art—her conception of it, anyway. She was going to have a pop art show. Her idea of pop art was the Pepsi paraphernalia: bottle caps, plastic spoons and glasses with the Pepsi logo, trays, signs, and so on. She sent out Candygrams to a bunch of artists inviting them to her pop art exhibition, but when they got to her front door she slammed it in their faces—wouldn't let them in.

The "self-portraits" of self-promoting celebrities were my first examples of overt social criticism of American culture. People have argued that since I painted commercial objects and images from ads so lovingly, I must be subliminally fond of them. As a child I was bombarded by Rinso White radio jingles, slogans, Coca-Cola billboards, cigarette advertising, and then later in the 1950s, television and television commercials, but the fact is I hadn't watched that much TV since I grew up without it. I think we got our first set in 1950, so I would have been seventeen. Closer to the truth would be what someone wrote about me in *ArtForum.* They said that I was the painter of "the clutter that adds up to the emptiness of American space." It's not that I'm apolitical—I feel very strongly about civil rights and moral issues and I've done many paintings in protest against stupid wars, stupid laws, ruthless politicians, and greedy entrepreneurs—it's simply that I don't think artists should preach.

Many things that go on in this country and elsewhere get under my skin and in 1962 I painted *Silver Skies,* a fifteen-foot painting in which I juxtaposed quick flashes of a lot of things I was angry about (and some I liked): people thinking too much about their automobiles, young girls growing up too quickly, turning into grown-ups at age twelve, radioactive skies indicated by silver wood-grained wallpaper. The goose on the left is emitting a cry of pain—symbolizing nature overwhelmed by man's pollution of the earth.

Occasionally friends and fellow painters would stop by my studio on Coenties Slip, but I wasn't trying to show these paintings to anybody. I didn't want to sell them as a matter of fact. This was my

Source image—a Camel ad from *Life* magazine, August 27, 1951—for *Untitled (Joan Crawford says . . .),* 1964.

imagery—and I wanted to keep it around me. I hung on to my union card so I could make $150 a week doing billboards if things got tight. But I had no plans. I had five or six paintings that didn't look like anyone else's and I thought of them as my companions— this was my environment and I wanted to keep it that way to see what would evolve out of it. It wasn't because I was so sure of myself or anything like that—it was just that this was something new and I was curious as to what would happen next.

In the summer of 1961 the painter Steve Durkee and his wife, Dakota, came by the studio to look at my paintings. Durkee at that time was with the Allan Stone Gallery, the in gallery of the moment. They took on the new young artists. Later on Steve became very mystical, he bought a church and started his own commune somewhere out in the West where you couldn't talk. But when Dakota came over, she looked at my work and burst out laughing. "People are really going to be amused when you show them these paintings," she said. But then she sent Allan Stone and Ileana Sonnabend down to look at my work.

Allan Stone came in and for the first forty minutes or so just sat in a chair and read a newspaper, periodically glancing at my work. Eventually he looked up and said, "Maybe you could have a show with Bob Indiana in two years." I turned him down, and Bob did, too. In any case, I had no interest in showing my work at that point.

Ileana came back again by herself and stayed about four hours, giggling and looking under things. She had originally been married to Leo Castelli. After she left Leo, she married Mike Sonnabend, who lived to be one hundred years old. Ileana was advising Leo at that point, and rightly so, because she was smarter than Leo. She was really the brains behind Castelli. Later Leo would come down with Count Giuseppe Panza di Biumo to see my paintings. Panza strolled around. He would go, "Very nice. Very nice." Then he would say, "Uhmmmm . . ." and buy one. He ended up buying five or six paintings of mine. That was in 1961—an amazing day for me. But I wasn't yet with Leo's gallery.

One of the first people to visit my studio was the art critic and my aesthetic collaborator Gene Swenson. Through his writings Gene would legitimize pop in the art world. I had great conversations with Gene, and it was an exhilarating collaboration. In one's

Collage for *F-111*, 1964.
Photographic repro-
duction and mixed
media. 4⅞ x 22¾ in.
(12.4 x 57.8 cm).
Private collection.

life if you catch an artist when he is full of energy and ideas, he'll just spout off his feelings and what he is striving for and so on. The strange thing about those interviews is that they remain true thirty years later. Often you'll say something in an interview and read it a few years later and it's gibberish. But much of what was said still hangs in there.

Gene was a poet, he had a poetic soul. That's why he got on with artists so well—he was one himself. He could get you to say things you didn't even know you were thinking. When Gene asked me what I was trying to do in *F-111* I told him I thought of it like going toward "some blinding light, like a bug hitting a lightbulb." It felt like "a man in an airplane approaching a beam at the airport. . . . The ambience of the painting is involved with people who are going toward a smaller thing. All the ideas in the whole picture are very divergent, but I think they all seemed to go toward some basic meaning. . . . So it's allowable to have orange spaghetti, lightbulbs, flowers. . . ."

Since *F-111* involved a lot of images of technology, I explained to Gene that my ideal relationship to it would be some kind of man-machine hybrid: "I can only hope to grasp things with the aid of a companion like an IBM machine. I would try to inject the humanity into the IBM machine; and myself, and it, this extreme tool, would go forward. I hope to do things, in spite of my own fallacies."

Looking back at my interview with Gene about *F-111*, I came across this surreal image from the Vietnam War that sums up the horror and craziness of the whole thing: "I heard a story that when a huge number of bombers hit in Vietnam, and burned up many square miles of forest, then the exhaust of the heat and air pressure of the fire created an artificial storm, and it started raining and

helped put the fire out. The Vietnamese thought that something must be on their side; they thought it was a natural rain that put the fire out, but it was actually a man-made change in the atmosphere."

Gene had arrived at my studio with the idea that I was some sort of self-taught naïve painter, and was surprised to learn that I'd studied art. In my studio at the time were *Zone* and *Pushbutton* (or was it *I Love You with My Ford?*), each about six by eight feet, influenced by the scale and color of sign painting. He was particularly interested in the new art dealing with contemporary signs and symbols, such as Indiana's word paintings and Johns's alphabets. He stayed for several hours, looking and asking questions. Shortly after this, Gene wrote an article for *ARTnews* magazine about signs, symbols, and iconography.

Gene was a very intense person, very idealistic. He'd say, "Our country needs a leader, and I want to help." He was an activist, a Democrat, a socialist. He worked on campaigns for old Mayor Wagner, who was the mayor of New York from 1953 to 1965. Wagner did a lot of great things for the city—he built public housing and banned discrimination in it, created the City University system, and introduced Shakespeare in the Park. But ultimately, Gene became disillusioned with the workings of politics in New York, and his relief from politics was art.

One day I looked out the window of my studio and there were Ivan Karp, Dick Bellamy, and Henry Geldzahler—two art dealers and a museum curator (Henry)—sitting on the curb smoking cigars. I knew who two of them were but only barely. I'd met Karp briefly when he was collecting old stone ornaments off buildings that were being pulled down. Sharp, street-smart, nattily dressed, he talked a mile a minute in convoluted sentences. Bellamy I'd run into at the Cedar Tavern. Henry I didn't know at all; he was a curator at the Metropolitan Museum—plump, baby-faced, whimsical. A few minutes later they were knocking on my door and entering. Henry was walking and dancing around, and eventually Dick said, "Ah, I finally found something I can show." I didn't say anything. Karp took me aside and said, "Don't sign any papers." After he'd been in my studio awhile, Dick turned to me and said, "I'd like you to have a show soon." This was in the summer of 1961. I didn't say anything to him one way or another—I was noncommittal.

A few days later Dick asked if he could bring someone down and

Collage for *F-111*, 1964. Unidentified clippings and mixed media on paper. 10 x 11½ in. (25.4 x 29.2 cm). Private collection.

I said that was fine with me. He comes in with Bob Scull, the taxi fleet owner. Here's what happened with Bob Scull: he just bops in, says, "Fantastic, wonderful. This is a great American spirit." And he walks out the door. That was it.

Suddenly art dealers, curators, collectors, and fellow artists began showing up at my studio on Coenties Slip. When people came in, I'd just continue painting; I was used to that. There were people watching me work all the time when I was painting billboards. People used to look over my shoulder, so to speak, when I was painting the horses for *Ben Hur*, or Elizabeth Taylor in a bathing suit.

Dick Bellamy I knew as a kind of street poet from the Cedar Tavern who worked at the Hansa Gallery. And here he was all of a sudden wanting to be my art dealer—a very unlikely art dealer. You could call him a Beat, a street guy. He was an old soul and funny, and I liked him a lot. The ultimate goal of every young artist is to

Collage for *F-111* and *Orange Field*, 1964. Magazine clipping and pencil on paper. 3¹³/₁₆ x 5¾ in. (9.7 x 14.6 cm). Private collection.

have an art gallery show his work. And here was this scruffy Beat offering me a show at a gallery on Fifty-seventh Street! All the artists in his own gallery, the Green Gallery, were young: Dan Flavin, Don Judd, Claes Oldenburg, Mark di Suvero. Dick Bellamy never wanted to show Warhol. For some reason he never liked Andy, though many years later he did eventually show his work.

Dan Flavin was one of the most interesting artists who came out of the maelstrom of the 1960s. Dan had been a man of the cloth, a preacher, and that made his work very different in concept from the work of any other artist of the time, with the exception of Rothko. Dan was very religious and intense and he named his pieces after the Russian constructivists.

One day, the art dealer Richard Feigen called up and said, "Would you please come up to Vassar, because my sister is in charge of the art programs at the college and I want to get some artists up there to be on a panel for her symposium, so I'm asking you and Roy Lichtenstein, Larry Poons, and Dan Flavin."

So we go up there and we do this panel thing, and afterward we ask, "Where are we going to sleep?" And by this time Bob Rauschenberg had heard about the event and had come up with his dancers and was going to have a party—Bob was always looking for a party. So, okay, we go to this party at someone's house.

Finally I tell Dan I have to go. He was as eager as I was to leave. Poons joined us and we drove around trying to get a room in a motel in the area, but they were all filled for some reason, so we were forced to go back to this house. I remember sleeping on the floor of the house with all these girls running around and shrieking. Poons turns to me in the middle of the night and says, "I'm leading a wasted life!" It was a very strange outing.

Ivan Karp was Leo Castelli's right-hand man. He was an incredible spritzer. He could talk the talk, using street slang, high-falutin' art speak, and jokes, all at rat-tat-tat speed. He was a tireless promoter of new art—especially pop art—but there were certain artists and certain artists' work he couldn't abide and Flavin was one of them.

This all came to a head when Rauschenberg made some revolving plastic disc sculptures with imagery on them that you could see through. Leo was showing them downstairs at the Castelli Gallery. Ivan did not care for them. At one point some people came into the

gallery and asked Ivan, "What are those things downstairs? And Karp says, "What do you mean, that shit downstairs? I don't have a clue what that junk is." And who was standing there but Alex Hay, one of Rauschenberg's dancers, and he went downtown and told Bob.

Rauschenberg called Leo and told him, "Either I'm leaving your gallery or Karp leaves." An ultimatum. Then, at just that juncture, at that very moment, a Flavin piece was being carried into the gallery—Leo was taking him on. So the next day Karp says, "That's it! If you bring that crap of Flavin's in here, *I'm* leaving the gallery. That's not art, that's lighting fixtures! Tell him to sell it to the Tremaines." Burton Tremaine had made his fortune manufacturing fluorescent lighting fixtures. "I'm going off to write my book!" Ivan shouted as he made his way down the winding stairs.

So Ivan went off to write his novel and start his OK Harris Gallery—he got the name from a black train conductor. During World War II, Ivan had serviced bombers in the air force in the South Pacific. He was also a very interesting photographer. Like Henry, Ivan thought of himself as a kind of art magus; he would tell artists things they should do. Paint American Indians! Paint comic strips! Paint things that everyone knows! He used to say stuff like that all the time. He would say these things to Andy and Roy, puffing on his cigar with his Groucho Marx delivery.

The next collectors Dick brought over to my studio were Burt and Emily Tremaine. They said, "Dick, we'd like to buy this painting. How much is this?" He replied, "I'm sorry. It's already been sold to Bob Scull." I took Dick to one side and whispered in his ear, "I'm not selling anything. What do you mean 'sold'?" Emily ignored our little confrontation and went right on.

"Dick," she said, "tell me, how much is this painting?" It was a little painting, *Hey! Let's Go for a Ride*. Dick, equally unstoppable, said, "Three hundred and fifty bucks, and this one, *Zone*, is eleven hundred." "Oh, well, we'd like them both," she said. I didn't have any money, but I was still not sure that I was ready to sell my work. "Think it over," Dick said. "You have sales here, buyers, major collectors." I thought it over. If I sold these, I figured, I could buy a lot of paint with that money. So I sold those paintings, and whatever else I did, Dick sold.

When Dick sold *Hey! Let's Go for a Ride* to the Tremaines, he

called me up. "Jim," he said, "listen, I can't get a trucker right now to take this over to the Tremaines. Do you think you could wrap it up and run it over there?" "Sure," I said. So I went over to their Park Avenue apartment, the doorman directed me to the staff elevator, and I went up. There they were, Emily and Burton Tremaine in this beautiful, huge apartment with four big de Koonings on the wall and a couple of Klines. As you went through the hallway, there on the right-hand side was a Picasso, which the Tremaines always said was painted at the time the Nazis marched into Paris, and then on the other side of the doorway was Klee's *Departure of the Ghost*. They looked at my painting and they said, "Well, let's take down *Departure of the Ghost* and put up Rosenquist!" So they hung it up then and there, and although my painting was replacing a classic piece of modernism, I thought, This looks pretty good! This fits! This is unbelievable. *Hey! Let's Go for a Ride* was a ghost of a kind, too, that face. The Tremaines had the passion and the courage of true art collectors.

And so did Morton Neumann. He had a good eye and a ruthless acquisitive nature, which led to a fantastic collection. He was an entrepreneur who'd made his fortune from a pomade to straighten black people's hair. He had many modernist paintings, and the joke about him was that his walls were so covered with art you couldn't find the light switch, but Morton would say, "Oh, the light switch is under the Picasso."

One day Morton showed up at the Green Gallery. There was an Oldenburg sausage laying on the floor, it was a ladies' silk stocking stuffed with material, tied together so it looked like a sausage. Morton comes in. "What's that, Dick?" he asks, and Dick says, "Oh, that's an Oldenburg sausage." Morton: "Okay, I want it. How much is it?" "I'm sorry," Dick tells him, "it's already sold." Morton picks it up and puts it in his pocket! And says, "I'll just take it, Dick!"

"No, no, you won't! I just sold it for six hundred bucks." The thing has been lying on the floor in the dust—you wouldn't have paid a dollar for it! But Morton wants it. So he puts it in his pocket, but Dick is physically wrestling with him to get it back. "No, no, Morton, you can't have it!" And eventually Morton has to take it out of his pocket and put it back on the floor.

Morton had collected four or five Joan Mirós, and he finds himself on a cruise ship to France; as he's walking around the ship, he

suddenly sees *Miró*! Miró is sitting there, in one of those deck chairs with a blanket! And Morton—he had this horrible French accent—says, "*Bon-jer, missure Miró, come on tally vou-er?*" and, "Just look at what I have!" Morton has a dummy that he'd gotten from the publisher for a book on Miró, with a jacket and the title and everything but inside is all blank pages. So he says, "Um, *Missure Miró, s'il vous plaît, voulez-vous faites un le dessin pour moi?*" And then Miró says, "*Cou-leur, cou-leur,*" meaning, "give me some crayons, you know, and I'll do some drawings for you." So, Morton rushed to the ship store—no crayons. He ran around the ship—no crayons. Then, just as he was about to give up he saw a little kid and the nanny, and the kid is coloring a picture using crayons.

"Madame!" says Morton, addressing the nanny, "Madame! I would like to buy those crayons." She says, "No!" Morton persists: "Here's ten dollars." "No! No!" says the nanny. Morton, exasperated, just grabs them right out of the kid's hands, runs down the deck around to the other side of the ship, and hands them to Miró, who does a number of drawings for him in the book. Morton was very good at getting free art from artists. He was something of a maniac—he was possessed. I loved him.

In January 1962 I had my first solo show at the Green Gallery. Dick's gallery was one big room with white walls and a wooden floor. A few of the paintings were six by eight feet, so we hung them back-to-back on cables and made a room divider out of them. The Kennedy painting wasn't included. Dick, for his own reasons, hadn't selected it. About any show you are in, you can ask, "Why wasn't this or that painting selected?" until you're blue in the face, but in the end it just isn't your choice.

The show sold out before it opened. I was amazed because there wasn't much of an art audience in New York in those days. I remember Ray Donarski, my dear friend from the League, and I were sitting on the floor of the gallery and wondering if anyone would come to the show. About 150 people eventually turned up, which seemed a lot.

Count Giuseppe Panza di Biumo, Robert and Ethel Scull, Emily and Burton Tremaine, and Jan Streep were some of the collectors who bought paintings from that show. Being able to sell your paintings, not living like a millionaire or anything, but just giving you enough money to have a place to paint in and work in—that's what

it was really about, making it possible for you to work and also have a little fun. When the money came, great. Sometimes it did and sometimes it didn't. It's very sobering to see a list of shows in the back of a 1959 issue of *ARTnews*. Out of the hundred or so artists listed, you'd be lucky to find three painters you'd recognize. Among artists, fame is very fleeting.

The scale of my paintings turned out to be at the very heart of pop art sensibility. Giant economy size. Bigger is better. Pop art took the exaggerated claims of advertising to the level of parody and irony; by inflating these banal objects, we gave them a kind of absurd monumentality. The blowing up of commonplace objects was soon taken up by other artists and became one of the characteristics of pop art style. After I had my first show at the Green Gallery, suddenly a lot of big pop paintings and sculptures entered the art world: Oldenburg's giant hamburgers and big stuffed pizzas, Warhol's monumental Elvises, Lichtenstein's blown-up cartoons, Wesselmann's great American nudes. I started that—I'm the one who gave steroids to pop art.

Actually there *was* no pop art yet—it hadn't got its tag, but by 1962 critics and magazine writers were aware of the new trend and wrote about it under a number of different names. The first exhibits showing this kind of art were called new realist. It was the British art critic and curator Lawrence Alloway who coined the term pop art because the paintings (allegedly) celebrated popular culture (the reverse was true in my case and, I would say, in Lichtenstein's, too).

Strictly speaking, pop art started in England with Richard Hamilton and Peter Blake. They were doing collages of pop culture images in the mid-1950s, but somehow English pop art didn't work as effectively as the American brand. I think the beginnings of pop art in England probably came from the Kitchen Sink school, which focused on everyday objects as a subject for art—like in John Bratby's paintings. He's the artist who did the paintings for the film *The Horse's Mouth*.

Richard Hamilton's collage *"Just What Is It That Makes Today's Homes So Different, So Appealing?"* from 1956, with the muscle-bound guy holding a lollipop, predated my, Andy's, and Roy's work by at least five years. To me, the British never had the scale or dynamism that made American pop art so indelible—it was all done in small-scale pictures. There was no context for them. I feel I was

very lucky to grow up in the United States in the 1930s, '40s, and '50s when we had pastel-colored toilets, rose-colored refrigerators, overflowing supermarkets, Sugar Ray Robinson's pink Cadillac, and all that glitzy stuff and consumer grossness that other countries didn't have.

When I went to Russia, in 1965, there was no color *anywhere*. None. *Nyet*. I saw a truckload of potatoes go by, very pastoral, in wooden boxes—and it was like an early painting by van Gogh, all burnt umbers and grays. It was very drab in Leningrad. There were beautiful pastel-colored buildings, but there were none of those vibrant, jumping-out-at-you colors you see every day in America.

Much as I have always objected to being pigeonholed as a pop artist, I did enjoy how very early on pop art effortlessly generated outrage. Jim Dine became the hot gossip in the summer of 1962 with his paint-cutting lawn mower at Sidney Janis. Other painters attached to the gallery were irate. Artists threatened to leave the gallery unless this offending trash was removed! Sidney showed Pollock, de Kooning, Franz Kline, and they were all outraged and did leave the gallery. Newspapers dismissed pop art as junk and a fad.

Many of those European artists from the first wave of the avant-garde, Mondrian among them, had moved from Paris to New York during the war and their influence sparked the new American art movements of the 1940s and '50s. I was up in Sidney Janis's office once and he had three small Mondrians—he had just sold one for $45,000. He said, "See these paintings?"

I said, "Yes."

"Mondrian came into my gallery in the forties. He was freezing and needed an overcoat, and I said I would try to sell the paintings for him. I sold all of them for six or seven hundred dollars. Then the guy came back and said he didn't like them and couldn't live with them. I gave Mondrian four hundred and fifty dollars and I kept these paintings."

Now, he'd just sold one for $45,000 and he still had the other two. Mondrian loved New York—the energy, the speed, the *grid*! But he died poor. He's buried under a simple stone in Queens.

By 1963 pop art had almost become respectable with the Six Painters and the Object retrospective at the Guggenheim, curated by Lawrence Alloway, featuring Dine, Johns, Lichtenstein, Rausch-

enberg, Warhol, and me. That same year, the Albright-Knox Gallery in Buffalo bought *Nomad* for $4,400—my first museum acquisition.

The idea for *Nomad* came from my own life, from endlessly moving around as a child. In the painting the word NEW on the Oxydol detergent package of course means the opposite. On billboard paintings they always wrote *new*—which meant shit, it meant old. When they say *improved*, it means they've taken the good stuff that was originally in it and put cheap, less-effective stuff in instead. Anything I wrote on those billboards I always assumed meant the opposite.

The New York art world of the 1960s was animated by its brilliant and eccentric cast of characters: the rascally Larry Poons, the incorrigible John Chamberlain, the mysterious Marisol, the bizarre Lucas Samaras, the sphinxlike John Cage, the oddball dancer and dealer Alexandre Iolas, and the legend of the art world: Marcel Duchamp. There's often an unexpected contrast between an artist's life and art, as in the filigree art and hard-living life of Agnes Martin, whose eccentric behavior included buying coffee in her pajamas at the Sailors' Home on the waterfront.

Everything got charged in the cyclotron of the 1960s—art, politics, social change, racism. I watched as my friend LeRoi Jones became radicalized and transformed himself from lyrical black poet into black militant. George Lincoln Rockwell, the white supremacist, walked into the Cedar Bar and began taunting LeRoi. "We don't hate you niggers," he said, "we're just trying to bring you up to our level!" Everybody in the bar was egging LeRoi on. "Hit the motherfucker, Roy, hit him! Hit him!" LeRoi said, "Nahhhhhh, forget it."

About a week later, he was picked up in Newark, New Jersey, with two pistols, and thrown in the slammer. Overnight he'd become the gun-toting firebrand Amiri Baraka, outrageously denouncing Lady Bird Johnson as "a bitch" and LBJ as "an SOB" on TV. This was before the seven-second delay. I knew him fairly well in the early days; I used to go over to the apartment where he lived with his wife, the poet Hettie Jones, and hang out with them. A few years ago Hettie wrote a memoir of her life with LeRoi and the Beat scene called *How I Became Hettie Jones*. We were good friends,

but as time went on LeRoi became more and more doctrinaire. There was a party at the Dom on St. Mark's Place where the Velvet Underground used to play for Black Arts for Amiri Baraka. I went to it with Larry Poons and a British art critic. I walked in and said, "Hi, Roy! Good to see you." He turned around and walked away—he wouldn't even talk to me. He didn't like white people anymore; he would have nothing to do with them.

Art movements that formed around artists in the past had been small closed circles: painters gathered informally among themselves. Many of the abstract artists didn't know one another. At one time Clyfford Still, Attilio Salemme, de Kooning, and Ad Reinhardt were all living right next door to each other, and they never met. They eventually ran into one another through James Harvey, the abstract expressionist painter who, as an industrial designer, had come up with the Brillo box design. He used to have slide shows of photographs he'd taken on his travels to the Far East, of temples and mosques and camels. Artists would show up at these things, see other painters, and go, "Oh hi, how are you?" I was kind of blown away that these people didn't know one another.

The other place abstract expressionist gatherings took place was at the Friday Night Club, where there were intense arguments about art. You paid fifty cents to get in, you had a free beer, and people got up and held forth about Art. They were not cool cats at all, and they argued ferociously. I went to a few of their meetings, and Milton Resnick always talked a lot at these affairs. The first one I went to was the memorial for Jackson Pollock. People got up and said, "Jackson will live with us forever. His art will live on and on." De Kooning got up and with tears in his eyes said, "Goddamn it, no! He's six feet in the ground. He's not with us forever."

I happen to know the tree that Pollock crashed into quite well because I used to live on that road. You'd come around Fireplace Road and there was a tree sticking out right by the side of the road. You'd swerve to avoid it. That's what he did, and then he hit the next one.

The art world of the mid-1960s was cool; there was none of the Sturm und Drang of the abstract expressionists, but it was a whirlwind of interactions. It was a time when the art world had expanded to include socialites, rock stars, movie stars, underground writers, scene-makers, models, and art groupies.

This was at one of Bob Rauschenberg's loft parties, ca. 1963.

Part of the reason the art scene of the 1960s was so cohesive is very simple: nobody had any money. Everyone went to everyone else's openings and the parties afterward with jugs of wine and Motown music blaring. There were parties all the time. Parties for openings, antiwar parties, parties for eclipses, parties for the hell of it. Even when things didn't work out, I would always have a big party, saying, "Hey man, it's really great to be able to live and paint and have a big party afterward. It's payback time." The difference between so-called pop artists and European artists from the same era was that we were all quite friendly and we didn't put each other down the way the Europeans did.

I remember a party at Rauschenberg's studio with an out-of-work Dennis Hopper looking scraggly but still carrying a big roll of $100 bills. Charles Henri Ford used to have parties at the Dakota with the actor Zachary Scott (married to Ford's sister Ruth), who dressed in a pirate shirt and had a hoop earring in one ear. Ford was the editor of *View* from 1940 to 1947 and a close friend of the painter Pavel Tchelitchew.

I didn't really hear of Andy Warhol until sometime in 1964. He was a very frail, young, odd-looking guy. I always felt he was obsessed with the speed of life. In a strange way, Andy attracted attention because of his wig and his blank personality, which were both really disguises. I saw him once at a party at the Sculls' in Great Neck. He was quiet, polite, and odd, but without any of the posing that he later affected. He was a very single-minded person; he had this drive to work, work, work.

When Andy and I were alone, he would chatter constantly, but then when he was with people or being interviewed, he wouldn't say anything. One time on Madison Avenue, he walked up to me and said, "Oh, you're the best artist." I think it was a put-on. I said, "No, Andy, *you're* the best artist." Then he would say, "No, *you're* the best artist."

The sardonic, courtly Roy Lichtenstein was a World War II veteran and had gone through so much horror that he didn't let many things bother him. Andy was a different matter altogether. He was

mischievous and provocative—often almost unintentionally. For instance, he was obsessed with Jasper Johns. The flags outside his Exploding Plastic Inevitable show, the multimedia performance he created at the discotheque on St. Marks Place, read:

<div align="center">

JASPER JOHNS
LIVE TONITE!

</div>

A joke, needless to say. Being the most laconic person I know, Jasper was the least likely artist to become an entertainer. Andy's playfulness was not appreciated by the austere, enigmatic Jasper himself, but this didn't stop Andy from having GO TO BED WITH JASPER JOHNS pillows made.

You'd always see Henry Geldzahler at these events. As the curator of the twentieth-century wing of the Metropolitan Museum, later the New York City cultural commissioner, and then chairman of the National Council on the Arts under Nancy Hanks, Henry was a champion of the arts for the city. He would call me up and say, "Hi. I'm alone. You're alone. Come over and let's be alone together." Peter Rosen made a documentary about Henry Geldzahler a few years ago called *Who Gets to Call It Art?* You see that Henry is the missing link to a period in the art world that people don't know much about.

Henry Geldzahler in my Broome Street studio in front of *F-111*, which measured 10 x 86 ft. when finished.

Once I was having lunch with Henry and Daniel Spoerri, who lived at the Chelsea Hotel. Spoerri was a Swiss artist who would take people's finished dinners—their table settings, cigarette butts, old mashed potatoes, and chicken bones—and glue them down on boards and hang them on the wall. That was his art. His titles were like *Le petit déjeuner de Bruno*, you know, with the date and whose breakfast it had been. As we were finishing up our meal, Spoerri was collecting our plates so he could embalm them in a work of art. He was curating our lunch!

I remember one night, I was living in a tenement apartment on the Upper East Side for $50 a month and I invited Henry and Andy over for dinner. After dinner, around ten o'clock, Andy said, "Would you like to go see my movie?"

"What movie is that?" I asked.

"Well, it's a movie called *Sleep*, and it's playing down on Twenty-eighth Street in a theater."

"Sure, let's go," I said, "but when does it start?"

"Oh, it already started. It started at seven o'clock."

"Well, haven't we missed most of it by now?"

"Uh, no. We can go anytime."

Henry giggled, but I didn't understand.

We got down there and Andy goes first to the ticket taker and says, "Is there anyone in there?"

"Well, two people came at seven-thirty and I think they left, and then two people came again at eight or nine. I think there is one of them still in there. Five more people came around eight o'clock," she deadpans, chewing gum. "Three of them left after ten minutes. Two more people came around nine but then they left. . . ."

"Oh, gee," Andy said. "Maybe I should have called it something else. What do you think I should have called it, Henry?"

"How about *A Big Smash*?" Henry said.

"But that's *two* words, Henry," Andy said. "I think all titles should be one word, don't you, Jim?"

We went in and I think we were the only people in there. We sat there watching John Giorno sleep. It was a very peculiar movie: just John Giorno sleeping for eight hours. There was no sound. Henry and Andy started talking, gossiping. They paid no attention to the guy up on the screen but I was getting worried. Forty minutes into the movie, he hadn't moved. There was no movement whatsoever. I became alarmed. I thought he was dead. "Is he dead?" I asked Andy. "Uh, no," he said matter-of-factly. Then a tear started to form in John Giorno's eye, and I said, "Thank God he isn't dead." Henry got up in front of the screen and started dancing in front of the projector.

I was very briefly in one of Andy's films. I sat in a revolving chair for a couple of minutes; it spun around and he filmed it—so, in essence, he shot my head tumbling through space like a futurist sculpture.

Then there was the dark side of Andy: his disaster and electric-chair paintings as dire as medieval depictions of hell. In the *Tunafish Disaster* painting he shows two ladies who died from eating contaminated tuna fish. He offered to trade it for one of my paintings. I declined; one of those unfortunate ladies looked like my aunt Tillie.

I once watched Andy paint. He had an almost reverent detach-

ment in the way he worked, as if he were painting an icon and didn't want to leave any human print on the canvas—or as if the canvas were a hot plate and he didn't want to burn himself. He would touch the canvas quickly with his brush and then withdraw it.

And then there was his idiosyncratic approach to portrait painting, a process some have seen as a soulless assembly line: taking photographs of the sitter, converting them to silk screens, squeegeeing the image onto canvas, and then swabbing the color on with a mop. This prodigious output of his—hundreds of "heads" in various stages of completion—was, in its way, as deliberate and stylized as the work of any court painter. I always liked these paintings the best.

Andy liked to tease people. They'd feel threatened and humiliated and get mad, but it was for the most part just mischievousness on his part. There was a side of him that was chilly and remote, and because he was so cool and detached, people's feelings got hurt; they, in turn, would try to get their revenge on him.

After he got shot, he got rid of all the crazies around him, but actually that was the second time somebody came up to the Factory with a gun. This very funny, wild artist named Dorothy Podber, a friend of Ray Johnson's, had walked into the Factory one day in 1964 and shot a bullet through a stack of Marilyns. They're known as the *Shot Marilyns* and are now very valuable.

Many years later one of Andy's superstars, Naomi Levine, came down to my studio in Florida. She asked me to loan her $300. I had pneumonia and couldn't see her. I had a guy from West Virginia who was working for me, and he told her to go away—he was an old country boy. She said, "Don't touch me, you fuck. I have a gun." He said, "Okay, lady." After I gave her the money, she went away.

I used to travel with Roy and Andy, Ivan Karp and Leo, for various group shows around New York State, and there were several occasions when people tried to hurt Andy. Once we were up on a balcony at a big industrial facility and below us there was a big pile of chemicals, this huge mound of powders. Someone tried to push Andy over the rail into this chemical waste. You couldn't tell who it was. Andy and I wheeled around but there was no one there.

Another time I was on the street with Andy, uptown on Madison Avenue, and someone tried to push Andy into oncoming traffic. I'm sure it was one of the disgruntled people whom he used to tease.

Occasionally I hear these programs on NPR with people saying things like, "Oh, Andy . . . it's like his art just magically came out of nowhere." Of course it didn't. Andy was very practical, very astute, and a voracious absorber of ideas and images.

Roy Lichtenstein was a different story altogether. I was amazed by Roy from the first time I saw his work in the 1950s. He was ten years older than I was and already very accomplished. He didn't just come out of nowhere with his comic-strip paintings. He had a very extensive knowledge of cubism and modern art in general. The first things of his I saw were paintings using American Indian motifs in a cubist style. I had copied Indian signs and symbols in caves in Minnesota, but that was when I was quite young—I didn't know anything about cubism back then. After the war Roy had studied art. He went to school and later on taught art. I was amazed at his knowledge of cubism, futurism, Russian constructivism—he was a scholar of modernism. His style and sense of composition was just brilliant.

The first I heard that Roy was making pop art paintings was when Dick Bellamy came to my studio in the summer of 1961.

"Jim, you've got to have a show soon," Dick told me decisively.

"Oh, and why is that?" I asked. I wasn't too interested because I was still trying to establish my ideas with these new paintings.

"You think you're the only artist in America doing nondrip paintings?" Bellamy asked accusingly.

"Why do I get the feeling you've got something to tell me?"

"Yeah, there's others out there. There's a guy in New Jersey— he's doing comic strips!"

"*Comic strips?* Hmmmm."

Andy had started out trying to paint comic strips, with and without drips, but it wasn't a direction he chose to go in—especially after he heard about Roy, probably from Ivan Karp.

I first saw a painting of Roy's in early 1962 at Emily and Burton Tremaine's apartment. It was a small cartoonlike painting of a Roto-Broiler. Emily Tremaine asked me what I thought of it and if she should buy it. "Yes," I said, "absolutely," because it wasn't like

anything I'd seen before, and to me art was all about surprise and invention—something that would expand the perimeter, enlarge the dimensions, of whatever came before.

Roy had his first pop art show at Castelli's around the same time I had mine at the Green Gallery. There was a tiny piece in *The New York Times* that mentioned Roy Lichtenstein and *Joseph* Rosenquist were showing new works.

Roy reminded me of my cousins who'd fought in the infantry in Germany in the war. They came home with the postwar American Dream, which promised a house, a wife, children, a car, and an airplane! My cousin Archie held on to that dream even as he approached eighty years old. I'd call him up and ask his wife where Archie was and she'd say, "Oh, y'know, Jim, he's out there tinkering with his '58 Cessna."

I think that Roy's early pop paintings were comic book–style poems on that postwar American Dream. I'd heard that he'd been a draftsman, so this might account for his hard-edge style: no blending, no drips. Later in his career, Roy's ability to create witty, dynamic images, variations on mediated imagery, was unexpected and ingenious. He always made the canvas do things you never thought it could do.

Once, looking at a recent batch of new paintings, I said to him, "Roy, I didn't know you were such an inventive colorist." In his shy, diffident way he just smiled that mysterious smile of his.

In 1963 Philip Johnson asked a number of us to do paintings for the exterior of the New York State movie theater at the New York World's Fair. A beautiful model appeared at the fair, Dorothy Herzka. She eventually became Roy's wife and was a primal force in his career—she worked very hard promoting him, taking no credit for his success. I remember one time being at a party with Bob Rauschenberg; the two of us looked at Dorothy, and Bob turned to me and said, "Jim, we need someone like that!"

I was always touched by Roy's modesty. At his Guggenheim retrospective, when he was asked to get up and speak, all he said was "Thank you," and sat down again. I noticed the Aga Khan at Roy's table. I turned to Roy and said, "I didn't know that you knew the Aga Kahn." Roy said, "I don't." I miss Roy. I thought he would live out a long life, somewhat like Matisse, in a chair with a maulstick, making paintings.

With Bob Rauschenberg
at an opening at the
Castelli Gallery.

My mentors were Robert Rauschenberg and Jasper Johns. Rauschenberg was an intuitive genius; always in impulsive pursuit of hit-or-miss first impressions and refusing to edit, inspired by Kerouac's "first thought, best thought" theory of creation; buoyantly involved in group-mind collaboration in his work. On the other hand, Jasper Johns has a cerebral, enigmatic mentality; a medieval, God-is-in-the-details attention to minutiae in his painting of alphabets and numbers.

While I was living on Coenties Slip, Jasper invited himself to my studio to see my paintings. He looked around and said, "Where did you learn to paint like that?" Always oblique, enigmatic. When I went over to his place I saw this little painting called *Device I* and I laughed. "I thought you would like that," he said slyly. I saw what I thought it was, a self-portrait: two rulers like windshield wipers had smeared the paint in a circle, while two coat hooks held the fork and the knife or spoon. I say it was a self-portrait, because obviously it was about Jasper. It was like an aesthetic machine. The artist was the device, a kind of machine for painting. But then again, all paintings are self-portraits.

Jasper has a very dry sense of humor. While he was working on a project with Edward Albee, he told me this joke using his high, ecclesiastical voice: "This turtle was walking along and it was robbed by two snails. The turtle called the police, and when they asked him 'What happened?' the turtle said, 'Well I don't know, everything happened too fast.'" He's an eccentric, Jasper, but he can be very acerbic. I gave a big party at one point and in the middle of the festivities I saw Bob talking to Jasper—I wondered what they were saying to each other. Bob's face dropped as he walked away from Jasper. He turned around, came back toward me, and said, "Can't he ever say anything nice?"

In the 1960s we were in love with the moment, the Now, but we also venerated our odd progenitors. In 1964 Andy, Bob Indiana, Charles Henri Ford, and I made a pilgrimage to Joseph Cornell's studio on Utopia Parkway in Queens. Cornell made these beautiful, surreal boxes that looked like exhibits in a bizarre personal museum—which in a sense they were. Ray Johnson used to call him the Boxer.

Cornell seemed a hundred years old. His mother served us Kool-Aid and cookies. Joseph had a crippled brother who liked railroad trains, so Bob made him a collage of the front of a locomotive and sent it to him. Joseph's studio was in the basement. I didn't get to see it until much later, after we became friends. He called it "the Habitat." Down there were little boxes piled up, collections of feathers, dolls, old prints, ball bearings, daguerreotypes. In the boxes he'd written messages to himself about adjustments in his work.

Charles Henri Ford was the reason we got to see him. Charles had put Joseph in *View* magazine many times. Andy loved his work, too, of course, and Joseph did anything Charles said, like "Let's go outside, Joseph, you lie down on the grass and put the artwork over your face." And very meekly Joseph would say, "Oh, okay." We went outside, Joseph lay down, and Charles took his picture. And then we left.

My mother-in-law lived right near Joseph's house, so when I went to see her, I'd call up Joseph. "How are you doing?" I'd ask. "I'm right next door and I'd like to come over." Once I called him from New York and I said, "Joseph, I'm cleaning out my studio and I have something I'd like to send you." "I'm cleaning out my studio, too," he said, "and I don't want it!" Then he paused and asked, "But what is it?" "It's a photo of a reindeer trapped in a dry reservoir," I told him. "Very well," he said. "Send it along." Then I phoned him again from Sag Harbor. I was in an old, decrepit dime store and found some World War II doll clothes attached to a piece of cardboard; on the cardboard it said, "If you send this piece of cardboard in to us, we'll send you an extra brassiere or shoes," or something like that. I thought that was just up his alley so I sent it to him, thinking, Wow, this might appear in one of his pieces. Sometime later on I was out at his house and he took me down into his Habitat in the basement where he had all his works. He had a little box with a slot in the top where he put in "corrections," as he called them, which changed the picture, changed the diorama. Then he pulled down one of his art boxes and asked, "Do you think this is gauche? Do you think this has merit?" I said it was beautiful, absolutely beautiful, and he said, "But I'm going to change it."

The last time I saw him was at Zachary Scott's funeral at St. James' Church at Madison Avenue and Seventy-second Street.

There was Joseph, two days' growth of beard, long overcoat, Indian moccasins, pacing back and forth as if he'd just walked out of his house to pick up the morning newspaper. I never saw him again.

During the 1960s there was something going on almost every night. Openings, happenings, underground movies, experimental dance at the Judson Church, avant-garde concerts with David Tudor, and endless loft parties. We would get invited to movie premieres and off-Broadway performances free. There were cocktails at collectors' houses. We'd be invited to the Sculls' or the Tremaines' for dinner. We would run into each other in a bar. Then there was Mickey Ruskin's art central, Max's Kansas City. Max's was kind of a history-of-art bar with archaeological levels. At the entrance would be John Chamberlain and a few other abstract expressionists arguing and fighting in their epic manner, then there would be people like Frank Stella and Larry Poons in the booths, and finally in the back was Andy Warhol and his coterie.

We would go to Elaine's occasionally, and just as frequently get kicked out. It was a writer's bar. At Elaine's you had to be careful. We'd go there after an opening or a party for a drink. One time I was there with Mary Lou, the photographer Mel Sokolsky and his wife, Button, Bob Rauschenberg, and a few other people. Some guys at the next table were smoking joints, so Elaine came over and yelled, "You fuckin' idiots, get the fuck outta here! You're gonna have me closed down!" She was a tough old lady. So, what do they do? Two of the people slide over to our table. One was Daniel Cordier of the Cordier & Ekstrom Gallery. They order a bottle of champagne for Bob Rauschenberg. Then Daniel Cordier says, "I am a prince. I have ten rooms on Central Park." And Sokolsky says, "You don't look like a fuckin' prince!" And the other guy says, "Shut up, you!" And then Sokolsky gets up and says, "I'll kill ya!" "I've never seen anybody killed before," says Bob. "I wanna watch this!" In the end we all got thrown out. Bob went off with Cordier and his friend. Later we decide to go down to Fifty-third and Park to the Brasserie for one last drink. At the Brasserie who do we see but Bob Rauschenberg with the painter Elaine Sturtevant sitting on his back like a monkey! So I said, "What happened?" And he says, "Well, I went to his ten rooms on Central Park and it was

weird, so I turned around and left." Some kinky shenanigans going on. The nights were like that; we just kept going and going. . . .

All I did was work, eat, sleep—and drink. Bob and I worked like crazy. We would be tired after work and go out to a bar. It was work and bar, work and bar, work and bar. I remember going out every night for almost seven months in a row—and waking up with a hangover almost every morning.

In 1963 I was one of sixteen painters in Dorothy Miller's Americans show at the Museum of Modern Art. Dorothy was very elegant and dressed in black most of the time. She had a house in upstate New York, lived to be ninety-nine, and always looked mysterious. I told Gordon Hyatt, the TV director who made *Who Gets to Call It Art?*, that when he saw her, to give her this message: "We all love you and think you are incredible, a wonder worker. You've done so many amazing things in so many great shows, you are a national treasure." In answer to what I'd said about her I got the message back: "Oh, pooh-pooh."

She married a government official, and they cooked up this idea in 1958 of sending American abstract expressionist paintings to Europe to show that America was a progressive, democratic country—the idea of using art as a diplomatic or subversive tool. At her memorial in 2003, Aggie Gund, president of MoMA, said, "Dorothy Miller sent weapons of mass abstraction all over Europe to show them who we were."

I needed a bigger studio, and in the fall of 1963 I heard about a space that had been a former Cuban hat factory at 429 Broome Street. Ron Westerfield, a fellow artist, and I asked the landlords how much per floor. They said $250. "Okay," I said, "but how about if we give you two-fifty for two floors." So we each got a floor for one and a quarter. That went on for a couple of years; when they upped the rent to $350 I moved out to East Hampton.

At the Broome Street studio, I began experimenting with objects, including wood (*Nomad*), chairs (*Candidate* and *Director*), and painted Mylar and plastic sheets (*Morning Sun* and *Nomad*). I also worked on freestanding multimedia constructions and neon artworks (*AD*, *Soap Box Tree*, and *Untitled*). Incorporating objects into paintings in American art began with Rauschenberg's combine

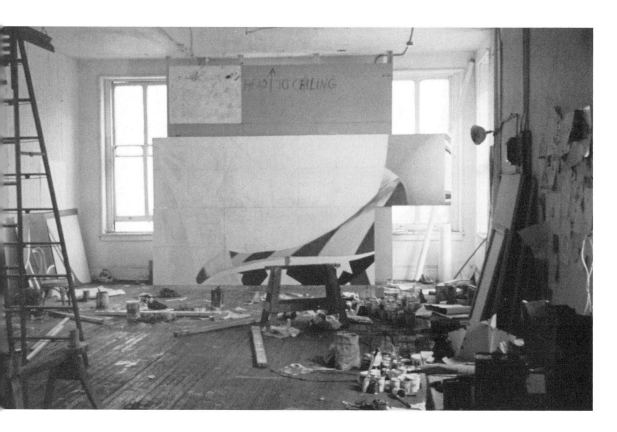

paintings and Jasper Johns's pieces, with plaster casts, rulers, and neon.

Different studios affected both the subject of my art and its size. At Broome Street, for instance, I painted *F-111*, and I also got into multimedia works. I did a couple of things with trees. I chopped one in half for *Capillary Action II*. It consists of a sapling split in two, and a painting with multicolored paint dripping down its clear, thin plastic surface, sandwiched between the young tree's halves. I put three smaller plastic-covered stretchers on the surface of the larger one and a wobbly line of square-shaped orange neon above the surface.

I'd done an earlier version of *Capillary Action* the year before using panels attached to the surface of the painting; the title refers to a tree's ability to soak up moisture. Around that time I'd seen a photograph of a meadow with a tree standing in the middle of it. I couldn't get that image out of my mind. It kept flashing on and off in my head—in one phase it was extremely artificial, then it would revert to being completely natural again, like a landscape in which

nature becomes increasingly modified by man until the natural and artificial blend into each other. I wanted to create an artwork that could somehow project these two opposite states simultaneously. I wondered what kind of environment people would have in the future—or would want to have. Working on *Capillary Action* felt like throwing out reason and inaction and doing something to protest.

Capillary Action II had neon, a tree, and a canvas that you could see through. It was more abstract. What inspired it was a trip I made to visit my parents when they were living in Texas. While I was there I went to an amusement park called Six Flags Over Texas. It was hotter than hell, and as I was walking into the park, I noticed huge ceiling fans in the trees outside, moving the branches. It struck me: Was the whole world going to end up as an amusement park?

Noon, which I painted in 1962, has a flashlight bisecting two segments of sky. It's the idea of looking for something with a flashlight in the middle of the day, looking for something that's missing but that isn't where you lost it, like Diogenes looking for an honest man at noon in broad daylight. I was fascinated by the fact that light can actually make things disappear. You can camouflage a whole fleet of trucks just by putting strong lights on them. Instead of the trucks you'd see a blank space.

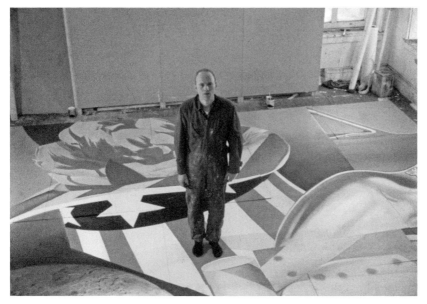

Standing on part of the World's Fair mural.

I've made a few paintings using lightbulbs. In 1963 I made a ceiling-mounted work with lightbulbs and the ground plan of a typical suburban house with a two-car garage called *Doorstop*. In 1961 I'd painted *Reification*, meaning that you reapply something and change it. It's a memoir of lightbulbs burned out on a billboard. When the light is on, it's one thing; when it's off, it's another. Recently an artist won the $400,000 Hugo Boss Prize for merely coming into the room and turning on a light.

Pop art and pop artists got a lot of coverage in the press, and much of the media curiosity focused on Andy, who had an instinctive talent for generating publicity. Art openings became events and, as it had in Paris in the 1920s, art once again created scandals. And it wasn't only Warhol's Brillo boxes and electric-chair paintings that stirred things up. There were many truly wild shows that had nothing to do with pop art, such as Jean Tinguely's self-destructing machines at the Museum of Modern Art and Niki de Saint Phalle's exploding sculptures at the Iolas Gallery on Fifty-seventh Street. I shot at them with a .22 rifle; the sculptures were filled with paint, and when the bullets hit them colored paint burst out.

By 1964 media interest in pop art had escalated—it was now apparently a worthy subject for TV. CBS's *Eye on New York* did a segment called "Art for Whose Sake" on pop art. It was mainly about the sculptor George Segal but also covered my second solo show at the Green Gallery. They interviewed Sidney Janis, Dick Bellamy, and Bob Scull. It was all done in the rat-tat-tat fashion usually reserved for crime stories.

In January the Sidney Janis Gallery had a show called Four Environments by Four New Realists, featuring George Segal, Jim Dine, Claes Oldenburg, and me. I had my second dialogue with Gene Swenson: "What Is Pop Art? Part II." Despite its notoriety MoMA ignored pop art entirely; instead, in 1965, they mounted a major exhibition of op art, a movement that turned out in the end to be a digression. But then MoMA didn't acknowledge abstract expressionism until 1959 either, when it was more or less over.

For the twenty-by-twenty-foot mural that Philip Johnson had commissioned me to do on Masonite for the Theaterama building at the New York State Pavilion for the 1964 World's Fair, I painted an Uncle Sam top hat catching hot rivets and flowers for construction of a skyscraper. Then I put in the moon—NASA was already

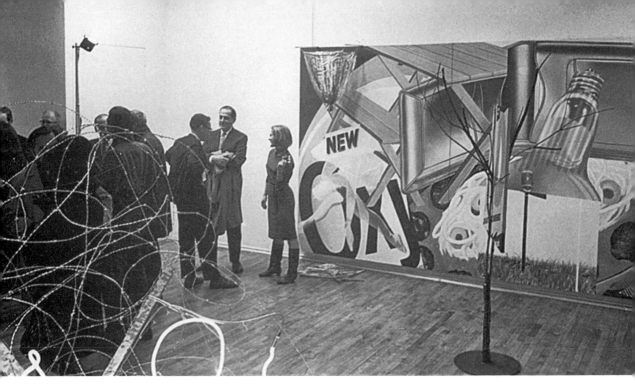

planning moon shot by that time—and peanuts because I thought of astronauts throwing American peanuts into space. The car is a Mercury, but I only showed the letters *ury*, which spell out, "You are why?" In other words, "Who are you? Why do you exist?"

Philip asked me to do a second mural for the New York Pavilion but I couldn't, so I told Larry Poons about it. "Larry," I said, "there are these huge disposable buildings that have big walls, and they asked me to do things about that, but I'm already doing one and can't do another one right now. But it's just perfect for you!" A huge dot painting that vibrates on the side of this building would have been stunning, but he wasn't interested. He could be very contrarian and it wasn't always in his best interest.

Larry's paintings were like an equation. He would make a grid on his canvas and start by putting a dot in the upper right-hand corner of the square, then he'd put the next dot in the adjacent square halfway down the right side, and in the next box another dot at the bottom of that square. He would rotate the position of the dots like a clock. It was a crazy optical boogie. The color of the ground would be red, maybe, or amber or green. It was interesting how peculiar they would look altogether—they just vibrated off the canvas. A beautiful dot painting on the side of a building would be

better than any neon sign. Later on *Life* offered him eight pages in the magazine and he turned that down, too.

I had a painting of Larry's called *Mary, Queen of Scots*. It was about ten feet tall, and I hung it for about ten years in the country before I eventually sold it. In Aspen Larry would ask me over to see his paintings.

"Aw, Larry," I'd say, "it's beautiful, the ground looks like a dirty-brassiere pink, and the dots are warm."

"You really like it?" he'd ask with childlike incredulity.

"Yeah, I love it!"

A week or so later, I'm at his studio again.

"Come on," he says, "I want to show you something." Now the dots looked like a dirty-brassiere color and the ground was warmer pink. And then he pointed to the other one. It was in the corner all ripped up.

Larry's paintings were originally based on musical composition. And then the critic Clement Greenberg came along and messed him up. Larry would make a big painting, tack it on the wall, and Greenberg would come in and say, "Now, take four inches off the right and two inches off the left." Greenberg composed the paintings for the artists; what a bunch of baloney that was.

The New York World's Fair in 1964 was the last World's Fair that anyone could believe in. Ken Kesey and his Merry Pranksters showed up in their psychedelic-painted school bus, Furthur. For his commission Andy painted grim and funny criminal pinups, *Thirteen Most Wanted Men,* for the New York Pavilion, but as soon as the powers that be caught on to Andy's little joke, they made him take it down.

Pushing the limits was part of the thrust of 1960s art. During the inaugural dinner at the World's Fair's revolving restaurant, there was a screening of an avant-garde movie by Bob Whitman: in front of a roomful of fancy people, a huge behind appeared on the screen, and out came a giant turd.

In 1964, through Leo, I was offered a show at Ileana Sonnabend's gallery in Paris. Ileana was Leo's ex-wife; my showing at her gallery, I felt, was tantamount to joining the Castelli clan. Mary Lou and I went to Europe tourist class on the SS *France;* it was very elegant and fun. I had my own storage space on the ship—where you'd

Opposite: This was an early version of the World's Fair mural.

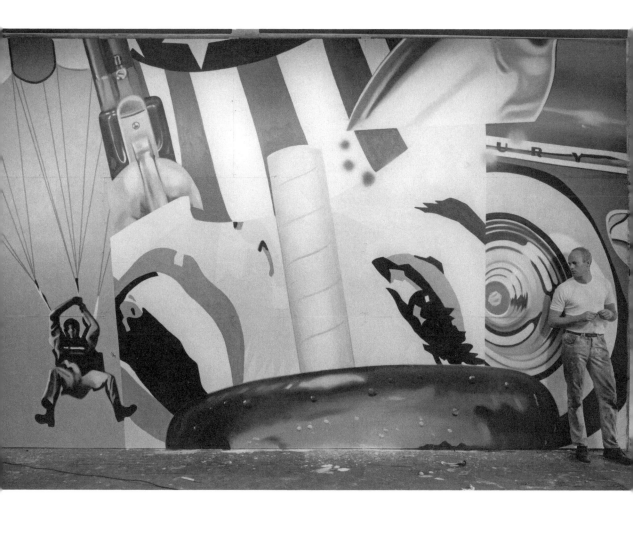

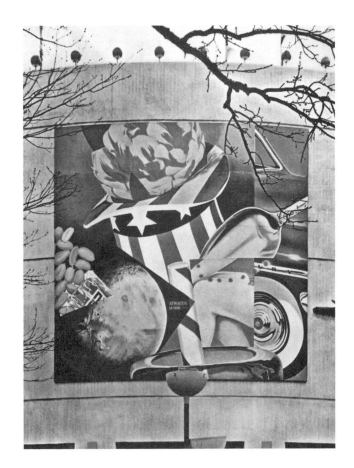

This is the World's Fair mural installed on the outside of Philip Johnson's Theaterama building, New York State Pavilion, 1964.

normally put your car, I put all my paintings. It was a six-day trip, but at the end of the voyage, it got rough. I've never been seasick in my life and I wasn't then, but even the tough old sailors were throwing up.

Ileana wanted us in Paris in June, but since we got to Europe three weeks early, the painter Toti Scialoja lent us his studio at 83 rue de la Tombe Issoire in the Fourteenth Arrondissement on the Left Bank. It had a mansard roof with a skylight. Mary Lou was pregnant with John, and we went to La Coupole restaurant practically every night and hung out there until three or four in the morning. It was a big, democratic place, very friendly to American tourists. An American guy would see a friend there, stand up, and shout, "Hey, Louis, it's me, Joey, from Brooklyn." And the waiters would cheerfully move his silverware over to his friend's table. The owners were famous for having hidden Jews during World War II.

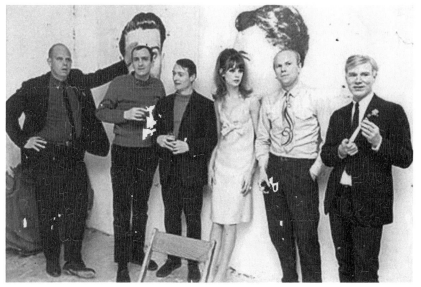

In Andy's studio, 1963, (*left to right*): Claes Oldenburg, Tom Wesselmann, Roy Lichtenstein, Jean Shrimpton, me, and Andy Warhol in front of Andy's *Thirteen Most Wanted Men,* which was rejected for the World's Fair.

Ileana was Romanian and very funny. When she set up her gallery in Paris she made a strong statement. I think the French government gave her a hard time. There was a reaction against her—like who does she think she is coming here and trying to invade Paris with this new Americanism? Parisians were doing quite nicely without American art. Then Ileana came along and said, "Screw you. We are new and this is a new art scene. We are different now." She was brilliant. In the newspaper where galleries are listed, there would be line after line discreetly announcing upcoming shows. When it got to Galerie Sonnabend, instead of just putting her address, Ileana had a little smeary paintbrush. It was smart advertising. She put my name up all over Paris. We got to hang around with a bunch of artists from the School of Paris: Alain Jacquet, Walasse Ting, Pierre Alechinsky, and Sam Francis. They were a very friendly bunch and not one bit chauvinistic. I really liked them, and when I got back to the States I had a big clambake for them in my cold-water flat.

Ileana had many visitors to her gallery and people said it wasn't all because of the art. She'd brought over boxes of American toilet paper; the French loved that. The toilet paper in Paris at that time was like cardboard. She and Leo were divorced by then and her husband Mike Sonnabend, a former harbor captain, was a lot of fun;

with him I explored the arcane byways of Paris and walked around Versailles.

André Breton, Joan Miró, and Alberto Giacometti came to my show. The great eminences of European modernism had mixed reactions. Giacometti said, "It may be some kind of poetry, but it isn't painting." After the opening, Charles Henri Ford threw a party for me on the Quai d'Orsay with an imported Tahitian girl sliding down the baroque banisters. Barney and Annalee Newman came, as did Mary McCarthy and Aaron Copeland.

At my opening Edouard Jaguer, who was the neosurrealist pope at the time, and Pierre Alechinsky got into an argument about what kind of painter I was. Jaguer said I was a nouveau surrealist; Alechinsky vehemently disagreed. "*Non!*" he said. "*Absolument pas. Rosenquist is ze new Russian realist!*" The argument got so heated that little Pierre socked Jaguer on the jaw and knocked the guy to the floor. I thought, Wow! Paris is a fantastic place! They get into fistfights over aesthetics.

As it happened, around the time of my exhibition there were multiple surrealist shows all over Paris. The galleries dug out all their surrealist works. Fantastic things—a squirrel living in a violin, fur teacups—but they were small in scale, all medicine-cabinet size. While I was there I went to the Iolas Gallery to see Max Ernst's giant sculpture, *The King Playing with the Queen*. When I asked the price, Iolas said $280,000. It sounded outrageous at the time.

Paris had always been the place where people would take you in, where you'd go to study. Like John Singer Sargent and all the other American artists and writers, I, too, felt I was in a nest being taken care of. There has always been this feeling of camaraderie between the French and the Americans.

I rented a Fiat, and Mary Lou and I drove to the south of France, where we met up with my old friend Ray Donarski in Juan-les-Pins; from there we drove to Venice before returning to Paris. I'd invited my parents to come join us and had bought a VW bus in Wolfsburg, Germany. When my parents got to Paris we drove down through Austria, saw Hitler's Eagle's Nest and all the destruction caused in World War II—gutted buildings, bomb craters. There were museums with the whole entranceway smashed in, where some young American soldier had pulled up in the tank and said, "Hey, lookey here, I'll be damned if this ain't a darned old museum

with stuff in it." And just drove the tank through the front door to take a look. In Venice I found a place for my parents to stay with a marble floor and breakfast for $1.80! My parents then flew home, and we went back to Paris and stayed there for four months.

I didn't work while I was in Europe, but Paris had a huge effect on my art. Pierre Snyder invited me to the Louvre to see what my reaction would be to this vast storehouse of European art. I was intimidated, of course, by the enormous accumulated history of painting. It was overwhelming. It must be hard for an American art student to study in Europe; the weight of history is so overpowering. I felt it might be very inhibiting to the young French artists that I met, too. Whereas in America or Australia, there is no history. You can do anything you feel like doing and you don't have to worry about how it relates to all the art of the past. In Europe the past looms over you—everything has been done already.

When I got back to the States, things had gotten strange. The eccentricities of my always unpredictable dealer, Dick Bellamy, had flourished in my absence. I had two shows with Dick. My first inkling that things might be going awry was when Mary Lou and I went to stay with him on Cape Cod. He was living in a house with broken windows, sand on the floor, beach mats for beds, cement blocks for pillows. Bushes were growing in through the windows.

We arrived, had a few drinks, and then I said "Let's go to Ciro & Sal's restaurant for dinner." We came back to the house and Dick showed us where we were going to sleep. We slept on the plastic beach mats, too; Dick's girlfriend, Shaindy's two kids, Andy, and Sherry had to sleep on old army cots. The next morning, Andy and Sherry said they were hungry, so I made them some scrambled eggs and toast. There was a knock at the door; I went to answer it. A young guy, very dressed-up, was standing there. "Is Mr. Richard Bellamy here?" he asked. "The director of the Green Gallery on Fifty-seventh Street in New York?"

"Shaindy," I said, "where is Dick?"

"He's out," she said, "collecting unemployment."

I had the guy sit on an army cot and wait for Dick to get back. Dick arrived wearing a wrinkled jacket; his glasses were broken, cobbled together with Scotch tape, and he was cleaning them as he walked by us into the house.

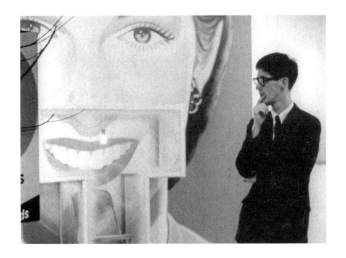

Richard Bellamy at the opening of my show at his Green Gallery, 1964. *Untitled* (*Two Chairs*), 1963, is behind him.

"Dick," I said, "there's a young man here who wants to see you."

"Are you Mr. Richard Bellamy, director of the Green Gallery on Fifty-seventh Street in New York City?" he asked, a little incredulous at the sight of the scruffy, unkempt fellow before him.

"Yes," Dick said, "that would be me."

"I have these paintings . . . ," the guy begins. "I've been painting all summer and I would really like for you to see them."

"I'm really sorry," Dick says. "Our gallery is full at this time and we are not taking any new artists . . ." His voice trailed off and he walked away.

The painter shrunk back in disbelief. This is the director of a big New York gallery?

After that Dick became stranger still. I didn't know what was going on with him. He used to come over to my studio. He would crouch down on the floor and say, "I don't know, Jim, I just don't know. . . ."

"You don't know what, Dick?"

"I don't think I'm going to open the gallery. I'm not going to open it up this fall, that's for sure, and I think I'm going to close it forever in the spring."

"Okay, Dick, but just tell me why?"

Dick had love problems. His explanations didn't exactly make sense.

"Dick," I said. "If you keep telling me this, I'm going to have to find another gallery."

Roy Lichtenstein and Ivan Karp with me at my 1964 Green Gallery show.

"Well, I just don't know what I'm going to do, it's all a question of, you know . . ." I didn't.

Around the time I was breaking with him, I went out to lunch with him and Bob Scull; Bob was his financier. After lunch was over Scull said, "Well, Dick, are you paying?" Dick just pulled out his pockets—they were empty. It was a gesture he'd done a hundred times before. He'd gone around for years with nothing in his pockets. Scull laughed it off and paid the bill, but Dick didn't realize that as a professional guy he should have taken care of that, if only to show that he was a guy in charge of a gallery. I said to myself, I can't be in the gallery if he can't even take care of things like this. It wasn't about money. It was about taking responsibility.

In September 1964 my son, John, was born. Mary Lou and I were extremely happy with this new addition to our family. John was an easy baby, and our life seemed idyllic. At the time I was a visiting lecturer on art at Yale for four days with the abstract expressionist painter Jack Tworkov. I attempted to communicate the Chinese idea that energy is ethical. In evaluating a student's curious artwork, I had to ask, "How many painted turtle shells did he do?" When the teacher told me, "Only one," I said, "Well then, don't pass him." I was not cut out for an academic career.

In the fall I had my first one-man show in Los Angeles at the Dwan Gallery. I stayed on Malibu Beach at Virginia Dwan's place. She was a big, tall girl, very wealthy, from Minneapolis. The morning after

Claes Oldenburg holding a stretcher at my Broome Street studio, 1964.

the show we got up and for breakfast she had a cigarette and a cup of coffee. I told her, "Virginia, you can't exist on coffee and cigarettes." I looked in her refrigerator; there was one pomegranate and three eggs. I made her a pomegranate omelet and another cup of coffee, then made her take a run with me down the beach. When she lived in California, she showed Franz Kline and a few French painters. Later, she opened a gallery in New York with John Weber and then she stiffened up into minimalism.

In LA I began hanging out with Dennis Hopper, who was then in his wild and woolly days. The home life of Dennis and his wife, Brooke Hayward, was bizarre. He was working as a photographer; he took great photographs, but the rest of his life was chaotic and inexplicable. I accompanied Dennis as he prowled through the unlocked houses of aspiring actors and actresses. In one house we came upon a strange young John Drew Barrymore and his daughter, Blythe. These were the old days in LA; nobody turned a hair if you just walked into their houses. LA was a strange place but free-wheeling, high, and handsome. Just a few years later, people would open their doors with a gun in hand.

I painted *Lanai* shortly after I'd come back from LA. The title is from those glassed-in rooms you find there; you could see them in some of those residential hotels where aspiring actors and actresses hung out until they got the call from the studio. People biding their time, studying, wasting their time. *Lanai* is based on impressions of Hollywood in the mid-1960s: a spoon picking up peaches, an upside-down Buick, a girl by a pool offering a joint to someone outside of the frame of the canvas. A nude girl offering you a joint; that, for me, was California—bright, interesting in a strange way. The spidery wallpaper roller pattern represents radioactivity. I sold *Lanai* for $2,400 and, forty-five years later, it was insured for $5 million.

Sometime in 1964 I happened to be on a plane from LA to New York and ran into Leo Castelli. "Jeem," he said, "if you ever thought about leaving Dick Bellamy, please consider me first." A year later I took him up on it. Leo was urbane and mysterious. He was both courtly and visionary, and his interactions with his artists were unique in the art world.

Leo was always asking me, "Well, Jeem, what is the title?" And then I'd start to think about a title, and wonder why I work so hard to think of a damn title when I've just worked so hard *not* to have a title for the painting. Leo's license plate read UNTITLED.

How to Build an F-111

I came back from my first trip to Europe full of energy and curiosity. I began asking myself, what am I going to do for my first exhibition with Castelli?

I knew what I wanted to do: one very big painting, something epic and enveloping. The only way I could do that at Leo's gallery was with a painting that wrapped around the whole gallery. The gallery was approximately 22½ feet wide and 24 feet long. It was a little place, a room on East Seventy-seventh Street. Many big shows were held in this small room. I remember John Chamberlain having four huge metal sculptures in there. You could barely get them into the gallery, and once they were in there you could hardly fit in any people. The gallery was a little place with a big reputation. I wanted to fill the room, but I didn't know more than that.

I didn't find the idea of making one very large painting daunting at all. When I was working on billboards I painted the equivalent of fifteen one-man shows a year. It was like training for the Olympics.

Perhaps because my father had been a pilot and I'd wanted to be

one, too, I'd always been interested in new aircraft. That was my hobby—airplanes. I knew every airplane that was ever made. In late 1964 I noticed a photograph of an airplane that was in the experimental stage. It had probably not been flown at that point. It was called the F-111. I never saw the plane itself, since it was top secret, but I managed to get some photographs and plans of it.

I remember thinking, How terrible that taxpayers' money is being spent on this war weapon that is going to rain death down on some innocent population halfway around the world for some purpose we don't even understand, while at the same time this warplane is providing a lucrative lifestyle for aircraft workers in Texas and on Long Island. Here's something else that contributed to my painting *F-111*. Early in 1964, Paul Berg did a cover story for the *St. Louis Post-Dispatch* in which he described going on seven combat missions in a helicopter. He broke the news to readers in St. Louis about defoliation and other unpleasant aspects of the war, but people back home wouldn't believe it. This was all before I came to consider the F-111 as subject matter. *F-111* has been called an antiwar painting, but actually war was not something we talked about that much at the time. I did know about Vietnam, of course, even though it was still only what was then called "a police action"; it was still very small, but escalating—the body bags were starting to come home. Around the time I was contemplating the painting, I visited my parents, who were living in Dallas, Texas. They had been there for a number of years—they were living there when Kennedy was assassinated. Once again I visited the Six Flags Over Texas amusement park.

I saw a great big, rusting hulk of a six-engine B-36 bomber quietly corroding away on a runway at the park, and I thought, Isn't that amazing. This warplane is now an amusement-park toy. It was one of the first things I had seen like that, a postwar relic that hadn't been used in combat like the B-24 or B-25. My father had worked on military aircraft during the war, but this B-36 warplane was something new. The B-36 was the first strategic bomber we had, and it became obsolete very quickly. Supposedly its purpose was to guard against a threat. I asked myself, *what* threat? Later, when I started working on *F-111*, I asked myself a similar question: Why is this new plane, the F-111, being built? For defense? Defense against what? When you think of these conflagrations and

all the money spent on obsolete weapons that could have gone into health research, hospitals, and public works, it was such misguided thinking.

So, one idea I wanted to include in this painting was about the lapse in ethical responsibility. We were paying income taxes for what seemed to be an already obsolete fighter plane, for a war machine that was this monstrous vacuum cleaner for taxes. Under the Johnson administration, we were being subjected to an even bigger vacuum cleaner: the Vietnam War.

Barnett Newman was someone I liked to talk to about painting. Barney used to question what *it* is. I talked to Barney all the time, but I didn't necessarily understand everything he said. He was always trying to explain one-ment to me; the mysterious concept of Singular.

I was in Great Neck at a party with him and there, out in the bay, was a stick poking up out of the water. Barney turned to me and somewhat enigmatically said, "That's *it*, that's what *it* is." I began to think that "it" was it because of peripheral vision. Everything that is fed into the side of one's eyes is what lays claim to reality. It makes you think about your orientation. In a sense his idea reminded me of a sensation I'd had while painting billboards. When you get close to an image, all you see is the color and this one line you're painting. This concept was very critical to Barney's way of thinking, but I didn't exactly understand why. Then I came to the realization that peripheral vision is how one-ment applied to the way we see things. You could see how important this question had become to Barney Newman: if you want to focus on that one element in a painting, you draw a single line in the middle of a huge color painting. This was the format of many of his paintings.

I thought a lot about his work, but I never really cared for it. I always wondered, what is he trying to do? He would make these huge, long paintings with one vertical black line. It occurred to me that if you focused on this one line, your eye filled with all the other color coming at you from the two sides. The art critic Robert Hughes used to fume about Barnett Newman's paintings. Barney had a very poor view of critics, anyway. "Art criticism is to artists," he used to say, "as ornithology is to birds."

Monet and Jackson Pollock had also experimented with the concept of peripheral vision. I'd seen a photograph of Monet standing

in the middle of his paintings, which were spread around him on the floor. Monet set his canvases around the room and looked at them in order to get the right kind of color saturation in his eyes. All this color was streaming into his eyes, so whatever he looked at was inflected by peripheral vision. If you were to paint a room all red with red lights, the color of things in that room would look different than if the room were dead white. That was the idea: context and juxtaposition determine one's perception.

For that reason, Pollock walked on his paintings and painted them directly on the floor. His method provided a total saturation of the eye because he was only five feet from the floor. The painting was all around him; he couldn't escape it because he was right on top of it. The way Pollock saw *Blue Poles* is not the way we see it. He was immersed in it; he was inside it. When I began *F-111* I would try to do something similar: to put the viewer inside the painting as it wrapped around the walls of the Castelli Gallery. The idea of a painting that surrounds the viewer came from many different sources, but Pollock and Monet were the two main influences— painting as immersion.

I measured the walls of the Castelli Gallery, and made each wall on Broome Street match these dimensions. I arranged all the elements I was going to include by making each wall into a continuous sequence. That picture was made out of fifty-one panels.

I thought again about Barney Newman's theory of the effect of peripheral vision when I went to look at an exhibition of nineteenth-century paintings at the Metropolitan Museum later that year. In an attempt to duplicate the way these old paintings were originally displayed, the museum had hung them one on top of the other right up to the ceiling against red wall covering. That wall covering interrupted my thinking. Everything comes from somewhere. It made me ask myself, how does the dark red background and the way the pictures are hung affect the way I'm seeing these paintings? If your eye is looking straight ahead, the light coming in from the side of your eye dictates what you are looking at. This I applied to *F-111* by coloring all the walls.

With all these ideas percolating through my head, the photograph of that F-111 bomber began to loom in my mind. I was aware that I needed a large central image on which to hang all the other elements, and I knew that the F-111 fighter was the latest hot

new thing. So at the end of 1964 I got cranked up and went to work using this newly hatched bomber as the armature.

There was no master blueprint for *F-111*. I was so used to doing huge outdoor signs based on small thumbnail sketches that I didn't need an overall diagrammatic plan. Although I made a number of collages for *F-111*, I felt I could work on it freely without too much planning beforehand. Often I'll work on a painting until I feel it's complete and then end up changing three-quarters of it. I learn from each painting, especially the big ones.

For many of my later shows at Castelli, Leo would not come to the studio. I guess he considered us both professionals and there was no need to check on works in progress. Anything you had in your mind, he was totally for it. He'd just be very happy when the show arrived. "Jeem," he'd say with a mixture of relief and exhilaration, "you've done it again."

But with *F-111*, Leo did come down to see the painting, and he was very excited. He was at Chambers Street so often that he conducted business from there over the phone. I remember Leo rushing into my studio sometime in late 1964 and saying, "Jeem, Jeem, I have to use the phone!" And I heard him on the phone saying, "Yes, yes, yes, yes, yes!" to someone on the other end in that Continental accent of his that could make the simplest English word sound foreign and exotic.

When he got off the phone he said, "Jeem, you are not going to believe this. I just sold Jasper's *Diver* for thirty thousand dollars to Vera List." That was an amazing sum at the time. In 1988 *Diver* sold for a record $4.2 million to Norman Braman; six months later Jasper's *False Start* sold for something like $17 million—and so it goes on. Andy used to say, "I get money, and it seems to go up somewhere and never come back!" And that seems to be with the art, too.

Leo loved *F-111* so much he would often bring people with him to see it. As I started to work on the painting, other people in the art world heard about it, word of mouth spread, and I soon had streams of visitors. Alan Solomon came down, as did Roberto Matta. Bob Rauschenberg came with his boyfriend, Tony Curtis visited, as did Richard Feigen, Ileana Sonnabend, Virginia Dwan, David Lloyd Kreeger, and Christo. I took Polaroids of everybody who came.

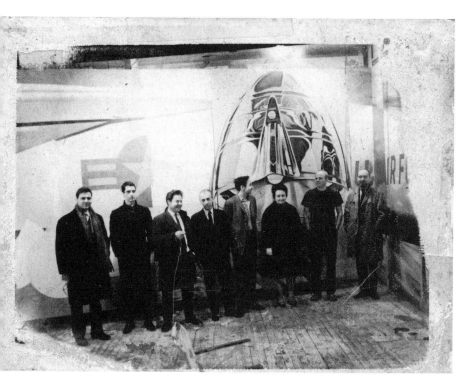

In front of *F-111* at Broome Street: Michelangelo Pistoletto, Steve Paxton, Otto Hahn, Leo Castelli, Bob Rauschenberg, Ileana Sonnabend, me, and Alan Solomon.

Early on Gene Swenson heard I was working on a large painting and came down to see what I was up to. He walked around the painting, which covered all four walls at Broome Street, then interviewed me and wrote a long piece for *Partisan Review*. Because of the political and cultural implications of *F-111*, Gene was very excited about the painting. Gene was a poet, a writer, and a determined political person, and although I often questioned Gene's fierce reactions to the news of the day, time and time again his predictions came true. I came to fear and respect his judgment.

Radicals, painters, politicians, collectors, and journalists turned up at my studio, and by the spring of 1965 the war in Vietnam had escalated to the point where it was causing serious protests.

I tried to make my studio an interesting place to work in because I could never get outside. At one point, I put sand all over one part of the floor and set up a beach umbrella and some fake sunlight and beach chairs. I thought I might as well enjoy myself while I was working on *F-111* because as far as I knew I was making a painting that was probably going to be unsalable. My original idea was to sell the painting in bits and pieces, and sometime later, the people who bought the pieces could all get together and compare them.

In *F-111* I used a fighter bomber flying through the flak of consumer society to question the collusion between the Vietnam death machine, consumerism, the media, and advertising. In my eagerness to involve and envelop the viewer, I used two reflective aluminum panels that could mirror the observer and provoke him to question what he was seeing—and they changed if the person moved.

This wraparound painting was installed in the Leo Castelli Gallery in April 1965. On a panel eighty-six feet long and ten feet high, I generated incoming, larger-than-life images of angel food cake, tinned spaghetti, a Firestone tire, a beach umbrella, light-bulbs, a hair dryer, and a radiant little girl—all overlaid with hallucinatory realism onto ominous images of an atomic mushroom cloud and a depth charge—luridly splashed along the side of an F-111 fighter plane with the words U.S. AIR FORCE painted on its fuselage.

THE SPAGHETTI. As you entered the gallery, on the right there were four aluminum panels that shaded into silver-colored strands of spaghetti and then into spaghetti-colored spaghetti in tomato sauce, with the nose cone of the F-111 poking through it. The spaghetti was flak. It was like a World War II plane flying through flak. In *F-111*, you were flying through spaghetti.

Ivan Karp used to collect carved cornices from nineteenth-century buildings. You'd see sailors with pipes, guys with toothaches with a piece of cloth around their jaw, eagles, all sorts of strange things. Beautiful heads of mythological characters with beards that turned into leaves, river goddesses, and caryatids supporting Corinthian columns. I began collecting them and that's how I met Ivan. I ran into him on the Upper West Side; I was there with a friend in front of a building being demolished. We'd come to get a lion's head, and as we were standing there, we saw it disappear right in front of us! We climbed up into the building and there was Karp. So I thought, What are they going to be replaced with? Modern buildings with blank metal panels. What are the youngsters going to collect, these featureless pieces of metal?

So one day I asked Dick Bellamy, "What the hell is this stuff that Donald Judd's doing? I don't understand minimalism, explain it to

me." We were out at an airport, and Dick said, "Have you ever walked between two great big airplane hangars and it made you feel very small and very strange?" "Yeah," I said, "I know that sensation well. I grew up around airplane hangars." "Well," Dick said, "*that's* minimalism!"

For this spaghetti area and other parts of the painting I used aluminum panels that I painted over to give the effect that aluminum was underneath the entire painting—which worked because people would frequently come up and ask me if the whole thing was painted on aluminum. Actually it's canvas and aluminum. I experimented with paints, colors, textures. I put an aluminum panel with a wallpaper roller pattern on it right in the middle of the spaghetti to reinforce the illusion that the spaghetti was also painted on aluminum, which it wasn't. I used fluorescent paint to cover up the oil paint color underneath it, so if this ever faded away, there would still be a painting there. Franco-American-colored spaghetti with Day-Glo paint on top of it. The Day-Glo paint made the spaghetti look radioactive, as if it were glowing. I was experimenting; I didn't know what was going to happen. Luckily, the Day-Glo paint has turned out to be pretty long lasting, although some of it has decayed.

THE UNDERWATER SWIMMER. In the next panel, the diver with the aqualung gasping for air reminded me of the big gulp of air that a nuclear explosion consumes—which relates to the nuclear explosion in the adjoining panel.

THE ATOMIC BOMB AND THE UMBRELLA. At resorts in Utah they used to advertise: "Come and watch an atomic bomb test," as if it were a show. People would sit under beach umbrellas with their iced drinks and watch these mushroom clouds in the desert. So this panel and the previous one are linked. It's as if you were in Utah at a resort and watching an enormous atomic bomb go off as someone gulps for air or is being killed. The bubble metaphor relates to the bomb. One was wet and one was death. Air and death.

THE FALSE-ALARM FLAG. On the bottom, underneath these two panels, the spaghetti becomes gray and turns into a rumpled piece of gray fabric. The idea for the fabric came from the kind of cloth they use in toy guns where you pull the trigger and out comes

a flag that says BANG! So the cloth had a military implication; it related to the false threat, the kind of threat that had created the F-111 to begin with.

THE LITTLE GIRL UNDER THE HAIR DRYER. What intrigued me was the paradox of all these middle-class families prospering from building this death-dealing machine, which is why I put the little girl under that bomb-shaped hair dryer. That image was a metaphor for the jet pilot's helmet. The little girl was really the pilot of the plane, just as middle-class society was really the momentum behind the plane. The little girl under the hair dryer is a big-stretch metaphor; this little girl from Texas or Long Island is the thing that was pushing the market that built war weapons. She's the motivation and the beneficiary of this way of life that guarantees that everybody have all these things—the house in the suburbs, the TV, the washer-dryer, the lawn in the backyard. The grass behind her is painted in radioactive shades of green. The little girl in the painting was a child model. When she saw a picture of *F-111* she sent me a picture of herself grown up. She'd become a beautiful blond woman with two beautiful blond children.

THE LIGHTBULBS. These lightbulbs are falling from the bomb-bay doors. They are red, yellow, and blue—pastel colors like Easter eggs. A lightbulb is a metaphor for an egg; the idea of the fragility of the eggshell and the lightbulb, which both burst when dropped like bombs.

THE INSIGNIA. Here's an odd thing. The emblems of the North Korean air force on their planes are the same as the American ones, only the colors are changed. That made me think about the huge effect color can have. Color in this case denotes a critical shift in the nationality of two countries that were once in a deadly conflict. The same symbol in one color meant friend. In another color it meant enemy.

THE BIG FIRESTONE TIRE. I painted the tread on the bottom of the snow tire (which suggests something cold) in a very bold, precise way. It reminded me of a king's crown. It's a Firestone tire, but to me it implied the idea of industry, the military-industrial

Opposite: I am working on *F-111* at Broome Street.

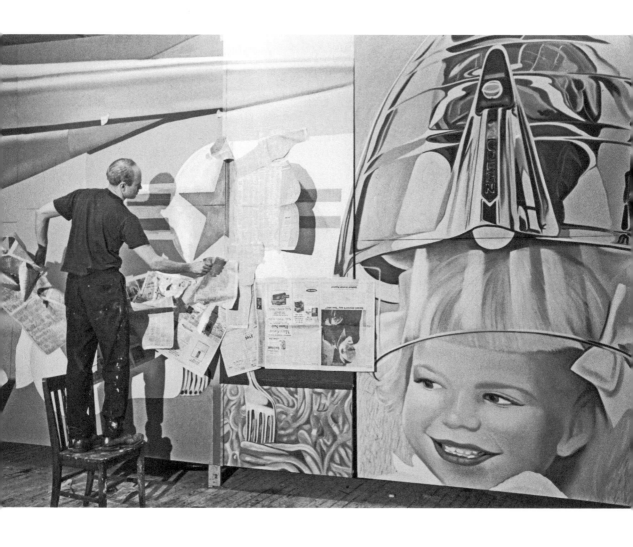

complex, so it represents some sort of capitalistic enterprise like General Motors, which was the highest-grossing corporation during the Vietnam War. It grossed something like $450 million, an astronomical sum of money at the time.

I'd planned to have aluminum columns in the center of the gallery representing stacks of silver dollars; something like Warhol's Brillo box idea, but before Andy did them. I was going to paint lines around the cylinders to indicate coins and then I was going to paint the image of a silver dollar on top. Ironically, because of the Vietnam War, I had a hard time getting these cylinders made and finally abandoned the idea.

THE CAKE. For me, the hole in the angel food cake was a metaphor for the missile silo. But this and other associations probably weren't evident when *F-111* was shown. The little flags on the cake read NIACIN, PROTEIN, RIBOFLAVIN, and so on. I was always surprised at the idea that food products had to advertise that they had added all these ingredients.

THE HURDLE. In one corner (the painting covered all four walls) there was a runner's hurdle that someone could run into. It was as if I had thrown myself into a corner with a blank ending.

NUCLEAR WALLPAPER. I used a wallpaper roller to evoke fallout, to suggest a heavy atmosphere filled with radioactivity. The first time I saw a pattern applied with a wallpaper roller was in the hallways of Richard Brown Baker's apartment building in New York. I thought it looked like heavy silver rain, possibly radioactive, what's now called acid rain. At that time the air quality in Manhattan was horrible. You would open your tenement window and in would come these sulphurous fumes. The air from the outside was worse than the air in the room.

You can still buy these wallpaper rollers with different ugly flower designs. In *F-111*, it was part of my experimentation; I was using all sorts of techniques, but not because I liked them. That wasn't the reason for including either the techniques or the images, but I'm sure much of this imagery got misinterpreted. People looking at *F-111* may have thought I had some kind of admiration for

this tacky wallpaper design, the way Andy might have used it, but nothing could have been farther from the truth.

I used jukebox paint on part of the painting, sprayed on in an emulsion the way it's used on pinball machines and jukeboxes. It was another experiment, like the fluorescent paint sprayed on top of an already rendered image.

A lot of people saw *F-111*, and it was well covered by the press. I remember Holly Solomon wanted to buy a piece of it. I gave a big party at my loft in 1965 to celebrate *F-111*; Tony Cox and little Julian Lennon came, along with Tony Curtis and Karlheinz Stockhausen. There was a seven-piece black blues band.

Eventually *F-111* was shown all around the world: at the Moderna Museet in Stockholm, in Rome, at the Jewish Museum in 1965, and then in 1968 at the Metropolitan Museum, where I restored it; I actually painted on *F-111* at the Met. Then it was shown at the Whitney in 1972 and at the Venice Biennale in the international section in 1978, and it was installed on the top floor at MoMA for its reopening in November 2004.

A month went by, and as we were taking the painting down Bob Scull walked in and went to talk with Leo. A few minutes later, Leo came into the front room where I was working and said, "Jim, guess what. Bob Scull wants to buy the whole thing." And I said, "Fantastic." I went into the back room and Bob Scull was sitting there. I remember I had a hard time making conversation. What do you say to someone who is buying your painting? Bob was buying like crazy in those days, but he wasn't paying huge prices—probably below $10,000 for most things—even for works by Jasper Johns and Larry Poons. He had just bought a whole show of Larry Poons's paintings, and I remember him saying, "I haven't bought a whole show in a long time." He was very proud of himself for buying *F-111*, and it made the front page of *The New York Times*. The headline read: "This Painting Needs a Hall Not a Wall!" The price was $45,000. But for any young American contemporary of mine, it was something of a breakthrough. The sale generated some excitement. It was an affirmation that everyone wanted. It seemed to say, "Hey, there is something to the younger American art." I was thirty-two.

Bob Scull was a funny guy and a real character. Sort of a social adventurer. He was shrewd and at the start of the recession in 1958

I am just back from Russia, in my rain slicker, talking to Robert Scull at Leo's Jasper Johns show at his old space, 4 East Seventy-seventh Street. Leo is in the foreground talking to art historian Barbara Rose.

he told me, "When I saw my taxi drivers getting into the stock market I knew it was time for me to get out." He took all his money out of the business, sold all his stocks, and became totally liquid at that point when the market took a dive. Then he bought a million dollars' worth of taxi medallions and started Scull's Angels, the radio cabs. Later he sold Scull's Angels, divorced Ethel, married an English girl, and was happy. Then he up and died.

Scull was very astute about the economy, and a very clever businessman. He was the kind of predatory character who, when he sees a weakness—even in a friend—he'll attack. He'll eat his own tail if it gets in his mouth.

He used to help Castelli out financially and do these counterintuitive deals with him. If Leo told Scull the price for a Jasper Johns, he would say, "I'll give you more." I couldn't believe that. This is the exact opposite of what any collector would want. Scull wanted to pay a higher price for the piece at a publicized sale in order to make the Johns paintings he already owned more valuable. Bob Scull studied art with the designer Raymond Loewy, so he actually had a background in art and he loved the idea of the wild and crazy artist—except that most artists lead very uneventful lives, painting away in their studios. He wanted his collection to go into the Met, but then he had this altercation with the museum and he sold off everything at auction.

I was once at a cocktail party Scull gave in Great Neck and

With Bob Rauschenberg
and Debbie Hey, a
professional dancer, at a
party at Rauschenberg's
Broadway studio, 1965.

everybody got drunk. I'd gone out there with John Chamberlain
and Jasper Johns. After some serious drinking they got into a big
fight, and I didn't want to ride the whole way back to New York
with the two of them feuding. So Bob said, "Just stay in the library
and my driver will take you back to the city." That was cool. While
I was hanging out in the library I opened up his photo book and
there were pictures of Bob—top hat, tails, the whole works—and
Ethel in a white carriage with four horses going to Queen Eliza-
beth's coronation.

Bob was a great character but his wife, Ethel, was another mat-
ter. Sometimes I would go to the Whitney with Leo Castelli and
Ethel Scull would be there. As soon as she'd catch sight of us she'd
start shrieking, "*James Rosenquist! Leo!*" in a voice that would strip
varnish off furniture. Leo would immediately make a sharp right-
hand turn and I would make a sharp left. Leo was funny that way.
He didn't want to deal with her at all. She was never the prime
mover in assembling that collection. When she and Bob were get-
ting divorced, they wanted me to testify, but I begged off.

I went to see Bob in the hospital when he had his leg amputated.
I brought him a print to hang on his wall in his hospital room, and
when Ethel saw it she said to me, "You gave Bob a print! Where's
my print?" So I sent her this little print of a lady's shoe with a hole
in the bottom of it and a lightning bolt hitting it.

Another time, when I was still in my Coenties Slip studio, Dick

said, "The Mayers are coming from Chicago and they want to come to your studio and see this painting of yours I've been telling them about." Mr. Mayer was Sara Lee cakes, the guy who made the frozen cheesecake. I said, "Dick, I'm really sick, I think I've got pneumonia, I can't even get up off the couch, but I'll tell you what I'll do: I'll be lying on the couch in the loft and I'll leave the door open and hang the painting on the wall, and you just open the door and look at the painting. I won't be able to ask you in, but you can look at it."

About two hours later, there's a knock on the door, the door opens, the Mayers step in, and just then a huge wharf rat stands up right in the middle of the floor! The Mayers see me on the couch, they see the rat, see the painting, and say, "We'll take it!" Then they slam the door and leave. The painting was *Blue Spark*. It's now in the Julio González Museum [Instituto Valenciano de Arte Moderno] in Spain. The Mayers paid $450 for it.

In the summer of 1965 I was invited to be an artist in residence at the Aspen Institute for Humanistic Studies along with Allan D'Arcangelo, Larry Poons, and Friedel Dzubas. I was asked if I wanted to join an Eastern Thought seminar. I said yes immediately. I had a great curiosity about Eastern philosophy and Zen because I felt that influence in a number of artist friends: Marcel Duchamp, Ray Johnson, Jasper Johns, and Agnes Martin.

In the East there is an idea of doing something simple over and over again to release one's mind. I think of Jasper Johns painting something he knows, like a flag or numbers, over and over, and at the end he winds up with an idea similar to what he started with.

Dr. Wing Tse Chan, a Chinese philosopher at the Institute, explained to me that the conception of the self in Chinese philosophy is similar to the gallons and gallons of ocean water that go through an oyster; one grain of sand can produce an irritation, and that irritation turns into a pearl. The pearl may be ugly or beautiful since beauty is in the eye of the beholder, but it is the sum of your life experiences that have turned you into what you are. Education plus experience is what makes an individual unique.

At Aspen we had a mix of Chinese philosophers, Japanese anthropologists, historians, avant-garde artists, and Washington lawyers. We did lots of reading. We'd get a big cowboy breakfast of blueberry pancakes and then go to lectures early in the morning for

about three or four hours, and that was it. We were encouraged to talk back and forth with the professors and the philosophers. Dr. Wing Tse Chan brought in a Zen scroll from the fifteenth century showing a big red Chinese drawing of a rooster.

"What do you think of that?" he asked.

"Well . . . ," I said, "it's an exciting picture—colorful, bold, and tough—for its time. But today it wouldn't look as strong."

"Oh," he said mockingly, "maybe I should raise the price, then." He was always trying to put me down.

One day Larry Aldrich came in and said, "Last night I believe my wife and I achieved satori."

"In your case, Larry," Dr. Chan said, "I think not."

He asked some Washington lawyers, "How do you decide when to sentence a man to death in the West?"

"We'd look over all the precedents in Western jurisprudence," they said, "and try and make our decision based on that." They then asked Dr. Chan how they would decide to sentence a man to death in the East.

"The judge put black hood over head and say yes or no."

"But isn't that judging on a whim?" the lawyers asked.

"Isn't your way judging on a whim also?"

He was seventy-six years old in 1965 and sharper and quicker than most of the younger people he was talking to.

I was given a studio, but I didn't paint while I was in Aspen. I didn't have time. I was there with Mary Lou and John, I was going to lectures, and I saw a lot of people. I had a party for David Hockney, who had just come to the States. He was a young, skinny guy with those giant cartoon glasses. He happened to be breezing through Aspen. It was the kind of place a lot of people breezed through.

Paint Tube in a Mousetrap

MY ENCOUNTER WITH RUSSIAN
PAINTER EUGENE RUKHIN

F-111 went around the world. From Aspen I flew to Stock-holm, where they were showing it at the Moderna Museet. After the exhibition I embarked on an adventure to see my friend the Russian painter Eugene (Evgeny) Rukhin, whose life would end tragically, under mysterious circumstances. Eugene had seen a Museum of Modern Art catalog with some of my paintings, got interested in my work, and we became pen pals. He sent me a Russian book of art with all the illustrations in black-and-white. I sent him masking tape and staple guns. He sent me records and more books.

In Stockholm I went to the Russian consulate to get a visa to visit Leningrad. The consulate had mirrors outside their office. It was spooky. They would watch you approach the consulate through big mirrors that faced onto the street. I went into a room with nothing in it except a slot about eight feet up in the wall. I looked up and could barely see a face in there looking down at me. I put my

passport into the slot and said, "I would like visa to Leningrad." The guy peered at me and said the only word he knew in the West, "*Domani,*" in Italian. I took this to mean that I should come back tomorrow. I went back the next day, and they gave me my visa. I flew to Leningrad; I arrived wearing my cowboy hat, cowboy boots, and a rain slicker. Some old lady tried to pick my pocket the moment I got there. I turned around and I hit her. As soon as I did it, I got scared. This was not my country; it was a pretty ominous place, and the Russians were very paranoid about foreigners.

We stood in a long line to find out where we'd be staying. They put every other person in a different hotel. I'd been on the plane with two Jewish fur traders, New York guys, and they'd told me there was only one decent hotel there. The other ones were dumps. When my turn came, the woman said, "You go Ansonia Hotel."

"No," I said, "I'm not going there—I'm going to the other one."

She looked at me ferociously and told me to step out of line—she didn't know how to deal with me. People in the Soviet Union didn't talk back to officials. But in the end I got the hotel I wanted. I had a huge room with an old mattress on the bed and one lamp. There was a telephone, and I got the impression everything was tapped. They listened to everything you said, everything you did. I was followed all the time. Every time someone took a picture of me, there was that same guy standing in the background of the picture. It was at the height of the cold war. There were a lot of patrols, a lot of restrictions. "Do this; do not do that," one was constantly instructed by one's minders. You weren't allowed to walk

around by yourself. "*Nyet*" to walking around. No cameras. No pictures of anything. The KGB followed you everywhere.

In the morning they told me, "Now you go on tour."

"I don't think so," I said. "I'll just walk around, if it's all the same to you." And I walked out the door and got a cab. The cabs in Moscow were old green cars. No signs on them identify them as taxis. The cab took me to Rukhin's house in a suburb of Leningrad, which still had battle emplacements from World War II. There was an old lady mopping the floor. I knocked. Eugene opened the door. "Rosenquist," he said, surprised, "what are you doing here?" He invited me in. He was over six feet tall, and had a head of dark hair spreading around his face, with a big beard.

For a studio he had a small room ten feet by ten feet. With a razor blade, he had cut a little trapdoor in the wallpaper where he stashed Cuban cigars, a little booze, and books. He would wallpaper over them when he was done. His mother was an archaeologist, and he got out of doing anything by pretending he was working for her so that he could paint. He took me around to restaurants and other places; wherever he introduced me, people seemed totally befuddled. Eugene's painting would be of a bed in a dark room with one single light coming through like it does through a cell window; then he would make a painting out of one die. Part of a die with numbers on it.

His paintings were extraordinary accretions of objects and signs on a layered surface, involving drippings, broad brush- and rag strokes, and cracked paint. Eugene applied stencils, pressed seals taken from icons, and reproductions of EXIT signs found in apartment buildings. He also attached found objects discarded by society—furniture fragments, old fabric, and locks. He incorporated everyday objects from Soviet life—combs, hair, feathers, Christmas ornaments—often with a sense of irony, such as a paint tube caught in a mousetrap. He had moxie; he was on the verge of doing something really great and becoming known internationally. In 1976 he was killed.

This was my first encounter with a Soviet painter. I was constantly dodging the KGB. They had it in for Eugene. They were paranoid about anyone who was different. Just the fact that he spoke a number of foreign languages—English, French, and German—made him suspect in their eyes. He had become a target

of their attention for nothing at all. The only vaguely radical thing he'd done outside of his paintings was to have taken part in the famous bulldozer show, during which the Soviet authorities bulldozed off the street all the art that was on exhibit.

I hung out with Eugene for a few days. We went to the department stores. They would have four or five suit jackets in the entire store. At the restaurants, lunch consisted of barley, mashed potatoes, pastry, and one little meatball, if you were lucky. Eugene told me he'd begun painting in 1963, "much to the surprise of my friends," as he put it, because he'd been trained as a geologist at Leningrad University. That same year, an exhibition of American graphics traveled to the Soviet Union and gave him the rare opportunity to see my works and those of Johns, Rauschenberg, Dine, Indiana, and others firsthand. Rukhin was inspired to become an artist from that show and from the support that he got from a group of dissident artists around him. Eugene was a key figure in a movement of radical artists; he's become a legendary character in Soviet art circles. When I returned to the States I dedicated the screen print *Whipped Butter for Eugen Ruchin* to him. The images were a toy wheelbarrow, an abacus, and butter.

In the fall of 1965 I met Marcel Duchamp, the god of modernism, at Yvonne Thomas's apartment. I brought him a sunflower flyswatter—when you hit a fly, the flower would open up—and a Mona Lisa New York button by Ray Donarski. Contrary to the aloof, mysterious character he's usually depicted as, I found him down-to-earth and funny. He was a very normal guy for being a genius, and an enigmatic genius at that. I asked him if he'd studied Eastern philosophy. He told me he'd only read *Zen in the Art of Archery*. He would mysteriously appear and vanish at lectures and openings, his collar pulled up over his head. "Was that Marcel Duchamp?" people would ask. He was a Dada ghost.

A lot of people think they can be Marcel Duchamp. They'll say anybody could get a urinal, put it in a show, and call it art. But Duchamp's implied ideas have an uncanny accuracy. *Bottle Rack*, for example. Right there he nailed the idea—the concept of the readymade. Painting the mustache on the *Mona Lisa* was an amazingly prophetic act.

If you paint something that the mind already knows, the path of

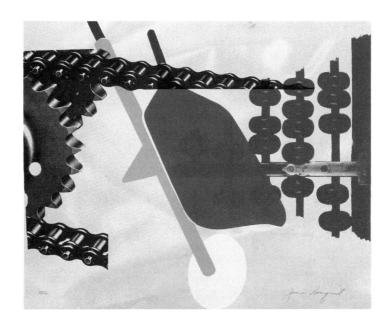

Whipped Butter for Eugen Ruchin, 1965. Color screenprint. 24 x 29⅞ in. (61 x 75.9 cm). Edition: 200. Printer: Knickerbocker Machine and Foundry, Inc., New York. Publisher: Original Editions, New York. Collection of the artist.

the painting in the mind becomes the real thing. In a Jasper Johns painting, for instance, you see a flag or a target, but it is covered up by layers and layers of encaustic paint. That is the real journey, not just an image of a flag or a target.

A while ago I went to the Paul Cézanne show at MoMA. A bunch of teenagers was there. One of them said, "I could paint like that."

"Oh really?" I said. "You can paint like that?"

At the beginning of the show there was a big wall announcing the exhibition with a door in it, and behind the wall was the show itself—the Cézanne paintings.

So I asked these kids, "If you had never seen these paintings, if you had never walked through that door and seen a Cézanne, do you still think you could paint like that?"

"What do you mean?" they asked.

"There is your answer," I said.

If all of a sudden we discovered some incredible work in a tomb that blew us away, in a style we had never seen before, we would not be able to paint like that had we not first seen it. That is the force of imagination; it happens all the time. You say anyone can make a flag or a sculpture of two Ballantine beer cans, but only if you've first seen it in your mind.

•

In 1966 I commissioned the fashion designer Horst to tailor a suit made out of brown paper, which I wore to museum and gallery openings. How it came about is this: my lifestyle at that time was painting all day long, having dirty paint-splattered clothes. I didn't have any dress clothes, so I'd go to Silver's Tuxedo, rent a tuxedo for $50, wear it to a friend's opening, like Bob's retrospective at the Jewish Museum, then return the tux, put on my paint clothes again, and go to work.

I got tired of renting tuxedos. Then one day I had this idea. I called the Kleenex company and asked if they would make me some paper tuxedos. "Well, no," they said, "we couldn't do that, but what we can do is to give you all the paper you want." And so they sent over a whole load of brown paper. At the time they were making ladies' panties and clothing out of that kind of paper. I took this paper to Horst and he made a beautiful suit out of it; I mean it really was well done. Diane Arbus's daughter, Doon, did a story on it called "The Man in the Paper Suit" in *The New York Times Magazine*. The idea of the paper suit was that it was disposable—and fed into the disposable idea, the disposable person.

People would stop me on the street and ask what it was I was wearing. When I told these guys in the garment district, they became alarmed; they said if it ever caught on, it could ruin their business. I only wore it about eight times—at one point I dyed it black. In October 1966, I traveled to Tokyo to participate in the show Two Decades of American Painting at the National Museum of Modern Art. And it was in Japan that the paper suit finally came apart. At the time Jasper Johns wrote the printmaker Tatyana Grosman a letter: "Nothing much new. Rosenquist's brown paper suit broke at a geisha bar today." He is a man of very few words.

Years later, in 2006, I was commissioned to do three huge pictures for the Deutsche Guggenheim in Berlin—a new museum between the Deutsche Bank and the Guggenheim Foundation. During the planning stages of the exhibition, Hugo Boss asked me, "Do you think we might reproduce that paper suit of yours and donate the money to charity?"

"I don't see why not," I said. I gave him pieces of the original paper suit, and they made hundreds of whole new editions of it and sold them for $450 apiece. I wore one to the opening of the Deutsche Guggenheim; there was a fashion show, and I walked

I am wearing my paper suit, being admired in the garment district in New York, 1966.

through it with some of the models and some movie actors and other people wearing paper suits and that was about it. Retro pop.

The thing about pop art is that it was accessible. Even if the attitude of the painters was ironic in relation to pop culture, it fitted in seamlessly with the media image of it. It was fun, everybody *got* it, and it had none of the elitist overtones of other kinds of modernism. Magazines seemed to like it. In 1966 *Playboy* commissioned me—along with Andy Warhol, Larry Rivers, George Segal, and Tom Wesselmann—to create a painting that would transform the idea of the Playmate into fine art. I painted *Playmate*, a pregnant girl suffering from food cravings. Next I designed my first book jacket: neon laid over spaghetti and grass for Lucy Lippard's *Pop Art*.

At the Art Gallery of Ontario in Toronto that year, I participated in a panel discussion, "What about Pop Art?" with Marshall McLuhan and my friend the art critic Gene Swenson. Poor Gene stuttered galore. He would engage in some deep, philosophical idea or other and McLuhan, who was very fast and articulate, would just roll right over him and make fun of him. Halfway through this horrible ordeal I whispered to Gene, "Why in the world did you select us to do this?"

It got worse. We were up on the podium when McLuhan went into some deep philosophical rant, and as he really got into it, with fantastic enthusiasm, he stood up, his chair hit Gene's chair, and Gene went flying right off the platform.

McLuhan barreled on in a giddy mood as though nothing had happened. From the audience, someone said, "Mr. McLuhan, I've read all your books and I disagree with you."

"Oh, you've read all my books?" he said. "Then you only know half the story!"

Someone else asked, "Mr. McLuhan, what would be a metaphor for the effect of media on contemporary culture?"

"A metaphor?" McLuhan said, then he gave a sort of Joycean, Mad Hatter's dictionary definition: "A man's grasp must extend its reach or what's a meta for?"

I don't know what I think about the supernatural. Strange things happen all the time that you can't explain with logic or physics. Perhaps we ascribe mysterious properties to coincidence or fore-

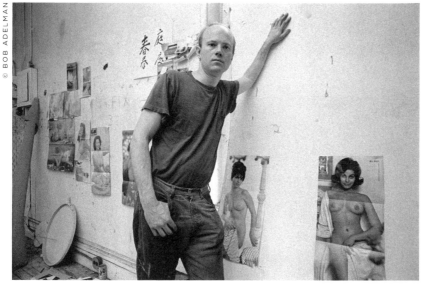

In front of pictures sent by *Playboy* so I could do a painting for their offices in Chicago. The painting never arrived and was found in a box in a railroad yard a year later.

sight because we just don't fully understand how things work in the universe. One of the more uncanny things I've experienced was the premonition my son, John, had when he was about four years old. I was taking him and Mary Lou to see the sculptor David Mishnick who had been my helper when I was painting billboards. On the stairs up to the studio, John started to cry.

"Mama! Mama!" he said.

"What's the matter, John?" I asked.

"Daddy! Daddy!" he said.

No one came to the door when we knocked and the door was locked. Eventually we left not knowing if he was inside or not. When the police broke down David's door, they found him dead in his bed. He had been there for about a week.

Around this time I became interested in how the use of color in advertising and on TV affected the image you're looking at. *Aspen, Colorado* (1966) is a painting of a TV screen with the test pattern colors. The image is blurry as if you were trying to tune something in. It's done on a shaped canvas—plywood on the edges of a rectangular canvas to duplicate the shape of a TV screen. Reality is different on TV; the color on the screen is a metaphor for color in reality, almost like the rotogravure color you see in comic strips.

I did a few of these TV screen images. *TV Boat I* (1966) is a pic-

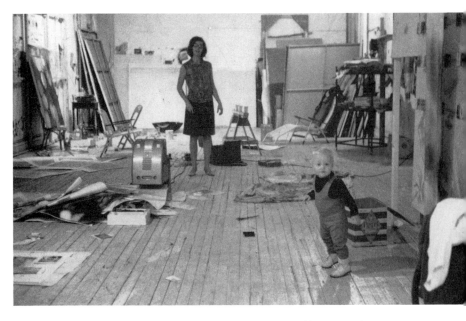

ture of two people on vacation getting into a sailboat as if you were
seeing them on a TV screen. I liked the idea of using these strange
colors, the kind of blurry, garish colors you would see on old color
TV sets. *Deep Pile* (1966) was about how color is seen in advertis-
ing, the kind of heightened, almost hallucinogenic color you see in
ads for deep pile carpets.

Big Bo was done on another shaped canvas, the kind you might
see on the highway—signs in the shape of ducks or dinosaurs, or in
front of a club. The canvas is now in the Museum of Modern Art in
Nice, France. It sits there and people ask what it means.

Frank Stella came by my studio one day while I was painting *Growth
Plan*. I don't think he liked it very much. He found it disturbing,
and it was meant to be. The composition for the painting—all
these children standing in rows—had to do with a murder I had
witnessed.

The children on a playing field is like looking at humanity and it
also reminded me of a lineup. I was friendly with the owner of this
particular gas station on Houston Street where I always got my gas.
He knew I was a painter and he used to ask me, "Are you painting
the clouds with sunshine?" I had an old Chevy Corvair and one day
I went to get gas. While I was in the gas station, a bunch of Italian
and Irish guys drove up and yelled at the owner, "Yo! Fix my car!"

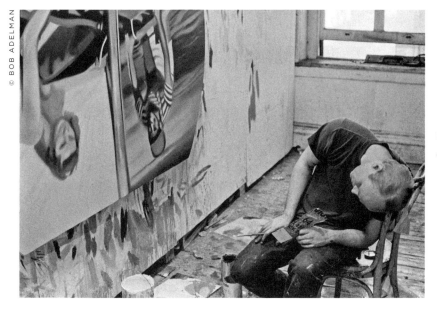

I am checking the composition on *TV Boat I.*

"Come back in one hour and I'll see what I can do," he said.

"No. You fix it *now.*"

They got into a scuffle, the owner fell down, and one of the guys came up with a longshoreman's hook and this bastard beat on the back of the owner's head with it. I'm no hero, but when the guy came up to me and said, "Watch it!" I hit his arm and ran to the First Precinct Station.

"Come along, James," they said. We went back to the gas station. Everyone had left by that time. They took the owner to the hospital, and I went back to my studio. About an hour later the cops called me. "Come over to the precinct, James." They'd caught the guys, but in the meantime the gas station owner had died. They had the four guys sitting there in church pews in the precinct as I walked in. That wasn't right—it was putting me in jeopardy with these guys once they'd seen me. Then from behind a screen I identified them. "Him, him, him, and him." There were no other people in the lineup.

Now these guys knew who I was. So I called up Bob Scull and told him what had happened. He said, "Jimmy, I know all about it from my detective friend, Jack Feder. You'd better get out of town for a few days." I had to go to a grand jury in about a week, so in the meantime I went to Provincetown. I took my wife and Mel Geary, my old friend from Minneapolis, up there with me.

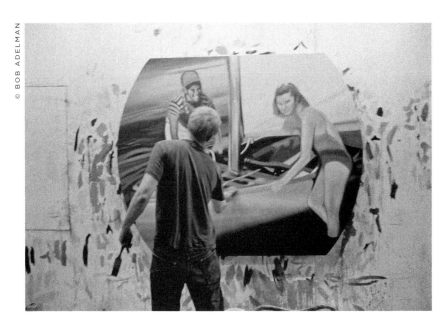

Finishing up *TV Boat I*.

I knew people in Provincetown; someone I talked to said he thought there was a house for rent that Henry Geldzahler had just moved out of. Henry had left in such a hurry that there was still stuff cooking on the stove. We stayed there for two days, and then I went back to New York and testified against the guys. They copped a plea and got off on a lesser charge and were back on the street, which obviously troubled me.

A year later I took a detour on the way to East Hampton and went by Coney Island for a hot dog. A guy came up to me and said, "I know you." I said, "I don't know you." It was the murdered man's son. After that chance encounter I became concerned that the guys I'd identified as the murderers would come and find me. I called Scull again, and Bob sent this detective friend of his to see these guys. The detective paid them a visit and said, "You are famous, and he's famous. If you touch him, you're going to get to be more famous than you ever want to be—get it? So don't ever bother him, understand?"

After I exhibited *Growth Plan* I noticed a number of painters making photo-realist paintings of banal subjects. As far as my relationship to photo-realism goes, the only thing I did in that vein was that painting of those little boys standing on a playing field. It was more like a shot in the dark.

The interaction between photography and art is an interesting

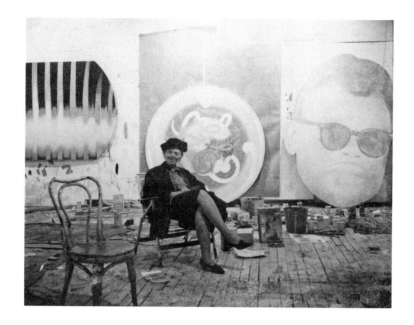

Tatyana Grosman was visiting me at 429 Broome Street, ca. 1966; it was always great to go out and do prints at her place in West Islip.

and thorny one. Photography has influenced painting since its discovery by Nicéphore Niépce in 1826, and since the early 1960s, with the arrival of pop art, the relationship has become more and more complex and insidious. When you take a photograph you get what you get. You can say it's reality, but it's just as much a simulation of that reality as a painting of the same subject would be. You can manipulate a photograph in the same way you can a painting— but it's more deceptive, because people assume they're looking at reality.

In art, if you paint nature, you alter it. Artists like Andy and me used photographic materials, but since they were never quite what we wanted, we altered them. Images are always a matter of selection. The photographer waits for the situation to arise—a guy looking across a puddle with his reflection and the sky and everything else he can frame—and then captures it and it's art. Photographers like Brassaï and Henri Cartier-Bresson are great because they understand that photography is not just a documentary process.

You could always alter a photograph in the darkroom; the original picture may have been very crude, but you could use different techniques to create emphasis, contrast, framing, and so on. Now it is different: you can manipulate photos endlessly using Photoshop. You can change anything into anything else digitally, but I don't see the point. My friend Mel Sokolsky called me and said he was work-

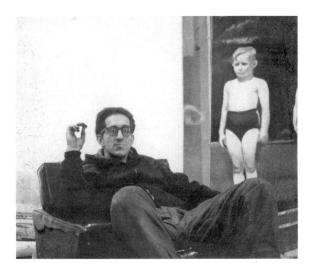

Frank Stella in my studio
with *Growth Plan*
behind him.

ing on a film; did I want to come over and see what he was doing and have dinner? I went to see him in his studio and there he was altering this movie *frame by frame.* Bringing up the bushes, taking the shadow off the actress's face—*click, click, click*—as he went. But it was so time-consuming he couldn't even go out to eat.

About two weeks later I was in Paris and I went to the Louvre. There were two paintings by Vermeer that had never before been together in the same place. One was called *The Astronomer* and the other was *The Geographer.* There was the same guy with a long nose looking out a window, but in one there was an astrologer's chart and in the other there was a map on the table. Both were amazingly painted. You couldn't have changed those things in the painting digitally; you couldn't change a shadow here or there, because of the manner in which he painted. On each picture he used many different styles of brushwork, from precise rendering to a kind of precursor of pointillism. It was two hundred years before Georges Seurat. You may be able to enhance a photograph but you can't enhance a Vermeer. I read that David Hockney thinks Vermeer used a camera obscura or some other optical instrument to make his paintings, but I'm not sure he has that proven. Even if Vermeer did use some optical method, the brushwork is so different in these little paintings that in some places the paint quality resembles a skin rash, while in other areas the surface is smooth as glass.

•

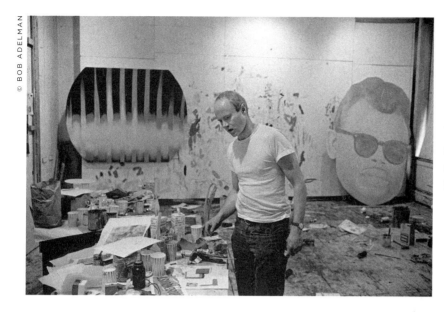

The Broome Street studio with *Waco, Texas* on the wall and *Big Bo* leaning against it.

Ray Johnson used to call Larry Poons Baby Modigliani. Larry was dark and handsome. With a big Poons show coming up, his dealer, Leo, was getting nervous.

"What is the problem?" he would ask. "Don't you think we could supply Larry with some more canvases?"

The dancing dot in the square was his ingenious invention. It was a fascinating effect. The collector John Powers was ready to buy anything that Larry painted, but Larry's objective around this time was to buy a GT 350 Mustang race car in California for $7,000.

"I'm going to go out there and get the car and come right back," Larry told me.

"If you wait a week or two, I can get out of here and we'll go to Malibu Beach, stay with Virginia Dwan, and have movie star parties."

Larry and I didn't go. I went later with Allan D'Arcangelo; we had a ball. Larry brought the car back, took it to the racetrack in Aspen, tore the body off the chassis, and had that fixed. Drove the car back to New York, parked it in front of his loft on Church Street, and went into his studio. The next morning he woke up, and the car was totally stripped.

Poons's show at Castelli was looming and Larry was still ripping up canvases. When we all began—Larry and Andy and Roy and I—

Standing in front
of *Growth Plan.*

there were no deadlines. Dealers like Leo Castelli or Dick Bellamy would just say, "Let's have a show of your work." You would start thinking what you were going to do in the gallery, put together a body of work, and when it looked like a show you'd set a date with Leo and exhibit your paintings. But as people became more famous and the price of paintings went up, the scheduling of shows became more serious.

On three different occasions Leo offered Larry shows at Castelli, and time after time Larry kept canceling. Finally Leo became exasperated. In the spring of 1966, realizing Larry was not going to be able to come through, Leo asked me, "Jim, do you think you could put together a show in one month?" I had five works done and I told him I thought I could do it, but I wish I hadn't, because my thoughts were only beginning to form.

In 1967 I painted *U-Haul-It* for Lorenzo Bandini. He was an Italian race-car driver, hence the Italian flag on the right with the shadow lettering. He was handsome, thirty-four years old, and got burned up in his car. His face was gone. That's why I put the hot butter in the frying pan in the picture. He lived with no face for about four days and then his wife pulled the plug. While I was thinking how I would do this painting, I was driving east at noon on the Long Island Expressway. The traffic was heavy and in front of me was a U-Haul rental trailer full of household goods, which was

Leo Castelli visiting
the studio in 1966.

inadvertently forced into the lane behind a hearse in a funeral pro-
cession; for a moment the funeral cars with their headlights on
were forced to follow the U-Haul sign. In the painting you can
make out the words *U-Haul* under the images on the right. So
that's how a rent-a-truck got into a eulogy for an Italian race-car
driver.

I was rushed into the show at Castelli, and regretted it even
though all the paintings sold. If they had only had a little more time
to bake, I could have made a point. At the opening I had such seri-
ous misgivings about the work I wore a lumberjack shirt, a Snoopy
hat, and dark gloves. I just stood in the corner of the gallery and
tried to be as anonymous as possible. Leo came over and stood by
me for a while and asked, "Jim, what are you doing in that disguise?"

I can paint very fast. Ideas would come to me and I would paint
them, although it doesn't always work quite as easily as that. Some
take time to come to light. I put a lot of sketches on the wall, and
then whatever bores me, I scrap. I can still spot an image on a sign
along the highway in Florida that fascinates me. Most of them don't.

I made one of my infrequent sculptures between 1963 and 1966.
It was called *Tumbleweed* and it consisted of three four-by-fours
wrapped in chromed barbed wire and neon. I saw a tumbleweed as
big as a house going across the road as I was driving in Texas and
reproduced it in chrome-plated barbed wire, thinking about capi-

With Leo and his former
wife, Ileana Sonnabend.

talism and shiny barbed wire that keeps people in prison. I'm fasci-
nated with the idea of creating illusions, but I'm more interested in
doing it in two dimensions as with painting.

In November 1967 I created a large-scale installation work of
aluminum foil and neon tubing, which hung from the ceiling of the
field house at Bradley University in Peoria, Illinois. I did at least
two additional versions of this work, one of which was constructed
and installed in Robert Rauschenberg's studio space in a former
chapel on Lafayette Street in Manhattan. The Peoria installation
also included a film program by the experimental filmmaker Stan
VanDerBeek.

Bob Scull wanted to have a party for me, but my loft, which was
on the Bowery at that time, didn't have enough space. So Bob
Rauschenberg generously said, "Hey, you can have a party here . . .
on two floors, if you want to." Bob's building had a big, peaked
roof, and we were way up there on it, dropping block and tackles
through two vents. I made this platform with chicken wire, neon
signs, and rolls of aluminum foil attached; we hoisted that sucker
up and it went up to five stories in the back—and we had the lights
bouncing off the aluminum foil. Ahmet Ertegün, the owner of
Atlantic Records, contributed a rock band called the Scarecrows,
and every time the drummer hit the drums, the whole thing would
go *shoo-shoo-shoo-shoo*, so it was an impressive effect.

Gene Swenson appeared at that party. He was parading outside
holding a big blue plastic question mark over his head. I went out-

side and said, "Gene, come on in! You're missing the party!" "No!" he said. He wouldn't budge. At that point I got concerned he would do something crazy. I said, "Bob, Gene's parading outside with a question mark. Can you go out and get him?" "Yeah, I can go get him." So Bob went out and put his arm around him and said, "Come on, Gene, come on in."

I was worried about Gene's erratic behavior, because I had this huge contraption tied off with ropes through the window to two radiators in the basement for anchors. Gene looked at me and said, "I bet if someone cut the ropes, that would fall down and kill everybody."

Dismantling the platform was really nerve-wracking. When we got downstairs, we had the jitters. "Boy, we're tired," I tell Bob. "We're gonna go home, we'll come back and finish tomorrow." And Bob says, "Hey-hey-hey-hey, have a drink!" So he fixes us two huge scotches. After we drank them, Bob says, "Let's eat." I had a '62 Oldsmobile Starfire convertible outside, and I say, "I know, let's go to El Parador restaurant on Second Avenue and have a Mexican dinner." "Good idea!" Bob says, lurching toward the car. So Bob is riding with me in the front seat, we're going by Astor Place, I make an illegal left turn, and a cop pulls me over. This was very bad because I'd had a lot to drink. The cop says, "Let me see your license and registration." I get out of the car and in a too-booming voice say, "*Yessir*, Officer, what seems to be the trouble, sir?" Like I was really in control of the situation. Just then Bob says to me in a drunken sailor's voice, "You don't know what it's like! It's all nothing! You'll find out! It's nothing!" And then passes out. He was stone drunk, snoring. The cop looks at him incredulously. "Yessir, yessir, Officer, I know, I know," I say, trying to cover the situation. "It's a wrong turn, I made a mistake, I made a mistake!" He gave me a ticket for an illegal left turn and let us go. We get down to the restaurant and we can't get seated right away, so Bob has three margaritas while we wait, and I have a couple myself and am feeling pretty whooped by the time the food comes—which I ended up eating because Bob didn't want to eat, he just had more margaritas.

Next day, my helper Billy McCain and I came back to take down

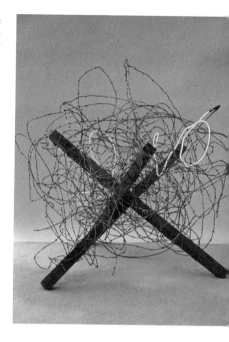

Tumbleweed, 1963–66. Chromed barbed wire, neon, and wood. Approximately 54 x 60 x 60 in. (137.2 x 152.4 x 152.4 cm). Collection of Virginia and Bagley Wright.

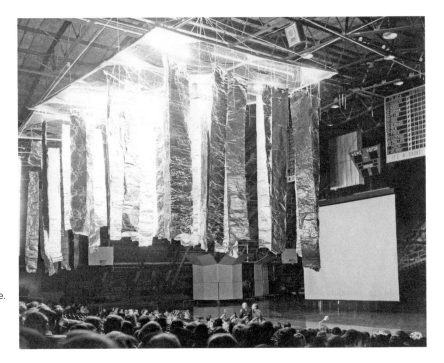

Untitled installation. 1967. Aluminum foil, chicken wire, and neon. Robertson Memorial Field House, Bradley University, Peoria, Illinois. I am seated in front with Stan VanDerBeek. In 1970 I installed another version of it in Rauschenberg's studio for a party the Sculls gave me.

the installation. We had terrible hangovers. "Oh, God, Billy," I was saying, "my head is falling off, oh, my head!" And as we came in there was Bob. He says, "Hi, guys, how are ya?" He's got a glass in his hand with vodka and grapefruit juice in it and he says, "Have an eye-opener!" "Oh, no, thank you, Bob, if I had another of those I'd never get this thing down." Those were the good old days.

Walking on Air

A NEW STUDIO

EAST HAMPTON

PAINTINGS ABOUT SPACE
AND POLITICS

PARIS 1968, LSD

HORSE BLINDERS

HORIZON HOME SWEET HOME

Feet of upside-down basketball players . . . a white man's shoes sitting on the head of a young black American . . . a white line bisecting black heads . . . a 1950s Chevrolet . . . a slice of white cake with chocolate icing . . . the faceless head of a black man in a suit, painted orange. Overlaying three panels a pair of red-framed tinted glasses opened for the viewer to look through, but

they are opaque—a man cut in two, images of water and sky, and a mother and child exchanging secrets.

Painting for the American Negro (1962–63) is one of my more overt social commentaries. The eyeglasses in the painting, instead of making things clearer, are cloudy, suggesting that things are being covered up; the mother is whispering to her two children something that they don't quite understand about black people. It's like painting *on* an eyeglass, instead of through it. The question seems to be, what is the truth? Artists keep looking for the truth, but truth can be very ugly, it can be a veil or a pair of glasses you put on so you can turn a blind eye to things you don't want to deal with, such as how our perceptions of black people are distorted by stereotypes. The picture was painted during the turmoil of the civil rights struggle, and it's in part about the middle-class black who is educated and successful but is still being discriminated against. *Painting for the American Negro* and *Capillary Action II* (1963) were the two works of mine the National Gallery of Canada in Ottawa bought when I had my first retrospective there in January 1968.

By 1967 the Vietnam War was escalating out of control. Lyndon Johnson's mistaken domino theory was the guiding foreign policy: if we didn't stop the communists in Vietnam, all Southeast Asia would fall. I thought the domino theory made no sense. That spring I contributed a nine-by-twenty-four-foot painting, *Fruit Salad on an Ensign's Chest*, to the Spring Mobilization to End the

War in Vietnam, a rally in New York. It had a woman's hand pouring salt from a saltshaker onto a field of combat medals (referred to in the military as "fruit salad"). It was displayed on a flatbed truck from which poets read their work. It got destroyed during the demonstration by people throwing tomatoes and rotten vegetables at it.

At that same demonstration, I protested in front of the public library with Allen Ginsberg, Mark di Suvero—and my father, whose allegiances were torn. Like a lot of people of his generation, protesting a war seemed unpatriotic to him. I confronted my dad with the alternatives: you can either be on the side of the radicals protesting an unjust war, or on the side of the cops, the politicians, and the arms manufacturers. It wasn't a hard choice for him to make once he realized what was involved. Later on, we got trapped in a police cordon at the United Nations and I helped him escape under the riot barriers.

Another antiwar painting, my thirty-three-by-seventeen-foot *Fire Slide*, was installed in the U.S. pavilion at Expo '67 in Montreal, in a geodesic dome designed by Buckminster Fuller. The idea for this painting was that we had become the firemen for the world and we were putting out fires in a reactionary mode.

In Honor and Memory of Robert F. Kennedy from the Friends of Eugene McCarthy was one of my first experiments with painting on Mylar, clear five-millimeter polyester resin. The chair in this picture is painted on Mylar extended out from the painting about four inches. Underneath it there is something else, but you don't know what. It's like the confetti on the floor of the convention and the empty chair that would have been Kennedy's.

That year I was one of 418 artists to contribute to the California Peace Tower, also known as the Artists' Protest Tower. The tower, a fifty-eight-foot-high tetrahedron constructed on an empty lot in Los Angeles, was covered with canvas panels painted by artists and others to demonstrate their opposition to the war in Vietnam. When the lease on the site expired and was not renewed, the tower was dismantled and the panels were sold in a fund-raising effort by the Los Angeles Peace Center to raise money for the cause. A revival of the Peace Tower occurred in 2006 at the Whitney. I gave some chromed barbed wire on a panel for that show.

"Buckeye cubism" was the way the critic Hilton Kramer de-

scribed *F-111*. I could almost accept that as a left-handed compliment. But when he went on to say that including it in an exhibition of history painting at the Metropolitan Museum of Art in New York alongside three paintings from the museum's permanent collection—*The Death of Socrates* (1787) by Jacques-Louis David, *The Rape of the Sabine Women* (ca. 1633–34) by Nicolas Poussin, and *Washington Crossing the Delaware* (1851) by Emanuel Leutze—was "an idea of stunning vulgarity and insensitivity," I begged to differ. The Met chose *F-111* to be part of this exhibition. Naturally I was flattered, but I never said I was making an epic history painting. I was a painter of antiheroic paintings, maybe.

Anyway, when my pop imagery, flak-spattered fighter plane was featured in the exhibition History Painting at the Met in 1968, it blew up into a big brouhaha. Henry Geldzahler, writing in *The Metropolitan Museum of Art Bulletin* for March, cited *F-111* as a "symbol of the industrial-military complex of our times, a paranoiac subject worthy of Dalí." Why would I want to argue with that?

A month later, in *ArtForum*, Sidney Tillim discussed the loan of *F-111* to the Metropolitan Museum of Art, claiming—absurdly— that it provoked gasps of horror among the "professionally 'advanced' crowd" (whoever they are). But though he himself "simply felt threatened, they felt shame, the shame of an avant-garde chicken coming home to roost in a way they had neither imagined nor desired."

He continued his diatribe by going on to say, "But I suppose it was necessary to come up with a work of high kitsch [Leutze's *Washington Crossing the Delaware*] that would provide a transition from the high art of these French masters to the high camp of *F-111*." Tillim concluded by saying that the structure I used (a variant of synthetic cubism) precluded "those illustrative values which are a prerequisite to the expression of sentiment. Picasso's *Guernica* fails to generate emotional power for the same reason." Well, at least I was in good company there.

In 1966 I was still very much into Eastern thinking and I began to consider how I could dematerialize my paintings. This may seem an odd ambition for a painter, but I have never felt that a painting is a fixed thing. Even with my earliest paintings on canvas I had wanted to destabilize the viewing situation by creating images that hit the

observer at different times. Now I wanted to fracture that experience further. You would come into the gallery and *walk* through my paintings.

I came up with a way you could actually pass through my paintings by stippling paint on strips of polyester Mylar that hung from the ceiling. The paintings themselves would be like one of those Italian beaded curtains, but instead of beads I would paint imagery on transparent plastic strips. You would literally be inside the imagery—but paradoxically, at the moment of entry, the painting would become invisible. When you were inside it, the image would disappear and then come together again after you'd passed through it.

The first plan for the walk-through environment was called *Wind Row*, an installation involving a lot of different paintings. The idea was a path through a cornfield (all of this had to do with Eastern philosophy). An image of someone putting on his overshoes and a path through a field, Nature's cornfield. It would look like something coming out of a big cardboard box.

The underlying concept was the idea of molecular transference: to simulate molecular displacement by reconfiguring the structure of inanimate objects so you could pass through them. You could exchange your molecules with that of the painting. It was a replication of an experience from subatomic physics where a person could, for instance, walk through a wall—like "Beam me up, Scotty"—but this was long before I had ever seen an episode of *Star Trek*. By the rearrangement of molecules you could walk through something solid.

Despite all my efforts, my previous paintings had been interpreted as if seen through a window; now my ambition was to let the viewer actually walk through that window into the art and become part of the picture. And that's what I set out to do.

At the entrance to the gallery I envisioned a shiny piece of an automobile that you walked through. Beyond that there'd be a cornfield painted on canvas. You would walk around the gallery from left to right and experience these paintings one after another, all these very strange, fragmented images, and then you'd walk out. A tour of fractured, dislocated imagery, a path, like the Tao of Lao Tsu. Taoism, Lao Tsu's philosophy, is just a path to something. Taoism is more individualistic and mystical in character than Confucianism, and greatly influenced by nature.

I am jumping through *Wind Row,* an installation in which I painted on Mylar strips. It had to do with Eastern philosophy, but the idea was the viewer could get *inside* the image, which would disappear until one emerged. You had to walk through it to get into the show at Leo's gallery in 1966.

Later on I did a piece called *For Lao Tsu* where you could walk through a big piece of plastic cut into strips. On it there was a windshield wiper, wiping the imagery clean, something you could travel through that might trigger ideas. It's hard to explain why I would ever want a windshield wiper scraping paint off a canvas, but it was the idea of erasing an image while at the same time walking through it. It was like an experiment of Duchamp, who affixed with varnish the dust that had collected on the glass surface of *The Large Glass* while it was lying on the floor of his studio for several months. Or Picasso letting his work get dusty because he said dust protected it. Dust. Time dust.

Elements from the Lao Tsu work evolved in 1967 into what became the *Forest Ranger* installation, a labyrinth of imagery on vertical Mylar strips that hung from the ceiling and filled up an entire room, and again through which the viewer could walk. There was an armored car being cut in two by a giant meat saw. The armored car and the meat saw are on two different pieces of intersecting Mylar. It was shown in Venice at the Palazzo Grassi in 1967 for the first time

Forest Ranger, 1967.
Oil on slit and shaped
Mylar. Two intersecting
panels, 9 ft. 6 in.
(289.6 cm) in height
each. Museum Ludwig,
Cologne, Ludwig
Donation, 1974.

along with other paintings on slit sheets of Mylar (*Sauce* and *Sliced Bologna*), then in Paris with Ileana Sonnabend in 1968. Visitors to the gallery were reluctant to walk through them, but whenever I was there I urged people to try it. "It's the *point* of the piece," I told them. "If you don't walk through it, you'll miss my meaning."

Aside from the armored car, the sliced bologna, and the soup ladle, there were a number of other pieces I painted on Mylar strips. I did many, many paintings in this style. I wish I still had the different parts of this installation collected in one place, but they've been dispersed. I had all sorts of weird stuff going on in there: a pat of butter going in through a big microphone, and a fedora that hung in space—you could kick it, and you'd kick the hat and it would sprinkle, fall apart, and come back to being a hat again—the images would reconstitute themselves as things after you had walked through them. That was me trying to do magic stuff.

At some point in the mid-1960s, the dealer Sidney Janis wanted me to do an exotic show at his gallery. I said, "Well, that sounds inter-

Visiting de Kooning in 1964 in his East Hampton studio.

esting, Sidney, but I'm really trying to get away with my family now." "Well, you know, I have a little place on the North Shore of Long Island near Wading River, and you're welcome to go out there and stay," he told me. So Mary Lou, John, and I went there and I loved it. That really started me thinking about being out of the city, because I'd lived in New York a long time, much too long.

When I think of it now, changes come about quite quickly. The incident that triggered my move out of New York City happened one afternoon in 1966 when I was taking John to the park. On the corner of the street we were crossing, a bus blew exhaust smoke right in his face, and he started to cry. "Goddamn it, that's it," I said. "I'm taking him to the country. We're moving to East Hampton." De Kooning had moved there the year before and John McMahon, who worked for de Kooning, encouraged me to join him out there. I got the sculptor Hans Hokanson to build me a studio. He'd built de Kooning's studio; he was friends with members of the Band and some other musicians from Pennsylvania, and as soon as it was finished I started working.

The high ceilings in the East Hampton studio allowed me to paint a number of large canvases, such as the ten-by-eighty-four-foot *Horse Blinders*, *Area Code*, and *Flamingo Capsule*, among others. Many people came out to visit when I was painting: John McKendry and his wife, Maxine de la Falaise, Larry Poons, Henry Geldzahler, John Chamberlain, Ultra Violet. Not all my visitors were as provocative as John and Ultra.

On Easter Sunday John arrived and immediately began to unroll a big length of tar paper across my lawn. Ultra took her top off and began crawling on her hands and knees across the tar paper, then climbing up in a tree like an animal—all of which John was recording on film. This was all going on just as church was getting out, and my neighbors and the postman stood there watching it with their mouths open. "It's an artwork," I said. That explained everything—crazy New York artists—except that I had had the illusion I was going to fit in to this little community in peace and quiet.

The year 1968 was a revolutionary time in Europe, too. I had a show in Paris and saw the radical students, who wore red shirts and sweaters, demonstrating with autoworkers and farmers. They

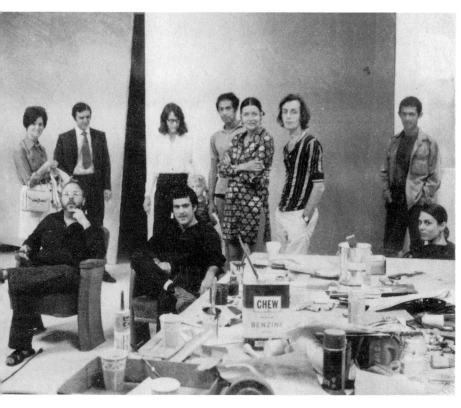

When I was doing *Horse Blinders* in East Hampton, people used to come by the studio. Here, in 1968, are (*back row, left to right*) Myra and Roger Davidson, Mary Lou with our son John, Henry Geldzahler's friend, Maxine de la Falaise, John McKendry, Christopher Scott, and Lucinda Childs; (*front*) Henry Geldzahler, Larry Poons.

marched down the street, the more belligerent of them randomly attacking passersby and running away, but they couldn't overturn the government. When I got back to East Hampton, it was getting pretty wild there, too. Lots of dope and flower children. I considered joining them and had a close encounter with LSD. For a while I had a lot of LSD in a paintbox that I intended to take at some point, but since I kept it with my painting materials, it disintegrated, and that was the end of that. On acid, some people heard the music of the spheres and some went off into space and never came back—I saw the terrible effects of LSD on Billy Barth, the musician who played at my midsummer party. He took too much and flipped out.

When things become peculiar, frustrating, and strange, I think it's a good time to start a painting. *Horse Blinders*, my second wrap-around painting, started out as entirely nonobjective. But you always have to deal with the tenor of the times. Every election year, I start out feeling idealistic and positive, hopeful for a change but

I am climbing out the window of my East Hampton house, ca. 1973.

then inevitably everyone I vote for loses. When Nixon won I felt like I had a ball and chain around my ankle. I went back to imagery again. Images began to impinge on the process, which naturally changed, too. In this case, the times provoked my activism, and little by little I began introducing more and more images into the painting.

Horse Blinders is a political pun, optically expressed—with vision just outside the scope of direct sight, and aluminum panels reflecting and distorting light, imagery, and the viewer. The idea came from an experience in Stockholm. When I showed *F-111* there, the two directors of the Moderna Museet were Carlo Derkert and Pontus Hultén. Carlo called himself a young Marxist, even though he was in his fifties. He said, "When hanging an exhibition, we never have a tough painting on the left. We always hang the hard paintings on the right because, as you know, the left is softer." I thought, This situation is like sparring partners; some areas are softer than others. And I wondered, what the hell is that about? So I decided to do a big painting where you couldn't see left, and you couldn't see right. You could only see straight ahead. *Horse Blinders* was the result. It was neither right wing nor left wing. In that sense, as in *F-111*, the painting was about peripheral vision, about looking at something and questioning it because of everything else you're seeing at the same time, the things on the peripheries that affect your vision. And like *F-111*, the ten-by-eighty-four-foot *Horse Blinders* wrapped around the walls at the Castelli Gallery.

Sketch for *Horse Blinders (Butter as Existence, Melting Across a Hot Pan)*, 1968. Collage, watercolor, plastic, and masking tape on paper. 22¼ x 30 in. (56.5 x 76.2 cm). Private collection, Houston.

One of the central images is a telephone cable. The splay of colored wires from the cut telephone chord is almost like futurism. I liked the flowerlike image it created. Some people said I was doing pop futurism because of the multiple explosions of the wires coming out of the casing. The telephone cable here is meant to be like Alexander the Great cutting the Gordian knot; his reason for doing this was the same as mine in cutting the Bell cable. We thought Bell telephone was the perpetrator of all kinds of nefarious deeds. We were all weird about corporations then. The telephone company was public enemy number one. There were ethical questions being discussed involving government spying. It was long after McCarthy times, but we were concerned about the Vietnam War and the scandal of the Pentagon Papers.

Around this time I made friends with a couple of young guys at the University of South Florida. One of them said, "We've got to do something. We ought to blow up the electrical station in Tampa. We ought to sabotage the electric system. They're overcharging us, they're in collusion with the government, permitting the FBI to spy on private individuals, to wiretap people's phones." This guy was building up his case with all this inflammatory rhetoric, egging us on. I was joking with him and said, "Yes, let's do it!" Guess what? That guy, I figure, was a plant from the FBI posing as a student. After six months he disappeared, and no one ever saw him again.

The fingernail underneath the cable has a big rainbow on it that represents either paint underneath the artist's fingernail or the idea

of a fingernail fragment from a DNA analysis. DNA was in the news around this time. Francis Crick and James Watson had untangled the structure of DNA in 1953, and its possible applications were being talked about. The idea was, how do you identify somebody? In the past you did this with fingerprints—in the future your identity would be known through your DNA. There were aluminum panels in all four corners that reflected and distorted the light and color and images from the adjacent panels. I love the way the aluminum panels in the corners very faintly reflect the images they are facing—and the smoothness and subtlety of those reflections.

In the panel adjacent to the severed phone cable there's a spoon rapidly stirring something in a bowl. A spoon mixing up something delicious then blends with the plume of a rocket going toward the corner panel, and the corner panel is reflecting all of this. I like the color of the purple smoke in this panel. It's smoke from Israel's Six-Day War, which was going on at the time.

My assistant Bill McCain once said to me, "You know, existence is like a piece of hot butter in a frying pan." In this painting, there's a stopwatch next to the pat of butter, which gets reflected in the corner. It changes when you walk around the room; it brought action into the painting without having to use any gadgets. The images to the right of the butter in the frying pan are evocative of a very spacey Eastern idea; a stream of consciousness is suggested in the jagged plywood shape and the grain and patches in the plywood.

The implication was that you have one swift race through life. Life is like a quick burn, a quick sizzle. It's an existential idea. So, in *Horse Blinders*, I had a piece of hot butter going across the pan being dipped in water. I enjoyed painting the water surface; I was intrigued by the rippling blue lines of light in swimming pools. The painting was exhibited in London in 1968. I think David Hockney started painting swimming pools around this time. Ideas are airborne—whatever it was, we both began making big splashes.

Leo Castelli never came out to East Hampton to see the painting. He'd already assumed it was going to be good. Once *Horse Blinders* got to the gallery and we started to assemble it, Leo liked it. It sold immediately, almost before we had finished hanging it. We had only gotten one wall up in the gallery when Dr. Ludwig from Cologne walked in. He was a memorable collector. A huge,

tall guy with great big feet, he was married, but his secret love was the painter Nancy Graves with whom he had a passionate affair. Ludwig died in 1996, and Nancy is dead now, too—poor dear.

Ludwig strode into the gallery and took a look at the painting. "*Ach, so ganz schön! Phantastisch!*" he said, although only one wall had been put up. "What is the cost for this here?" he said to Leo, who said to me: "Let's put all the rest of it up and he can come back and see the whole thing." He came back right away at nine o'clock the next morning. "What are we going to charge him?" I asked Leo. Leo said, "Well, your *F-111* was fifty grand, so why not say seventy grand?" Leo said, "Dr. Ludwig, it's seventy thousand." "Ha! Seventy thousand *dollars*?" Ludwig said incredulously. "Are you maybe kidding me?" Just then the phone rang. In my mind's eye I see Leo on the phone—at the gallery, at the studio. He was always on the phone, whether it was down in Aripeka or in East Hampton. Leo disappeared into the back room of the gallery. It was Philip Johnson on the phone. He, too, it turned out, wanted to buy it.

I was left standing there with Dr. Ludwig, someone I didn't know at all. I just came out with the thing that happened to be on my mind at that moment. "Dr. Ludwig," I said, "did you know our secretary of the interior, Walter Hickel, just sold our offshore oil rights in California for seventy million and we have had serious oil damage out there, which has killed a lot of wild ducks, and you can't make a duck with seventy million dollars."

Leo heard this as he came into the studio and he said, "Yes, Doctor, we are the ducks." Right on cue. When Ludwig heard that Philip Johnson was on the line bidding on the painting, he jumped right in: "*Mine!*" Dr. Ludwig bought it and there it sits in his collection in Cologne. It has been loaned twice, but he wouldn't lend it for my retrospective at the Guggenheim.

Horse Blinders drew on my education in Eastern philosophy and history. *The Tale of Genji* had a huge influence on my way of thinking. I was impressed with its open-endedness, its refusal to make conclusions or to adhere to one genre or another. Whereas in the West, a story would be a comedy or a tragedy, would have a happy ending or a sad ending. The stories in *The Tale of Genji* and other Eastern sources end with a provocative ambiguity.

There are any number of artists who put images together arbi-

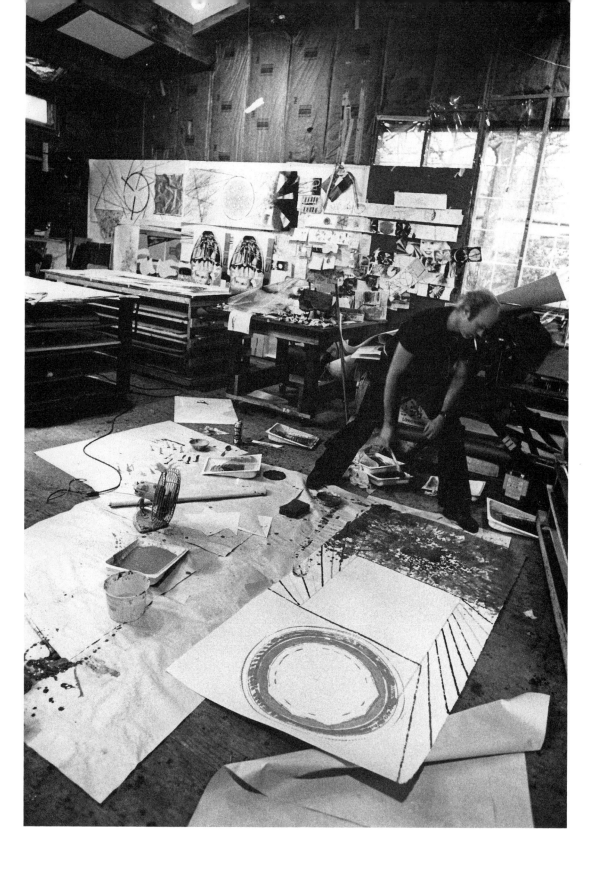

trarily, images that don't seem to make any sense, at least not to me. I work hard to create some kind of meaning out of the things I use—that way I can at least derive a question from them. They suggest meanings but they don't draw conclusions. The work has an intrinsic meaning for me, but remains open to multiple interpretations. I want to encourage the possibility of exploring meanings beyond those I put there. Which is why I work so hard to not arrive at a title, or why I give my paintings enigmatic titles. I count on the viewer bringing something to the work. Viewers have their own thoughts. It's almost like the game Radio where you switch from station to station catching snatches of conversation, commercials, news, and music that you jam together in your head into a sort of Dada radio station. I feel if the images in my paintings are powerful enough, they may end up suggesting something beyond the idea I started with. It's my intention to make images that provoke points of departure. I don't write stories with my paintings. I let the viewer do that.

Flamingo Capsule was another one of the big canvases I did in East Hampton—9½ × 23 feet—and there was also one called *Area Code*. They faced each other. They were both the size of Leo's walls. Like *Horse Blinders*, *Area Code* has a lot of cable images in it, plus a bird. *Flamingo Capsule* is a tribute to the three astronauts who got burned up on the launch pad. Flamingo, meaning red, referred to the fire in an encapsulated space. There are balloons in the painting and a big bag that the astronauts used to suck food out of.

In 1971 *Flamingo Capsule* had just come back from being exhibited in Europe when a collector offered me $30,000 for it. I said no at the time. Sometime later, when the Centre Pompidou was opening in Paris, Leo called to tell me they wanted to buy *Flamingo Capsule* for $80,000. "Great!" I said. But in the meantime I'd joined in a protest against the French government because they'd sold the Egyptians twenty jets to use against the Israelis. I didn't really think about it much, but I protested it, as well as the fact that the French had released some terrorists—maybe not the perpetrators involved in killing the Israeli athletes at the Olympics but terrorists nevertheless. There I was in a full-page article in *The New York Times*, listed among the protesters with Arne Glimcher, who started it all. About two weeks later Leo calls me up and says, "Jeem, because you were protesting, the French don't want your painting any-

Opposite: Painting in the East Hampton studio.

more." A little later on, Leo called me again and said, "There's a man from Tehran who wants to buy the painting for ninety thousand dollars."

I told him, "No. I don't want to sell it." This was during the reign of the shah. I remember Leo getting a little exasperated, exclaiming in that accent of his: "Why don't people in the gallery tell me these things? How do I know that it isn't for sale?"

"Well, every man has his price," I said. "And now I want three hundred and fifty thousand dollars."

"I can't possibly ask that price, because it's an insult. No no no."

In the end he offered it to the shah for $360,000. But just then, the shah died, and the deal fell through. The painting went back in my studio and I was very happy to have it there until I sold it to the Guggenheim in Bilbao, Spain, in 2003. I have no policy at all about keeping certain of my works, and I don't have very many of them. I don't have a great art collection, either, and I'll tell you why: I've never had an adequate place for keeping anything, and I've always been afraid of things getting destroyed. My thought is: if they're owned by collectors and museums all over the world, they are safer. I don't have to worry about them.

Through a series of personal and political tragedies in the late 1960s, Gene Swenson began to lose his mind. He wrote about pop art and New York poets like Frank O'Hara. He organized two wonderful art exhibitions. The first was called The Other Tradition, which was beautifully hung by Gene and Sam Green at the Museum of Contemporary Art in Philadelphia. The second was an exhibition at the Museum of Modern Art called Art in the Mirror. Frank O'Hara had been a curator at MoMA, and after his death, Gene was offered Frank's job. Before he could take up his position there, he got appendicitis and almost died. I visited him in the hospital; he was very sad and angry that he was not able to carry through with Art in the Mirror. They passed him up and gave the job to someone else. Art in the Mirror opened, but naturally it didn't have Gene's touch. It was the beginning of his mental deterioration.

In 1968, just after Bobby Kennedy was shot, Gene was in terrible shape. He'd tied his life to the Kennedy family in an obsessive and

unhealthy way. JFK's assassination had hit him very hard; when Bobby got killed, Gene became psychotic. The assassinations in 1968 of both Robert Kennedy and Martin Luther King rocked Gene's world. Then Ted Kennedy got into this mess in Chappaquiddick with a young woman, and Gene just couldn't handle it. He carried on walking around Manhattan with that big blue plastic question mark above his head, speaking on brownstone steps outside the Castelli Gallery.

About this time, Gene became bitterly jealous of the success of an old schoolmate, Henry Geldzahler. He was jealous of Henry's position in the arts. He challenged Henry to a $10,000 riddle: whoever had the best answer would receive $10,000. Henry didn't reply right away, because I think he thought the note sounded ominous. Gene then sent a ten-color funeral wreath with the word *Henry* on it to a statue at the Metropolitan Museum. In *The New York Times* the next day, there was a statement from the director of the museum that went, "Our statues don't accept funeral wreaths. . . ." Gene didn't take this lightly; neither did Henry, who was afraid. Gene became more and more angry that his ideas were not getting across and he could not get a real platform to speak from.

He began hearing voices, the voices of his friends, girls and so forth. "I hear voices all the time," he said. "I can't stand it anymore."

Eventually he checked himself into Bellevue. I went to see him. He was in a big room with tables all around it and no doorknobs on the doors. Gene was sitting at a table with a big Chinese character map set up and an alphabet map. I walked in and said, "Hi, Gene!" Nothing. I sat down and asked how he had been. No response. Out of the blue Gene went, "Aha!" and pointed to a Chinese character. He made a bizarre connection based on something that somebody just said and this Chinese character. He was very clever. In an anguished voice he yelled, "I want a dictionary." There was another inmate in the room, a Southerner who'd been a truck driver. With a drawl he said, "That's all right, Gene. We'll get you a dictionary. Just simmer down, boy."

Shortly after that, Gene got hepatitis C from a bad needle he'd had while he was at Bellevue, which did have a reputation for being dirty. Next thing I knew he was in St. Vincent's Hospital. I went to

visit him there, too. He was sharing a room with an old Jewish man—the hospital didn't know he was crazy; his history hadn't followed him to St. Vincent's. They didn't know his mental state at all. I was on my way to go visit Gene again when I saw him walking down the street. I said, "Hi, Gene. Did they let you out?"

"I'm going to dinner."

"Do they know where you're going?"

"Yes, they do."

He asked if I wanted to go along. I thought I should follow him. I went to dinner with him and this whole group of people who looked like characters from *Rosemary's Baby:* the underground people of New York. I knew some of them individually and then when they got together, they became a baleful force. You could see intimations of dark stuff. Dark thinking.

I said, "Gene, come out to East Hampton and chill out. Let's write a movie about space travel." The idea was that these astronauts had been in space so long they didn't know what their destination was. They became kleptomaniacs and were stealing one anothers' ridiculous things, like golf clubs, that reminded them of Earth. He seemed interested and began putting something together. He visited us in the country and we did some work on the script. A number of strange things happened that weekend. We went to the beach. He cut his foot and had to get it stitched up.

Then we went for a stroll in Sag Harbor, and as we were going down the street we looked up and read the theater marquee, which said such-and-such a movie was playing. A few blocks later we turned around and passed the movie theater again. The theater marquee had changed and there were new films listed. Gene looked at me very portentously and said, "Did you see what I saw?"

"Didn't I tell you, Gene," I said, "somebody must have come in there in a hurry and changed the movie titles." But there was no convincing him. He was certain that dark magic was going on.

He was very upset because he was going to Kansas to meet his brother who was a captain in the army, and he hated the army and the idea of his brother's being in the army. I took Gene to the train and let him off. When Gene was about to get on the train in East Hampton to go back to New York, the sign on the railroad car above his head read KANSAS EXPRESS. I quickly jumped out of my car; I was about a hundred feet from where Gene was standing, and

I am experimenting here at Broome Street with my room installation *Horizon Home Sweet Home* (1970), which had twenty-seven panels and dry-ice fog.

said, "I see it too, Gene!" He turned around and gave me a strange smile. He got on the train and went back to Kansas. Out there, while he was driving in the car with his mother, they hit an oil tanker and were both killed.

Gene was from Lawrence, Kansas. His father was a country guy who owned a gas station. A typical middle-class family, they hadn't a clue about what Gene did or that he was gay. I went out there and delivered a eulogy for him. Even his father didn't know who he was.

I always say that every painting is a self-portrait and I wonder if this doesn't apply to writing, too, because some of what Gene had to say about my paintings could be read as a kind of autobiography. In *The Other Tradition*, he wrote:

> The abstract patterns of our inner life are the only things important for the artist. Art criticism in general refuses to say that an object can be equated with a meaningful or esthetic feeling, particularly if the object has a brand name.

> The paintings of the other tradition are not . . . mirrors of society. They are mirrors of what happens to us without our knowing or realizing it. In a way they might be said to objectify experience, to turn feelings into things so that we can deal with them.

In 1970, with *Horizon Home Sweet Home*, I was continuing experiments I'd started in 1967 with *Forest Ranger*. Now I took this idea further, using shimmering reflective Mylar panels alternating with painted canvases and dissolving the gallery floor in dry ice, so you walked through the exhibition utterly immersed in the environment and became an integral component of the painting.

While I was working on *Horizon Home Sweet Home*, Claude Picasso came by my studio with the photographer Gianfranco Gorgoni. They were buddies. Gianfranco came to take photographs at the studio. At that time Claude was married to Sidney, a girl from Connecticut. They had a child named Jasmine Picasso. Gianfranco told me that he had gone with Claude to see Picasso in the south of France, and Picasso wouldn't let them come in; he made them stay out on the lawn. Disowned his son. It was a very sad situation. Then Picasso died and what happened? Claude became head of the Comité Picasso and, despite the way he had been treated, he always staunchly defended his father.

When I was in Paris in the late 1990s, I stayed at the Hôtel Costes. Since I was in the neighborhood of Claude's office, I went across the street to say hello and ask him how he was doing. I told him I had just come back from Spain and had this thought about the imagery in his father's paintings.

"I bet Picasso was influenced by the shape of the cacti you see in Spain," I said. "His series of bather paintings remind me of cacti."

"No!" Claude said. He was very aggressive about his convictions. "Picasso was influenced by the angular faces of peasants."

I had arrived at the idea behind *Horizon Home Sweet Home* back in 1969. I had an idea about dislocation in space, with astronauts looking in their monitors trying to find their way home. To achieve the feeling of dematerialization, I wanted to create an effect of painted panels that appeared to be floating in space. I interspersed painted monochrome canvas panels with the aluminized Mylar panels, which would shimmer and reflect the colors. The Mylar was slightly crinkled, with the chrome-plated Mylar mirroring what's in front of it, so what you see is a reflection, and a reflection can look like anything. It was an extension of my concept of dissolving the painting as an object, immersing the viewer in the painting, and making it an environment—color as a state of mind.

Working on *Horizon Home Sweet Home*, which was installed in the lower, open area of the Whitney Museum for my 1972 retrospective.

Next I had to find a way to make the gallery floor disappear. I tried to create the effect a lot of different ways. First I bought a Broadway smoke machine, a little machine with mineral oil in it and a heater to produce the smoke. You press a button and out would come this dense white fog. I tried it out in East Hampton— it obliterated almost three blocks. Solid fog. It just covered every-

These are the dry-ice canisters of the installation at the Whitney.

thing, and, worse, it left a little oily residue everywhere, on people, too, so obviously I couldn't use that in a show.

Next I went to carbon dioxide—dry ice and water. It produces a nice fog and it stays down at floor level because it's heavy. The only problem was it created a lack of oxygen, so it's not good for pets or small children because there is no air down close to the floor. I would warn visitors not to bring babies or dogs to the show. It is a little air lesson. It also had this strange side effect: it attracted mosquitoes.

I was fascinated by color not painted with a brush. The color of *Horizon Home Sweet Home* was changed and muted by the dry-ice fog at the bottom of the panels. It looked like an airbrush was blending the colors as you watched the dry ice wash over the panels.

I chose the colors by experimenting with how they would react to the different effects. A couple of assistants who I was working with would mix the paint. Some would be one color, blue or white; others would be multiple colors, shaded from red to darkness and from pink to darkness to orange. The effect was that of a horizon or a sunset. All these horizons searching for home.

During the event fog blanketed the gallery floor. It was so thick I could lie down in it, then rise up out of it. The dry-ice fog would last for about two hours. I've showed it about four times, most recently at the Miller Gallery in conjunction with my Guggenheim retrospective. It didn't look bad without the fog, either. It was a minimalist installation before its time.

Horizon Home Sweet Home was installed along the four walls of the Leo Castelli Gallery's front room. It was made up of twenty-seven panels (twenty-one are colored, and six have reflective silver Mylar film loosely stretched over them) staggered along the walls of the gallery space, with dry-ice fog hovering along the floor. Prior to the exhibition at Castelli I had experimented with the *Horizon Home Sweet Home* in my Broome Street studio, as well as in a loft space on Wooster Street owned by the art dealer Richard Feigen.

I've often thought of taking this idea even further, putting an appendage on the side of a skyscraper with long glass mirrors, a colored glass floor, and a glass ceiling so that when you walked on it you'd have the illusion of walking across empty space.

My World Turns Upside Down

In January 1971, I went down to Tampa to collaborate with Donald Saff at the University of South Florida's Graphicstudio on the print series *Cold Light Suite*. I went back to East Hamp-

ton and said to Mary Lou, "Why don't you come down with me. You and John can have a minivacation in Florida." It was freezing in New York. So Mary Lou and John came down with me. John was six years old at the time.

One night, February 12, we went out to dinner at a local restaurant. Afterward, as we were heading back to the motel, a hit-and-run driver crashed into our car and took off. It was pouring rain; the conditions were terrible. And then, unbelievably, we got hit again by another driver.

The two collisions had devastating consequences. My wife went into a coma for a month, and my son, for six weeks. When they finally regained consciousness both had lost the power of speech.

The strangest thing happened to John. His eyes were open but he wasn't responding to anything I said. I didn't know what to do. I kept reading him his favorite book, *The Cat in the Hat*, doing the different voices. Finally I had an idea. I had my sister-in-law call the hospital room on the phone. The phone rang and I said, "John, it's for you." He took the phone and said, "He-ll-ooo." That ended the silence. He thought he had to answer a phone; it was more important than a human being. It must have been an instinctual reaction but I was overjoyed to hear him speak again.

Mary Lou recovered her speech in a more mysterious way. She had been in her hospital room the whole time. Finally, one day when she was still not recovered, I put her in a wheelchair and wheeled her outside. She looked up and said, "Oh look at the trees, aren't they beautiful?" They were the first words she spoke. Then I took her in the car to a stream and she said, "Oh look at that, look at the water!" She had been seriously hurt. I was very ferocious about getting Mary Lou back on her feet, but she was reluctant to do physical therapy.

John had his pelvis broken, a fractured skull, and every goddamn thing. His left arm and hand still get treatment. Intellectually, my son is fine; physically, he still has problems. He has a spastic left hand and a limp, and has been in physical therapy for thirty years.

I was lucky. I came out of it with only three broken ribs and a concussion. Bob Rauschenberg and Leo Castelli flew down to see me in the hospital.

Bob entered carrying a bottle of Jack Daniel's and said, "How about a drink?" A collector from Toronto, Roger Davidson, and his

wife arrived. All these people crowding were in my room as if it were an opening. The head nurse came in and said, "This isn't a bar, boys."

The automobile crash was like a lightning bolt that struck my family and utterly changed my life. It was devastating in ways that I still cannot really bear to think about. At the time, I hardly knew how to deal with it. And it took me many years to recover. In some ways, I never have.

While John and Mary Lou were convalescing in a Tampa hospital, I stayed in Florida and worked, praying for a way out. After they had regained consciousness they went back to East Hampton to undergo a long series of rehabilitation programs. My parents happened to be living in East Hampton when the crashes occurred. They looked at me and said, "What are we going to do now?"

"Listen," I said, "I will go out and get the money." At that point I was $60,000 in debt. I grabbed what money I could and told them, "Spend it!"

I had convinced my folks to retire early but I could see they weren't going to have enough money to live on. Their pension wasn't adequate; they had no savings. My father would have had to keep working in his old age, but I persuaded them to retire and move to East Hampton. I told my dad, "You can work with me, and I will pay the bills." He helped me make things, all sorts of gadgets; he was a great inventor.

My parents were lovely; they drove John and Mary Lou to doctors and therapists. My parents, John, and Mary Lou stayed in East Hampton while I went back to Florida to finish the print series. After the accident there was such chaos and physical and mental pain that I desperately needed to work.

I kept the studio at 420 Broome Street for a couple of years, then the landlord upped the rent. But by that time I'd pretty much decided to move out to East Hampton. I gave it to a couple of young painters: Jeffrey Smith, a British artist, and Shinohara from Tokyo. Jeffrey brought his girlfriend and their new baby with him.

"Whatever happens," I told him, "if someone stops you on the street and asks you where you are living, don't say anything, keep your mouth shut."

And wouldn't you know the next thing that happened was the

real estate agent saw Jeffrey coming out of Broome Street and said, "Hey you, did you just come out of that building? Are you living up there?" To which he replied (high-pitched Brit accent), "Yes yes yes." And that was the end of that.

I had my studio in East Hampton, but I was very, very depressed. My wife and child were convalescing for a long time out there. There was so much commotion with all of that, it was unbelievable. I was here, there, everywhere—but hardly ever home. I was scrambling. Eventually I got a studio on the Bowery and started work there and I just kept on working, working, working. I thought maybe I could work myself out of this.

People often ask me, "How did the crash affect your art?" The 1970s were a disaster for me because of this accident. After that crash, I was in a state of turmoil, but I have always said, "Suffering doesn't make great art." Poverty doesn't make great art. Mental illness doesn't make great art. Great art is made in spite of these things. Being poor, as many artists are, only complicates your life. You spend your time scrabbling to pay the rent, to buy food, paint, canvas. As for me, after the accident I was very depressed and desperate. I was very much at the end of my rope, and it brought out in me images of—anguish. I don't think the paintings that I did in the period after the crash were all that good; they were essentially ideas about my existence and hopelessness.

In 1972 I joined the antiwar demonstration in Washington and, along with a number of others, was arrested and jailed. I lay down on the ground along with Jon Voight, Robert J. Lifton, Dr. Spock, and the speechwriter for Barry Goldwater. Dr. Spock was giving me advice on how to avoid injuries: "James, keep your elbows into your body so they don't kick you in the ribs." He was protecting his babies: us. George Plimpton got up and read a declaration of war in Vietnam (you can't undeclare a war that hasn't been declared). Barry Goldwater came out of the Senate, looked down on the ground, saw his speechwriter lying there, and ordered him to get up. He refused and was arrested along with the rest of us.

I was thrown into a tiny cell along with a psychiatrist, who became completely paranoid and freaked-out. Across the hall was a one-eyed Pakistani, raving, threatening to cut off his wrist. I looked

through a hole in the wall into the next cell and I saw the artist Robert Morris; we had the same art dealer, Leo Castelli. Fortunately, the next day I got out.

Perhaps because of the accident and the stress and guilt surrounding it, Mary Lou and I had drifted apart. One day in 1973, when I was living in my Bowery studio, I saw this beautiful girl walking along. She had a little studio there, and I would run into her at Moishe's Deli. She was a talented painter—her paintings had been in Whitney shows. She'd seen my paintings at the San Francisco Museum of Art and found them poetic and surrealistic. She used to say I should have been a poet. We soon began working and living together.

I was painting *A Pale Angel's Halo* and *Slipping Off the Continental Divide* when I met Susan Hall. This was a metaphor for my past life and my future: yesterday, today, and tomorrow. That's what it is.

The central image is the staircase. In the wrinkled rainbow behind and to the left of it you can just make out a figure. The dark window below the stairs is the door frame of the car from my accident. It is the black of the accident. The black on the stairs was just the darkness. Stairs descending over darkness. I was depressed when I did it. The crumpled psychedelic image was what I was leaving behind. I scrunched up the canvas, sprayed it, and stretched it out again. A wrinkled rainbow. You have a rainbow, but you have trouble.

There is another aspect of this, too. How do you talk to an alien? How would you talk to somebody with no language between you? Someone who can't speak English. You can't reach him with Chinese, either. But you might be able to communicate with him through geometry. If you generated geometric symbols for ideas, aliens might grasp what you're saying.

On old Zen scrolls a triangle, a circle, and a square represent the universe. So I used these symbols with Chinese characters in them to represent the idea of communication. Behind these symbols is a color field, strokes of paint put down using a roller.

The Chinese characters are all mixed up. In the triangle it says *circle* in Chinese, in the circle it says *square*, and so on. It represents confusion. Confusion under the stairs. Waist deep in water and practically drowning.

At the time I showed a drawing in Paris there were many Chinese officials there. About six fat guys in Mao suits came to look at it carrying little red books. "Chinese man never buy that," they said, because of the mismatched symbols and Chinese characters. It was confusing and mixed up and they thought it was an anticommunist joke. They didn't like it.

The pale angel of the title relates to a pun: the white semicircle on the left-hand side is the handle of a pail. It poses a question: How do you grab an angel? By her hair or by a handle? Whether it's an angel or not the question still stands. When something comes out of the blue how do you hold on to it? Behind the handle is a wrinkled rainbow, and below that I put a sheer piece of Tergal material. It's just a continuation of my interest in playing with the picture plane. It's like hanging sheets. Very delicate.

The book on the right-hand side is upside down. You throw a book on the floor when you walk out of somewhere in frustration. It was like the motivation to move on, just to get up and go, to leave your home and go somewhere or do something. I had left home when I was twenty-one years old. That was it. I never went back. One way or another, you leave your home, you slip off the Continental Divide, which goes east or west. When I was little, I wanted to build an airplane and leave Minnesota and get away in the winter. This painting was like saying good-bye to my past. Originally I had decided to go east but now I asked myself, where am I? That kind of idea.

Eventually Susan Hall and I took off for California. I was in love with Susan and thought of marrying her. We stayed at her parents' house in Point Reyes. It was beautiful there, a wilderness area. I made some sketches for my *Calyx Krater Trash Can* sitting at the kitchen table. I turned the garage into a work space and I started to convert an old barn into a studio. I worked on large pieces of paper, made collages and mock-ups out there. I loved northern California, the light was beautiful. John came out. Raccoons were running through the living room; he loved that. I was thinking about moving out there. But one problem with California: you can't talk to people in New York at any reasonable time of the day or night and that's where my gallery was, and where a lot of my friends and fellow painters were. I decided that California was not for me and began to think where I might move.

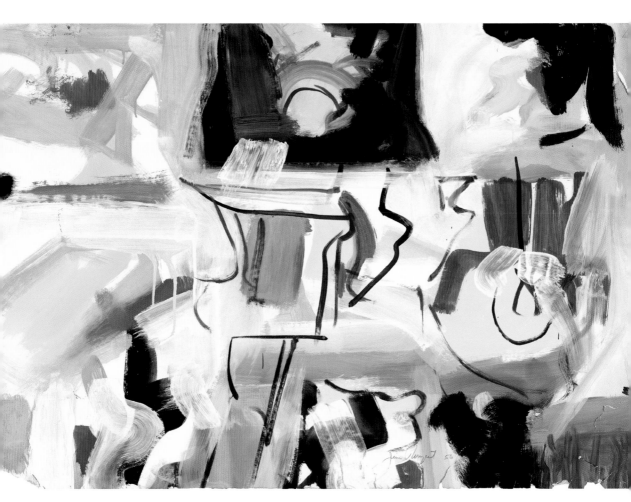

Untitled, 1956. Acrylic, watercolor, and india ink on paper. 25³/₈ x 38¹/₂ in. (64.5 x 97.8 cm).

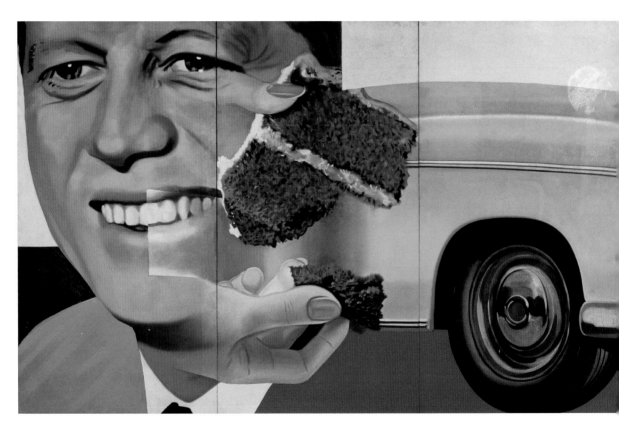

President Elect, 1960–61/1964. Oil on Masonite. 7 ft. 5¾ in. x 12 ft. (228.0 x 365.8 cm).

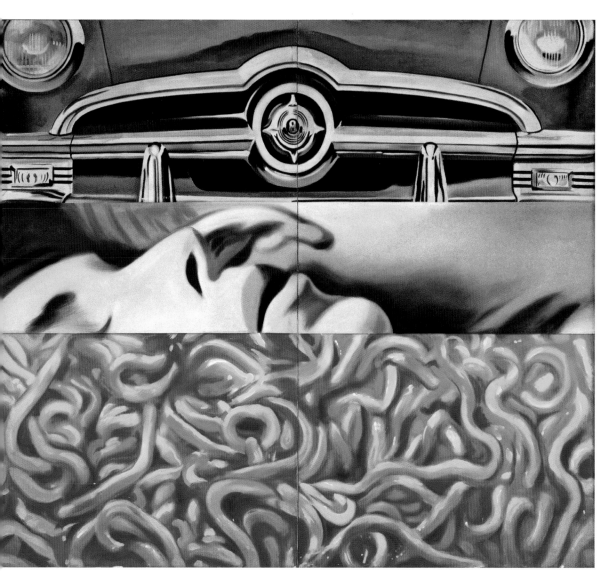

I Love You with My Ford, 1961. Oil on canvas. 82³/₄ x 93¹/₂ in. (210.2 x 237.5 cm).

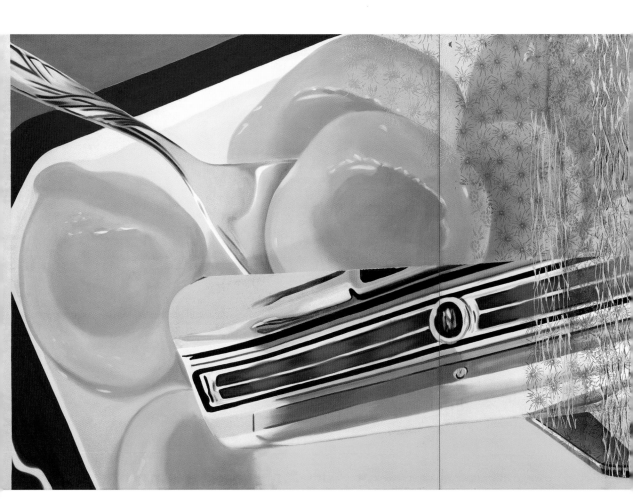

Lanai, 1964. Oil on canvas. 5 ft. 2 in. x 15 ft. 6 in. (157.5 x 472.4 cm).

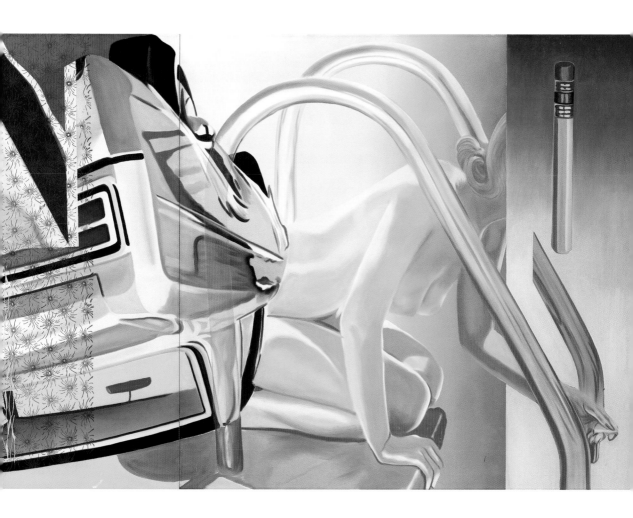

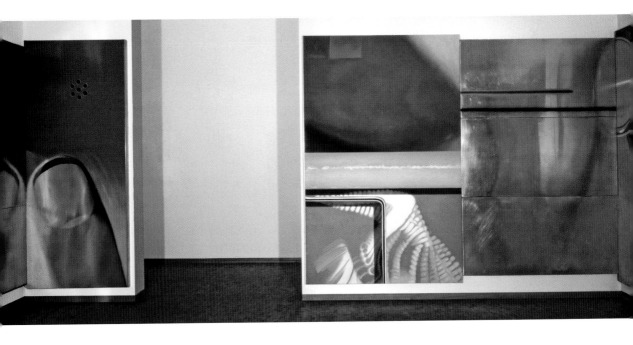

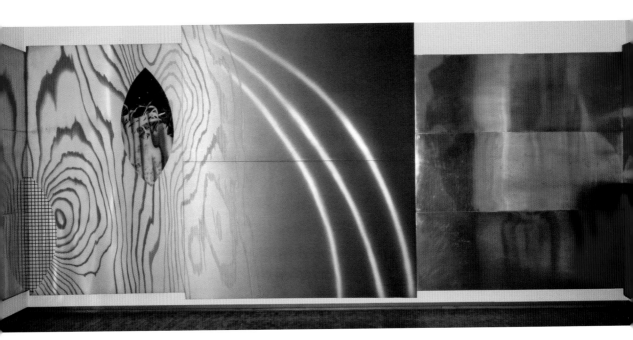

Horse Blinders, 1968–69. Oil on canvas and aluminum. 10 ft. x 84 ft. 6 in. (304.8 x 2575.6 cm) overall.

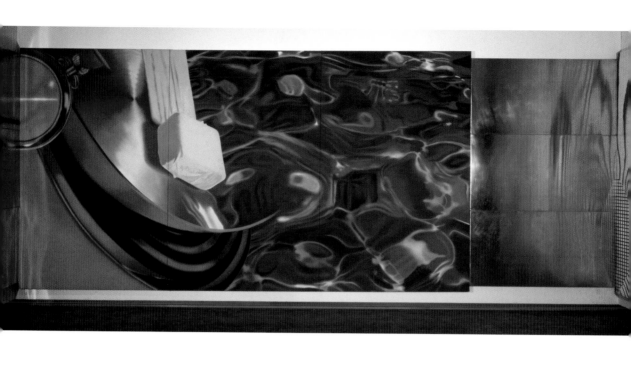

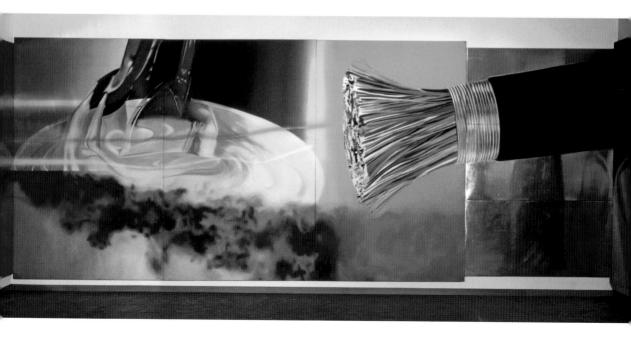

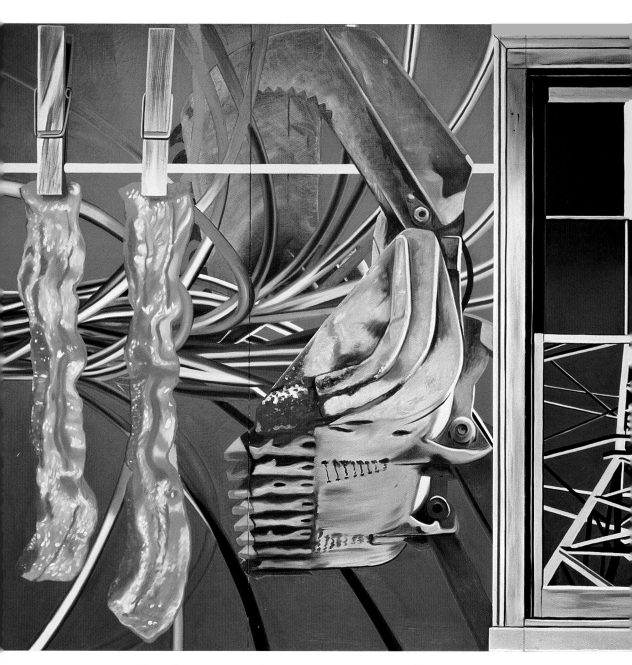

Industrial Cottage, 1977. Oil on canvas. 6 ft. 9 in. x 15 ft. 3½ in. (205.7 x 466.1 cm).

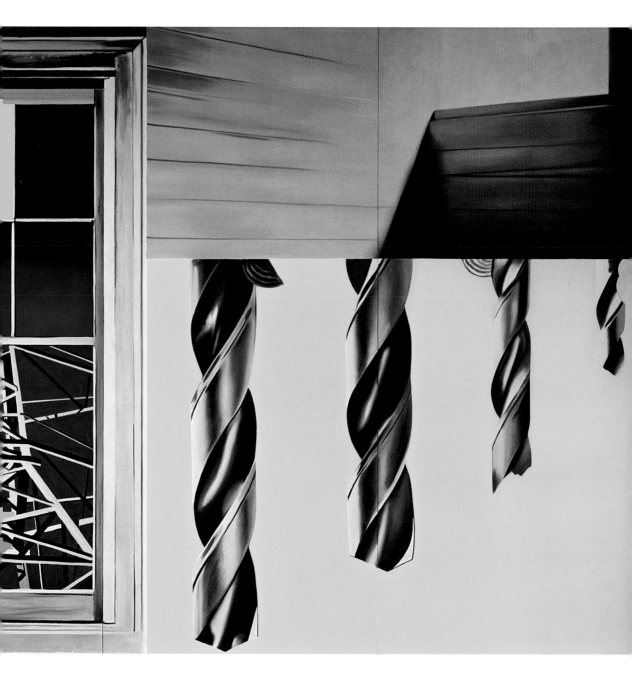

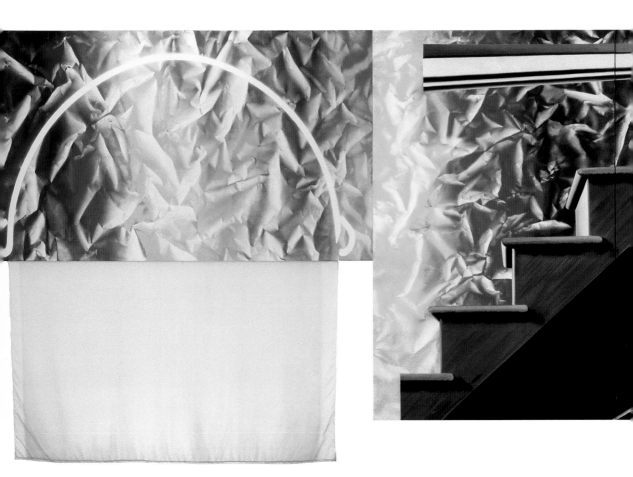

A Pale Angel's Halo/Slipping Off the Continental Divide, 1973.
Oil and acrylic on canvas, with marker on Tergal. 9 ft. 5 in. x 30 ft. 11¼ in. (287.0 x 943.0 cm).

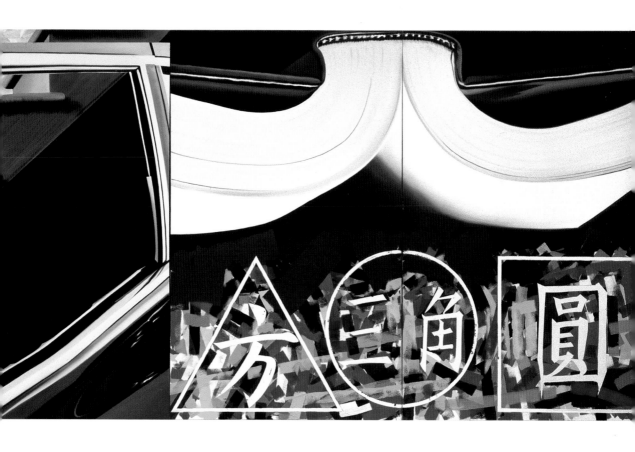

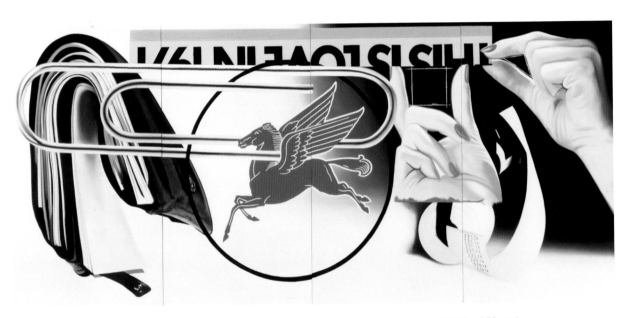

Paper Clip, 1973. Oil and acrylic on canvas. 8 ft. 6¼ in. x 18 ft. 8 in. (259.7 x 569 cm).

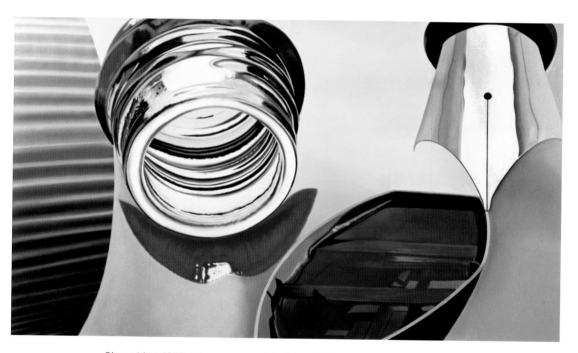

Sheer Line, 1977. Oil on canvas. 6 ft. 9 in. x 12 ft. 3 in. (205.7 x 373.4 cm).

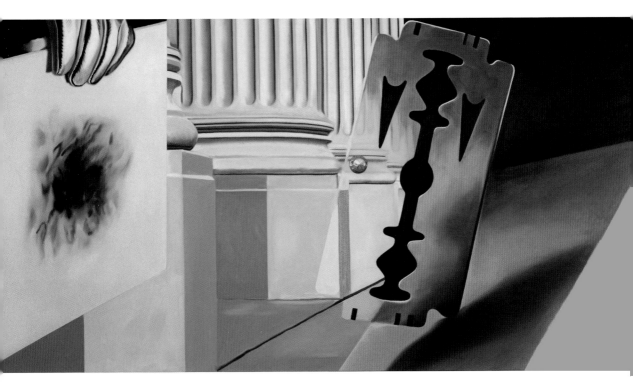

Chambers, 1978. Oil on canvas, with metal doorknob. 48 x 96⅛ in. (121.9 x 244.2 cm).

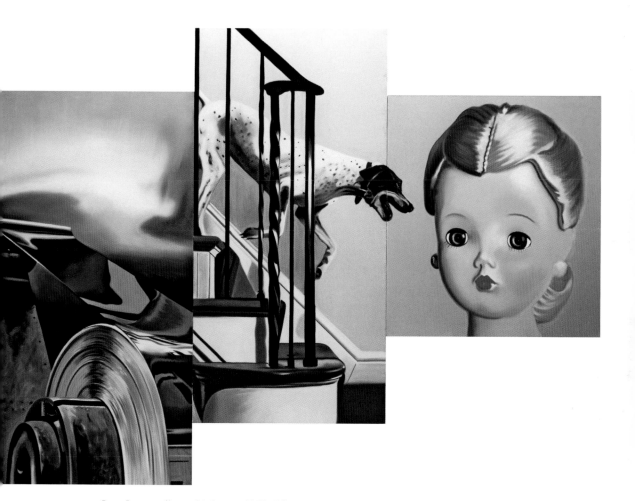

Dog Descending a Staircase, 1979. Oil on canvas. 84 x 108 in. (213.4 x 274.3 cm).

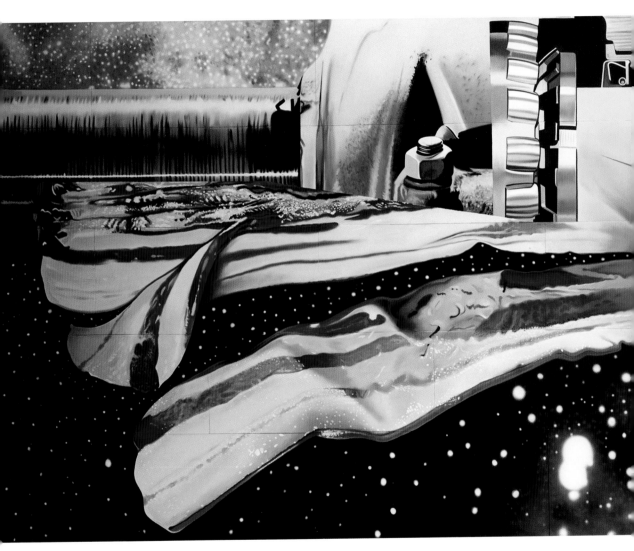

Star Thief, 1980. Oil on canvas. 17 ft. 1 in. x 46 ft. (520.7 x 1402.1 cm).

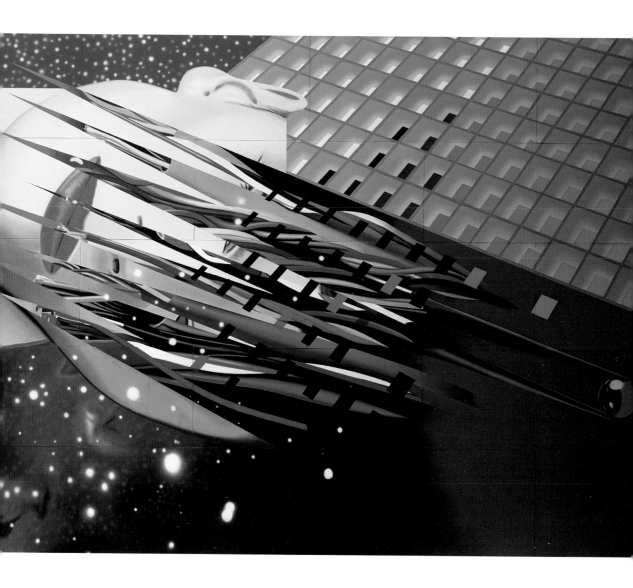

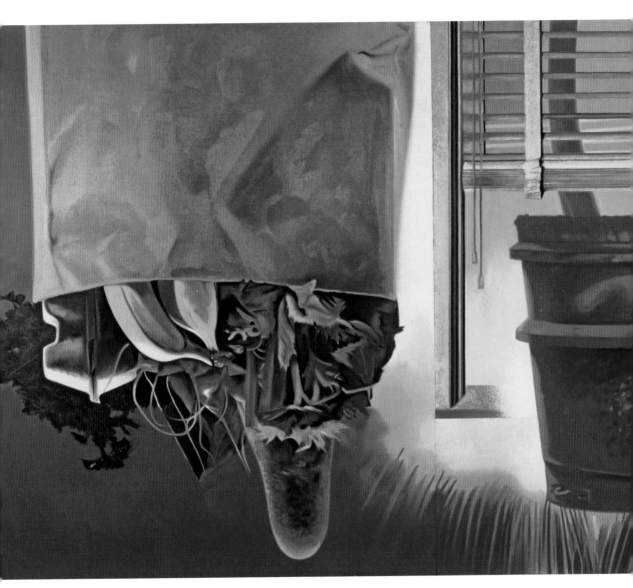

House of Fire, 1981. Oil on canvas. 6 ft. 6 in. x 16 ft. 6 in. (198.1 x 502.9 cm).

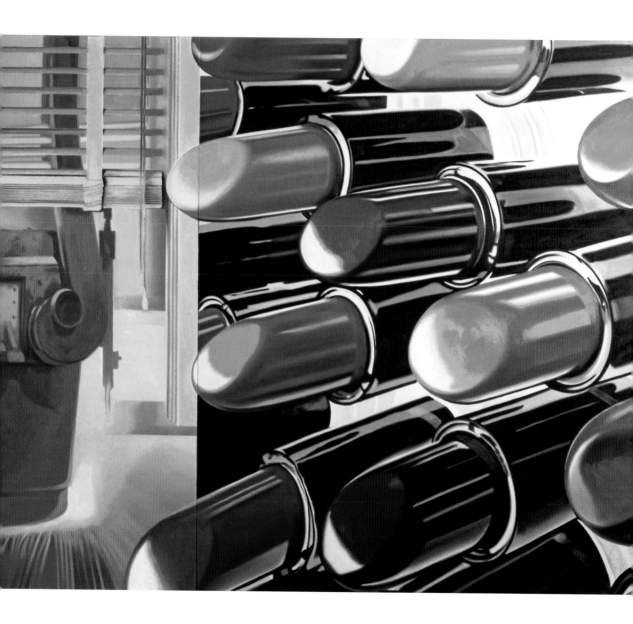

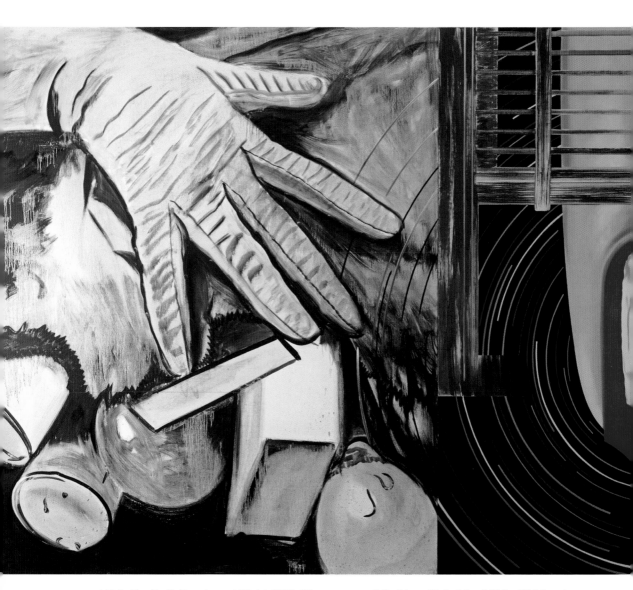

While the Earth Revolves at Night, 1982. Oil on canvas. 6 ft. 6 in. x 16 ft. 6 in. (198.1 x 502.9 cm).

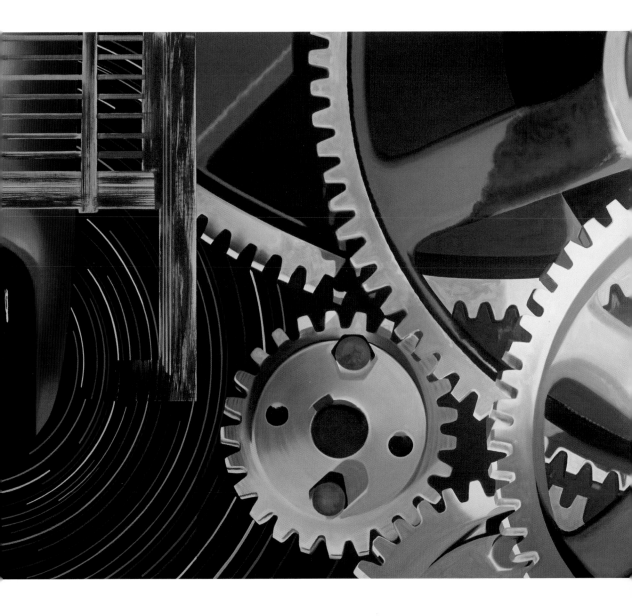

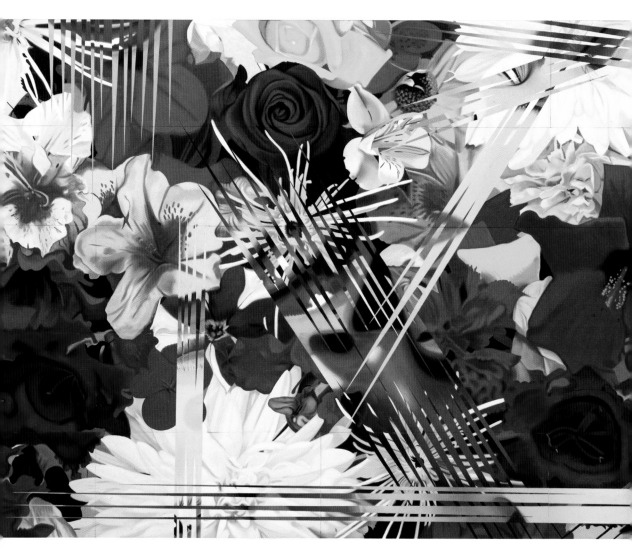

The Persistence of Electrical Nymphs in Space, 1985. Oil on canvas. 17 ft. ½ in. x 46 ft. (519.4 x 1402.1 cm).

Animal Screams, 1986. Oil on canvas. 11 x 18 ft. (335.3 x 548.6 cm).

Welcome to the Water Planet, 1987. Oil on canvas. 13 x 10 ft. (396.2 x 304.8 cm).

The Serenade for the Doll After Claude Debussy, Gift Wrapped Doll #16, 1992.
Oil on canvas. 60 x 60 in. (152.4 x 152.4 cm).

The Meteor Hits Brancusi's Pillow, 1997–99. Oil on canvas. 102 x 72 in. (259.1 x 182.9 cm).

The Swimmer in the Econo-mist #1, 1997–98. Oil on canvas. 11 ft. 6 in. x 90 ft. 3 in. (350.5 x 2750.8 cm).

The Swimmer in the Econo-mist #3, 1997–98. Oil on shaped canvas.
13 ft. 2¼ in. x 20 ft. ³/₁₆ in. (402.0 x 610.1 cm).

The Stowaway Peers Out at the Speed of Light, 2000. Oil on canvas. 17 x 46 ft. (518.2 x 1402.1 cm).

Speed of Light Illustrated, 2008. Oil on canvas, with painted and motorized mirror. 7 ft. x 12 ft. x 6½ in. (213.4 x 365.8 x 16.5 cm).

We went back to New York and I rented a two-story loft on Water and Wall streets. I put in a kitchen. I still had the loft on the Bowery. When I worked there I used to frequent the old bars across the street with the Bowery bums, go have a beer, listen to their stories. Bums always have great stories, and often they're very eloquent—they just have bad endings.

At some point after I got back from California, Don Saff called me and said, "Hey, Jim, what are you doing? Why not come down to Florida and make some more prints and maybe make some money, too?" In 1973 I went down to Florida and rented two huge abandoned dime stores from Booky Buchman in Ybor City, an old Cuban section of East Tampa, at 1724 and 1726 Seventh Avenue. I rented one for $300 a month that I worked in and the other that I lived in also for $300. I made prints with Don and painted down there.

I was glad to find a new place to work and live because after the car crash, I wanted to begin again. I was determined to change my life. I decided Florida was the place to do it. Besides, I thought, I don't want to hang around New York in the winter with a pipe wrench fixing leaks in a cold building.

Ybor City was an amazing place. It had been founded in the 1800s and became a thriving Cuban community, but after Castro became persona non grata with the U.S. government, the area declined and it became an impoverished neighborhood. Many of the structures had not been changed since the nineteenth century—the area had not yet been "renovated" or discovered; in fact it was crumbling. Surrounding the main street were a few side streets in varying states of disrepair, and then there were large sections of city blocks that were nothing but vacant lots, old pharmacies, Cuban cigar factories, palm trees, a lot of Spanish architecture. So what remained had a wonderful authentic Cuban atmosphere, with the buildings painted in tropical greens and reds. Very few people lived there so the streets were mostly empty, especially on the weekends.

It was said to be a little dangerous at night. It had been a high-crime area, so they bulldozed part of it. I was warned not to go there. But I didn't find it dangerous at all. I've got pictures of me lying across the yellow line in the street like a dog. It was totally quiet and mostly desolate. Then, right in the middle of it, there was Arnold's Art Supply store on Seventh Avenue. Buddy Arnold.

Strange place for an art store, but I was thrilled to find it there. He said for me to take whatever I wanted. He said, "Pay me back when your luck changes." And I did.

Artists and musicians moved into the abandoned storefronts because the rents were so cheap. Dan Stack, who would become my assistant, had a studio there. It was also not that far from Tampa Bay, so you got a whiff of salty seawater in the air when the wind was right. We used to eat at the Columbia Restaurant just down the street from my studio. It had simple Cuban food, and was quiet and dark—felt cool even though it probably wasn't. No air-conditioning, just good food and a slow ceiling fan to make it seem truly tropical. I remember having lunch there with Leo Castelli when he came down to look at my work.

The spaces in Ybor City were so huge that they could have been minihotels, and on a couple of occasions they were. I remember one time in 1973 my son, John, came down to stay with me. After his visit I took him to the airport, but when we got there the airline was on strike, and who were sitting in the airport but Rauschenberg's people: Saskia, and Susan Ginsberg with her dog. I said I'd try to help them out. I called about twenty hotels in Tampa but they were all filled up. "Well," I said, "you can come to my studio and crash if you want to." I had some couches and went and got some sheets, and they all came and slept on the couches and on the floor. A lot of people. The James Rosenquist Hotel—cheap nightly rates! The strike ended, but the airline wouldn't take Susan's dog without a physical examination. "Well, I have to leave it," she said, "I've got to get on this plane." She left the dog with Saskia. "But I hate dogs," said Saskia. "I eat dogs." Saskia wasn't crazy about adopting another dog so he gave the dog to Don Saff to take care of.

Although personally I was in a state of turmoil, at the same time I was in an expansive mode. I had begun to experiment working with paper and self-destroying works, one of which used the Coca-Cola logo printed on Tergal polyester. One end was dipped in a trough of colored ink that got absorbed into the fabric by capillary action. The color would sneak up, soaking up the Tergal fabric, and eventually infuse the Coca-Cola logo. That was *Capillary Action III*. I still have it.

Another experiment I made was *Shelf Life*. It was a full-size door and on top of the door was a little can of paint with a string

This is downtown
Ybor City.

attached to the doorknob; every time you opened the door, the can fell on your head. It was like an accident, but a fortuitous one. If you'd left the paint on the shelf, it would have dried; the shelf life would expire. But if you do something, if you open that door, although the resulting action might hurt you, you are doing something, something is going to happen, something gets done.

I was experimenting. I thought I was really cool. I went down to Ybor City with a couple of rolls of paper and tried to do everything, anything I could with paper. I'd cut it, chew it up, burn it up, bend it, and cut it to try to do new things with imagery in paper. I did everything but swallow it.

I was using Arches paper. It's very strong; you can soak it in water and it remains resilient. I've always painted with oils, but around 1974 I began using acrylic, water-soluble paint. If you want to lay down a big flat area in color in a hurry, you use acrylic and then paint on top of that with oil paint. You can't reverse the process—acrylic won't adhere to oil paint, it will peel off and fall apart. Every medium has its own quality. If you're technically proficient, you use anything as long as you think it will last.

I would take a big piece of Arches paper, put it on a frame so that it dipped in the middle, and pour the surface of the paper full of water. Gallons of water. Then, with this water puddle in the middle, I'd pour paint into it and poke a hole in the paper so that it drained out like a natural process. It left a beautiful flowerlike

With Bill McCain, cleaning up under a silk screen in my Ybor City studio.

shape going through the paper. I did the same thing in some paintings, too. It was a new way of thinking about paint and canvas: the patterns that paint makes when going out through a hole.

The idea came to me when there was a dry spell in Florida. People were building houses beside lakes, but after a while there was no more lake. It was all just grass and mud. People wanted to have lakeside property, they kept getting closer to the puddle, and then the lake disappeared; the color of their dreams ran out as if through a drain. That led me to paint *Pyramid Between Two Dry Lakes*, which had two multicolored puddles with a pyramid in the middle.

I did a drawing show around that time and sent the artwork to Australia. Shipped it all that way, had a show, and they all came back—unsold. As soon as they came back the Australians called up and said, "Look here, old chap, you know those drawings you sent us?" "Yes, what about them?" "Well, here's the odd thing. We'd like them back." "All righty!" I sent them back, and they bought them all.

The following year I created the largest print ever made at that time, a lithograph, *Off the Continental Divide*, with ULAE (Universal Limited Art Editions) in West Islip, Long Island. It was 43 × 79⅛ inches. The title referred to that critical point in my life when I was deciding whether to go to California or to New York.

I kept working in Graphicstudio creating the *Cold Light Suite* of prints when a commercial printer named Sam Shore came along and offered me a small amount for the whole series. Nothing basically, just a few thousand dollars. I was reluctant but in the end said okay. Then along came the dealer Paul Cornwall-Jones, who made me a better offer: $35,000 for the whole series. I went to see Sam and said, "I'm sorry, but I can't do this with you. I have to unsign the deal." He was a decent guy and he let me out of it.

With that money I paid off a lot of debts. I kept working, kept running here and there and anywhere to work, trying to sell paintings or do anything I could to make money. I had huge bills from the continuing physical therapy for my wife and son, but I managed to put enough money on the table to keep us going.

Working on a painting of *Capillary Action III*, which is on a scrim in my Bowery studio, 1973.

In this period of my life I didn't do that many paintings—I mainly worked on making prints. I was living mostly in Florida but going back to New York a lot. I wasn't getting much feedback on my work. Then the Whitney offered me a retrospective. Marcia Tucker interviewed me at great length in bars, in my pickup, in my loft on the Bowery, in taxicabs. She was very bright and wrote a terrific catalog essay. I'm always interested in what ideas my paintings give rise to, even if the interpretation is not what I had in mind. Discussing *Early in the Morning* Marcia Tucker wrote:

> Time and distance, for example, cannot be specifically defined in reality; they can only be described in terms of each other. The mysterious, haunted isolation, the ironic humor, the emotional incongruity of *Early in the Morning* (1963) seem to be related in this respect to one of Rosenquist's many stories:
>
> > One time, we were dropped off by a railroad track, no towns, no houses. It was green and everything, small birds up there in the trees and this big round ball, this big round tank with a stairway up the side, a storage tank next to a railroad track. It was my job to paint it white, the whole thing. And I would go up there and take my shirt off, and I was wearing dark glasses because it was so bright, and I was painting, starting from the top down and painting this thing white, the stair-

In *Shelf Life* (ca. 1973), when you open the door, a can of paint falls on your head; if you don't take a chance—open a door to new ideas—it will become stale.

Opposite: The studio in Ybor City was a former storefront. The crates are full of Arches paper, and the work on top was a canvas made like a sink: pour water into it and the color drains through the middle.

way and the top and everything. I was painting away and occasionally a plane, like a cattle rancher's plane, would go over maybe once or twice a day and then someone would pick me up at the close of the day.

So I'm working there all alone and I looked down the railroad track and a figure was running down the track. So I kept on working and I kept on working, and it's still running. So I thought, "Well, when he comes by I'm gonna go down and talk to him." So I took my time. I wiped off my hands, and I wiped the paint off my face and I grabbed my shirt and I just slowly walked down the stairs and I looked down and he's still running. He was about a half a mile away, which is a long way—a mile is a long way, as you know. It's a helluva distance.

So I went down and I stood right by the railroad tracks like a conductor. I stood there, looked both ways, and he kept coming. As he came closer I could see that he was a young boy with no shoes on and no shirt and a pair of bib overalls, about 13 or 14. And I said, "Hey," because he was going to go on by, and he comes up panting, and I said, "What's the matter?"

"New horses, new horses, shipped in!!!" And another couple of miles down was a corral next to the railroad track and they got a supply of new horses for sale and new calves, and he was so excited about going down to see them that he was running all the way down the railroad tracks.

But whereas distance and time are described in his anecdote, the painting renders them tangible. On a two-dimensional plane, there are legs that run obliquely without moving, that stretch into space without shortening the distance between themselves and us. The picture is small (only 56 inches across), yet suggests a vast scale, for the sky and ground are at once close up and far away; imposed on the sky are details of the sky, fractured into non-sequential planes.

It didn't matter that my story had nothing to do with *Early in the Morning*—the painting provoked some thoughts and sent her down those railway tracks.

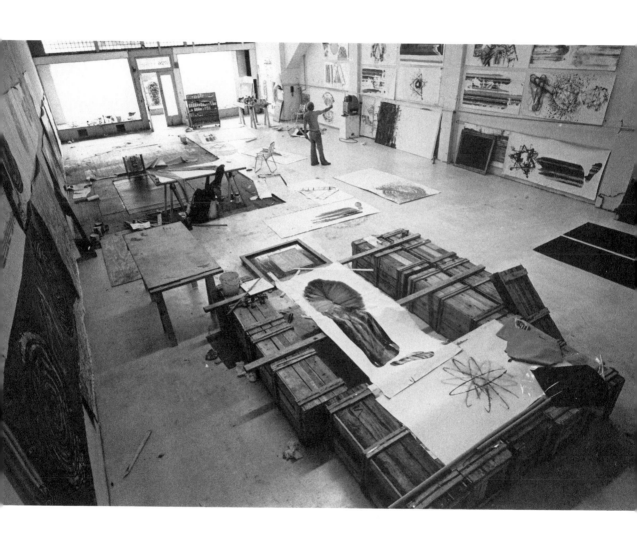

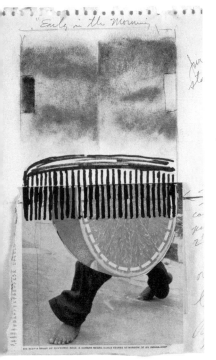

Collage for *Early in the Morning*, 1973. Magazine clippings and mixed media on paper. 13¹⁵⁄₁₆ x 13¹⁵⁄₁₆ in. (35.4 x 35.4 cm). Collection of the artist.

I think of my paintings as memory banks; they remind me of different parts of my life—where I was and what I did. It keeps my sanity. Things get destroyed, friends die or move away, and there's little that remains. I remember when Jimmy Durante's house burned down, he lost all his photos and copies of his movies, and he was devastated because there was not much evidence of all the stuff that he'd done in his life. When I see paintings that still exist, I say, "Yeah! I lived them. I remember that. I *like* that!" My paintings are like a stamp collection—things that happened so long ago.

But then came the worst review of my life. John Canaday in *The New York Times* called my work "death" and described my retrospective at the Whitney as an invitation to a wake. In a letter to the *Times*, I protested his insensitivity in light of my situation, the permanent injuries to my wife and son in the car crash: "I know more about death than Mr. Canaday," I wrote. "I prefer life. Long live artists, long live art collectors, long live art dealers, long live art critics, but damn a person like Mr. Canaday."

It was quite easy to move back and forth between New York and Florida. It was $99 each way from Tampa to New York. You didn't wait in any long line. I had a set of clothes here and one set there and didn't pack anything. I left the car at the airport. I was finishing up projects with Don Saff and working on big abstract paintings.

My paintings from the 1970s, like *Paper Clip* and *Sheer Line*, are saturated with personal meanings; I thought a lot about the enigmatic parallels between autobiography and art. The objects in all my paintings come from many different things: what is on my mind, images I see in magazines and newspapers, metaphors for ideas and memories. When I was a little boy in North Dakota, there were these blinding snowstorms, and you had to look for something, like a snow fence, that stood out and that looked familiar in all that whiteness to help you home. That was the start of *Snow Fence*, which I painted in 1973.

But I rarely base a painting on just one image. *Snow Fence* is about looking for a way home in a storm but it's also about marking time, crossing off the days. This was a very dark period. The literal

image of the lines marking off the days came from when I was put in jail after protesting against the Vietnam War in Washington. Being in the slammer and doing all that stuff in Washington. The nails are asking a question: Are you marking off days, or are you going to use the nails to build something? Sometimes it's hard to tell whether you're wasting time or using it well.

I painted *Paper Clip* in 1973. People sometimes ask me things like, "Why do you always paint fruit and paper clips?" As if I'm the fruit-and-paper-clip artist. I painted one painting with fruit salad in it—and maybe a few peaches here and there. I'll tell you where the paper clip comes from: it reminds me of a trombone. The paper clip image is just a circular track with things hung on it, things adding up to nothing on a paper clip: a Pegasus enclosed by a big circle, a billfold filled with blank pieces of paper, a broken egg, a woman framing an empty square, her other hand holding an upside-down sticker reading, THIS IS LOVE IN 1971, and a printed receipt from a cash register adding up to zero. This was my state of mind at the time. That's when I was broke. Emptiness, zero, nothing. For me a paper clip has the look of a Möbius strip, something that goes around and around and around and just ends up where it started. The paper clip painting has a triangle (the wallet), a circle, and a square in it. Abstract elements, basic geometric shapes. The Pegasus in *Paper Clip* was also a memory for me: the flying horse was the icon for Mobil Oil, and my dad worked for Mobil. I had to pull a wagon in the parade with the Pegasus symbol on it. I was a gas station kid. But here it's Pegasus caught on a hook. Andy used the Pegasus image, too. But for Andy it was just an aesthetic choice, a sign of a sign.

I also made a sculpture, *Paper Clip I*, using this image. Inserted at the end of the paper clip is a piece of Plexiglas in the shape of half of a pair of eyeglasses. I became fascinated with the shapes of the glasses. Who came up with this shape?

I'd do these paintings, big collectors and curators would come and look at them, and they'd walk out empty-handed. I remember collectors coming to my studio in New York, including Dr. Ludwig and Sidney Lewis. "Wonderful!" "Great!" "*Fantastique!*" "Stunning!" And they'd leave, and I'd never hear from them. My works weren't exactly selling like hotcakes. Sidney Lewis went to an auc-

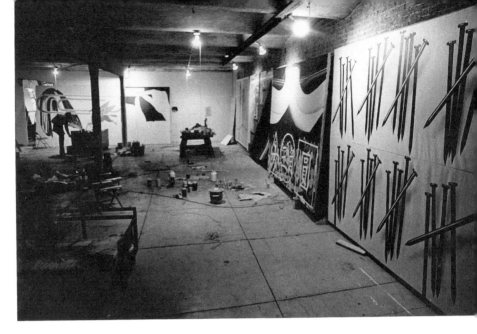

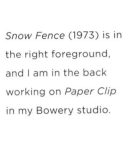

Snow Fence (1973) is in the right foreground, and I am in the back working on *Paper Clip* in my Bowery studio.

tion and bought an old painting of mine for $45,000 that I had sold for $750 in 1964. It really boiled me up; he didn't like my current work and then went out and bought my old work. I was really down on the mat, just scraping by. There was one guy who called me up. "Jimmy," he said, "I heard you're really in trouble, I'm sending you a check for ten grand tomorrow. Give me a couple of drawings in the future." That was Sam Dorsky, the uncle of the actor Richard Dreyfuss. Sam's dead now, but he's got a museum up in New Paltz called the Sam Dorsky Museum of Art. The funny thing about this most desperate period of my life when I couldn't sell anything to anybody is that every painting they didn't buy is now in a museum or a big private collection.

One day in 1972 I met Rubin Gorewitz, an accountant who specializes in artists' taxes. Gorewitz started talking about artists' rights.

"What about artists' rights?" I asked.

"They don't have any," said Gorewitz.

"I can see that," I said.

Artists used to come to me and ask, "What can we do about this?" And I'd say, "Well, you and I can get together and form some kind of power group. If we stick together, we can probably do something."

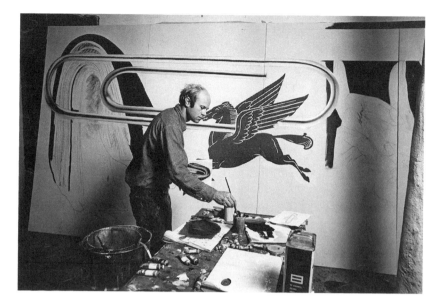

The Pegasus in *Paper Clip* (1973) was partly a memory, the symbol for Mobil Oil, where my dad had worked.

I soon got a painter's-eye view of art and politics. In 1974 I attended Senate subcommittee meetings with Bob Rauschenberg to lobby for legislation regarding artists' resale royalties. The idea was that artists—in my case, and that of most of the artists who started out in the early 1960s—initially sell their work for small amounts of money. Eventually these works of art increase in value astronomically. Many paintings that originally sold for a few hundred dollars are now worth millions.

People think, Why should we give a royalty to an artist who's already well-known and has money anyway? When they hear the colossal prices paintings sell for now, they don't realize the Jasper Johns that would be auctioned for $7 million in 1987 originally sold for $700.

F-111 originally sold for $45,000, of which I got half; twenty years later its value had increased more than twenty times. I didn't get any benefit from it. This sort of rise in value did not escape the attention of people who would soon begin buying art for reasons that had nothing to do with aesthetics. The art market is something of a poker game. Like poker chips they can change hands with big chunks of money and without specific value attached to them. I don't mind if someone makes money on art, as long as the artist also makes some of it.

In 1974 I spent a lot of time with Bob Rauschenberg working for artists' rights. Here I am at a Senate Committee Hearing with Bob. We're, standing behind, left to right, John Brademas, Ed Koch, Jacob and Marion Javits, and Claiborne Pell.

Bob Rauschenberg and I lobbied for artists' rights in Washington. You can't just march in to the Senate waving papers—the only way you can get there is with a chaperone. We were in Jacob Javits's office and Jake was mulling it over when Marion Javits piped up, "I'm going up there with you boys and we're going to lobby this thing!"

"I'm with you, kid," I said, and we went over to the Senate. When we got there Marion tugged Hubert Humphrey on the sleeve and told him, "These two boys would like to say something to you." So we told him our dilemma—that our paintings were going to be resold for millions and we'd see no profit—and said that if the bill passed, we could get tax deductions on the market value for artworks donated to nonprofit, educational, and other institutions, and so on. Humphrey said, "Oh, that's for the Senate, and we've got the Javits-Brademas Amendment up for a vote right now that we could attach this to. I'm all for it." We asked for a 15 percent royalty. In August the Senate passed Javits's amendment to the 1969 Tax Reform Act, allowing artists to receive equitable tax credit for their donations valued up to $25,000. It passed the Senate but failed the House. End of story. Alan Sieroty rewrote it for California and got it passed for 10 percent, where it exists today, but it is barely enforced except between museums.

In 1975 I designed the set for Twyla Tharp's *Deuce Coupe II*, performed by the Joffrey Ballet at City Center. Unfortunately, the sce-

nic artist destroyed my concept by cutting my painting up into different panels, and I think they long ago disappeared.

That same year Mary Lou and I got a divorce. The financial setbacks, the overwork, and the emotional strain of the aftermath of the accident had all worked to destroy our marriage. My relationship with Susan didn't help, either.

Aripeka Jim

I PUT DOWN ROOTS IN THE GULF OF MEXICO

I was working in Ybor City, finishing various projects. When I had time off, Susan Hall and I would take my 1974 white Chevy three-quarter-ton pickup truck and go on long drives. One day I drove down this little road off the highway on the Gulf of Mexico, forty-five miles north of Tampa, and came to Aripeka, a little island that you get to across a bridge. I drove in through the cabbage palms and there was this rickety old house a few hundred yards from the Gulf. A guy was standing there. I stopped and got out of the truck, and he introduced himself as Paul Simmons. "Welcome to paradise," he said. It was twenty-eight acres of palms and brush and undergrowth. I asked who owned the place and he said a lady whose husband had died.

I didn't have any money. I was still struggling, but I borrowed from some art dealers—$8,000 there, $5,000 here, and another $5,000 from over there—and offered the woman who owned it a $20,000 down payment on the property. She said no, she wouldn't

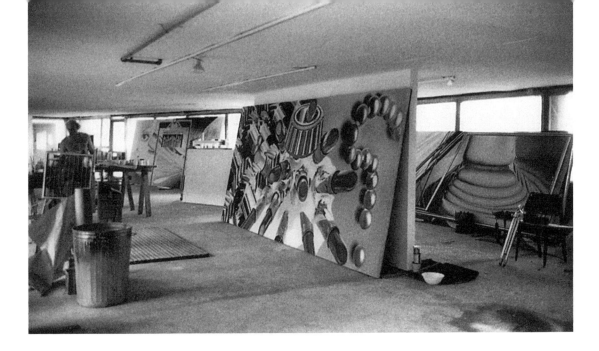

Inside the Aripeka studio, 1977.

take that. So I wrote to her doubling the offer. The problem was she never opened her mail. She lived in Nashville, and I never heard from her. Time passed and eventually she called me. "Y'all still interested in buyin' my land?"

"Yes," I said, "but there's a little problem. I don't have any money now."

"Aw, don't worry about that," she said. "I'll give you a mortgage."

It's been very easy for me to work in Aripeka. If I have an idea I can carry it through. If you have an idea in New York you have difficulty even *starting* it: just getting your materials, getting to the damn art-supply store, Pearl Paint, Steve Steinberg; you've got to watch out for the cops every time you use a car to pick things up.

So, I bought this land with little or nothing. Of its twenty-eight acres, twenty-four or twenty-five are underwater. In the beginning we slept in the rickety old house, which is now the office, and I bought most of the adjoining land.

Then it just happened that an architect walked in my door, Gilbert Flores, a wonderful guy. He was a Cuban, very conscientious and very interested in indigenous traditions. We laid out an imaginary house on the floor in Ybor City. We wound up putting two *chikkis*—the traditional Florida Indian house raised up on poles so it gets rid of the mosquitoes—together at a slight angle. Mosqui-

Gilbert Flores designed a stilt house for me in 1976. My studio was originally on the main floor; I subsequently constructed two steel hangarlike structures as my studio.

toes don't usually fly way up; they hover near the ground. The Seminole Indians build houses like this; in the middle they have a fire, and the smoke helps keep the mosquitoes away.

Bobby Aiello, who'd gone to Paris with me in 1972 when I had a show at the Grand Palais, heard I'd bought this land, and he called me up and said, "We're not doing anything right now, you wanna build something?"

"Yeah, I do," I said, "but I don't have any money." I told them what I told the lady from Nashville. "Aw, hell, Jim, we trust you," they said. "I tell you what we'll do. We'll charge you one thousand dollars a week, you put the material on the ground, and we'll build you a house. You can pay us back in the future. Pay us by the week, and we'll come work. It's cold up North."

I went around and bought used material. I bought anything I could find cheap. Got big cypress logs from a nearby mill. Occasionally I'd sell a painting, and the building would progress. The original house on the property was kind of a wreck. They tore out the floors, opened up the ceilings, put in a shower, and lived there while they built the house. In a month almost half the house was up. After the house was finished I still owed them $5,000. Whenever I got money I paid them.

I had some other guys do the Sheetrock, and I started living in the house as it was being finished. The guy who was doing the drywall was Bill Molnar. I asked him if he would like to continue working here. He worked with me for the next twenty years. My

neighbor, Paul Simmons, asked, "Do you need someone to wire your house?" He'd been an electrician with high voltage in rock mines for twenty-five years. Normal wiring would have cost me about $6,000. Paul said he was retired and preferred to trade things. I asked him what he wanted to trade, and he said his wife had always wanted a glider. I couldn't find a glider, so I bought him a new Chevrolet four-door instead. Then I bought him a pickup and next gave him a new Cadillac that someone had given me. He didn't like that one. I would say, "What do you want now, Paul?" He said he wanted another pickup. What a wonderful person. He worked in Russia, Sweden, and London with us.

In the 1970s New York was going bankrupt, so I was able to buy a five-story building on Chambers Street very cheaply and convert it to a studio and a residence. And like many other new studio spaces in my life, it gave rise to a new phase in my paintings. My place on Chambers Street came about because I've made it a practice my whole life never to burn my bridges with people. Years earlier, when I was evicted from Coenties Slip by the Fergang brothers, Herman and Melville, I said, "You evicted me, you gotta help me, man, help me get a rent-controlled apartment."

"Okay, Jimmy, we'll try." They said I was evicted from a rent-controlled place, which I wasn't, and I got a rent-controlled apartment real cheap, $32 a month, five rooms. Many years later they called me.

"Jimmy, we always knew you wanted to own a piece of Manhattan. Go to Chambers Street and see Mr. Korash and Mr. Rapee." They were two little fellows. One was an international bridge champion. They owned the whole block. They showed me two buildings, one for $80,000 and one for $120,000. I liked the one with the elevator in it.

Well, how the hell am I going to do that? I asked myself. I went to Castelli and said, "Leo, I need twenty thousand dollars. I have a chance to buy a building." He said, "I don't have much spare cash, but here's five thousand dollars." Marian Goodman, the art dealer, gave me another $5,000. "Here," said Sid Felsen, who owns Gemini G.E.L., "buy the boiler." He gave me $8,000. By hook or by crook I got the money together, renovated the whole building, plus the elevator, and all of a sudden I had a house in Florida and a building in Manhattan

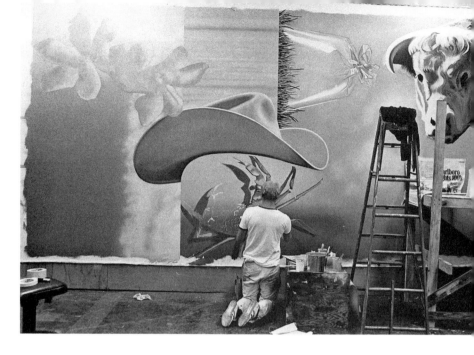

Working on the right panel for *Tallahassee Murals* (1976–78), my first commission, in a rented studio in Ybor City, 1978.

When I got the building on Chambers Street I again made paintings up to the height of the ceiling, which was around eighteen feet. I painted *Chambers* there. It's about the artist and the law. I'm the artist, the square on the left is soot on a panel, representing my art; at the far end of Chambers Street there's the law—city hall, the courts, all these governmental buildings with Greek pillars. The razor blade represents the severity of the law, toughness; it looked very sinister, so I covered it with an actual doorknob.

I started to paint a seventeen-by-forty-six-foot painting in my new space. My idea at that time was to have an opening in my studio, because Leo's gallery wasn't big enough. Just then Leo called and said, "Jeem, Jeem, I must show you at the new gallery on Greene Street." I go down there. He opens up his coat expansively and says, "What do you think of this? Go home and measure your painting." I saw it would fit with just a foot to spare. I showed *Star Thief, Four New Clear Women, Persistence of Electrical Nymphs in Space*, and *Through the Eye of the Needle to the Anvil* there. All seventeen by forty-six feet. Lucky for me those paintings also just happened to fit in museums.

As soon as the house in Aripeka was finished I started to work like crazy making art. The house went up but I had no studio. I screened in the area underneath the house and started painting.

•

My first commission was from the state of Florida in 1976. At that time the Florida Arts Council included Lois Harrison, Arthur "Buddy" Jacobs, and Suzanne Teate Bos. They asked me if I would paint two murals for the new state Capitol in Tallahassee. I told them I could do two ten-by-sixteen-foot or ten-by-eighteen-foot paintings for $30,000 each. "Well now, that's fine with us," they said, "but this has to go before the entire Florida Arts Council. You know, we have to get their approval and all that." The typical bureaucratic rigmarole. So, members of the council next arranged a series of meetings for me. At one of these early meetings, an old-timer got up and said, "Are there gonna be any nekkid women in it?" Buddy Jacobs said, "No sir, but there may be a naked cow."

The proceedings did get pretty silly at times. Next thing, I met with the governor. He was dressed very formally, wearing tails and pin-striped pants. His hair was perfect, and he was made up like he was going to be on TV or something. He was an incredible character. I liked him. I met him in the new Capitol, which was finished by this time. He said, "Come over here and sit down by me." Then he sat down and looked me straight in the eye. "Now, James, you do like this building, don't you?" It was a generic office building. I didn't care for Edward Durrell Stone's architecture that much, and I found this one equally uninteresting. But I said, "Yes, sir, I like this building" and he said, "Good." He was trying me out. He wanted to show me he was a cultured individual so at one point he said, "You know, I have a brother-in-law who does paintings. He does what you call nonobjectionable paintings." I figured he meant nonobjective paintings, but maybe he was making a little joke. I couldn't tell.

I went up to Tallahassee to meet the good old boys. Well, it was a little strange, that kind of political bureaucracy. I thought that the next step was going to be talking with a few people about my sketches and plans for the murals, but when I walked in, there was a room full of people, over a hundred bureaucrats—the Florida 100—in this big meeting room.

"Come right in, Mr. Rosenquist," one of the old-timers said. "We're gonna put your sketches right up here on the table on top of this chair so everyone can see what you've done." This was a bit unexpected to say the least because, to be honest, at this point I had done virtually nothing. I didn't yet have a sketch or anything like

that to present. All I had was a piece of paper with a scribble on it, an image ripped out of an old magazine and a photograph I had taken. It was just the beginning of an idea, really loose. Basically I had next to nothing, except a hangover.

So what else could I do but go straight into my Fourth of July oratorical mode? "I respect the great state of Florida," I said, "and this commission will provide me with an opportunity to get a real education about Florida because I plan to study the state's history as I do the painting." I paused and then I said, "But I'll tell you what I'll do. I'll paint these paintings, and if you don't like these murals when I'm finished, you can have all your money back."

"Oh no, Mr. Rosenquist," they said. "It's perfectly all right. I'm sure we're going to love them." Those were the good old boys—straight out of *Li'l Abner*—and the chief good old boy pipes up and says, "I love your work, Jim, and if I have to run somebody over I'm going to see that you get that job." As it turned out, he knew quite a bit about French impressionism. "I rather admire Cézanne myself," he said. These pork-choppers in Tallahassee weren't exactly as ignorant as I thought.

I was going to use historical figures in the mural. I went to libraries at the University of South Florida in Tampa, the University of Florida in Gainesville—all over really because I wanted to use pictures of statesmen and maybe Indians. I was going to put in Chief Aripeka and Andrew Jackson, the first governor of Florida. But it turned out that Andrew Jackson was a bad man: he killed the Dutch who helped the Indians, he executed two English subjects and committed other atrocities.

There were virtually no photographs of the Indians. Every once in a while I would find a drawing done by a soldier. I finally found a little drawing of Chief Aripeka, but he had tobacco juice running down his chin and really looked like a scraggly fellow. Besides, he was a medicine man and a battle planner, not a warrior. He wound up selling fish to the settlers at the end of his life. He didn't seem like that heroic a character.

All the Indians I found looked strange. And they were wearing ladies' dresses, garters on their sleeves, very fancy. I found out in an old soldier's journal that the Indians would attack the settlers, and the chief would put on the ladies' garments because an Indian war party had captured a Shakespearean troupe and put on their cos-

tumes. You can imagine how bizarre it must have been to see Indians dressed up like this. So then I thought, No more Indians. In the end I decided not to use pictures of people at all. Also in his journal this soldier had drawn the flora and fauna and described his clothes, the heat, and food in slang so contemporary I felt I was reading something from *The Twilight Zone*.

Then I thought of ecology: how living on the Gulf of Mexico is really like living on a mountain because the flora and fauna are very fragile. They exist in a delicate balance, not because of the altitude but because of the salt water. That kind of natural balance became my theme. I painted a big cowboy hat floating on the Gulf and under the hat was a crab, which was something the commissioners liked because it referred to the ecology of the shoreline. Then I threw in a mockingbird—the state bird. And, in spite of the old boys' admonition, I put in part of a palm tree and a pine tree being cut down for the paper industry. The tree had the state seal instead of a growth ring, and a monarch butterfly, which is the state butterfly. Things like that, things that are part of the state. I included the state lizard, which is an alligator. I put in a little beach shack out on the water that they used to have in Florida, tied with a rope to a big, fake phosphate rock as if to hold it down during hurricanes. The state is known for its phosphate; there was not an actual rock, but a casting of a phosphate boulder. Then I had a big bull poking his head around the right edge of the canvas. There are a lot of cattle in Florida, apparently more than anywhere else in the United States. You just don't see them.

Since it was Florida, I thought the painting should look tropical, and I decided to include at least one naked girl since they had asked me about that possibility. I put in a naked lady with stars reflecting in the water as she slips into the pool. But the image was disguised: it was a refracted image of a girl coming from a sky full of stars into a pool full of water. It was as if she were breaking the surface of the picture, whether that surface was water or some other substance.

Schoolkids go to see the murals, they see all kinds of things in them. After it was finished, there was an article in *Florida Trends* magazine that said, "Since the Rosenquist paintings in Tallahassee are now worth about $400,000, why doesn't the state government sell them to pay off part of the public debt?" I felt like replying to the article and saying, "All right, buddy, do that and then try to

apply for new grants from the government. Just see what happens. All your local institutions will have a hard time getting any funding for the arts." Aside from a few like that, I think people in Tallahassee are pleased with the paintings and aren't in any hurry to part with them.

Aripeka back then was 250 dwellings and only 150 people—more houses than people. But that was thirty-five years ago. People have started coming here and putting up monster houses, ugly great mounds, but the foliage eventually covers up everything anyway. People down here planted some beautiful things. After ten or twenty years you really can't tell that the houses are right next to each other.

While digging and building my place, I found nine Indian arrowheads. Aripeka was settled in 1866, named for the Aripeka Sawmills Corporation, which had adopted the name of that early-nineteenth-century Seminole leader. Apparently Babe Ruth hunted bears out of the window of the Aripeka Hotel. For a while they had my name up on the historic sign by the post office. I told them to take it down; I don't want any advertisements. I told the postmaster I would do a couple of T-shirts for him—a black T-shirt with a big white mosquito saying, DON'T BITE. I'M A FLORIDA SMACKER.

There are a hundred varieties of palm trees, but the most prolific kind are the cabbage palms. You don't see many palm trees inland, but the coast is loaded with them. And they've got their own way of talking down here, their own language. Like, "It won't fester overnight, will it?" Meaning you can let it go till the morning. Or: "It knows we come to get it, don't it?" A bad rain is "a toad-frog strangler" or "a lighter knot floater."

It's around this time of year, in June, that things start to come out. Walking catfish do actually move out of the Gulf; they want to be on the ground. *The New York Times* asked me for my New Year's wish. I said, "I hope there is peace all over the world, and I hope the walking catfish gain their legs." There are two- and three-pound spiders here; they're so heavy, when you knock 'em off the wall, they go *plop*. The population of Aripeka is carpenters, boatbuilders, mostly simple folk. In Aripeka people live conservatively. There are not many retirees, and the gated communities and new developments of McMansions are far away from here. People always

seemed afraid to come over here to this side of the tracks. I think it was too wild and nutty, at least it used to be. The road I live on connects to Highway 19 and this was one of two ways to escape, which is why it's called Shine Lane, short for Moonshine Lane. We had drugs and smugglers here till about ten years ago. At one point, twenty-six Cubans came ashore with tons of marijuana. The guy who organized it never was indicted—they didn't have a search warrant. He got off scot-free, but the Cubans all went to jail.

Local activities are mud-boggling: monster trucks compete in a muddy swamp hole, and there are machine-gun rifle ranges. There are redneck flea markets where you can buy all variety of things you can't imagine—inflatable mermaids, talking key chains, smoke-spewing demons, and used transmissions.

Susan was hesitant about moving to Florida. She thought she had to be attached to New York for her career. She was first here in August and it was hot, hot, hot. I didn't have air-conditioning then. This house wasn't quite built, and we were sleeping in a little shack back by the office.

Susan was also painting down in Aripeka but her work is very different from mine—mystical landscapes and mythical animals. She had very deep ideas, and she was trying to put those ideas into paintings. She was a California girl, kind of a hippie who grew up in the 1960s. She introduced me to transcendental meditation.

To do transcendental meditation (TM) properly, you have to do it sort of regularly for twenty-minute periods. When I was first studying Eastern philosophy, I would always hesitate about making decisions. TM teaches you to rest and then work to the best of your ability, whether it's doing the dishes or making a painting. You don't qualify the action. You just do it well. TM helps your memory, and consequently it helps with a lot of other things as well.

I went to see the Maharishi in Madison Square Garden. He was sitting there on a big pillow with a flower. Some kid in the audience got up and said, "I've been having headaches for three years and I can't stand it anymore. I'm getting headaches from too much meditating."

"I suggest that you see medical doctor right away," said the Maharishi. "But, contrary to what you are saying, I think if you had not been meditating, your headaches would be far worse."

You have to get a mantra, which you pay something like $125 for. The three-syllable thing is probably an evolution of that. I was supposed to get my three-syllable mantra from this woman who was in New York. But she was only in New York for a week, and I couldn't catch up with her, so I didn't get it. That might explain a lot of things.

A Greek Vase

THE DEATH OF A FRIEND

CHAMBERS STREET

AUTOBIOGRAPHY IN ART

THE END OF A GRUELING DECADE

STAR THIEF

Over the years, I kept sending things to my dissident friend, Eugene Rukhin. Sometime in May 1976 I had about six pairs of jeans I'd bought and was ready to send him when I got the news that he'd been killed—the information came to me on a little piece of paper tucked away in a magazine his wife sent me. It said, "Eugene is dead. I'm his widow and I'm allowed to leave the country. Will you store Eugene's paintings?" I took another little piece of paper, tucked it inside of a magazine, and wrote "Yes" on it.

I was in Florida when I heard about Eugene's death. He was only

political in the sense that he was expressing himself. He was an artist, but the government was afraid of him and his legend. No one seems to know very much about what happened.

A few months later, on the sidewalk outside my building on Chambers Street, there arrived three crates full of his work—his paintings smelled from the fire that killed him. I stored them for about nine years. Soon after I received them, Eugene's widow came to the States, bringing her two children and a dog. Right away, she moved from New York to West Texas because she was paranoid and thought the KGB was everywhere. She was a successful jewelry designer. She had a beautiful daughter named Masha, who became involved with "a perfect Texan redneck"; when the boyfriend jilted her, she killed herself.

Eugene died in a suspicious fire; people suspect he was killed by the KGB. He'd participated in the fall outdoor art shows in Moscow in 1974 and the later Leningrad shows, and came to be seen as a symbol in that he was uncompromising in his opposition to the artistic status quo in the Soviet Union.

People think the KGB gave him a shot of poison in the arm and then burned his building down. Several other people were killed in the fire, too—other so-called subversives who just happened to be in the same building at the time. He was thirty-two years old.

Around this time, I began work with Gemini G.E.L. on lithographs, experimenting with long rolls of Arches paper, cutting it, pulling it together to create three-dimensional areas. Back in New York in the winter of 1978, I found I'd become so accustomed to life in Florida that I'd begun to feel like the walking catfish of Aripeka. Freezing weather, and all I had to wear was a cowboy shirt over two Hawaiian shirts.

All in all, the 1970s were a disaster for me and forgettable for many other painters, too. When I asked Roy Lichtenstein about that decade, he said he couldn't remember it. The art world became obsessed with gadgets, installations, and videos. A sign of the times: on a gallery door, I saw a note that read, "Closed because we blew a fuse." The new mania for installations only awakened my nostalgia for painting.

By the end of the decade, things began to look up. In 1977 I finally got going again. I made a whole bunch of fifteen-foot-long

This was at Gemini G.E.L. in Los Angeles in 1977; I am working on the lithograph *Star Pointer* (1977).

paintings in my studio in Aripeka. I painted an entire show for Leo Castelli there: *Evolutionary Balance*, *Sheer Line*, *Terrarium*, *Industrial Cottage* among them. That's when I started to feel good, to feel different. The twelve paintings were all large, twelve to fifteen feet wide. I had painted my way out of my depression.

I was in love and my relationship with Susan was good. Many of the paintings from this period are bright and positive, but not all of them. I painted *Dog Descending a Staircase* there, which consisted of three really bleak images: a baby doll's face, a dog walking down stairs, and an industrial tin mill. The image of a man, a woman, and his job.

Most of my paintings have personal meaning for me, and I use the images intuitively to represent ideas, states of mind, feelings. To me, the bed in *Terrarium* is about love in a bottle. Critics claim they see menacing phallic objects, missilelike lipstick arrays, and threatening gears in my paintings of the 1970s and '80s. Some of the art I made in the 1970s was very different from what I painted in the '60s, but not because I'd become obsessed with sex, had developed a violent vindictive streak, or had become a raging misogynist.

What's going on in *Terrarium* is a lot more subtle and elusive.

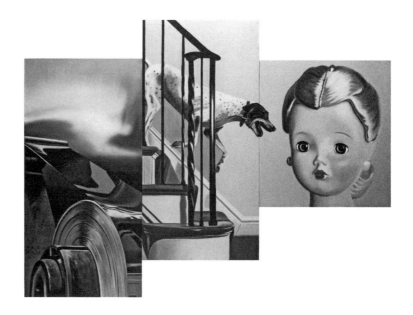

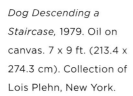

Dog Descending a Staircase, 1979. Oil on canvas. 7 x 9 ft. (213.4 x 274.3 cm). Collection of Lois Plehn, New York.

The bottles containing the tomato and the woman's face allude to an ancient Japanese paradox. Your favorite pet climbs into your antique vase and he starts growing in there without your noticing it. All of a sudden, you realize what's happened. What do you do? Break the vase and save your pet? Or . . . ? It's an unanswerable riddle. The face in a bottle is like your love in a jar . . . what do you do with it? The tomato probably represents the woman, and you have to smash the bottle to keep the tomato or just let the tomato rot. You take your favorite thing and you strangle it. The woman-in-the-bottle riddle. So, it's a pun, a visual koan with a twist. I used similar imagery in *The Glass Wishes* (1979), which has an Oriental eye in a broken glass. It's a wish something hadn't happened. You let your love go away, break, or become something else. I think of these images and try to put them together; they're enigmatic because there's a causal link missing that the viewer supplies. People want to know about them, what they mean exactly, and pick them apart, but I can't do that.

All I can say is that I painted the things that needed painting. The objects were chosen for specific reasons and perhaps have more personal resonances than some of my paintings from the 1960s. Whatever I'm feeling I need to express through images, symbols. Often I would flatten the images out until they were almost unidentifiable, as in *Paper Clip*. Sometimes I just didn't want

This is *Terrarium* outside in Aripeka, 1977. The face in the bottle alludes to an old Zen koan.

to say too clearly what was going on. There's a mystery to them, and what had happened was also a mystery to me. Enigmatic symbols kept the adrenaline up.

The title *Sheer Line* referred to the pen point and writing on the edge. It's not a pun. It's an idea. The sheer line was the top edge of a boat half-sunk in water. The mouth of the bottle was a big soda bottle that comes in from top to bottom. It was about a lot of things, echoes of shapes and the chameleon nature of color. When I was painting billboards, one day they'd ask me to paint a big orange, the next day they wanted me to paint a big Early Times whiskey bottle. I'd mix the color and realize the whiskey bottle was the same color as the orange. In *Sheer Line* I played with that idea in a blend from one area of paint to another. The idea of transforming things right in front of your eyes just by using color. The woman's skin blends into the color of the sun, the color of the water, and the ripples are echoed in the top of the soda bottle.

Industrial Cottage is a metaphor for people living next door to an industrial park, to industry. Going along Highway 19 in Florida, I saw a fence around a cemetery and a sign on the fence said MOBILE HOME FOR SALE. So, it's about the horrible zoning they have around U.S. 19 in Florida and Highway 9 in New Jersey, gasoline alley. In these places you see big American flags and horrible smog so thick people can hardly breathe. And nothing but little ugly houses next

Collage for *Sheer Line,* 1977. Magazine clippings and mixed media on paper. 15⅞ x 18⅝ in. (40.3 x 47.3 cm). Collection of the artist.

to gas stations and factories. The painting is about what it's like to live next door to a big industrial polluting area. In the upper right-hand corner there's a window in a shack, where someone's living; it's kind of a negative picture, with images on a clothesline. There's bacon on the clothesline, copper wire and a bucket, and something being torn down. If you live near a power station, the juice from the towers emits radiation that will burn out your bulbs. It's not good for your health. The painting now belongs to the Smithsonian American Art Museum.

People have said my imagery in the 1970s changed, became a little more sinister, harder—lipstick and the gears and so forth—and maybe it did, but you have to approach each painting individually. *Highway Trust,* for instance. Every painting starts with an idea, and the idea behind *Highway Trust* is that under President Eisenhower you had to pay taxes to build new highways whether you owned a car or not. It doesn't matter if you don't own a car or if you ride a bicycle or never leave your house: you still have to pay for these highways, and the highways end up in big cement parking lots all across our country. So in *Highway Trust* I painted a big swirl of pudding or cement going into a car.

The day of my opening at Castelli's I got bitten by a cat down in Aripeka and got a bad case of cat scratch fever. That night I went to my show and I was swelling up. I was wearing a Hawaiian shirt. "Excuse me," I said, "but I think I've got to go to St. Vincent's." Everybody came to my show and they all went out to dinner and celebrated my show while I went to St. Vincent's. The doctor told me to take off my clothes, put on a gown, and lie down. The emer-

gency room was chaotic: they were shouting "Code blue, code blue." The doctor said, "Okay, get out of bed, put your clothes back on, and go sit over there." Then someone said, "Four gunshot wounds coming in." Then they said "Code four" or something like that. "They got away." I had to take my clothes off and put them back on again. They brought in a little kid about two years old and very dirty. The cop who brought him in said, "Here. Take care of him." The nurse asked what she was supposed to do, and he said, "You know. Give him a bottle of milk and put him to bed." They finally gave me a couple of tetanus shots, and I went straight from there to my opening party.

The show at Castelli was a big success. Leo sold two or three of the paintings right away, and eventually sold them all. I got my mojo back in 1977. If the 1960s was a nonstop party, the 1970s for me was a long, terrible hangover. There were the early years of that decade when I felt I was just a worker, that I couldn't escape gravity. By the 1980s there was a chance of being a free soul again. Suddenly, I felt uplifted. It was like the past was behind me; my family was in place. They were getting the care and therapy they needed and finally getting well. I still looked after my parents. My mother and father were a tremendous help, but it was the work—the painting—that really saved me. I'd been swimming underwater for so long, I felt like I had come back from the dead.

In 1972 the Metropolitan Museum deacquisitioned works of art from their permanent collection, among them paintings by two great twentieth-century artists—Modigliani and Soutine—in order to buy the Calyx Krater, an ancient Greek vase by Euphronios, for a million dollars. I was stunned that the Met would do such a thing.

Only six signed vases by Euphronios survive, so he has fewer extant works than Vermeer. I have nothing against Euphronios, but I didn't see why two great twentieth-century artists had to go on the chopping block for his fifth-century vase. A final irony of the Calyx Krater was that the Italian government subsequently claimed that the vase had been looted from Cerveteri, a necropolis near Rome, and demanded its return. It was given back to the Italian government in 2008.

The ridiculousness of the idea of selling a Modigliani and a Soutine weighed on my mind, and while I was brooding about it, my

friend Ronnie Westerfield took some peyote and had a dream about Greek drawings on a garbage can. I thought, I know what I'm going to do, I'm going to make miniature Calyx Kraters as garbage cans and make them out of *solid gold.*

Then I ran into Sid Singer, who's in the diamond business. He said, "Jim, I'll pay you for ten cans. I bought gold at one hundred dollars an ounce." Gold hadn't been on the market for years. I bought $50,000 worth of sheet gold, cut up the sheets into the shape of cans, and then Don Saff, my old partner from Graphicstudio, etched the gold using aqua regia. We dipped the metal sheets into the acid, and it turned yellow, which was the gold. We lost maybe $800 worth of gold in the process. You could buy a machine to extract that gold, but the machine to do it cost a lot more.

We made etchings of Greek figures from the Krater. I made wooden shapes out of oak to mold the cans around. I made every single one myself, using eleven ounces of gold in each can. Eleven ounces of gold, $11,000. That's $1,000 an ounce just for the gold alone, never mind the art part. I put the striations in the metal so that they looked like actual garbage cans. Then I patined them so they would look like dirty old garbage cans, with a little gold chain attached to each. And then I had this bright idea of having real diamonds in the bottom of each garbage can. The thought was that a bum searching for a sandwich looks in the garbage can, sees the diamonds, and it's like the end of the rainbow for him.

Time goes by, prices change—enormously. The price of $1 million the Met paid for the Calyx Krater now doesn't seem so outrageous. But in 1979 you could buy a Picasso, a three-by-four-foot Picasso painting, for $105,000. Today, it's worth maybe $3 million.

What was Thomas Hoving, at that time the head of the Met, thinking, selling a Modigliani and a Soutine? Time changes everything—taste, money, value—in art especially. At that moment, people cared less for Modigliani and Soutine; now, they're *very* expensive.

After I'd finished the garbage cans, I made a few etchings of the Calyx Krater. One was called *The End of the Rainbow-Calyx-Krater.* I was teaching myself etching. Spit by spit and bite by bite, and I got pretty proficient at it.

Despite my dismal experience in trying to get artists' rights for the resale of paintings, I did another stint in Washington a few years later. In 1978 I got that call from Joan Mondale, wife of Fritz Mondale, Jimmy Carter's vice president, because she wanted me to serve on the National Council on the Arts, which advises the National Endowment for the Arts.

"I don't think I can do that," I said. "Because I have an open arrest record in Washington. In 1972 I got put into a dirty Washington jail in the evening and got out the next day."

"Oh, don't worry about it, Jim," she said. "The Democrats will absolve all of that."

The FBI came to my house and checked me out. They looked around to see if I had any porno magazines. "Only for artistic purposes," I said.

"Have you ever been a member of the Communist Party and do you respect the Constitution of the United States?" the FBI agent asked me.

"I do not want to answer that on the grounds that it may incriminate me," I told him.

My accountant was present. He said, "Jimmy, you know you were never a Communist."

The guy leaves and goes on to Tampa to question this other artist, Rick Trawick, a friend of mine.

"Do you think James Rosenquist is a patriotic citizen and upholds the Constitution of the United States?" he asked Rick in that robotic way federal agents talk.

"Man, that is right out of a *Superman* comic book," Rick said.

It took me about six months to get my FBI card, which allowed me to go into the White House. That led to my being there at Jimmy Carter's inauguration. Jimmy Carter walked out of nowhere and kept on coming, walking toward the White House until he became president. On a cold winter day my son, John, and I, shivering, watched him carry his own suitcases up to the White House. The plainspoken peanut farmer from Plains, Georgia.

I served five years out of six on the National Council on the Arts; then Ronald Reagan came in, and although he was an artist himself, he started cutting money for the arts from $155 million down to $97 million. The city of Berlin alone allocates $900 million a year

Sculptor Mark di Suvero is talking to Joan Mondale in my Chambers Street studio in 1978.

just for its arts budget. Why did Reagan slash the arts budget? Because he had the idea that the private sector should support the arts. But you need government funding to fund outlandish ideas. The private sector plus corporations like Mobil Oil are very nice—and very conservative. Ronald Reagan's whole history was just so readable. He felt he'd been cheated in the movies, and joined the Screen Actors Guild to fight that. Then he began working for these big corporations like GE and became a conservative, the governor of California—I even worked against him and supported the opposition, Edmund Brown. When Reagan came in he was in a cutting mood, but then he ended up putting us trillions of dollars in debt for war weapons. I feel like I've seen that time and time again. Our government couldn't give a damn about art, about history or the past. But a nation isn't recognized for its wars, it's recognized for its art and its architecture—its culture.

On the National Council we had a left-wing chairman in Livingston Biddle; he'd been an ambulance driver in the Spanish Civil War for the Republican side, the antifascists. He was terrific. But at the time in Washington, you could count the government people who were helping the arts without taking your shoes off: Claiborne Pell, John Brademas, Jacob Javits, Livingston Biddle, Ed Koch, and Sid Yates were our very few defenders of the arts in Washington.

I was surprised at what was involved in being on one of these government committees. I didn't really know the protocol, the prescribed topics of conversation. I had my finger on the button, in case I was asked, but I barely ever was. Then, when I didn't have a clue, they would say, "James, could you clear this up for us?"

I've had senators and congressmen ask me, "What good is an artist, anyway?" I couldn't believe it. In my speeches I would answer that with, "An artist provides an abstract mental garden for people to live, think, work, and exist in." I said something like, "Why don't they spend the money on fertilizer and see if something grows?"

I was there listening and learning, the only artist on the panel. There were a couple of actors and people from other disciplines. I'd go there three days at a time, four or five times a year, which was a lot. It took up a great deal of time, and I can tell you it doesn't help your career.

One of the problems is that in our country, we lack an audience. If you're going to have art, you have to have an audience for it. One day Livingston Biddle said, "James, there are six of our great states that aren't asking for any art help at all. Should we go out and give them something anyway?" Nevada, Utah, states out that way. This was in 1978; it's probably changed considerably since then, but that was quite a sobering thought—they hadn't even asked!

The government is very shortsighted in its approach to cultural exchange programs. When Rauschenberg, for instance, wanted to go to Cuba, the government did everything in its power to stop him. He went there anyway and sponsored the whole thing himself. The government got pissed off galore—but that's rigid bureaucratic thinking for you.

In the last year I was on the committee, I didn't go to the meetings very much because I found it futile. I also learned that most of the politicians were just rubber-stamping the stuff. They didn't read anything. We'd be sent a pile of books for the meetings; I'd go out on the boat and read, but I'm not sure how many others ever looked at these documents.

Some quirky questions arose now and again. For instance, we'd be asked, "Are we going to fund a movie on tattooing?" And this old boy gets up and says, "I ain't funding anything about marking the human body." But then it turned out that those tattooing movies were about Eskimos and people from the South Pacific, so they ended up funding it. When anything to do with sex came up, they'd say, "Give that to Geraldine Stutz." She said, "I'm not touching it; we're not going to get involved in that junk. Give it to

the animal husbandry or the Museum of Natural History people." She was at I. Miller Shoes in the 1950s and gave Warhol his start before becoming head of Henri Bendel.

The big problem was tributary funding. You give a grant to one institution and then that institution would fund something else that we'd never signed on for—but in the end the NEA would get the blame for it. We might give money to a university, for instance, and then that university would give it to the photographer Robert Mapplethorpe, who would go out and do a show of absolutely hair-raising pornographic images—and then the NEA would get slammed for funding Mapplethorpe.

Whenever I met with Joan and Walter Mondale, the Secret Service guys were crawling all over us, watching us eat lunch or walk to our cars. The Mondales' assistants would come and interrupt constantly. "Uh, excuse me, but please will you sign this." They worked all the time. Joan would say to me, "I'm so busy and I'm so scared I'm going to forget things." So I said to her, "Why don't you try transcendental meditation? Then you can mentally retain stuff." When I ran into her later on, she said, "Thank you, that was amazingly helpful. I'm a lot better now."

Van Cliburn, the classical pianist, was on the committee. His history was that he was browbeaten into practicing every minute of the day as a kid. Fifteen hours a day. It's a wonder he still enjoyed playing the piano at all. A discussion came up about an artist who wanted to do sounds in Times Square, sounds emanating through the subway grates. But his project was unrecordable. So Van Cliburn said, "Why are we funding this thing if you can't even keep it for future generations? It's just ephemeral sounds going into the air." I agreed with him on that one.

Public funding of the arts can be misguided and misplaced. You can't shove art down people's throats. Robert Moses and Alfred Barr put up an Alexander Calder sculpture in Harlem. It wasn't popular and eventually the people there said, "Get that out of here." So it's often a question of how you can sell a piece of art that's unfamiliar. You can't just plonk it down and expect people to get it. You have to educate people about art; otherwise they won't want it sitting in their front yard anymore. You can't just set up a piece of sculpture in a park and hope for the best.

You also can never tell where your painting is going to end up.

Years ago, I saw a large painting by Frank Stella at an auction. It had been bought by a bank in England where it was hung in back of the tellers and it looked beautiful. It was an exciting painting, one of his fluorescent pictures, and the bank used it as cheery decoration. Eventually, it was sold at a much higher price than the bank had originally paid for it.

In a similar vein, Calder had a big mobile at an airport in Dallas, Texas. It was something like sixty feet long. Believe it or not, the airport thought they had a pink elephant on their hands. They didn't know what to do with it and sold it. I think Norman Braman bought it for a song.

A more thorny problem is the fate of an artist's works after his death. Dan Flavin had a lot of pieces that were made strictly for exhibition, and he said he wanted them destroyed after the shows were over. Flavin died in 1996, and after his death the family wanted to have those pieces, because that's all they had, pieces that were all beaten up and battered. But in a certain sense, it makes them look better, because their history is now part of the sculpture.

Ideas for paintings often turn up from sources that initially seem to have nothing to do with the final work. *Isotope*, for instance. The idea came to me in 1979 in a curious way. I was artist in residence for a month in Madison, Wisconsin, close to where all those rock-and-roll singers crashed into Clear Lake, Iowa, in 1959: Buddy Holly, Ritchie Valens, and the Big Bopper. And while I was there, I remembered I'd taken a Northwest Airlines flight to New York that same night, February 3, 1959. In 1967 Otis Redding's plane crashed close to Madison, into Lake Monona. In 1990 another great guitarist, Stevie Ray Vaughn, died in a helicopter crash in Lake Geneva, barely two hundred miles away from where Buddy Holly and Otis Redding crashed.

I began to think about fate and safety and how impossible it is to guarantee anything in life—to protect yourself from the unexpected. You cannot protect yourself from every eventuality; even if you were able to, you would end up imprisoning yourself. *Isotope* is a metaphor for the house as fortress, living in a pressurized environment. The big peach represents the thing you want to protect—your wife, your children—and in order to keep it from harm, you've imprisoned it in this mechanical place that is meant to keep

it safe but which has become instead a sort of prison. The panel on the right had this strange air coming through a vent—the same air that came from the room. You may think you have protected yourself from contaminants by using an air purifier, and you may think you are safe from any outside harm, but none of this is going to make you safe from radioactivity or anything lethal of that nature.

Sometimes the memory of an old friend who died young evokes a constellation of images. That was the case with Gordon Matta-Clark. The fates of painters are difficult enough—lack of money, lack of recognition, ill health, self-destruction—but perhaps the cruelest fate are those problems that arise out of the work itself. This was the case with Gordon, an artist who used to cut buildings apart. He would slice through the corner of an old building and then take a photograph of it. Unfortunately, it brought out all the contaminants from the walls, and he was poisoned by the dust and insulation that were released when he was working on his projects. He died tragically young, at thirty-five, of pancreatic cancer. I painted *Vanity Unfair for Gordon Matta-Clark* in his honor in 1978, the year he died. The image at the bottom of the painting is his mailbox—35 being his mailbox number—with the mail never collected. The blueprint of a building, a fork, a pair of scissors for his life being cut short.

Sometimes the imagery is based on something simple that could almost be a saying or a line in a popular song, like *The Facet*, which I also painted in 1978. It's a woman holding her husband's hand. What's supposed to be the ruby on her engagement ring is actually a life-size car top with Day-Glo windows. The promise of her wedding is a lot of dirty dishes. She gets this ruby and a lot of dirty dishes. The painting isn't an illustration of that idea; it's more that the idea gives rise to a collage of images—a kind of rebus of emotion.

Ultra Tech, which I painted in 1981, is a strange picture both for its imagery and for its construction. Sometimes you see an image and it appeals to you for reasons you can't exactly explain—for its strangeness or simply its form as an abstraction. I was looking through a Hanes stocking catalog and came across a photograph of a pair of legs in nylons. The *look* of that pair of legs fascinated me for many reasons; the simple *look* of something, not what it actually

is. The legs allude to some form of traveling, and they're on top of a nut that reminded one of a motorboat propeller. I was also attracted by the ultraviolet color of the telephone, hence the title. The purple and green are almost the same value of tone—they're complementary colors so they vibrate. The idea of high-tech travel with those silk stockings appealed to me.

It's actually two canvases. I was juxtaposing them in order to manipulate the picture plane, playing with the way these canvases fit together in the composition. There is an empty section at the top left where the white wall of the gallery would show through, and then there's the white behind the image of a bearing shaft with a squeeze nut on it. So the white wall and the painted panel, which looks like a white wall, create an illusion about things in space and things on the canvas. This off-kilter design and the interplay of the whites gave the painting an oscillating dynamic. The squeeze nut reminded me of the bottom of an outboard motor. It took on a futuristic look. There's a sort of deliberate anomaly to the imagery and the way the picture is constructed—things put together in the painting, hopefully, that will spark something in the viewer.

Naturally, things that are weighing on your mind are going to leak out. With *Untitled (Between Mind and Pointer)*, on one level it's about accuracy as in *Zen in the Art of Archery* or in Marine Corps practice. When you're centered, you just shoot and hit the bull's-eye because it's in your mind. But it also has a personal meaning for me. I painted it in 1980, nine years after the accident in which my son, John, was so badly injured. To an extent it's about his hand

Untitled (Between Mind and Pointer), 1980. Oil on canvas. 6 ft. 6 in. x 5 ft. 6 in. (198.1 x 167.6 cm). The Museum of Modern Art, New York, Gift of Philip Johnson.

being crippled. It's also about the transmission from his mind to the pronator muscle. There's a T-shirt with no arm in the sleeve, a phantom limb.

Late in 1978, while I was away in New York, Susan Hall, my companion of five years, left. She wrote me a note that read, "When you get back from New York, I'm not going to be here." For a long time after that, I seemed unable to form any lasting attachments.

When I was in New York, I threw a lot of parties on Chambers Street with live music. If a show sold, I'd have a big party afterward; if it didn't, I'd still throw a party. I met many young women during my ten years as a single man: writers, gynecologists, cinematographers, and artists. The one thing that bothered me about them was their high-pitched voices, voices that went right through me like ice picks. For some reason I found this very unsettling and went in search of a woman with a low, mellow voice.

Sometime in late 1979, Bob Adelman, a photographer I'd known since the early 1960s, called me up. He'd taken many pictures of Leo Castelli and me when Leo was a dark-haired, dashing young guy and I had a little more hair myself. Anyway, Adelman said,

"Jim, I have a friend at CBS, Chad Northshield; he's the executive producer of *CBS Sunday Morning*, and he wants to do a program about an artist working on a major painting. And, at the same time, *Life* magazine wants me to do an eight-page color spread of the artist painting. Would you be interested?"

Yes, I was interested. I started thinking about what in the world I would do. I knew I needed to knock 'em dead, so I decided to do a seventeen-by-forty-six-foot painting, a painting as big as the largest wall in my studio on the ground floor of Chambers Street. I planned to paint it there and show it there, have the opening in my studio.

My initial ideas for the painting were vague and formal—they had nothing to do with imagery. I knew I wanted something angular across the center of the painting and something that looked like a waterfall coming down from the top. I also wanted a circular figure in the lower right-hand corner, but that was about the extent of my original composition. I paint anonymous things in the hope that their particular meanings will disappear. I treat the image the way it appears, as a reproduction. I try to get as far away from nature as possible.

Like *F-111*, *Star Thief* is assembled from smaller panels. I set my carpenters to work building stretchers for a forty-six-foot painting—*Star Thief* was maybe to be the first of a series. After I had the canvases together, I began working on my sketches and thinking, trying to put all the elements together. I worked on ideas down in Florida and up in New York.

I thought of a metaphor for work, for exploring, for discovering. It occurred to me that you cannot get into space, or even into your own mind, without a lot of work. It's much the same as my being unable to do a painting without a lot of initial planning. Doing the work allows you to challenge your own ability to envision the next step. It allows you to see further. Without the preliminary work, the sketches and planning, without metaphorically building a telescope, I'd never be able to get to the finished painting. The preliminary work allows me to see beyond the point where I started out.

I began to think of an astronaut, or the person who sees something bright in the sky and wants to go there, to a point of light; someone who gets senators and congressmen to help him build a rocket ship. What thought, I wondered, seduces a person into leav-

ing Earth? That's why the picture is called *Star Thief*. After he gets going out into space, he begins to see this *new*, more interesting point of light farther away. A twinkling object in the sky that beckons him. But then when he gets out there, he wants to detour to yet another star that now looks even more interesting than the one he's reached. The first star is the thief that seduces you into setting out; then you forget that first goal and take off for the second; and so on and so on, getting deeper and deeper into space, into thinking. *Star Thief* is a cosmic allegory, a metaphor of work. The star is a thief, the thief that induces curiosity, pulling people to go to a distant thought.

I used intergalactic imagery because I had followed the space program since it started. The succession of events went something like this: first they put fruit flies in space and kept them alive; then they put monkeys in space and kept them alive; finally they put human beings in space and kept them alive. They could keep them alive, but they might not be able to keep them sane. I was interested in the psychological aspect of space travel. The painting is also about the idea of astronauts trying to keep their sanity by bringing things from Earth with them into space, little mementos of home.

I once met George Goodstadt, the artist who was designing the patches for the space program, at a studio in New York. I asked him what he was doing, and he said, "Well, all of the astronauts are former military people. The government was going to send anonymous men and women in white suits into space with no flags, no names, nothing on their suits, just free people up in free space, but none of the astronauts would put up with this. They all wanted patches, flags, and name tags. They all wanted to have a mission. My job is to design the political patches." I wanted to explore that issue in *Star Thief*, how Earth's problems were being taken out into space: pettiness, bureaucracy, nationalism, and eventually war and conflict.

A painting depicting outer space and space travel I knew was going to involve technology, but one has to be discriminating in the use of it. I've studied the visuals of technology and found them pretty dull. I've looked at diagrams of electricity, at computer diagrams of the lungs of a fish. The idea of technology is fantastic, but unfortunately the look of it can be boring.

What I am interested in is the interaction between humans and

These photographs by Bob Adelman appeared in eight pages of *Life* magazine in February 1981. Adelman documented the five weeks in 1980 it took to paint *Star Thief*, which was 17 x 46 ft.

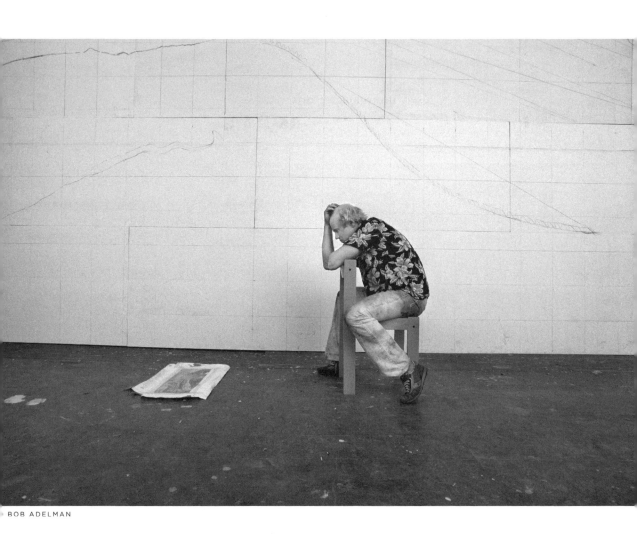

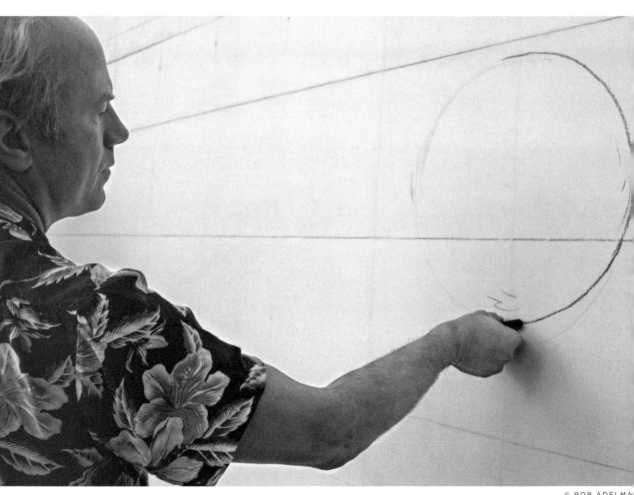

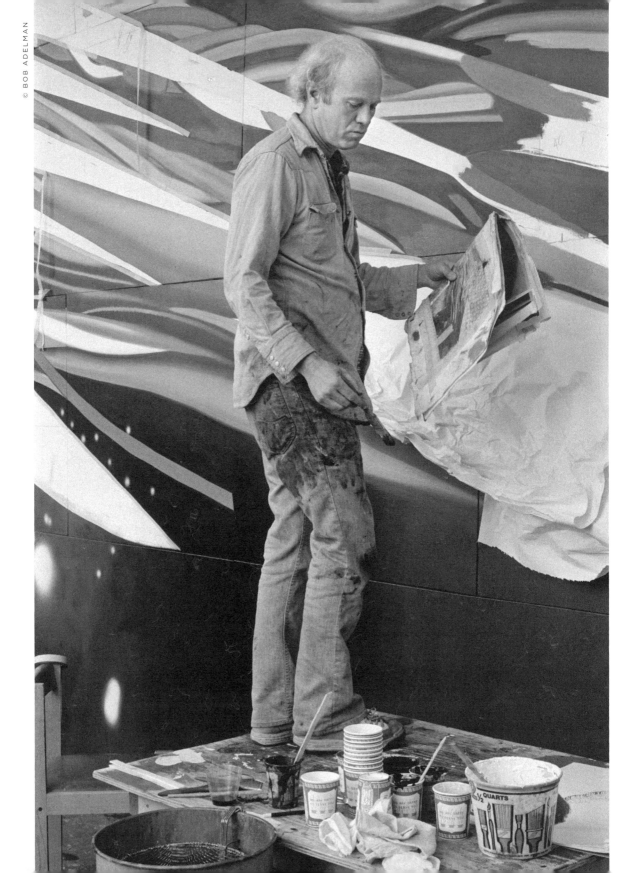

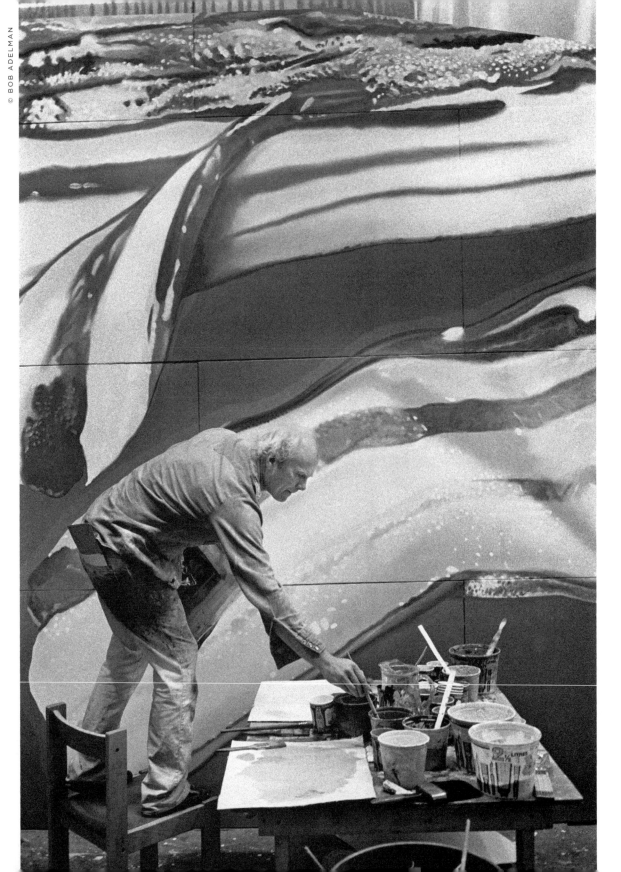

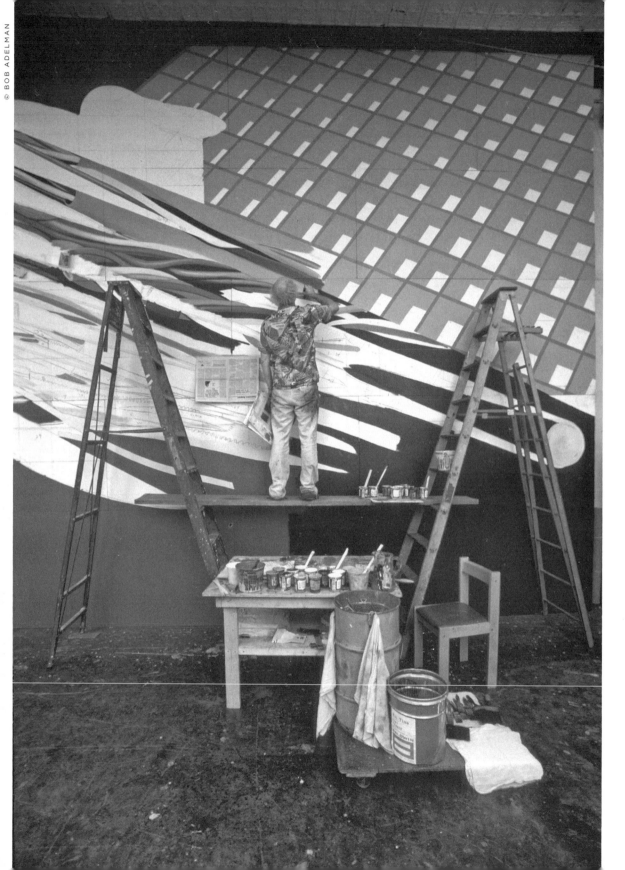

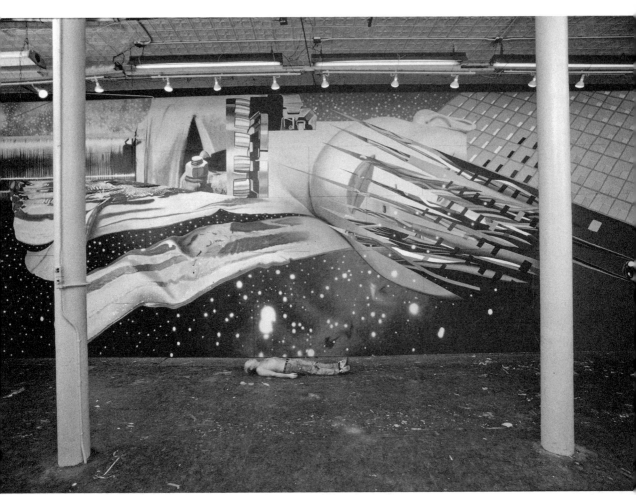

machines, the effect of technology on people. For instance, what will the future be like for young people? Will they live in a high-tech apartment or in a meadow like a little lamb?

The compelling reason I paint has something to do with making an idea visible, showing myself that I have an idea and am realizing it instead of just sitting around talking about it. I began writing down my thoughts, creating maquettes. My reason for making the painting so gigantic was to create a grand gesture, to make a painting so large that no one could possibly walk by it because it was just too big, too awkward.

I thought of a fractured head. A heavy, heavy head sleeping and thinking, lying there on a pillow. In *Star Thief* I began using a new technique to expand the depth of the picture plane. This was the first time I used a woman's face cut up and shredded into strips in a painting, a device I would expand on in paintings like *The Persistence of Electrical Nymphs in Space* and *Animal Screams*. I fill in the cross-hatched area with an image. That way I get two images for one.

And then I saw a photograph of a pillow block, which I thought was funny as hell, because a pillow block is a device meant to hold an extremely heavy weight. It's a technical term. I thought, Why don't I put this fractured sleeping head on a pillow block, which itself is resting on a nuclear cloud. The painting has a big shaft in it, representing the technology involved in space travel or any kind of travel, for that matter, and then there's the bacon—which caused me all kinds of problems. Why bacon? Everybody asks me that. Bacon is meat, and this piece of meat represents animal—not necessarily a human being, but an animal, because we're all animals. Some animals have better brains than others, different kinds of brains; but we are all united by our mammalian structure, by our carbon-based nature. That was the meat of the matter. Those better brains were the path to space.

The process of painting *Star Thief* was simultaneously being photographed by Bob Adelman and filmed by this gorgeous woman, Cynthia Lund, who worked as a camerawoman for CBS. It was chaos in the studio. The crews were arguing and running around as I painted, there were lights all over the place. We had a regular party in there. It was aired on *CBS Sunday Morning* with Charles Kuralt.

With my parents, Ruth and Louis, in front of *Star Thief* (1980), still in progress.

In the end I didn't actually have the opening at my studio. It took place at Castelli's new Greene Street Gallery, with CBS filming the process of taking the painting over to the gallery, the opening, the whole thing. I had a couple of other pictures in the show, but *Star Thief* was the center of attention.

Four guys came in from Dade County, Florida, and said they wanted to buy the painting. "It's been selected by the Metro-Dade County Art in Public Places Committee for installation in Terminal Two of the Miami International Airport," they said.

"Well, that's just great," Leo and I said.

"How much is it?" they asked.

Well, we didn't know exactly. They said, "We'll make you an offer." A little while later they wrote a letter offering $285,000 for the painting.

At this point, things began to happen that hadn't happened before. I had already started the second painting in the series, and it would have been great to sell the first one. Leo's lawyer, Jerry Ordover, wrote to Dade County that we were thinking about accepting their offer, but would they send us a formal proposal? Well, we already had a formal proposal. So, because he wrote that unnecessary letter, they were able to turn the painting down.

At some point during this period, Jan van der Marck went to see Frank Borman, then the CEO of Eastern Airlines, with the other people from Dade County. They showed him a photograph of *Star Thief*, but it was shot at an angle with the bacon all to the near side. Borman threw everyone out of his office because he was so angry about what was happening with his airline and everything else, saying that as a former astronaut he had been around the moon ten times, and "space doesn't look like that. I've been in space, and I can assure you there's no bacon in space. I've never seen enormous strips of bacon in outer space."

When it came to an explanation to the press, Borman put out a reasonable-sounding PR response, saying, "I am told the painting in question represents the artist's interpretation of space flight. Although I am admittedly unschooled in modern art, I have had some exposure to space flight, and I can tell you without equivoca-

tion there is not, in my mind, any correlation, spiritual or material, between the artist's depiction and the real thing."

But according to Roberta Griffin, chairman of the thirty-member Citizen Arts Commission, which advises Metro on which artworks to buy for public buildings, Borman was anything but reasonable. "It was impossible to talk to the man," she said. "He was quite angry. He was anti-art. 'Neither Eastern Airlines nor their employees are paying for this painting!'"

Borman presented his case very deceptively, as if he were protecting the already embattled Eastern Airlines workers who had endured two pay cuts with the implication that the money for the painting was coming out of their wages, when he knew this wasn't the case. The money wasn't coming out of their pockets, or out of the taxpayers' pockets either. Taxpayers' dollars don't pay for art or anything else at Miami International Airport. Airport funding comes from revenue bonds. Indirectly, these are paid for in terms of airport rental fees based on passenger head counts per airline. In other words, the more passengers an airline carries, the more rent it pays the Port Authority (and the more money it makes). From a tax standpoint, airlines at Miami International have the only free ride in the world. They pay no taxes—city, county, or state—which made the whole fiasco even more ridiculous.

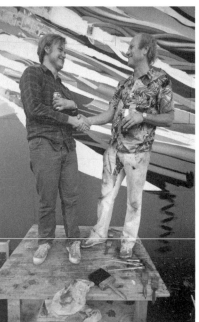

With my son, John, in front of *Star Thief* at Chambers Street, 1980.

© BOB ADELMAN

Well, my answer to Borman about the flying bacon was that I doubted he had ever gotten off the launch pad, because if you see a murder, you testify that you've seen a murder, not a photograph of a murder. He had never seen *Star Thief*, only a photograph of it. Maybe it was because he was in such a tumult; his company was going belly-up. Maybe he was out of his mind because of that.

By the way, the bacon isn't animal fat in space, it's a metaphor. It's about being a living creature, a pig, a human being, a fruit fly, a monkey, or any animal that goes into space. The difference between human beings and other creatures is that you have to keep humans from going crazy, letting them take golf clubs and teddy bears and all kinds of crap with them to remind them of their parallel existence on Earth.

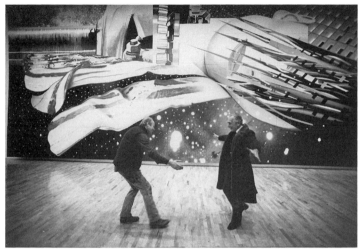

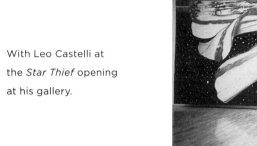
With Leo Castelli at the *Star Thief* opening at his gallery.

The bacon symbolizes flesh as meat that we eat, as well as the tender fiber of which we are all made. It spoils, it's vulnerable, and it stands for the transient and the unpredictable. Since eating bacon for breakfast is now frowned upon and may well go the way of all flesh along with the rest of American eating habits in the brave new world of the future (space travelers eat reconstituted food), bacon is now sufficiently endangered, and its portrayal properly nostalgic, that it begins to be a subject fit for art. Bacon is out of style. It's therefore ripe for use as a generic image.

I didn't consciously intend it, but the bacon looks like strung-out banners or like the stripes of the American flag, with the stars trailing behind in the background. It's not necessarily a reference to the American flag, either, except in the sense that the image of the flag is imprinted on every American's mind—which is why Jasper Johns chose it as an iconic image.

"It is obvious that the colonel does not believe in art," wrote the art critic Jan van der Marck, "that he likes to see representations of things as they are. . . . But the very function of art is to surprise you."

Artistic surprises clearly were not for Borman. Eastern public relations man James Ashlock explained that No Frills Frank, as Borman was called, liked to see things two-cents plain. "It was not so much what it did look like as what it didn't look like. Borman is basically a fundamentalist, and that makes him a realist. When he looks at the moon, he wants to see the moon."

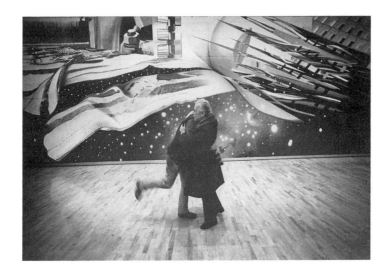

"Borman's objection to the program as a whole carried no weight," said Leslie Ahlander, Dade's Art in Public Places coordinator. "We don't feel that a person, however important, has the right to dictate whether we spend money on art in public places or whether we hang it elsewhere." But after about a year, Merrett Stierheim, who was the county commissioner, called up and said, "We can't pursue this matter any further. We're reorganizing our selection committee. We have other things to select, but no one can agree on anything. The *Star Thief* case is dead right now." The following day Burton Kanter, a collector from Chicago, called up. I don't think he knew about any of this, but he asked me if the painting was for sale. I said, "Yes, first come, first served," and sold it to him the next day. Now it's in the Ludwig Museum in Cologne.

In the end, despite all the ruckus about *Star Thief* and Borman and the bacon, it was probably just as well that it didn't end up where they wanted to put it. They'd originally planned to hang it at the Miami Airport near the Eastern Airlines terminal, which was used, among other things, as a holding area for international travelers. In other words, it would have been a fleeting decoration that distracted passengers would glance at as they were passing through. I'm not sure that would have been the best place for my painting. But at the time all this was going on I didn't know that—it was a straight-out sale, not a commission. The painting might have been seen by a tremendous number of people, but, on the other hand,

when you consider the situation at Kennedy Airport, the prospect isn't all that appealing. In the International Building the artworks are behind Plexiglas and they look horrible.

I have many newspaper articles and poems about the bacon brouhaha, and a beautiful piece written by Jan van der Marck in support of the painting ("displays depth and inspiration and is a very fine painting by one of the greatest artists of our time"). Day in and day out, there were letters to the editor—I have a huge stack of this nutty stuff with all those crazy headlines: FRANK BORMAN WON'T HAVE TO BRING HOME THE BACON AFTER ALL. BORMAN SPACE OUT AT AIRPORT! FLYING BACON! OF COURSE IT'S ART, AND THE BACON REALLY FLIES!

People are often amazed at what I go through to get a painting done. It's fun to be up a ladder creating new worlds on a sixteenth-of-an-inch surface. Visually, I like the idea of putting something on the canvas and then I can go back and question it and make it better, but if I didn't attempt the first phase I'd never get to the finished painting. I like to get images up as quickly as possible and then play with them. That's when something happens.

Four New Clear Women

In 1980 Leo opened a new gallery at 1020 Madison Avenue at Seventy-eighth Street with Jim Corcoran and Richard Feigen. It was called the Castelli, Feigen, Corcoran Gallery. Initially it was devoted to the work of Joseph Cornell. A beautiful little gallery, gorgeous architecturally. It was somewhat like Leo's old Seventy-seventh Street space. The three of them came to see me one day.

"Jim, how would you like to be the only living artist to have an exhibition in this gallery?"

"Absolutely," I said.

I had known Joseph Cornell fairly well, we had been friends, so I was sure he wouldn't have minded—he'd died in 1972, five days

Bob Rauschenberg and I are with the dealer Richard Feigen at the Castelli, Feigen, Corcoran Gallery, which Leo opened with him and Jim Corcoran. I showed *House of Fire* there.

after his sixty-ninth birthday. I had known Richard since the early 1960s. In 1963 I won a prize for a painting, *A Lot to Like*, at the Art Institute of Chicago. I had met Richard even before this, but I especially remember that night in 1963 because we got very drunk and Richard said, "If you want, you can stay with me." I remember asking myself, Who is this guy? Is he gay? Well, I don't know, but I don't think so. So we go back to his gallery and go upstairs, and there was this bedroom with two big beds. Richard drank four Alka-Seltzers and went to sleep—we'd both had a lot to drink. When he woke up in the morning, he went down to the gallery with an ice bag on his head and sold a Jean Arp sculpture for $40,000.

Not bad, I thought. I liked Richard. He is very forthright, not snobbish—and bright. He has a master's degree from Harvard Business School, so he's a smart fellow, but also a very generous person. He's also on the right side of social issues, and he's avant-garde in his way.

My show at the Castelli, Feigen, Corcoran Gallery was inspired by the state of the United States at the time of its bicentennial. The paintings for this show were all about American society. *House of Fire* was one of the paintings I showed there. It's meant to be a pun on America and its inversion of values. Coming through the window is a big bucket of molten steel, and next to it is a brown paper bag of groceries upside down, about to fall out onto the economy.

The bucket coming through the venetian blind, the house window, and the lipstick were supposed to suggest that America once

led in coal, steel, and rail, but that's all gone; now we're importing everything, including foreign oil. We used to be a house of fire; we were the world leader in manufacturing, in oil, steel, and rails. Now our economy has converted to software. The steel, now provides jackets for lipstick and the oil is the lipstick. The grocery-store bag tipped upside down is the economy going to hell.

While the painting was hanging in the gallery, Richard called up Bill Lieberman, chairman of the Metropolitan Museum's Department of Twentieth-Century Art, got him over to see it, and sold it to the Met for $135,000. Leo's influence was probably involved in that deal, too, but I don't really know. It was the first of my works acquired by the Met. In the 1990s they bought two doll paintings, and *Flowers, Fish and Females for the Four Seasons*. You never know about things like that. The museum world is very secretive. The reason they are so clandestine about this stuff is that they are trying to get things at a low price.

At a subsequent show I had at Castelli, Feigen, Corcoran in November 1982, I developed some of the themes I had begun to deal with in *House of Fire:* the contrast of organic elements with industrial objects. In 1982, in *While the Earth Revolves at Night*, I used the image of groceries falling out of a bag again; this time they are in free fall. In the center of the painting is a huge finger with a lacquered nail doubling as a pen nib, suspended at a window behind a venetian blind. The fingernail shaped into a pen point was dedicated to women authors who write and read at night while star movement and nighttime and machinery rolls on. It's about the quiet at night when people write. Her pen is inscribing star trails. I showed two other large horizontal paintings—*Reflector*, which featured foil-covered ham resting on a ball bearing, while in a separate compartment to the right I painted a tree trunk turning into a drainpipe; and *Deflector*, where the ham has turned into a mysterious shape wrapped in transparent pink plastic. I also showed some drawings done on frosted Mylar.

I even got a good review in *The New York Times*. "They may look like the posterish Rosenquists of yore, with their collagelike juxtaposition[s]," Vivien Raynor wrote, "alternately playful and calculated. But, in fact, the artist is far more ferocious and willful than before. . . . No one can accuse Mr. Rosenquist—always the most violent and least penetrable of the Pop artists—of mellowing."

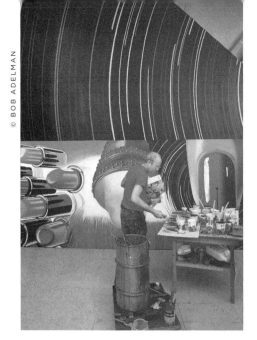

I am working on *Fahrenheit 1982* (1982) and *Four New Clear Women* is behind—these were the last paintings I did at Chambers Street.

That made me feel happy; someone in the art establishment was finally getting me again.

In March 1983, construction was completed on a large, naturally lit airplane-hangar-like studio on my property in Aripeka, Florida. It's 125 feet long by 50 feet wide by 26 feet high. I wanted a big, enclosed space with plenty of room on top. A family of builders put up this studio in about three weeks. It incorporated steel girders and corrugated metal walls approaching industrial scale. I also adapted the machinery of a hydraulic lift so I could work at various heights on large-scale canvases. It has huge overhead doors on three sides, and thirty-eight fiberglass skylights that provide a quality of light not much different from that outside. In the center of the studio is an air-conditioned, twelve-by-twenty-foot enclosure of wood frame and plastic sheet. Now I could create really big paintings, do huge commissions.

Men control the world and they have made a terrible mess of things because of their testosterone-driven aggression. I wondered what would happen if women ruled the world. *Four New Clear Women* is a kind of feminist work with a pessimistic subtext. I was struck by the social and political gains of women, and I began to wonder, if women are so wonderful—and they are—and if they're going to control our destiny, would they actually push the button?

Four New Clear Women depicts four ladies either smiling exhilaratedly or blowing up the world. At that time there happened to be a number of women who were heads of governments: Margaret Thatcher and Indira Gandhi, for instance. The painting was about these women rulers, and the question was whether they were also nuclear women. Were they going to be as aggressive as men in those positions or have a more humane vision of the world?

Now, I don't know if this is grossly insensitive of me or not, but another thought that went into *Four New Clear Women* was the paradox of women's power. Because of their biological destiny, women outlive men, so women end up with all the riches—older women inevitably control the destiny of the stock market, because their

husbands die, and in that sense women control the economy and run the country.

I painted *Four New Clear Women* in 1982 and 1983 at the Chambers Street studio. It's a big painting, the same size as *Star Thief.* Works like these were among the first paintings in which I layered interpenetrating images of shredded women's faces over a background of cogs and star trails, the mechanical and the eternal—and us.

I also used the shardlike images in the lithograph *Ice Points,* overlaying the image of a woman's face cut into strips against a starry white background. It was published in 1983 by Lazo Vujić in the portfolio *Art and Sport* to commemorate the upcoming Winter Olympics in Sarajevo, Yugoslavia. Shortly after I'd created *Ice Points,* terrorists blew up the stadium. Then they built it all back up again. I thought, Why do people blow stuff up, only to have to build it all up again? This concept led to another set of artworks, among them *Masquerade of the Military Industrial Complex Looking Down on the Insect World.* Often an idea lodges in your mind but doesn't materialize until years later.

Liv Ullmann, the actress, came to see my show at Castelli. She asked me to explain to her what *Four New Clear Women* was about. I said it was about Margaret Thatcher and Indira Gandhi and other women leaders controlling the economy and the fate of the world who were either clear about nuclear threat or were going to blow us up. She then said, "Oh yah, yah, I see. And what are you going to do next?" I thought I'd really get her with the title of the painting I was working on, so I said, "I'm going to do *The Persistence of Electrical Nymphs in Space.*"

"And what is that about?" she asked.

"It's the sound of all the souls after the earth blows up."

"Oh yah, yah," Liv said blithely, as if she took the end of the world for granted—probably from all those years of living with Ingmar Bergman.

In 1988 I made another painting using a similar theme, *Electrons Dance in Space,* which is an overlay of slivered faces on leaf and frondlike shapes on a cosmic background of stars and galaxies. Ulrik Swedrup, the Swedish businessman who commissioned it, used to interview executives with this painting in the background. I never

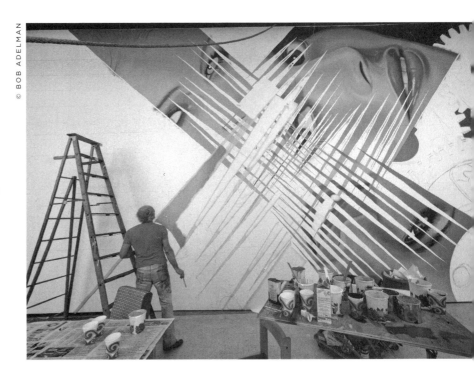

Four New Clear Women in progress at Chambers Street, 1982–83.

asked him how the concept of the electricity emanating from the souls of people floating through space affected the interviewees— perhaps, even for Swedish businessmen, such metaphysical conjectures are everyday notions in the land of the midnight sun.

I've always liked solving problems using visual means. Commissioned paintings inject a further element: the client's own ideas about the painting. So the problem becomes: how do I resolve what they want with what I feel like painting. Generally I paint whatever comes into my mind and hope someone will want to buy it. With a commission, the client chooses you because they like your art, but they also have their own ideas about how the painting should look—and that's when it gets tricky.

Over the years I've developed a number of strategies for working with clients. There are certain parameters and compromises inherent in the exchange, but one thing you can never do is make your painting into a decorative element. If you go down that path, you end up with a bad painting. The first thing I decided when I had undertaken a commission was that I'd listen to the client, think

about the site, and then paint my own riff on the subject—if they liked what I'd done, okay; if not, I'd keep the painting.

Sometime in 1984 Leo Castelli called to tell me that the owners of the Four Seasons were interested in my doing a mural to celebrate the twenty-fifth anniversary of the restaurant. Leo and I went up to the Seagram Building (the restaurant is on the ground floor) to talk with the owners, Tom Margittai, Alex von Bidder, and Paul Kovi. David Whitney, who bought art for Philip Johnson, was at the meeting, too. Philip Johnson and Ludwig Mies van der Rohe were the architects of the Seagram Building.

Many years earlier Mark Rothko had been commissioned to create artworks for the Four Seasons. Rothko had embarked on the commission believing that the Four Seasons was a commissary for the employees of the Seagram Building; being a dyed-in-the-wool socialist, he designed a series of intense monochromatic paintings that would speak to the workers. When Rothko finally came to see the restaurant, he was horrified by the elitist clientele and the expensive food and refused to let his paintings hang there.

When Leo and I went up to the Four Seasons to meet with the owners, they said, "We'd like a mural to put on that wall. Will you do a sketch for us? We'll pay you ten thousand dollars for your proposal, and we'll buy the sketch regardless of whether we take the mural or not. If we do take the large painting, we'll pay you one hundred thousand dollars." After I mumbled my thanks, I went away and pondered.

The price was fine. What bothered me was that when you agree to do a sketch, you're showing the client something less than the real thing. The smaller work, the something less, is never going to be as impressive as the finished painting. I was concerned about this possibility, which is always an issue with commissions, but I said, "Okay, but give me some time to come up with a few ideas, and then I'll show you the sketch."

By the time of the next meeting, the owners' curiosity had got the better of them. "What do you think you're going to do?" they asked. Off the top of my head, I said, "Well, I'm thinking of putting some flowers and ladies and fish in Saran Wrap in the refrigerator." The restaurant's PR man was there, George Lois. George is the guy who came up with the Muhammad Ali line "If you've got it,

flaunt it." He is a very sharp Madison Avenue character, and when he heard the idea he said, "Uh-oh!"

So I quickly added, "You know, so they don't smell." They thought that was funny.

"Well, we'll look forward to seeing the sketch," they said.

When I started thinking about the painting, my image of restaurateurs was as gregarious types, like welcoming bartenders who say, "Come on in and make yourself at home." I felt they really wanted a feeling of hospitality for the Four Seasons. At least one of the three owners is there every night; they were all great welcomers.

After I had measured the wall, I felt that the ideal proportion for the painting would be seven by twenty-four feet. That shape would set into the wall perfectly. I started making collages and taking photographs of fish in Florida, fresh fish, flowers, and fragments of women's faces. I usually make a sketch or a collage or a maquette before I start painting, because I like to plan things out carefully, but these sketches are strictly for my own reference. I've learned that it's important to only show a client what you want them to see.

I thought, Why not use a shape that looks like a Chinese gate with slivers that open in the middle to show salad, flowers, or fish in abundance. At first I was concerned that the fish might look a little harsh, a little tough, but then it occurred to me that they might *want* tough. The Four Seasons is a high-powered place, a restaurant where movers and shakers go to eat. So they wouldn't go for something saccharine or syrupy.

I went home and started a sketch in watercolor to scale, about four feet long. I got halfway through the thing and thought, The hell with this. I'm just going to paint the painting. And at that point, I started to work on the painting in Florida. Then, after I'd made the painting, I finished the sketch. When I came back to New York, I brought both of them with me, hung the painting in my studio, put the sketch on the floor, and then invited everybody over.

The first person to arrive was Philip Johnson. Then Tom, Paul, and George Lois came. There were a bunch of people there, including Jasper Johns, Judith Goldman, and Billy Goldston. We all had coffee, and they walked around my studio and looked at the painting. At a certain point when everybody was there, I said, "Well, ladies and gentlemen, there's the painting, there's the sketch. Which one do you want?"

"We'll take them both."

Well, that'd been my plan all along. By presenting the sketch and the painting at the same time, I eliminated the possibility of their rejecting the sketch. I put them in a position where they would have had to turn them both down simultaneously. There was no ambiguity about it; they knew what they were getting. There would be no questions about whether the finished work would actually match up to the sketch.

The slivered images in the painting are those of smiling ladies gorging themselves on the delicious food. The faces disappear in the middle of the painting, a cheek becomes the side of a fish. A fish head with a corsage. One of the fishes is supposed to be Tom Margittai and the other Paul Kovi, two of the owners.

"What's the name of it?" they wanted to know.

"Does it have to have a name?" Jasper asked.

"I have it," Leo said. "Why don't you call it *Flowers, Fish and Females for the Four Seasons*?"

"Okay, it's settled."

They looked at it for a while and then we took it to the restau-

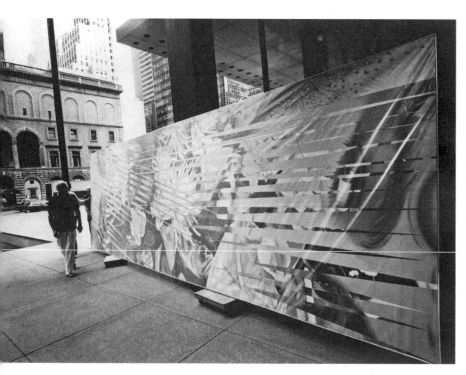

With *Flowers, Fish and Females for the Four Seasons* (1984) as it is being taken in to be installed in the private dining room off the pool room of the Four Seasons restaurant.

rant and hung it. At the party they threw for the painting I wore a white jumpsuit and an electric cord for a belt.

After turning down commissions for years, I suddenly found myself getting a lot of them. Later in 1984, the same year I painted *Flowers, Fish and Females*, the French automobile manufacturer Renault asked me to paint a mural for L'Incitation à la Création in Paris. I created *Eau de Robot*, roughly the same size as the Four Seasons painting, but its subject matter turned out to be far more industrial.

I didn't know how Claude-Louis Renard, "Mr. Fox," who was number seven at Renault, would react to it. His plane got into Tampa late in the afternoon, but by the time he got to Aripeka it was dark—I painted by the sun and never had lights installed in the studio. I suggested he spend the night and look at the painting in the morning. But he was very impatient. "I must see the painting tonight," he insisted. "I will look at it now and then I must leave you and go on with my travels." I had an old car parked at one end of the studio and the only thing I could think of was to use the headlights to illuminate the painting, so that's what I did. I started it up, pulled it around, and pointed the headlights at the painting. Renard took one look at it and said, "*J'accepte*," just like that, and was off again into the night and back to the airport.

Commissions serve a lot of different purposes. Even the Sistine Chapel wasn't painted just for the glory of God; the glory of the Vatican, maybe. It's also a tourist attraction, a focal point, an astounding work of art, and lot of other things besides.

In 1985 Gary Harrod and Tilda Brabson approached me to do a mural for the Ashley Tower Building in Tampa, Florida. Tilda is one of the Lykes sisters. Now, I'm not comparing the lobby of the Ashley Tower in Tampa to the Vatican, or *Sunshot*, the painting I did for Ashley Tower, to the Sistine Chapel; but as public works of art they do have a few things in common.

The purpose of having a mural in the Ashley Tower was to create a sense of place—something the Vatican didn't have to think about. The idea was to create a spot in downtown Tampa to attract interest, a place where people could say, "I'll meet you by that painting." Something like that. Another motive was probably to attract clients who might rent space in the building. During this

period, places like Dallas were in an economic slump because of the low oil prices.

They were interested in a large work, ten by eighteen feet or so, that would add something to the building and its presence. But Harrod didn't know much about art, and neither of them seemed to have the faintest idea what art cost. They were thinking in terms of a few thousand dollars. When I told them it would cost them around $150,000, Tilda said, "I don't think they'll ever go for that. I think the price is just out of line."

"Well," I said, "I'll come up with something, paint the picture, and then you can all come up and decide. If they don't like it, I'll just keep it."

I started thinking about what I would paint. I asked myself, what do you do when you come to Florida for the first time: you sit in a beach chair and the intense Florida sun disintegrates the fabric; it gets sun-shot. So that's what I decided to call the painting—it referred to the old, worn-out bottom of a beach chair. But once I had the title, *Sunshot*, it suggested to me the image of the sun shooting out of a barrel (in the finished painting I used the tube of a tractor connector for a three-point hitch—but it did look like a cannon). The word *shot* in the title caused problems. "Is that a gun I see in that picture?" inevitably people would ask. Maybe they were concerned because of the serious gun problem in and around Tampa.

"No, of course not," I'd answer. "It's a *metaphor* for a gun."

"Oh, that's perfectly all right," they'd say. "As long as it's not an actual gun."

I added a few more Florida images: a bow tie; a Spanish girl from Ybor City with gold paint on her face from a party; a touch-tone telephone; and the earth as an isobar weather map coming up through the bottom of the chair. I had wanted to imbue even commonplace objects like a telephone or a bow tie with that mysterious aura I had experienced painting billboards, while at the same time creating a kind of crescendo as the various elements—the large detail of the telephone, the map of Tampa—blended and contrasted.

When it was done I invited them up to Aripeka. They walked in through the studio door. Somehow, the bright illumination from the skylights in my studio came in like a shaft of light in a religious painting—it seemed to go right along with the imagery. "We'll take

it," they said, and they paid the price I'd quoted without blinking an eye.

Commissions are often a great advantage for me because they involve very large works—from the beginning I had used giant images to foil the picture plane. But commissions can be a mixed blessing because you are frequently dealing with committees or governmental agencies, and now that I was doing a bunch of commissioned paintings I began to wonder what the relationship was between the artist (me) and the people hiring me, and how did it factor into the art. People often ask me that—how do commissions affect the way I paint and the kind of things I paint?

I've given it a lot of thought, but in all honesty I don't think that they do affect how I approach my work. When I started out, there wasn't any market for my paintings and so I wasn't painting to fulfill anybody's expectations but my own, and I still don't. Art comes out of intuition. An artist has an idea, an image—even a nightmare—and the only way he can get it out of his system is to make art.

In 1986 I had a cameo in the movie *Wall Street*, attending an auction somewhat like the one at which *F-111* was sold for $2.09 million. The idea was to show that paintings had become the hottest commodities to invest in. Last year a Francis Bacon triptych was bought for $83 million by Roman Abramovich. But *Wall Street* wasn't endorsing this trend; it was made by a director and a star sympathetic to the notion that artists were getting tossed around by big-money people. Boy, did I identify with that.

People have said that the unholy marriage of art and big money began when the Sculls sold their collection at Sotheby's Contemporary Art Auction on November 11–12, 1986. The sale included my *Portrait of the Scull Family* and *F-111*.

At that auction the opening bid was $350,000, fifty seconds later the Whitney Museum offered $1.1 million, and thirty seconds after that a Citibank officer made the winning bid of $2,090,000 acting for an anonymous buyer. I sat there and I was stunned. As the bidding just kept going up and up, I remembered how grateful I was to get $22,500 for it back in 1965 ($45,000 minus Castelli's commission). And here I had just seen *F-111* become the second-most

expensive painting at that time by a living artist. I was so dazed after the sale that when I started to go home I realized I just couldn't— there was no way I was going to be able to sleep after that. Instead, my girlfriend and I ended up drinking champagne until three in the morning, even though Scull's heirs, not I, reaped the profits from *F-111*.

When I undertake a commission I always try to give the work edge. While I was working on *Sunshot* I felt the painting had a toughness to it, a kind of sharp industrial hide, but when it was installed in downtown Tampa I noticed that something peculiar had happened to it. The brutality I'd thought I was putting in the painting was no longer there—whether it was the golden shininess of the plastic of the big telephone against the deep blue of the isobar map, or the fact that when all the elements came together it exuded a more harmonious feeling, I don't know. But no matter how provocative you set out to make a painting, it eventually becomes established, acceptable—look at Salvador Dalí's *Premonition of Civil War* or Picasso's *Guernica*, two paintings about the horrors of the Spanish Civil War that people now look at as much from an aesthetic as from a political point of view.

In 1985 I completed *The Persistence of Electrical Nymphs in Space*, the painting whose underlying theme Liv Ullmann had not seemed to really register the year before. In that painting, flowers combine with fragments of faces, as if the life force is flashing out of these slivers. I was thinking about the possibility that the little life flickers that are in a human being persist in some electromagnetic form. I was thinking about where these nervous souls bounding around the universe go. The painting questions whether man has a soul or is merely electrical. If he's electrical, where does all that energy go if the earth blows up? The energy must go somewhere. It's a huge painting, a metaphor that appropriately enough looks like a flowery inferno.

I think of *Persistence* as Mahatma Gandhi's funeral. They burned a pyre with his body on it, but you have to ask what became of his spirit. If you watch people die, you sense something leave. In the painting there are fragments of people flitting around not knowing where to go. They're in space but disrupted. It's very peculiar.

I prefer to think life persists in another form rather than being extinguished.

In September 1983 I had a show at the Thordén-Wetterling Galleries in Göteborg, Sweden. It's not that warm in Sweden even in the summer; by September it's *cold* and people are hanging out inside bars and restaurants. I'd go out to bars with Bjorn Wetterling and I began to notice an odd thing: lots of stunning, single young girls standing at the bar drinking by themselves. I subsequently realized that they were country girls coming into the city just to socialize.

Three years later I was asked to paint a mural for the Opera Cellar, a restaurant, bar, disco, and café in Stockholm that was attached to the opera house. Again I saw these beautiful country girls at the bar being very friendly, much more flirtatious than American girls.

My idea was to make a painting about cultural differences, some of these brought about by the midnight sun, the months of darkness, the endemic depression among Swedes and how this led to a kind of feminine mystery. I made the principal figure a woman and surrounded her with hot-colored flowers—a bright orange-red picture that would radiate heat on a frosty night in February. It was eventually called *Ladies of the Opera Terrace*. When I finished it, Pelle Manson, one of the owners of the restaurant, came to Aripeka to see it with Bjorn Wetterling.

Bjorn loved it. "It's fantastic," he said as he walked into the studio. I wasn't so sure about Pelle's reaction. He was a little wary at first, but after about forty minutes he began to warm to it. The painting is 7½ × 21 feet and splits down the middle. Its two halves are on rollers that pull back to reveal a movie screen where the restaurant shows films.

As I started doing more and more commissions in the mid-1980s, I became interested in the process itself. Instead of simply pursuing my own ideas and feelings, I began wondering about what the clients were thinking—why had they decided on the commission in the first place?

One of the most common reasons generally has to do with a painting's ability to transform an anonymous space into a specific place, a rendezvous point, a specific *there*—as in the case of *Sunshot*. "I'll meet you under that sign. I'll meet you at that corner." Why

not "I'll meet you at that painting"? In the case of *Ladies of the Opera Terrace*, local politicians have taken to scheduling interviews in front of the painting. It's become a popular spot where social issues are discussed, so that particular painting has been seen a lot on national television in Sweden.

An odd, unexpected result of the success of a commission is that the painting attracts attention, becomes more valuable, and inevitably the owners start having this squirrelly idea about selling it. The question is then, would it be missed if it were removed? In other words, to paraphrase Gertrude Stein, would there be a "there" there?

Sometimes you make a painting for a specific place, and then the "there" disappears. In 1986 Ian Dunlop and his partner Jim Byrd approached me to do a mural for an exhibition space at the AT&T headquarters in Manhattan. They had worked at Sotheby's and Dunlop also was a private consultant for various corporations including AT&T. It turned out that they wanted me to do a painting to be hung in an exhibition space devoted to the telecommunications industry in the new Philip Johnson–designed building. It was an odd space with a ramp going up the side of the room and a goofy primitive robot with its feet bolted to the floor and buttons that children could push. They gave everyone a plastic name card with a number on it as they came in, which you could use to operate the machinery as you went through the displays. Your name would appear in lights while you were there. It was essentially a promotional gimmick disguised as an amusement arcade. As I always do, I told them there was no obligation to buy the painting. "I'm going to paint it anyway," I said. "It'll be a good excuse for me to get out of my chair."

AT&T is a communications company, so I thought about the nature of communication at its most basic level. I was thinking about all the attempts people make to communicate. How do you communicate with another person? How do we reach each other through language? How do we communicate with other animals? Then I started thinking again about how we would talk to aliens. I looked at all the different languages in the world and wondered what those symbols mean to people from other countries.

As I had done with the paintings *A Pale Angel's Halo* and *Slipping*

Off the Continental Divide, I once again began to think, How would you get through to a creature from another planet since Chinese, English, Latin would mean nothing? And I came to the same conclusion: you'd have to talk to them using universal symbols. Perhaps geometry.

So what would I paint that would work in this noisy, jangly place, a place devoted to information and communication? I wouldn't have started thinking and working on these ideas if it hadn't been for the impetus provided by the specifics of the commission. They didn't say what they wanted, but when I saw the place, it suggested an interesting line of inquiry.

When I began thinking about *Animal Screams*, I started going to the library and looking for characters and words in every language that meant *peace*. While I was researching this idea, I found the most peculiar-looking alphabets you can imagine and some very odd numerical symbols, too. I happened to be working on the painting when the CBS program *Sunday Morning* with Charles Kuralt did that segment about my work. On it I said, "I'm amazed that today there are all these alphabets that look like they come from Mars, but are from right here on Earth." So *Animal Screams* is a meditation on a universal language. I put the word *peace* in the painting in every language on the earth. I found 147 words for peace—they were clearly for earthlings, because we wouldn't be communicating with aliens using words.

I included animals we think of as vocal, creatures that can mimic human speech, a couple of parrots and a dog in the imagery. I took pieces of girls' faces and the faces of frogs and birds and wolves, and cut them up into geometric shapes—circles and squares and triangles—because those are the shapes the universe is made up of. I felt that if people saw something that looked like a form they recognized, like a slivered triangle with a human or animal image on it, they would begin to comprehend the message—a kind of pictoglyphic language. The biggest image would be that of an Asian woman coming through a geometric slice of a face, interspersed with every word in the world for peace. I injected a number of symbols such as the handshake from the United Nations emblem, symbols that stood for "happy family" and "continuing." The largest lettering in the painting is *pace*, the Italian word for peace.

Animal Screams, 1986. Oil on canvas. 11 x 18 ft. (335.3 x 548.6 cm). Collection of Sven Norfeldt, Göteborg, Sweden. I originally did this for Philip Johnson's AT&T building, so I was thinking about communication at its most basic level; the building was sold to Sony and the painting was never hung.

I called it *Animal Screams*, because as humans we're all these different animals trying desperately to say the same thing and getting misunderstood. That's what human beings are: animals that scream. They're screaming "Peace!" It had to do with some noisy, peaceful, chattering type of thing. The title also refers to the fact that I thought the people who visited this noisy atmosphere, this amusement parlor, would say, "Hey, there's our language."

Animal Screams was the most adventurous use of slivered images of faces overlaid on a background I'd attempted so far. I don't honestly know where the idea of painting faces and animals on these latticelike strips had come from. It occurred to me in 1978 or '79, and I first used the technique on *Star Thief*. One reason for it, though, was to have more space to paint in. If you suggest something on these strips, you can still see through them to what's behind them in the background—as if they were a window shade. I also wanted to create a sense of mystery, to make people wonder what the hell it meant. The mystery engendered by the scale and the fragmentation in *Animal Screams* is augmented with another, linguistic, kind of fragmentation—the Babel of language.

One immediate inspiration for the slivered faces was Picasso's

Bathers. He did a lot of bather paintings, but some were women with big fat hands and big stomachs and heads. I always admired the freedom involved in his taking a part of a face or some other part of the anatomy and changing its shape so that it became positively or negatively part of the picture space.

I first noticed this visual conundrum when I was painting billboards. I'd be working on a twenty-foot head for *The Wonderful Country*, and an old sign-hanger would walk right across it as it lay on the ground. I'd say, "Hey, watch it! You're walking on the star's face!" Or I would paint two movie stars on a piece of Masonite, then the carpenters would come along and cut out the silhouette with a scroll saw, but they'd often cut out the arms or the legs sloppily and in so doing, create a different shape from the one I'd painted.

So I took this idea of the two images, the face in the photo and the silhouette, and pushed the concept further by slivering the women's faces so that I would have the background of the painting—flowers, stars, and so on—overlaid with shards of women's faces.

When I'd finished painting *Animal Screams*, I brought it to New York to show to the executives at AT&T. The day I arrived, Richard Feigen, one of my dealers, informed me that AT&T had just laid off twenty-five thousand people. The men who had commissioned the painting couldn't be found at all. No one would take responsibility for it. Shortly thereafter, AT&T sold the building to Sony, who didn't want the painting. Three months later, a group of Swedish businessmen, including a gentleman named Sven Norfeldt, came along and asked, "Do you think we could buy it?" I said, "First come, first served," and settled for $350,000. The painting now hangs in Göteborg's Konstmuseum.

After finishing *Animal Screams*, I used some of the same elements in *Talking, Flower Ideas*. Ad Reinhardt once said that a good painting is one worth doing over again. Jasper Johns is a prime example of this. He painted maybe a dozen flags, a dozen targets. Sometimes I approach imagery—the shardlike faces, the flowers, the star trails—in a manner that may seem similar to the way Jasper painted flags and targets, but I am not doing it for the same reasons. In my case it's closer to the analogy of breaking off a love affair prematurely. That's why I go back to it. Sometimes you shift gears too

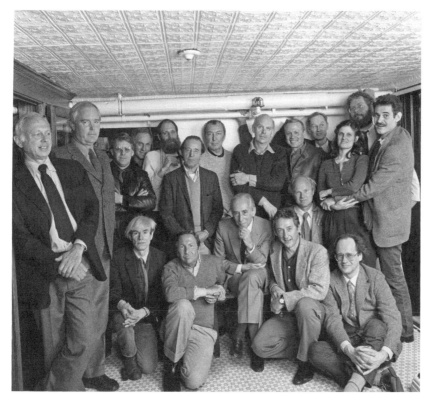

This was a reunion of artists represented by Leo Castelli in the basement of the Odeon restaurant. Sitting (*left to right*): Andy Warhol, Robert Rauschenberg, Leo Castelli, Edward Ruscha, me, and Robert Barry; standing: Ellsworth Kelly, Dan Flavin, Joseph Kosuth, Richard Serra, Lawrence Weiner, Nassos Daphnis, Jasper Johns, Claes Oldenburg, Salvatore Scarpitta, Richard Artschwager, Mia Westerlund Roosen, Cletus Johnson, and Keith Sonnier.

quickly and move on to something else before you've had time to savor an image, to explore it further. You have time to think about what you were doing, you have a better idea about how to use it to say something else.

Talking, Flower Ideas was also a commission, this time a happy one. It was for the Hearst Corporation's hundredth anniversary. They saw my show at the Whitney Museum and then called Leo and said they were interested in having me do a mural for their offices in an art deco building on Fifty-seventh Street. I went up to the space and looked. They had a Louise Nevelson sculpture there, an all-black wooden piece. From me, they wanted something bright and exuberant. I put the imagery together and painted the work. The interesting thing about this particular commission was that they were extremely positive. Maybe they didn't like the painting, but they liked that it could be delivered on time and perhaps they figured this is what modern art is—if we don't understand it, it must be good.

I once titled a painting *Time Flowers* in which the word *flowers* functioned both as a noun and as a verb. The flowers were colored tenpenny nails arranged in groups of five, the way prisoners mark time on the walls of their cells. The title of *Talking, Flower Ideas* works the same way. A painting is a kind of time machine. It has to have two almost contradictory qualities. It's essential that the painting communicate its energy and intensity to the person looking at it instantly, while at the same time it has to have elements that only become apparent after you have looked at the painting for a while.

Frank Stella said something interesting about the split-second nature of art. He said that the baseball player Ted Williams was the quintessential modern artist because of his fast eye—Williams claimed he could see the seams on a baseball as it came over the plate at ninety miles an hour. I want that instant punch when you look at one of my paintings, too—the immediacy of an ad or a billboard—but at the same time I want you to be able to read things in my paintings as they slowly rise to the surface. I'm often impressed by seeing something obliquely. That way I won't get tangled up with its meaning to the point that I forget the very thing that originally enticed me. I'll take it in in that initial flashing way, and then I'll take the time to look deeper.

What I think Frank meant is that seeing a painting is sometimes like love at first sight, something that doesn't have any barriers to it. With some paintings, you don't need words—or titles, either. You get it without anything intervening between you and your vision of it. Afterward, after you've absorbed that first visual blitz, you realize there's something deep in that black area that you hadn't seen right away.

The point of painting is to try to bring the something alive. Oil paint is nothing more than minerals mixed in oil, and to try to evoke an idea with that isn't easy and doesn't always work. But there's a special pleasure in the pure physical act of painting, of bringing a flower or a fish scale to shimmering life with such inert materials as paint and brushes. In the case of *Animal Screams* or *Talking, Flower Ideas* the challenge is to make an abstract painting in which you simultaneously convince people that they are looking at tangible, three-dimensional objects that they recognize from the real world.

Sometimes when I work in different mediums I feel I am chan-

neling all the artists who went before me. When I paint with pastels, I feel like Degas. If you really throw yourself into the medium, you can see where other artists have been. I felt like that working on *Stars and Algae*, a painting done in pastel, half in tones of green, half in the deep purple blues of outer space. There's a large bird perched on the edge of the green section of the painting, its tail ending where a giant star explodes. Algae is life, and everyone's looking for life in the stars. What I was trying to do there was combine the solidness of growth with the coldness of space.

In 1982 I met Mimi Thompson, a very intriguing woman working at the Leo Castelli Gallery. I ran into her again at an event for the writer Gary Indiana at the Mudd Club. There was Mimi jumping up and down and dancing. I fell in love. We fell in love. We fell out of love. We split up for four years.

In 1987 I was walking down Chambers Street and whom did I run into with paint on her clothes but my love from four years earlier, Mimi. We chatted; her mother had died, my mother had died. I asked her if she wanted to go sailing on a square-rigged Spanish galleon for the Tall Ships celebration. She said, "No, I have a date."

I found out she lived one block away from me—I saw her on the street again, and we began seeing each other. That summer we went to Caroline Kennedy and Edwin Schlossberg's wedding in Hyannis. We had a great time. I danced with all the Kennedy sis-

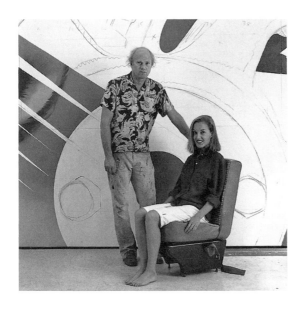

With Mimi in front of
Four New Clear Women
(1982) before we were
married.

ters, but not Jackie Onassis. She looked like a beautiful Cleopatra. I asked Mimi to marry me, and she said yes.

Our wedding was a big affair: we got married in a traditional ceremony with bridesmaids and ushers at the Presbyterian Church on Park Avenue, with many artists and relatives attending. My cousin Robert sang. Bob Rauschenberg, Jasper Johns, Roy and Dorothy Lichtenstein, and Caroline and Ed Schlossberg came. My best man was my cousin Dick Ryerson. The collector Marvin Ross Friedman came with his opulently dressed and many-named wife, Sheila Natasha Simrod Friedman. Things were going fast. We rushed to the Concorde and flew to Paris, then slowed down in Rome.

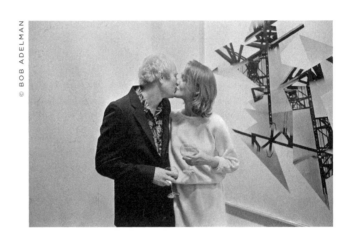

With Mimi at my opening at Dolly Fiterman's gallery in Minneapolis.

© BOB ADELMAN

Time Dust and Welcome to the Water Planet

THE ART OF PAINTING

WELCOME TO THE WATER PLANET

FROM RUSSIA WITH LOVE

DOLLS AND AIDS

HANDGUNS

COLLAGE AS A CONTINUING CONTEMPORARY MEDIUM

What gets me up out of my chair is the light in Aripeka; it's so shimmering and incandescent. The chiaroscuro is so intense, the darks are strangely colorful—you see all sorts of blues and greens in them that are gorgeous. The light sat-

urates everything. When it reflects off the Gulf, it brings energy everywhere. That's why Winslow Homer loved painting down here.

What I like to do is start painting midmorning. I begin my day around eight o'clock with some phone calls, have breakfast, and write letters. Then break for lunch and paint in the afternoon with the great light. That's when the colors really start flying. The light's good forever down here in summer. Then, about eight o'clock in the evening, the earth will start creeping into the color. I could start painting again after supper, or have a party—but in this humidity, painting six hours a day is enough. When sunset drops down, I say, "That's it. Thank God I didn't put electric lights in my studio."

I like to take my boat out into the Gulf for a swim in the evening. You can find almost any depth out in the warm, bottle-green waters of the Gulf of Mexico. I drop anchor and go for a swim when the weather is good. Shutting off the engine and heading overboard turns my head around and sorts things out at the end of the day. I've had dolphins come up within three feet of me. You think they're going to come right up to you, close enough to eat from your hand. But then all of a sudden—*poof!*—they're gone. It's fun to take the boat up to Cedar Key, have dinner and sleep over, and then get up in the morning and look for arrowheads at the mouth of the Suwannee River.

The series *Welcome to the Water Planet* reflects the lush vegetation and crystalline light in Florida. I painted the first one in 1987, and all in all I think I've done five different versions. Because of the imagery—the lotuses, the flowers, the stars—they may seem bright and cheery on the surface, but they all had a darker meaning. People around that time would ask me, "Why have you been painting flowers for the past few years?" And I'd tell them, "I'm looking for the evil in flowers, like Baudelaire's *Fleurs du mal.*" The bright colors of flowers are thought to be beautiful and sweet, but it's not necessarily so. Nature isn't there to provide a pleasant aesthetic experience for humans—it's there for its own purposes, and in any case, color is color. Those bright tropical flowers often have a poisonous-looking coloration.

Where I live in Florida is a kind of a jungly place, and I kept thinking of the differences between someone living naturally and someone living in a sophisticated environment like New York City.

That prompted me to think about incarnations, what forms incarnations can take: in people and plants and animals and everything else. In Florida I had an image of people hiding in the jungle. Then I'd go back to New York and I'd see the jungle in another incarnation: a beautiful girl with a lot of jewelry and a drink in her hand. I'd notice her fingernails and start thinking of them as claws, her teeth as fangs; her nose would take on an animalistic shape, like the snout of an armadillo or a raccoon. I was having all these strange thoughts, and began to imagine paintings in which I would mix up parts of people's faces with flowers, bushes, machines, and everything else.

Another idea, equally dark, occurred to me when I began to make maquettes for the *Welcome to the Water Planet* series. I started to think about the nuclear threat and how something so huge and catastrophic could just swim in and out of our consciousness. At first there were ban-the-bomb demonstrations, and then after a few years that died down and faded away. Then there was the Cuban missile crisis, and when that went away nobody gave it another thought until the accidents at nuclear plants like Three Mile Island and Chernobyl.

Welcome to the Water Planet was the idea of seeing the earth again from another perspective, from an alien perspective perhaps. The idea was: if aliens were to visit us, they would see the earth with both its beauty and its problems. And at the same time it was about seeing the earth as a Garden of Eden that we could lose in an instant. I was thinking about the subconscious of young people who have to take the threat of nuclear holocaust out from under their pillows and then put it back in order to be able to sleep. It's like this elephant in the room that everyone pretends isn't there.

I remember stories from my childhood about how the early settlers in Minnesota dealt with brush fires and forest fires. They would hide in a stream or a lake while the fire burned itself out, and I had in mind this notion—I don't know if anybody would get it—of someone hiding in the water as some nuclear star nova goes by. It all had to do with survival during some period of near extinction. But life and the creatures on Earth and the beautiful vegetation persist despite the overwhelming threat to their existence.

In *Welcome to the Water Planet III*, there's a water lily floating in space and above it is a sharded face over a stellar nova. I kept think-

Working on *The Bird of Paradise Approaches the Hot Water Planet* (1989), at Tyler Graphics in Mount Kisco, New York, in 1989.

ing of the painting's surface as hovering, something not really part of the landscape, more like a horizon between matter and energy. At the bottom a bird whose body and beak are composed of flowers is dragging a piece of skin—strips containing parts of a woman's face—through flowers under the water. An orange bird is making a nest with strips of ladies' skin.

Like the paintings, the print series *Welcome to the Water Planet* came out of working so long in the lush tropical landscape of Florida. But in order to re-create the humid, enveloping feel of the luxuriant plant life as a print, I first had to find a way to reinvent the way lithographs were made.

In 1988 Ken Tyler asked me to work with him at Tyler Graphics in Mount Kisco, New York. He said, "Why don't you come here and light the place up!" Ken was ready for anything. He was a true, fearless innovator—no idea, however improbable, could deter him. I decided to do prints as big as paintings.

We had no presses with beds six feet wide, so Ken produced large sheets of porridge-like paper pulp, which I would color with a ceiling sprayer, laying down colored pulp on this background. I would then make lithographic elements and glue them onto the large pulp surface.

The last and largest work Ken and I did together was called *Time Dust*, thirty-five feet long and seven feet high. This came out of an idea I had been thinking about: the area in space where the United States and Russia had jettisoned many tons of space junk. It occurred to me that this was a kind of permanent museum where nothing would ever disintegrate. Imagine an old square-rigged ship out there in fine shape, sailing on forever. The images in these works are in two catalogs beautifully produced in great color by Tyler.

After my mother died in 1987, I painted *Through the Eye of the Needle to the Anvil* as a kind of commemoration of her unfulfilled life. She was an adventurer at heart. I always thought of my mother as someone who was avant-garde and very smart. But toward the end of her life she became discouraged. When she was young she'd

been a pilot in North Dakota. Her hero was Amelia Earhart. I remember asking her if she had ever gotten her pilot's license. She said, "No, that was before women's liberation, but I flew all over the place anyway."

My mother's family didn't have any money. She'd learned to play the piano, had talent and wanted to continue taking piano lessons, but couldn't afford to. Women weren't supposed to do much of anything when she was growing up. I think my mother's lack of education was the source of some of her unhappiness. My mother was an artist, but she never really got to express that in her life.

After she and my father had retired, I said to her, "Why don't you do some of the things you used to want to do? Why don't you paint? I'll give you the paint."

"No," she said, "it's too late."

She was angry, and she didn't think she had the time to accomplish anything. "Impossible," she'd say. So, this painting, *Through the Eye of the Needle to the Anvil*, has to do with the end, with dying. In part, it's about the sewing needle. Like the way the tiniest point of intuition, feminine intuition or artist's intuition, can become a larger production, perhaps evolve into a movie, a play, or a dance.

Collage for *Through the Eye of the Needle to the Anvil*, 1988. Photocopies, photographs, magazine clippings, printed paper, and mixed media on plywood. 18½ x 36⅜ in. (47 x 92.4 cm). Collection of the artist.

With Mimi and newborn Lily at Chambers Street in 1989.

Something like that can come through the eye of the needle and become this weighty thing, like an anvil. I've always thought that the tiniest idea can evolve into a very large artistic expression.

For example, the special effects created by Douglas Trumbull for a movie such as *2001: A Space Odyssey* were accomplished using very simple means, perhaps a piece of plastic on a stick swirled through the air and photographed in slow motion. Trumbull's ideas were very mechanical, very nuts-and-bolts, yet he's thought of as being a high-tech designer. When I met him, he was working on this big, curved-screen setup, a small theater that seats ten to twelve people and moves around, making them seem to fly through space even though they're really standing still.

In November 1989 my daughter, Lily, was born. I was totally overwhelmed. It's miraculous to have a child. She was very bold, like a little boy. It was great to have a chance to look at the world from her perspective. I was very curious about what she'd see. She was in school nine years in the country and then went to a high school in New York City. Lily is now nineteen. She designs jewelry, has done a bit of modeling, and is at the Rhode Island School of Design.

When my son, John, graduated from college cum laude in English he said, "Dad, I don't want to be an artist." He's been a Web designer. He's become very successful and works for a real estate firm uptown. The best thing is that he now lives near me so I get to see him a lot.

In 1990 vandals slashed one of my paintings as well as one by Roy Lichtenstein at the Leo Castelli booth at FIAC, the International Fair in Paris. The vandals claimed they, too, were artists. They were making a point—but what was it? Leo didn't press charges. Subsequently, a restorer trying to mend my painting took it upon himself to paint a sailboat in the place where it had been slashed— that was almost worse than the original slashing. As a consolation, the following year I was awarded the Chevalier l'Ordre des Arts et des Lettres by Jack Lang, the French minister of culture.

In 1990, *F-111* was included in High and Low: Modern Art and Popular Culture at MoMA curated by Kirk Varnedoe and Adam Gopnik. The fusion of fine art and popular culture that began in the mid-1950s with Robert Rauschenberg and Jasper Johns, and escalated in the 1960s with pop art, was finally getting acknowledged by

the Grand Old Lady of Modernism on Fifty-third Street. By then pop art seemed almost classical when juxtaposed with Jeff Koons's stainless-steel dog and Damien Hirst's sheep in formaldehyde.

In February 1991 the Tretyakov Gallery, Central House of Artists, Moscow, mounted a retrospective of my work, Rosenquist: Moscow 1961–1991, curated by my old friend and collaborator Donald Saff. It was one of the first post–cold war exhibitions in Russia of an American artist. The only Westerners who'd had shows in Russia at that point were Francis Bacon, Robert Rauschenberg, and me. This was all due to the stupidity of the State Department. I still can't get over the fact that the National Endowment for the Arts turned us down. There was no American support whatsoever. As a consequence, we couldn't get indemnification for the show—meaning the government wouldn't insure the paintings.

The idea for a retrospective of my paintings in Moscow came about in a very odd way. A dozen Swedes got in touch with me, asking if I would like to have a show in Moscow and one in Japan as well. They explained that they had just desalted water in the coal mines in Poland and were planning to do further projects with drinking water along those lines in Russia and Japan. I didn't quite understand what the desalination of mines had to do with my paintings and their explanation was equally wacky. They wanted to promote their undertaking, they said, via tennis and art. It didn't make any sense, but who was I to argue?

In the meantime, I went to Tokyo and stayed at the Imperial Hotel, where a truly strange farce unfolded. The tennis-and-art Swedes flew to Tokyo to talk to me—we were even staying on the same floor in the same hotel, but we never met because also staying there was a nutty Swedish rock-and-roll promoter who was telling crazy stories to the Swedish contingent about being my agent and how I had been insulted by their behavior and refused to see them and they could only talk to me through him. It got strange.

I was meeting one Japanese museum director after another and each one told me about all these people who were looking for me. "Who are they?" I asked in vain. "*Where* are they?" But, for some reason, the Japanese wouldn't tell them I was there. Then my old friend the art dealer Richard Feigen arrived with his collection and things got even screwier. He had no sooner checked into the hotel

than he was tipped off by the Japanese that Interpol was after him, believing he was selling stolen art. But it was art that had been stolen *from* him. He was tracking it down. It was a misunderstanding that could have easily been cleared up by calling Interpol, but you can't call Interpol—they're not listed in the phone book. So Richard ended up creeping around the hotel, hiding out in my room like a fugitive. Finally it all got sorted out.

Because the Japanese are so secretive and because of the crazy Swede, the desalinating Swedes packed up and flew back to Sweden. We never talked, we never met, and I never got to find out what the magic link was between art and tennis. In the end, another Swede, Bjorn Wetterling, helped to fund the show in Moscow.

Anyway, the next thing I know two Russians from the Union of Artists show up at my Florida studio in February 1990. I made them piña coladas. They found them too cold and put them on the stove to warm them up—where, of course, they turned to pink mush. Still, we had a good talk. They said I could show whatever I wanted. It took months of work collecting paintings, then getting them cataloged and crated, but the big problem wasn't the logistics, it was the bureaucracy. Incredible red tape.

I went to Moscow in February 1991—it was twenty-four below zero. This was my third trip there. I'd gone there first in 1965 to meet with the artist Eugene Rukhin. The atmosphere changed radically between visits. I made my way there accompanied by nine workers, one secretary—the indispensable Beverly—one thousand pounds each of food and tools, and two cases of vodka.

It was glasnost and things were loosening up. There were bank strikes and many other anomalous things of that nature, but everyone was still afraid of the KGB. I don't know what the KGB thought about my paintings, which for the most part aren't political anyway. When people ask me whether my paintings are political or apolitical, I feel the same way Bob Rauschenberg did when someone asked him if there was God in his work. He said, "If God steps in, he's welcome." If I have something that's bothering me, I don't take that energy and throw it out; I incorporate it and move on.

At that time the Russians were starved for color. There was none in the streets or in their lives. I felt I could provide some entertainment for a month. I showed only oil paintings—no electrical gad-

gets, nothing scientific that the Russians couldn't do themselves. I didn't want to come in with a lot of fancy stuff like lasers, neon, and plastic. I showed a wide range of work, from the early stuff to my more recent seventeen-by-forty-six-foot paintings: *Star Thief, Four New Clear Women, The Persistence of Electrical Nymphs in Space,* and *Through the Eye of the Needle to the Anvil.*

I wasn't under any illusion I was going to find collectors there. You didn't sell paintings in Russia in those days, you were just happy to end up having a big show there. Although I found the situation for artists much improved, I saw that they still did not have materials. I was very sympathetic to their situation. Russian artists read Western art journals but they have an inflated idea of how Western artists live. They believe every twenty-two-year-old is selling his work for thousands of dollars.

Aidan Salakhov, the daughter of Tehir Salakhov, who was the head of the USSR's Union of Artists, told me that glasnost had had a curious, unexpected effect on Russian artists. They were having a hard time adjusting to their new freedoms because for so long they had thought of themselves as revolutionaries. Now that they didn't have to worry as much about government scrutiny, they weren't sure how to proceed.

After my daughter was born in 1989, I started looking at dolls in the stores at holidays. They looked fierce and ugly and not attractive at all. I saw something unsettling in those smooth, porcelain-like painted faces with their automatic eyelids.

I bought some old generic dolls, covered them in Saran Wrap, and took about four hundred photographs. Some of them looked terrifying, some looked sweet, some were just plain ugly. Out of the most peculiar ones I selected thirty-six and made paintings of them. I painted them exactly the way they looked in the photographs. I didn't make changes at that stage—I'd already made the changes I wanted to make with the camera. I didn't try to make the dolls any more abstract than they were in the photographs. The eerie quality in the paintings came from what I'd seen through the lens.

I called the 1992–93 series *The Serenade for the Doll After Claude Debussy.* Debussy composed five or six small pieces for his little daughters. I thought of my own daughter, Lily, who was three years

old at the time, and said to myself, What is my daughter going to encounter in the future? When she grows up, she isn't going to be able to have a love affair or a passionate romance without first making a business arrangement because of the AIDS crisis. I connected that idea with the wrapped dolls—it made me think about being infatuated with something you can't have because it's covered with plastic.

Gift Wrapped Dolls were exhibited in Paris at Galerie Thaddaeus Ropac in 1993, and at Castelli the following year, along with *Masquerade of the Military Industrial Complex Looking Down on the Insect World*. I also exhibited the doll paintings in Austria and Chicago. Because of their scary look, people had reservations about them. Of the thirty-six paintings, though, I sold quite a few.

In the spring of 1993 I had a solo show at Castelli in which I exhibited a new series: *Target Practice*, one of my more brutal series of paintings. I also showed them at Feigen in Chicago. Handguns are depicted with the hole of the barrel pointing directly at the viewer. Here's my idea behind the handgun paintings: in early America, farmers had a pick, a shovel, and a gun to shoot a squirrel for supper. The gun was a tool. That's how Lewis and Clark stayed alive. Their clothes rotted off them on the journey. All they had was gunpowder and shot, so with guns they managed to shoot some deer and other animals for food and clothing.

No one ever seemed to think that the handgun paintings were promoting crimes committed by handguns, so I was always surprised when people asked me whether I felt *F-111* could be thought of as promoting war and violence—it's a long, epic, wraparound protest *against* violence. At the time I thought, How come all of our taxes are building war weapons instead of strings of hospitals? Some of that money could also have gone to the National Endowment for the Arts, which when I served it had a budget of about $150 million; if you cut one foot off a nuclear submarine, it would save you $150 million.

The gift-wrapped dolls and the handgun paintings were unusual for me in the sense that I rarely use only one image in a painting. My natural inclination is toward collage.

George Grosz, John Heartfield, and Max Ernst used fantastic

juxtapositions to explore the bizarre fantasies of the subconscious. In *The Surrealist Manifesto*, the poet André Breton described the surrealists' objectives in using collage as their principal means of representation, quoting the nineteenth-century symbolist writer Comte de Lautréamont, who wrote of the beauty of a young man being like "the chance meeting of an umbrella and a sewing machine on the operating table."

Many artists make collages or maquettes before they start work, especially sculptors. I got a kick out of seeing Richard Serra's maquettes at the Larry Gagosian Gallery, little curved steel objects sitting on the floor, sketches for his gigantic pieces. It was interesting to imagine how these little maquettes would be turned into massive, thick steel objects weighing tons. I always wonder how accurately the model will reflect the finished piece. Alexander Liberman used to cut up soda straws and glue them together. These flimsy little things would be blown up to an absolutely huge giant sculpture and they still looked like soda straws.

My friend Edwin Schlossberg told me he heard the nouvelle vague director Jean-Luc Godard say that he was influenced by my paintings, which I found funny because I always felt I was influenced by Godard. Nouvelle vague movies focused in on objects; they slowed things down. You'd watch a kettle boiling, for instance, something you wouldn't have seen in earlier movies. These movies isolated common experiences and framed them; daily life was never the same.

Hollywood, when they made those big movies in the 1940s, had brilliant creative teams, from costume designers to art directors. That was Hollywood. Then what comes along? Nouvelle vague movies from France where the writer, the director, and even the star sometimes were all the same person. Films became a one-man band, they were low budget. There was a new wind blowing—it was a complete reversal of Hollywood, very abstract and modern, where Hollywood had been a big angel food cake. Betty Grable was a larger-than-life Hollywood doll; Delphine Seyrig was an existential heroine.

I've had a lot of different ideas for movies but they are all ideas related to collage, montages of different scenes. The sets would be a quick succession of scenes, cutting from someone in a position

standing near the Grand Canyon to Fiftieth Street and Madison Avenue. On the sound track you'd hear unrelated sounds and noises.

My aunt Dolores lived on a farm in North Dakota out on the prairie. She wanted to be a Hollywood costume designer and an art director. She took a mail-order class. But it was a long way to Hollywood from North Dakota.

The Other Side of the Wall

THE NO-NAME STORM

ARIPEKA REDUX

MASQUERADE OF THE MILITARY
INDUSTRIAL COMPLEX LOOKING
DOWN ON THE INSECT WORLD

The infamous No-Name Storm (or as Leo might have called it, "Untitled") struck Aripeka on March 13, 1993. Hurricane-strength winds and a tidal surge on the Gulf of Mexico from a tropical storm flooded the Aripeka studio and office. It was the worst thing that ever happened down here. It didn't come into my house because my house is built up on poles—but I got trapped up there for a couple of days.

The storm floated away a bunch of cars. Much of my archives—documentation, photographs, works on paper—were damaged. The office, which is a little bungalow, low to the ground, was under four feet of water. It destroyed our copy machines, computers, and

all. We had to tear out the walls and the floor of the office down to the ground and rebuild it. Otherwise it would have gotten moldy and everyone would have gotten sick. To avoid mildew, we stored the rescued documents in a freezer so that they wouldn't rot away. They had to be all picked apart and saved and dried out. My studio fortunately wasn't too damaged in the storm.

My father died one week before the No-Name Storm. If he had lived, it would probably have killed him. He was in a little house just down the road from me. At the end of their lives, both my mother and father lived in Aripeka. Toward the end my mother got very sick. She had diabetes, and my father didn't know what to do. I called my friend Marty Margulies in Miami and said, "Marty, my mother is really ill and I don't know what I should do about her." "Rent a plane and get her down here," he said. "I will put her in the hospital right across from Grove Isle, and you and your dad can stay free at Grove Isle, too." He was really great. They started changing her body chemistry and getting her back to health. The name of her doctor was Dr. Picasso, a Cuban. She recovered, but two and a half years later she made a mistake with her insulin, had a seizure, and died in the hospital. That happens with old folks; they forget what they've done unless the nurse tells them what they have to do and when. Sometimes she wouldn't take her insulin and other times she would take too much. My father's nurse was a very tough apple— good in a nurse, not so great in a wife. She'd make my dad get up and walk around and be more active. After my father died, she married my helper Paul Simmons. Paul used to say, "I take care of twenty widow women. I fix their toilets and their light sockets and when I retire I'm gonna give you ten of 'em, but I gotta warn ya, they're all over eighty."

Aripeka is a dot on the Gulf coast fifty miles north of Tampa. It is very woodsy. I've seen bears, alligators, deer, lizards, herons, and rattlesnakes. I came down to the studio one morning, and in the corner of a new painting there was a small child's handprint in a patch of deep red I'd painted the day before. But the odd thing was, there were no children around, as far as I knew. I got down on my knees and looked really close at the spot—it was a raccoon's paw print. I left it there.

It's very lush, everything grows here; you can eat fresh vegetables year-round. Bears eat hearts of palm, fish, crab, and honey—not a bad diet. When the Spaniards came here in the sixteenth century, Florida was a thick jungle. I became interested in the Spanish explorer Cabeza de Vaca. There are arrowheads from several hundred years ago that I found when I built my house. I found three stone grave caches marked between three old trees. My son, John, dug around in there a little bit, but we didn't dig them up. We never pursued it. We thought we would let the dead sleep.

I wondered who Cabeza de Vaca was. There are no pictures of him, but I figured he must have been pretty ugly if the queen of Spain dubbed him Cow's Head. The story is that Cabeza de Vaca landed somewhere around Tampa; later he was shipwrecked. And things only got worse after that. He had a horrible journey. His clothes rotted off him, and because there was no food, his companions would stop and wait for things to grow just so they would have something to eat. They killed a couple of their horses to make water bags out of their skins, but then those also rotted and they didn't have anything to carry water in. Cabeza de Vaca was captured by the Indians for a few years, they made him into a sorcerer, and as such he actually did save the lives of some Indians. They thought he was a God. An archaeologist told me Cabeza's title came from his cutting the head off a cow and eluding his captors by putting it in a fork in the road.

The Gulf is full of ghosts—old and new. On Pine Island, when you swim across the creek and get to shallower water, you are swimming on top of Civil War wrecks, all broken up. Nobody knows that, only the good old boys. We used to have some treasure hunters around here; cowboys turned treasure hunters.

Aripeka is a place lost in time, but New York is never far away. The phone rings and Beverly, my saintly assistant, says, "It's New York, Jim—it's urgent!" For people in New York everything is urgent. Wherever I am is where I like to stay, but when I have to take trips to New York, my life and my wife Mimi's switches into high gear. We're out every night at an art opening of a friend or a party. It's hard to get any work done, but New York is where the business gets done. And where Mimi and my daughter, Lily, are, too. When you have a child, you wonder how they are going to

turn out. Are they going to be more like you or more like their mother, or turn into another entity entirely—which is inevitably the case.

Lily was born in New York City. When she was little I began working with Ken Tyler at Tyler Graphics, and we started renting summer places in Westchester so I could be near the presses. We were spending a lot of money on rentals, and since the price of houses was going down, we bought a nice little house there, inexpensively. Lily went to the local school and spent her childhood in the country. We had a swimming pool and a backyard—a healthy and homey life.

New York is full of sudden transformations. It's a place where a rapid sequence of events can change your world from one moment to the next and produce another completely unexpected situation. I remember one day in particular: I was twenty-three years old, working on the waterfront, painting a WELCOME sign. Next thing I knew I was having a beer and some English sailors asked me to come on board their ship. I went on board and listened to their life stories. I had a few drinks and said, "Well, cheerio, chaps!" and left. I got into this cab, the driver's name was Happy Day. "Wow!" I said, a little tipsily, "Happy Day, what a name!" I got out of the cab and went into a bar to make a phone call. As I entered, a fist went *woosh* right past my face, hit another jaw, and the guy went back against the jukebox. An old Irish guy said in a thick accent, "Sherm, ya shoulda done that twenty years ago." Next, on Fifty-ninth Street, I saw Charles Laughton walking down Central Park South wearing a cape, tights, and a beret. Later on I went to an art opening and met Man Ray. The day just kept going on and on like that—things were happening two by two.

But I'm always happy to get back to Aripeka. Aripeka is its own out-of-the-way realm, where the best place for information is the general store, run by Aripeka's unofficial mayor, Carl Norfleet.

It was here in Aripeka that the idea for *Masquerade of the Military Industrial Complex Looking Down on the Insect World* came to me. I was walking across the path next to my house and, looking down at my feet, I saw an army of red ants carrying on their organized insect life. And what connected the ants with the military-industrial complex? At that time Russian cosmonauts had been cir-

Collage for *Masquerade of the Military Industrial Complex Looking Down on the Insect World*, 1992. Color photocopies, printed cardboard, printed paper, and mixed media on plywood. 16¼ × 41⅞ in. (41.3 × 106.4 cm). Collection of the artist.

cling the earth for over three hundred days and they were wondering, what with the change in the government, glasnost and all, whether there would be enough money to bring them down. The poor cosmonauts thought they were never going to come home again because the politics had changed. They stayed in space for a year, but eventually the Soviets brought them back.

I connected the image of my looking down on the red ants with those Russian cosmonauts looking down on Earth from such a huge distance and contemplating their fate. I remember being on top of a building in Times Square in the late 1950s, painting a billboard. I saw a cop car turning the corner and being blindsided by an ambulance. From where I was standing, I could have told the cop what was going to happen. Altitude gave me the advantage. In space it's very simple: the one who has the high ground has control.

The satellites that now circle the earth and photograph every neighborhood of every city with such clarity mean that we can almost see the anthill as clearly as when we are standing over it. From such height you can control and kill, whether the target is ants or people. After introducing mustard gas in World War I, the atom bomb in World War II, the Strategic Defense Initiative during the cold war, the aptly named MAD initiative—mutually assured destruction—and Star Wars (a way of waging war from space, basically), we are well on the way to annihilating ourselves.

One day I picked up a copy of *Soldier of Fortune*, a magazine for and about mercenaries. I found it very disturbing; it put me in contact with the grim new geopolitics. They have two pages in every

issue called "New Site Reps," which really means "new problems arising in the world where you can find work shooting people." In other words, job opportunities around the world for freelance killing. You get to know world politics in advance. You won't read those things in your daily newspaper. It opens on to a distant reality of which we are not aware, this grisly underworld of murder and expediency.

Star Wars weapons were being developed around the time I was thinking about *Masquerade of the Military Industrial Complex*, but one only heard about it obliquely. I remember seeing Carl Sagan on television talking about companies that were interested in sending artificial intelligence out into space. AI had now become a military priority. But what exactly they were planning we didn't know because everything involving the government is such a secret. When I was little, my dad worked on this airplane that everybody whispered about, the B-29. Things like the Norton bombsight and the B-29 were the big secrets of the day. You weren't supposed to even talk about those things.

My idea of associating the military with the behavior of red ants was intuitive, but the connection turned out to be quite literal. Defense Department scientists have now begun researching the behavior patterns of insects and their lower brain functions in order to find out if human behavior can be modified through cell mutation. They want to see if human genetics could be altered to resemble the inbred characteristics in ants and wasps in order to create a robotic ability in soldiers to wage war. They are spending huge amounts of money on developing perfect animals.

Carl Sagan wrote a book about behavioral patterns in such lower forms of life as ants and wasps, and compared their patterns of behavior to those of humans. Insects are productive, all right, yet make the same mistakes over and over again. The common wasp, for instance, will kill a spider and put the carcass next to her nest to feed the baby wasp. When an experimenter removed the spider, the wasp simply repeated her actions and put the spider back in the same place. No matter how many times scientists rearranged the furniture, the wasp just went on repeating the pattern over and over again. In other words, the behavior of insects is hardwired— it's a question of programming, similar to the way a computer

works. You program a certain kind of software to perform specific tasks and it will do them exactly the same way each time you activate it.

That kind of behavior in human beings would be crazy. People don't keep doing the same things again and again—or do they? Our habit of polluting the earth is irrational and self-destructive, so why do we do it? Why are certain behaviors repeated? Could it be, as Carl Sagan was suggesting, because human beings have obsolete brains? Are we still functioning instinctively according to our vestigial reptilian brain?

For instance, when programmers create advanced software—which is the equivalent of making an artificial brain—their programs are often used by the military for massively destructive purposes. Most modern weapon systems won't work without computers, which is why the military is so interested in artificial intelligence. Computers allow things like Stealth aircraft and other advanced weapons to be developed. From a survival point of view, the insect is way ahead of the Stealth bomber.

In *Masquerade of the Military Industrial Complex Looking Down on the Insect World*, the central form looks like a Stealth fighter. But it's a paper glider disappearing through the economy. I heard the Stealth technology is based on complex angles that deflect radar in such a way that the plane virtually disappears. It's invisible to us because it's a secret, but also because it was built to be invisible (it can't be detected by radar), so you have this weapon that can rain death on civilian populations costing billions of dollars that can't be seen and runs on computer chips—artificial intelligence that duplicates the hardwired behavior of one of the most primitive forms of life.

The complex folding of the skin of the Stealth bomber would be impossible without computers to control it. In that sense, the Stealth fighter is a kind of artificial intelligence. The fact that human beings continue to make such devices is also a function of some kind of perverse hardwiring in ourselves. There's a craziness about it not unlike the thinking that informed the F-111 fighter.

I'd used fluorescent paint on *F-111* in 1965 and while I was working on *Masquerade of the Military Industrial Complex*, I began looking for fluorescent paints again. In the 1990s, the only place

you saw fluorescent color was on soap boxes in grocery stores, which is why I used the Gain and Tide detergent boxes in the background.

Just to the left of the Stealth fighter is a katydid breaking through its skin, pulling out of its old exoskeleton in order to metamorphose. It's leaving its eye behind along with its shell. To the left of the katydid is a line drawing of an American flag. Initially I'd planned to cut through the canvas and have light streaming out, like jet or rocket exhausts changing their direction, by using a fluorescent fixture behind the painting. But in the end I decided to make it work without using any electricity or mechanical devices.

The big red ball on the right side of the painting is a red eclipse underneath a red star, a fat Russian red star. On it are the hands of a clock—an actual little clock that works—which stick out like pointers. In the center of the sphere is an eye, the eye of the moon—an eye *in* the moon—and the canvas at that end is shaped to follow the curve of the red planet.

Along the lower central part of the painting there are dots used in tests for color blindness. These are, in a sense, technical colors, not emotional colors. I was trying to stay away from the emotional impact of color because I wanted to tone down the expressive content of the image. There has to be meaning underlying the image—even if the viewer doesn't know what it is. It's the psychic goo that binds the whole picture together.

In the end the painting took the form of a make-believe Stealth warplane looking down on the butterfly dissolving into a color-blind-test pattern against a background of one president's Star Wars and another president's trade wars. Where the rest of the butterfly's body would have been are more color-blindness dots, a living thing dissolving into mere optical pattern.

Occasionally, I reuse images—like the green pencils above the butterfly wing—because these things seem meaningful to me in various contexts. The pencils in this instance were like a propulsion system, meant to convey the old adage that the pen is mightier than the sword. *Masquerade of the Military Industrial Complex* is about the irresponsibility of sending our children out to be killed. The father doesn't go to war himself—he sends his twenty-year-old son.

I've always been more interested in the subliminal force of the image rather than the purely visual aspects (i.e., the subject matter).

My thoughts about the objects in the picture and the ideas that motivate my painting are different from the work itself.

It was another presidential election year that prompted me to paint *Masquerade of the Military Industrial Complex*. I painted *F-111* when Johnson got elected, *Horse Blinders* (Nixon), and *Star Thief* (Reagan)—those were my comments on the state of the Union at those particular times. Bill Clinton came into office during an era that had witnessed the moral and economic collapse of the military-industrial complex about which Eisenhower had warned the nation when he left office.

We are constantly confronted with visual conundrums. Ah! you say to yourself. Look at that beautiful mountain! But when you get there you see it's only rock and dirt. Or you're driving in your car and, unbeknownst to you, you have a spider in a cobweb riding along with you. There's rust, nuts and bolts, all this other stuff careening down the road with you. It's the realization that at any moment there are other things traveling with you.

Jasper Johns was an inspiration to me by showing that painting was a medium that could express ideas. Critics called his paintings "pictograms." At the time, students were encouraged to splash paint to get a reaction, and it looked decorative. Jasper put forth an idea almost in the form of a pictorial language.

I grew up in seemingly the most normal part of the country, yet it was a place where improbable things happened all the time. Early on this gave me a key to the enigma of American culture. I paint generic things to emphasize plasticity, not fashion, in the picture plane. My imagery may seem enigmatic, but there is always a story behind the pictures. Nothing is arbitrary in my paintings. If you ask me, "What is that? Why are there tubes of lipstick there?" or "Why is that dog climbing the stairs?" I can tell you exactly what got me off the chair to paint it.

People ask me why I paint. I don't honestly know why, except that when I don't paint I get cranky. Maybe I paint to prove to myself that I had an idea. Marcel Duchamp said, "I stopped painting because my paintings aren't as good as my ideas." But I've never considered retiring. Retire to what? What Castro said about writers—"Dictators and writers never retire"—could also be applied to artists. I still have dreams and nightmares, so I still need to paint.

Mystery Painter

THE HOLY ROMAN EMPIRE THROUGH CHECKPOINT CHARLIE

THE SWIMMER IN THE ECONO-MIST

POP CULTURE

ELEANOR ROOSEVELT AND THE PALAIS DE CHAILLOT

DICK BELLAMY

The art world has its own logic. At the Art Basel Miami Beach art fair you get to see a microcosm of it. There are some six hundred galleries there. The best thing about it is that you don't have to spend a millionaire's fare to fly to Zürich, Beijing, LA, or everywhere else on the planet to see all the art that's being made.

I was at Miami Art Basel a couple of years ago, and my friend

Marvin Friedman said, "Look, there's one of your paintings." It was an exact copy, really well painted, of my *Dishes* painting from 1964. But this was a painting by Elaine Sturtevant. I had Marvin ask how much it was and the girl said, "It's not for sale to collectors. This is only meant for a museum." So he asked again, "But how much are you selling it for?" "Seven hundred thousand dollars," she said. It was signed Elaine Sturtevant/James Rosenquist. In the whole show there may be a few gems but not many. The only things I wanted to buy were some Hans Hofmann drawings. He was brilliant. He used to draw with a twig dipped in the ink, like the old-time Magic Marker. Beautiful and realistic landscapes. His landscapes have an electric charge, almost like van Gogh's, I think. He did great abstract things, too, with colored crayons.

Twenty-seven years after I painted *F-111* people were still asking me to do another one. In November 1996 Thomas Krens, the Guggenheim director, suggested a possible commission along the same lines. Krens's idea was an updated version of the *F-111* mural. "But there's no way I can paint another *F-111*," I told him. "That was another time, and I was another person."

"Well, but you could do a big painting on the *scale* of *F-111*, couldn't you?"

I said I'd think about it.

This was around the time I finished *The Holy Roman Empire Through Checkpoint Charlie*. Ultimately the commission from the German developer fell apart because he had an accident in his Ferrari that crushed his foot, and I ended up owning the painting.

Shortly after that Thomas Krens called me up and said the commission for an updated *F-111*-type painting was set—he wanted it to go to the Guggenheim Bilbao. Now I began to think about Spanish subjects and Spanish painters—Picasso, of course. I heard that the Guggenheim had wanted to get *Guernica*, Picasso's monumental antiwar painting, for Bilbao. I had a thing about *Guernica*; I'd looked at it for years when it was at the Museum of Modern Art before it was returned to Spain. At first I felt that appropriating one of Picasso's most famous paintings would be an outrageous thing to do—how could I possibly touch *Guernica*? But then I thought, Well, Picasso repainted Diego Velázquez, didn't he, so why not? And so I thought I'd start off by incorporating elements from *Guernica*.

Soon after I'd started working on *The Swimmer in the Econo-*

mist, the painting originally intended for Bilbao, the destination changed. It was going to be in a new Guggenheim museum in the former East Berlin, which shares space with the Deutsche Bank building. Now that the work was to be displayed in Berlin, the use of the *Guernica* image in the commission had another, ironic connotation, since it had been the German Condor Legion that bombed Guernica in the spring of 1937.

At the press conference when my Deutsche Bank paintings were installed, they asked, "Why do you have this American guy put these paintings up here when you could have a good German painter do them instead?" Dr. Breuer from Deutsche Bank got up and said, "My dear fellow, the answer to that question is that we are forming an international collection here. We want to be like Paris once was. We want to embrace artists from all over the world, not just German artists. We want to be a cosmopolitan city."

I began work on the paintings that would constitute a three-part installation: I wanted *The Swimmer in the Econo-mist* to reflect the new Germany and the Berlin of today, not the divided city of the past. I thought about how I might also reconfigure elements from *F-111*, since this was how the commission had started. If my pop protest against the military-industrial complex reflected its time, I'd aspire to do the same for *The Swimmer in the Econo-mist.* How would it reflect Germany and the turbulent 1990s?

The title came from an image of a swimmer in a fog swimming toward something, not knowing where he's going but just swimming, swimming, swimming. It's similar to the situation you get into when you're involved in a fight. Before you're in the fray, you worry about getting into it, but once you're in it, you no longer think about it—you're in the thick of it. There's an old Venetian proverb: "The artist swims in the water while the critic stands ashore." I thought of the average German worker, maybe a laid-off steelworker from East Berlin, struggling, not knowing quite where he's going—a little like me when I began this project—but forcefully working, working, working.

Only a few years before, East Berlin had been such a horrible mess it looked like they would never be able to put it back together. I went back to Berlin a few years ago and East Berlin looked like the year 2025.

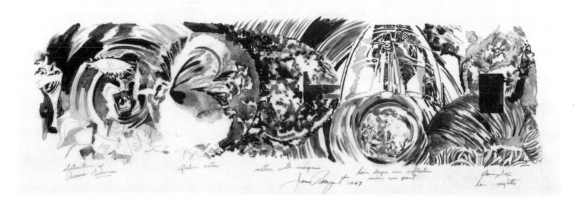

The Swimmer in the Econo-mist is a skewed post–cold war story of politics and economics, war and commerce. Nature and technology clash, and war and industry continue their old pact—the scaly collusion between politicians and industrialists. It's one I've told before—and not only in *F-1 1 1*—but this time it takes place in Germany after the fall of communism. I'm not a history painter, so there's no chronology, no sequence of events or even a linear narrative. I tell history in terms of fragments, the fragments butt up against each other, and the story gets told from the friction they create. I wanted to bombard the viewer with implausible juxtapositions.

On one level it's an allegory of a war weapon. In *Swimmer #1*, in the central panel, the plane on the left-hand side is a Stealth fighter plane. The black swirl next to it is the idea of liquid memory—how our memory is viscous, we forget things, we all suffer from cultural amnesia. In *The Infinite Sweep of the Minute Hand* and *The Hole in the Center of the Clock*, two paintings in my *Time Blades* series, I used the image of liquid memory again. In those paintings the clock face seems to be melting into liquid time, an analogy to the liquid memory of Dalí's *The Persistence of Memory.*

My father, born in 1908, saw the rise of the automobile, the airplane. He also lived through the two great wars. I had relatives in both wars; one was killed in World War II.

The way I finally figured out how to incorporate *Guernica* was as if it were being sucked into a time tunnel where it changes into a reflection that, in turn, goes into a meteor with an insignia on it.

Study for *The Swimmer in the Econo-mist* (painting 1), 1997. Lithographic tusche and pencil on Mylar. 16¼ x 45¾ in. (41.3 x 116.2 cm). Commissioned by Deutsche Bank in consultation with the Solomon R. Guggenheim Foundation for the Deutsche Guggenheim Berlin.

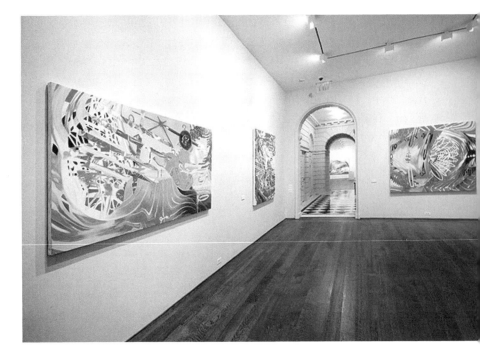

Time Blades, show at
Acquavella Gallery,
New York, 2007.

The idea of the meteor with insignia is that during the cold war and throughout my own history—the history of all of us for a number of decades—the threat of the bomb was imminent.

In *Swimmer* I set out to illustrate different kinds of fears that worried us: our involvement in self-destruction, our addiction to war weapons and brutality. The painting refers to a narrative of ideas of extinction: from hydrogen bombs, from a meteor, from ecological disasters or widespread hunger. Years ago we worried about the H-bomb, and then one day the Soviets turned their missiles away, but there were no celebrations. Unlike at the end of World War II, no mothers went out into the street and yelled and shouted. My uncle Tommy went out with his shotgun and fired off three rounds out of sheer joy when the Japanese surrendered. Well, this time nobody did anything. Still, it was a gigantic relief—for a moment—to stop worrying about the Soviet nuclear threat, though now there are new, more complicated dangers. But how do you alleviate these fears? You work toward something positive.

The Swimmer in the Econo-mist is semiabstract. I decided to use imagery people would recognize from the past. I made visual quotations from *Guernica* and *F-111* and then distorted them using an optical process I had developed to spin the images into a whirlpool

effect. It's a new device for me, really. It's like an exclamation that shows change, reflecting how everything has speeded up, how we are barraged with images, words, jingles. I utilized a visual device that looks like clothes in a washing machine, what people have called the "cosmic Laundromat" effect. In order to express the tumultuous tenor of our time, I needed a new vocabulary of momentum, speed, and immediacy to shake up the picture plane, to make it into a volatile surface strewn with black holes. While many of my earlier pictures were intentionally flat, here I injected a roiling propulsive energy into the painting, a new kind of pictorial velocity. It's a totally optical space.

I wanted the eye to swim through the kaleidoscopic images, get pulled into visual whirlpools; to make the surface unstable so the focus would zoom from close-up to long shot, from black-and-white to Technicolor. I wanted the viewer to get caught up in the welter of impressions, to make connections where none were explicitly stated, between the blurred fuselage of a supersonic fighter plane, a glob of black paint, fragments of Picasso's *Guernica* being sucked into a black hole, and a red meteor with an insignia on it crashing into abstractions of Kellogg's cornflakes boxes. Beyond that is a young contemporary German girl whose slivered face looks like a Slinky toy.

The price of supermarket cereal is one of my pet peeves. I put the cereal boxes in there because I have relatives who are farmers. Inside a box of cereal there's about six cents' worth of grain, and the box, when you buy it in the store, costs $4 or $5. Why is that? Which brings up a question I asked in some early paintings like *Brighter Than the Sun* or *Nomad*, which used a curved Oxydol box in Day-Glo and an atomic bomb blast. I wondered what was more powerful in a capitalist, media-saturated society: a hydrogen bomb explosion or the color of a soap box label?

I reuse images from previous paintings from time to time because they're part of my alphabet, rebuses for ideas I'm concerned with. In *Swimmer #3* I use the window from my 1977 painting *Industrial Cottage*, but here it's backlit with the colors of the German flag, representing a new dawn for unified Germany. The drill bits, also from *Industrial Cottage*, represent the heavy industry of the Ruhr Valley. The lipsticks are similar to those in *House of Fire* from 1981, but here they are melting and smearing.

The triptych as a whole deals with the differences between East and West Berlin when the wall was up, and how drab East Berlin was and how vital the West was. In *Swimmer #3* the little girl under the hair dryer from *F-111* (where she was a metaphor for the pilot and the economy that produced the obsolete bomber) is gone, but I used the hair dryer again (its surface reflects industrial buildings from the reunification boom). Here, thirty years later, the girl has become the widow who runs the world; she's an heiress on Wall Street. She holds the power and controls the world economy. Originally I had a man's image here. For a while it was just his hairdo, his brains were spaghetti—an early Franco-American spaghetti image—but I took that out.

There are subliminal memories in *Swimmer*. I think paintings should always have some element you come upon slowly or after time. The subjects of *The Swimmer in the Econo-mist* are also industry, consumerism, the chaotic nature of the economy, and Germany's identity problem.

Despite its apocalyptic imagery, *The Swimmer in the Econo-mist* isn't a doomy work. *Swimmer*, like *F-111*, is a diary of our times. It may seem tumultuous and dire, but at the end of the ninety-foot painting, things look more optimistic. I have a daughter and I'm sanguine about her future; we all hope that our children will grow up in a world without wars of ethnic cleansing. We all hope that the human race survives. I was going to call this painting *The Race*. It's a race, it's speed, it's racial, it's promoting the race regardless of what the race is. Race as in the human race, as in running a race. All of it. Like Thelonious Monk said, "All ways, *always*."

From the beginning of the twentieth century artists began incorporating bits of newspapers, tickets, ads, and so forth into their paintings. Stuart Davis, among others, painted ads, but somehow when it came to using these same things in pop art, critics started saying we were promoting the very products we satirized. Harold Rosenberg famously said pop art was "advertising art advertising itself as art that hates advertising," which was clever but untrue. The critic Donald Kuspit claimed that pop art, for all its supposed irony, "endorsed and embraced these mass images for the American world they signified—the infinite reproducibility of the images

suggested the inescapability and omnipresence of the world—thus putting an artistic stamp of approval on the American status quo."

When a company spends fifty times the money on advertising that it does on the product, something is wrong. We're bombarded with images, flooded with advertising, infomercials. Ads have always been around, but now there's more vapid noise and visual clutter. Now there are ten or twenty commercials during programs, instead of two. I'll turn on the TV to watch the news and I hear a commercial and turn to another news station and there's *another* commercial. Back to the first station and they still have commercials. You can't seem to wade through the commercials to get to any information. It's as if in our culture we're perpetually in a holding pattern over an airport and we never get to land.

Europe seems to lump American artists together no matter what era they're from. I remember when I had a show in London, they said, "Two Americans in town this week: Winslow Homer and James Rosenquist." I thought, Did they dig Winslow up, or am I dead?

In 1998 the French government commissioned a painting from me for the ceiling of the Palais de Chaillot. The Palais de Chaillot is on the Right Bank of the Seine in Paris, directly facing the Eiffel Tower. It was built for the 1937 World Exhibition.

I was called to Paris and brought Richard Feigen along to negotiate. We met with the Ministry of Culture. I asked if they had any thoughts. They said, "You know there are a lot of hungry people in the world." I said, "Yes, of course." The government was Socialist at the time, and they wanted some universal, uplifting theme.

I had very short notice for this commission and completed it in in four months. I had to finish it by the fall of 1998. It required eight pieces of Belgian linen canvas, 133 feet long and 24 feet wide, which they were going to glue to the ceiling—a technique they are experts at, having done it previously for Marc Chagall and the repair of a Eugène Delacroix. I started calling Belgium to find canvas, but everyone in the linen factories was on vacation.

I came back to New York and found just enough of this beautiful heavy Belgian canvas in Steve Steinberg's basement at New York Central Art Supply. I proceeded to go to work like crazy. The painting is huge—I almost broke my arm doing it. The idea behind

the picture was the fiftieth anniversary of Eleanor Roosevelt's Universal Declaration of Human Rights, which includes the right to walk across borders to avoid political persecution. The flags snagged on the barbed wire are refugees fleeing terror and oppression. The blue footprints are my feet walking across the canvas, symbolizing the long treks refugees have to take to avoid genocide and rape. I set to work and finished it by the end of November. The anniversary came and went.

The ceiling of the Palais de Chaillot was in a bad state of repair. They had to fix up the building before they could put the painting up, but they didn't have the money. It was still under construction seven years after I'd finished the commission. You do something for a government, they say they want to do this and that, but because they move with glacial slowness, nothing happens quickly. Months and years go by and little changes except for the arrival of a new flock of bureaucrats—at least seven ministers of culture have come and gone—who, since they hadn't been involved in the original commission, want nothing to do with you. As time went on I became more and more aware of the possibility that my mural would never get put up.

Since it was a ceiling painting, it led me to come up with another set of reasons to try to invent new pictorial devices for a two-dimensional surface. Although the ceiling of the Palais de Chaillot is flat, it presented another set of problems: I'm an old person and a young student of art. You learn something from everything you work on. I'd heard that Georg Baselitz paints upside down, but on a ceiling there is no upside down! For instance, if you're looking at a painting on a ceiling and something's upside down, all you have to do is turn on your toe and it's the right way up. Wherever you view it from, it's right side up. So it involved a whole other manner of composing. The solution was to work in circular compositions.

I put the lensless reading glasses in *Celebrating the Fiftieth Anniversary of the Signing of the Universal Declaration of Human Rights by Eleanor Roosevelt* because I read that the rebels in Central America killed anybody wearing glasses, since they thought anyone wearing glasses came from the elite, were intellectuals, enemies of the working people. It was also a reference to the Holocaust. Broken glasses in this painting are in memory of destroyed intellect, as they

are in *The Specific Target* and *Military Intelligence*. Military intelligence is a famous oxymoron.

Universal Declaration of Human Rights was a tribute to Eleanor Roosevelt, just as *Women's Intuition After Aspen* is about a woman's ability to think five years ahead. Women and artists have better insight into the near future than male politicians or bureaucrats.

I was invited to Anderson Ranch in Colorado to work on Adobe computers. They told me, "Bring some images of paintings, and maybe we can make them better and show you how to alter them using computers." I brought a photo of the painting *Women's Intuition*, but I quickly realized that the computers were slower than my thinking, and the changes that the computer made seemed to go backward toward the original compositional steps.

Computers have been a great help to architects because the software can simulate how huge hardware elements would fit in the design of the building. But in dealing with art, they don't always work well since computers leave their footprints on artworks. You see this clearly in ads from small advertising agencies.

In 1998, Dick Bellamy, one of my oldest friends and my first champion, died. He was just seventy-one. Dick was a Beat poet, a visionary, an artist with an artist's farsightedness who saw the world differently from other people, an innovator who first showed controversial artists like Donald Judd, Robert Morris, Claes Oldenburg, Lucas Samaras, and Richard Serra. Along with Leo Castelli, he almost single-handedly helped reimagine the art world after abstract expressionism.

At his funeral people said he was not a good businessman, and his gallery failed because he didn't make money. I got up and said, "You people just said Dick wasn't a businessman. In the first year he had the Green Gallery, it went from red to black in under twelve months. Paintings were flying off the walls." The gallery fell not because of business; it had to do with his emotional problems.

I remember Dick Bellamy and Bob Scull breezing into my studio in 1962. Dick and Bob were two very different personalities but they were both rogues with a mischievous sense of humor. They

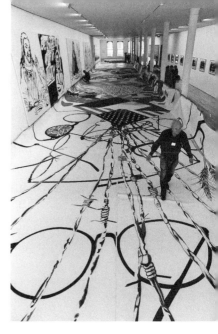

Walking on the 24-x-133-ft. *Celebrating the Fiftieth Anniversary of the Signing of the Universal Declaration of Human Rights by Eleanor Roosevelt.* We laid it out on an upper floor in the Guggenheim building downtown so people could look at it, since there was no wall space available that was big enough.

would be talking about the art galleries they were going to open and the names they would give them. "Show me the green" became the Green Gallery, and "Oil them up and steal their money" was the sly pun behind the Oil & Steel, the gallery Bellamy ran when he moved downtown. They don't make art dealers like Dick Bellamy anymore—dealers who are also poets and prophets. Dick came from a different era, one when art was a kind of bohemian religion.

The Speed of Light and the Shadow Boxer

In 2000 I began a series of paintings involving ideas about the speed of light. I've always been fascinated by the physics of light, the Einsteinian time/space continuum.

In the *Speed of Light* paintings I drew on Einstein's theory of relativity, in which he describes the different points of view of both a traveler in space and an observer. In these paintings, the spectator and the traveler looking at the same thing see it differently because of the light refraction. I connected this to the wildly divergent reactions to my paintings. I was always amazed at who liked what and why. I began to think that many supposedly sophisticated people were very naïve, whereas some of the people I had thought naïve had a sophisticated visual sensibility. Some people are visual—they see things metaphorically—and some people are literal. A literal person may be able to talk about a painting, but that person is often blind to the visual syntax of the picture. In my painting, what you see is what you don't get. What you get is what it is after it has changed. So, in *The Stowaway Peers Out at the Speed of Light* (2000), what people are looking at is something that has been changed by the speed of light in the same way that ideas shift in my paintings as you look at them. In this case I was melting objects into an abstraction. I was getting back to my pre-pop roots. Here I use it as another device to create the look of up-closeness from my billboard days. The idea was to make it look like a painting that then disintegrates into something else, an image changing form right in front of your eyes so that you don't know exactly what it is. I want people who look at my paintings to be able to pass through the illusory surface of the canvas and enter a space where the ideas in my head collide with theirs.

Since I was a child I've been fascinated with space exploration, probably because of my parent's involvement in aviation. Space travel is at the intersection between technology and imagination but, like anything the government or the military is involved in, it's an ambivalent enterprise—it has the potential for both transcendence and Star Wars type of destruction.

Science puts things in front of me that I don't understand at all. How do I react to such counterintuitive ideas? But that's very much like art. My paintings are accumulations of ideas and images through which I'm trying to propose questions.

The idea for *Stowaway* came out of a story I heard from a wealthy young South American couple. They owned a huge banana corporation and had their own ships. When they put the bananas in the ships they pump all the oxygen out of the hold to keep the bananas

from aging and prevent them from turning brown. Then they found they had this grisly problem: stowaways, hiding among the bananas, suffocated from the lack of oxygen. Naturally they were very upset by that and tried to guard against stowaways concealing themselves in the hold.

I called the painting *The Stowaway Peers Out at the Speed of Light*, because a stowaway is someone who doesn't know where he is going or if he is going to make it. A while ago, a guy from South America wearing very little clothing climbed into the nose wheel of a jet. The plane flew over the Andes and eventually landed at Kennedy Airport. He survived and ran out of the airport, but they caught him, put him on a plane, and sent him back. Then he did it again, and again they returned him.

In *Stowaway* I pushed my intrinsic interest in abstraction, in images without the baggage of images, and I pushed color and form around to create the most exciting surface I could imagine, trying to make light come out of a piece of paper. A piece of paper is white and blank, but if you put any multiplicity of colors in the right combinations, light will radiate from it. A couple of years ago I did a print called *Light Catcher*. It was, among other things, like light being poured from a cup.

I developed the swirling style of deconstructing objects in the 1990s and first used it in *The Swimmer in the Econo-mist*. It's a painted effect, it isn't computer generated. I like those old-school Hollywood devices. For instance, in the movie *Close Encounters of the Third Kind*, when the little boy opens the door, we see these big clouds rushing at him from the sky. How did they do that? They poured milk in a big fish tank, and as the milk dissolved into the water, the swirls of suspended milk looked like clouds, and they photographed that. This kind of invention always intrigues me— where you come up with imagery that befuddles the viewer. For my specific purpose these are the most effective techniques.

Any way I can make new images, I do it. I've done it with cameras, reflective materials, actual objects, and even totally abstract things. It's painted using an optical effect—what that is, I'm not saying; it would be like a magician telling his secrets.

Artists have different needs as they go through their lives and their careers. In a 1947 issue of *Life* magazine there was a big article on

I am in front of the office in Aripeka in 2002, with a mock-up of *It Heals Up: For All Children's Hospital* (2002).

Picasso. It asked, "Is he really a great painter?" There he was in shorts, this little guy, in a nine-room studio in Paris. He had done these big figurative paintings, and he had a new girlfriend, Françoise Gilot. The caption said, "His signature is the second one sought after by the GIs after Charles de Gaulle's."

The philosopher Isaiah Berlin divided artists and thinkers into two types: foxes and hedgehogs. Foxes, he said, are people who know many things, but the hedgehog knows one big thing. This would pretty much describe Jasper Johns and Robert Rauschenberg—Bob with his protean invention and Jasper's Zen focus.

Franz Kline was old school—even when those painters became famous and had money they didn't change. People used to say, "Hey, Franz, how're you doing, baby?" He'd say, "Oh, fine. I just sold a painting for a thousand and another painting for two thousand." And they'd say, "Then how come you look so bad?" So he bought a '57 Ford Thunderbird and parked it in front of the Cedar Tavern, but he was still wearing that old T-shirt and chinos, and then when people would ask him, "Franz, how are you, how come

you look so raggedy?" he'd take them out and show them the car. They'd say, "Oh!"

There was a totally different psychology to art in those days. I felt that I might never have a show, that it might be a long journey, and it seemed a definite possibility I might never sell anything in my lifetime. Art involved sacrifice.

Retrospectives are time bound and come about for practical reasons that have little to do with aesthetic movements or the history of art. Politics and money, as always, are functioning full steam ahead in the art world. They see big figures on the blackboard and they say, Let's give So-and-So a show.

My 2003 retrospective was the idea of Thomas Krens, the former maverick director of the Guggenheim. It began in the 1990s, shortly after I'd done the Deutsche Bank commission. I met with Tom, he asked me if I would like a retrospective, and I said sure. After not having had a major museum retrospective since Russia and Spain in 1991, I was thrilled.

Tom Krens is high, wide, and handsome. With him you never know what's going to happen next. He wanted to expand the Guggenheim all over the place—build a museum in Guadalajara, another in Singapore, another in Rio. When Rio fell through, Tom just steamed on. Some members of the board felt he was too much of an extravagant wild man and wanted to fire him, but in the end they voted for him because they *wanted* a wild dreamer.

While the Guggenheim was considering who should curate my retrospective, Don Saff took Walter Hopps to meet Tom Krens, and Tom hired Walter on the spot. Walter was a kind of maverick, too, a very well-known and brilliant museum curator, and the director of the Menil Collection. Walter was hugely instrumental in getting the retrospective together at the Guggenheim, despite being in poor health.

When I met Walter forty years ago, he was a tall, good-looking guy who was always full of energy and ideas, but when he showed up as my curator he was very frail. He had two pacemakers; he'd had an aneurysm and could barely walk. He said, "Jim, if I can't finish this, I'll find someone who can." Walter was a heavy smoker and couldn't function properly without his cigarettes, but the Guggen-

heim wouldn't let him smoke in the museum. I had my guys make scale models of all the proposed museums in my Chambers Street studio so Walter could plan and smoke to his heart's content.

The retrospective was a traveling exhibition of some two hundred of my paintings. It started off at the Museum of Fine Arts, Houston, and the Menil Collection in the spring of 2002, and from there went on to the Guggenheim in New York. In 2003 it traveled to the Guggenheim Museum Bilbao, and then to Germany.

Walter came to New York and worked unbelievably hard. In Bilbao Walter showed up to oversee everything, but by then his assistant, the radiant Sarah Bancroft, had taken over. By the time we got to Germany, Walter and I both had bad colds. He came home, lungs filled up with water, and he died in California. I heard he was very depressed at the end. I hadn't really gotten to know Walter until those last three years. He felt to me like the brother I never had.

The Guggenheim turned out to be a great space to show in; you could turn around and see all the paintings like a giant collage. As you looked up and down the museum's spiral ramps and across the open rotunda, it was, as someone said, like being inside a giant pinball machine.

How did I feel seeing thirty years of work in one place? I felt just the same as when I started, meaning I didn't know what I was going to do next. Well, I thought, man, here I am at a threshold again. Recently I was saying to Jasper Johns that I was having trouble with a certain painting, and he said, "It doesn't get any easier, does it?" But the paintings I have the most trouble with, it seems to me, are always the most interesting.

I got another commission in 2003 to do a painting for the Plains Art Museum in Fargo, North Dakota. This presented the opposite problem—how do you depict nothing? One idea I had was this: North Dakota's flat, the landscape is really the sky, the clouds and the sky. If you're standing in North Dakota, you look to your right and there seem to be clouds down to the left of you, clouds down to the right. It's is so flat you can almost see the curvature of the earth; you feel like you're standing on a dome. Which is why I painted the top of the earth seen from space at the bottom of the picture, North Dakota as a fragment seen from outer space in black, white, and blue. On top of that I put an Indian teepee sitting on a mound,

and hanging from the teepee is a cow's skull. North Dakota is float-ing around in space with cloud shapes, like a cow walking up a hill. For a long time I was looking for inspiration for the mural about North Dakota. I grew up there and my formative views were shaped there, but it was not easy to come up with something that was right.

How do you paint a state? A state of mind, now that's something I've painted many times. I spent a lot of time in a little farm town twelve, thirteen miles from Grand Forks, North Dakota, where my grandfather lived. When the Great Depression came along, my parents were always scrambling for work. They put me on the farm for the summer while they were searching for jobs and moving around. I used to play there, I picked potatoes with Mexican migrant workers, I shoveled wheat there during the big wheat glut of 1946 when America produced too much wheat. India had a famine, so all the farmers made out okay. These memories were all inspiration for the mural about North Dakota.

We all went to a one-room schoolhouse. Twelve different grades in five rows: third, fourth, and fifth grade were in one row because there were only two, three kids in each grade. The teacher was a son of a bitch who wouldn't let you go to the bathroom. Kids would put up their hands, but he wouldn't acknowledge them, and so some ended up going in their pants. The bigger kids, the farm kids, took him out and pummeled him with snowballs and beat on his head to be nicer.

We had to develop our own entertainment, which isn't like today where you have TV, movies, video games; you had to build every-thing yourself. I remember we played a lot of Monopoly in those days, listened to country and western, old-time country music. Hank Williams and Ernest Tubb. There was a junkyard with old tractors in it; you couldn't do much with that. I used to bring a big model airplane kit up there and fool around with it all summer. Occasionally, my grandparents would let me go into Grand Forks with them for supplies, and I would get to go to the movies. I'm telling you, I saw some really *strange* movies there in the 1940s: J. Arthur Rank British movies, some of the oddest films I've ever seen. I'd go to the zoo, but it was dirty and the animals were poorly taken care of.

Every two weeks, my grandfather would buy a case of orange

soda pop. If you were good, you got a bottle of orange soda pop or a lemon soda called a Lemmy ("Lemme have a Lemmy"). One time I was so hard up for a soda pop, I walked four miles in the heat through wheat fields to this little town, Mekinock, North Dakota. I walked into the grocery store and said, "Give me a root beer and a cherry soda and a Lemmy and somethin' else to go." Soda pop was a nickel in those days. Four miles was a long way for a little kid, and going back home, drinking these cold soda pops, my stomach was ice cold and it was hotter 'n blazes and when I got home, I didn't have one bottle left. I had to wait for the next case of orange soda pop.

In the 1980s I went back there and went into the local bar, and on the bar was a guy sleeping.

"Can you tell me where Gordon Hendrickson is?" I asked.

"Ya," he said, "you go down there to the first turn and then you make a right and you go down and make one more right, and they're right there."

But he never looked up at me. He was the town drunk, and there wasn't much of a town to be a drunk in. On my way out he says, "Ya, you must be Ruth's son then." He was the guy I bought the sodas from when I was little—he was the grocery store operator. Now he had a red nose and he was the town beer drinker.

Everything disappears with time, and when people die their mysteries go with them. I knew most of my father's side of the family going way back to the Civil War, but my mother's side, only a couple of generations back to my great-grandfather. My maternal great-grandfather was called Hendrick, and his son was called Hendrickson!

I recently found out some interesting things about my family. My father's mother died in childbirth at age twenty-four. She was a beauty, and my daughter, Lily, looks like her. Then my mother's mother, Gunda Stasted, died when my mother was about four or five, and both grandfathers took second wives and produced more children, so I don't have that much in common with my other relatives since my father *and* my mother were a different branch from the rest of the family.

And then there was my godmother, Thelma Quamie, who I was crazy about. She was quite large, and her sisters were pretty large, too. I have this memory of them wearing knit woolen one-piece

bathing suits. They were total sweethearts. Thelma Quamie's son, Jack, was responsible for getting me to do the Dakota mural. The landscape in North Dakota is the sky—the stars at night, the clouds in the daytime. At night I thought about the stars and light-years and the speed of light and everything that was sort of inexplicable. One could paint North Dakota as a question mark, because North Dakota seems to exist in my mind in a kind of dream light. But when I was there my feeling was always to leave and go somewhere else—it was a taking-off point, like my folks flying airplanes. A few years ago they gave me an honorary doctorate degree, and when I was flying out there, I picked up an issue of *The Economist* and there happened to be an article on North Dakota. It read, "North Dakota: excellent school systems." True. "Everybody gets high marks, they provide facilities for art and for science, everything in the schools." Then it continued, "But they lament the fact that after graduation they hang around North Dakota for two years and leave and never come back." They're gone. I was too.

North Dakota is very close to my heart, yet it's extremely difficult to visualize what that means. You have nature trying to struggle against the harsh winters, there are no mountains, just flatness . . . it's featureless and spare. Life is hard in North Dakota. When it gets to be winter in North Dakota things get brutal. Oil in your car will freeze if you don't keep the car warm.

Since you didn't have radio and you didn't have television, the old-timers would just sit and look out the window, because they were lonesome, and there was nothing happening. Gordon Hendrickson would just stare out the window at the white snow for days and days and days. It was grim. Someone would say, "Look at that! There's a baby blue coupe comin' up the road!" And the other old-timer would say, "What kind of a baby did you say it was?" These are the little things I remember. I had many great times in North Dakota, but because of that experience, I know I would never want to live in Australia, in the Outback, away from everybody. It's just too remote. North Dakota is just a very odd place. The state fruit is the choke cherry, the state drink is milk. Now, you can pick choke cherries and eat them fine, but if you put them in milk and drink it you choke. The state fish is the northern pike, a snaky-looking fish that has so many bones you can't eat it.

To develop a big mural painting, first of all you need some aes-

thetic ideas that are grounded. For me the process goes slowly, because I want to translate the aesthetic ideas into images. I can work and work and bang my head against the wall, trying for sparks, and nothing happens. Then I'll be here alone in my studio and suddenly in the middle of the afternoon, there it is. In two hours it's about done. Maybe that's because it's all been up in my head for so long. It's very peculiar. I've had tremendous ideas come one after another on a weekend and then nothing for a long time.

Ideas for paintings take a long time because I am dealing with thoughts that are general. My best ideas come to me while I am going to sleep, and if I don't write them down, I lose them. So if I think I've really got it, I get up and scribble it down, I don't care if it's one, two, three, four in the morning, I'll just scribble the scribble and then the next day, yeah, that's it.

When I was a teenager, I used to read adventure novels about World War II and characters who had tremendous adventures in the South Pacific and the Philippines. Then the war ended, and their lives seemed to fritter away into nothing. They no longer had a mission. This happened to my uncle Glen Strandberg, who was a medic; he treated prisoners from Dachau when the Allies liberated it. After the war ended he just wanted to get back to the farm. He's ninety years old now and he had a completely pastoral life. I flew out to see him for his ninetieth birthday, and there were about a hundred people at a ceremony to honor him at the civic hall. We went back to his house and had two, three whiskeys, and he said, "Betty, get my cigar box." So he got his cigar box and he pulls out this Nazi armband and he starts handing me pictures of piles of dead bodies in Dachau and I say, "Glen, this is horrible," and he says, "Yup." That's all. We're sitting there a bit stunned and the next thing he says is, "Oh, look out the window. Look at that little bird on the bush there."

North Dakota is as close to nothing as you're going to see, but there's nothing like nothing for generating ingenuity. My grandfather, now he was ingenious. He would chop a slot in the ice of the Turtle River, which was right near his farm, take the boards off the barn and stick them in there like a dam, then cut holes in the ice a little farther up and the water would push up and flood it into a nice, glassy surface. He'd flood it without any hoses or anything. He was always doing stuff like that.

Just beyond this river, which was like a stream, there was a barbed-wire fence with a gate in it. I'd go into the barn and look at the animals and I'd come back through the stream. One day it was nearing dusk, and I ran down to go through the stream, but somebody had closed the gate and I gashed my leg. They put this World War II medicine on it, where they crush up a sulfur tablet and pour it in the wound, and then pour kerosene all over it. Never sewed it up. I still have this big white scar right here on my thigh. My mother's brother broke his leg below the knee and never had it set; it was bent backward, and he left it that way. Many years later, in the 1980s, I went to visit him. He's sitting there in a pair of bib overalls, clean, with a little paint on them. I said, "Well, I guess you've been doing some painting then!"

"No, not lately," he said. "That was some time ago."

A pause, then he said, "Know what I think? I think that Jesse Jackson would be a good president, because he would be for us working fellers!"

I couldn't believe what I was hearing. Because all the men out there were Republicans (the women were all Democrats). I thought, Holy cow, that's pretty good! You can't put anything past them North Dakotans.

But I'm digressing, another habit I got from living back there in North Dakota where one thing inevitably leads to another.

My Uncertainty Principle

WHAT IS ART?

TIME BLADES

REMEMBERING ANDY AND ROY

THE DREAM WORKSHOP

All art is about feeling. Critics may talk about cool abstractionists and hot expressionists, but hot or cold, abstract or representational, it's all about eliciting emotion, otherwise we wouldn't do it. Josef Albers and Mondrian are often considered cold, analytic painters, but Albers's *Homage to the Square* paintings vibrate off the canvas like heat from a hot stove, and Mondrian's *Broadway Boogie Woogie* is about as kinetic as a painting gets.

Movies, from the very beginning, have affected painting. Many of Andy's paintings were like stills from a movie, and he treated his movies as if they were paintings. Film, with its cuts and flashbacks and close-ups, uses montage as its primary method of storytelling,

with image dissolving into image and sound superimposed on image. Experimental filmmakers like Stan VanDerBeek, Harry Smith, Ron Rice, Maya Deren, and Bruce Conner, who back then were experimenting with far-out effects, are only now influencing Hollywood. You see mainstream movies employing techniques that were once considered avant-garde. Audiences have become sophisticated at following the fractured trains of thought in movies.

Miles Davis's *Birth of the Cool* mirrored an idea in art in the 1950s and '60s: very cool things, nothing hot. But art students were still being taught to splash paint—in other words, to be hot. The style of pop art was cool—but how removed can you be from your own work, your own paintings?

On a flat two-dimensional surface, I try to paint layers and layers of ideas, and let them seep out as slowly as possible. In my paintings you only *think* you see it all instantly. I learned to make "all of the colors in the universe" from eight or ten separate tubes of Winsor & Newton. You really have to put the paint on heavy so it doesn't become dust in the future, because it's a very fragile surface. The new realist people used airbrushes, but an airbrush surface is fragile.

When *F-111* first started to enter my mind, I had begun to think of my life in our society as a joke. I thought, I know what I'll do, I'll make a painting that is a joke. I'll use an image of a not-yet-developed and already obsolete bomber and paint it in fragments. I still have a distance to go with paintings using fragments of realistic things. I'm thinking of going in that direction—things in the form of totally abstract prints. Leo Castelli used to say my paintings were composed of "fragments of fragments."

The traditional way of making oil painting is going the way of afternoon baseball. What's taking its place? Push-button pictures, pixels, photography, video, movies. Not only is the individual artwork vanishing, the materials for making oil painting are disappearing, too. They've stopped making my white paint! The paint that I was using at $125 a gallon has now gone to $596 a gallon. I told the supplier, "Forget it! I'm not paying six hundred dollars a gallon." I refused to pay that for white paint! But then what am I going to do for white paint? "Isn't anyone else making paint?" I ask. And now the government wants to cut out so-called poisonous materials like cadmium yellow and so forth, because they don't want kids to eat them. *Do* kids eat paintings? I heard one university is

eliminating its oil painting department because it doesn't want students to get poisoned, but, dammit, you're supposed to be a professional, to know to wear rubber gloves when you're handling toxic materials. I worked with white lead in the billboard days for years and years. I never got lead poisoning because I didn't get it on me, didn't eat it. Art is there to be consumed—but through the eyes.

I feel I was very fortunate in having to learn my craft well under pressure, being made to paint big advertisements in Times Square. If it didn't look good, you'd get fired in two seconds flat. One time I was painting a billboard for the movie *The Defiant Ones*, in which Tony Curtis and Sidney Poitier are two prisoners, a white guy and a black guy, escaping from jail. I remember the workmen carrying big images of the movie billboard out of the shop. Tony Curtis and Sidney Poitier were in chains, they were grabbing each other's chains so they could run, but it looked like they were grabbing each other's balls. So the boss says, "We can't let that go up like that with those two guys grabbin' each other's dicks! Rosenquist! Change that!"

In 1960 I went to an exhibition at the Michael Jackson Gallery called New Forms, New Media. At the time I was nowhere— I didn't know what I was going to do, what I was doing, or what I had done. The show was assemblage art, Bob Rauschenberg, Bruce Conner, moviemakers and so on. They had Bruce Conner's boxes with feathers in them and other strange objects. Bob had a painting there called *Winter Pool*, two canvases with a ladder up the middle. I thought it was like jumping in a pool of nothing, of emptiness, a winter pool with no water in it. It was on sale for $600. In 2008 the Metropolitan Museum bought it for $16 million. I wondered about that. Were they buying it for the content—it *was* an interesting piece of art—or were they buying it because it represented a specific moment in time in the art world, something from a long time ago that can't be retrieved or duplicated.

I remember years ago in the 1950s going to the Friday Night Club where painters would gather to talk about art, and the subject under discussion that night was: "Has the Situation Changed?" I was a young artist, I thought, I didn't know there *was* a situation in the first place—and now it's *changed*? After being around the art world for fifty years, I see it's ongoing. The situation is *always*

changing. It has all changed immensely with museums and exhibitions, the kind of art being produced.

Here's something that would not have happened even twenty years ago. The Guggenheim wanted to build a huge museum in Rio de Janeiro. They found someone to pay for it, $50 million, $75 million, $100 million. A staggering amount, so much money, actually, that the Guggenheim was going to siphon off some of the money to keep their flagship museum in New York running. But, just at that point, the Brazilian government stepped in. They wouldn't let them have the land to build the museum on. Why? Because there are too many starving children in Brazil—which is true. Now, the good part and the bad part is this: a single-minded guy wanted to do it and pursued it relentlessly, but you have a Socialist government with a serious concern about the welfare of children. I don't care about there being one more museum in the world, but it's too bad we can't build museums *and* help the children.

Museums continue to change as the world changes. You've no idea where your art is going to turn up. I heard my painting *The Stars and Stripes at the Speed of Light*, for instance, was on the cover of the telephone book in Dubai.

In November 2007 I had a show of paintings on the subject of time at the Acquavella Gallery called Time Blades. I had begun thinking about Time, time with a capital *T*, a few years earlier. While my retrospective was being installed at the Guggenheim Bilbao, my curators, Walter Hopps and Sarah Bancroft, took me to see some Paleolithic drawings in a nearby cave. They were very sophisticated. It left me with a strange feeling, and after that I knew I had to ask myself a few questions about time. I wasn't looking to answer questions, I was just trying to ask them: How do you use time? What do you do with it? Simple questions that lead to ideas about perception. I saw six drawings there. The ancient people who made them came from a period with a sense of time utterly different from our own. No clocks, no sundials, just the sun and the seasons. But what connects us to them is their desire to leave a mark. I came out of the cave and realized I was, for a moment, looking at the world with Paleolithic eyes.

The play of words of *Time Blades—Learning Curves* refers to

one's first experience of time as a child: school. Time is tough in school; you're under the gun, you're being tested against the clock. You also watch the clock to see when class is going to end—it's your first exposure to time as a constraint. The saw blades in *Zone*, *Time Blade*, and *The Hole in the Center of the Clock* represent this idea of time cutting like a saw. The title *The Chains of a Time Piece* is negative, but I also see the chains of time as a metaphor for change. With art, books, and movies you get a chance to reimagine time. Film montage and collage create a new sense of time, they throw the viewer into a new time loop.

According to Einstein there are no straight lines in space. Everything bends; in space, even time is curved. In *Time Blades—Learning Curves*, for instance, you might ask what you are actually seeing. Why is everything in the painting distorted? These aren't distortions, they're metaphors for the curves of space-time.

A couple of years ago I heard a scientist talking about time travel today, and they asked him, "Do you think you can go into the future and go into the past?" He said, "Well, the laws that exist now in physics according to quantum mechanics could allow you to go into the future—what you would need is a rocket ship that could achieve the speed of light—we don't have that yet, but the physical laws exist, according to Einstein's theories." But he didn't think it's possible to go back in time. And if you went into the future, you wouldn't be able to get back; you'd be there forever.

Taking an idea like time travel as a starting point, I developed a theme for a series of paintings. When I was done I could have written a dissertation on it. It's about the elusive aspect of time. I think in the future there are going to be intense investigations into the nature of time—and the results will be more counterintuitive than we could ever imagine.

In *The Infinite Sweep of the Minute Hand*, I put a laser clock in a slot at the top of the painting. From here the hands of the clock project across the room to the opposite wall. The farther away the work is, the faster the hands sweep across it, the greater the distance they cover. Or, if the hands of a clock in *The Hole in the Center of the Clock* project into infinity, the distance between the two hands as they project out into space will be colossal, even if they connect at the center. So, if you were to go back to the absolute

center, maybe nothing would move. Maybe time would stop and the earth would fall into orbit around the hole in the center of the clock. Thus, while nothing is happening at the center, the hands of the clock are sweeping across an infinite amount of space somewhere on the edge of our comprehension.

Scientists may project ideas about the fourth dimension and the space-time continuum, but art isn't science, and in the end what I'm dealing with are just pictures.

I've done quite a few paintings that deal with time *and* light. In 1966 I made this experiment: you are looking at a mirror in a room, the lights dim slowly as you keep looking in the mirror. Pretty soon you will only see shadows and shapes and then nothing. Now at that point there is nothing in the mirror at all, but still you see what is psychically there. The lack of light and the diminution of energy generates imagery in what is just a dark spot, a nothing. It is a very peculiar thing, something that happens without your even thinking about it.

People look and say, "What are we doing here? What the hell is this?" What happens is the energy reflected from the mirror starts to disappear and energy from the human being takes over. It then becomes your imagination that projects things. Some people ask if it's some kind of trick, others are alarmed. They start seeing demons in the mirror, fiends materialize in the emptiness. They project what they think they are looking at. If you were to turn the light all the way off and then point an infrared sniper scope on the area of the mirror you wouldn't see anything. It would be a flat back. Why? Because there is no energy coming off that mirror. With thermal scopes you get heat energy coming off bodies—which registers as a green image.

I intended to make a painting using this idea for a show at the Castelli Gallery in 1966. This was when Larry Poons had canceled and Leo asked me if I could put together a show in one month. In that exhibition I showed five pictures with this ensemble idea. I had bought a sniper scope from the Korean War and my idea was to do a painting of a lady holding a makeup compact with a big mirror in it. The viewer would aim the sniper scope at the mirror when it was daylight and then again when you turned the lights off—and nothing would be there. But due to the brief amount of time I had to get

the show together, I was unable to create a painting that would effectively convey this idea, so it remains, like the image seen through the sniper scope in the darkened mirror, invisible.

The passage of time brings about strange coincidences, unexpected ironies. Because of Chernobyl and how F-111s were used in a retaliatory strike on Libya, my work suddenly seemed relevant and contemporary. When I painted *F-111* the bomber hadn't been built, but by 1986 it was in action.

Then there's time in the long run—on a personal scale. One day you realize you may only have so many years left and that you'd better hurry up if you want to get what you've been planning done. Now I think about time more and more. There's nothing like having physical problems to remind you of time and mortality. In 2006 I had so many procedures I felt like a marionette in the hands of four different doctors. I was also at a crossroads in my work. I had two projects started, so I was worrying about these projects and my health. Fortunately, Rauschenberg's doctor, Dr. Aledort, took me under his wing in July and scheduled me for two operations on the same day. I went up to New York. Now I have two titanium knees by Dr. Russell Winsor and can do anything I want.

Many of my earlier paintings from the 1960s and '70s had private images in them, they related to intimate things in my life. They were sort of an autobiographical alphabet, but my more recent ones—the Time paintings—aren't anecdotal in the same way; they're more abstract, theoretical. They're about things I have only a vague notion of.

When I took up the theme of painting Time again, I had to think of something pictorially unique—and for that I knew I'd have to invent a new pictorial language. Something that had nothing to do with computer-generated images. I'm not a fan of CGI or any other digitally created or pixelated pictures; they always seem empty and vapid. I'm much more interested in creating illusions using physical, tangible elements.

One of my Time paintings has a clock in it; it's called *Speed of Light Illustrated.* It's a little far-out. "What do you mean, speed of light?" the viewer may ask. I could describe it. I could give them a long, dopey explanation; instead I gave it an enigmatic title and let

them figure it out. Then again, Time might have been too big a subject to bite off. "He's painting *Time*? Who does he think he is?"

In my new work, I have pictures involving images from outer space in them, because to me, space is a very abstract thing—star novas, black holes, solar wind—these are imponderables. Cosmological questions are hard to comprehend, so when I use images of outer space in a painting, it's to represent something incomprehensible—like the future. Most people relate to the future through experience. To get a handle on the future they look to the past. People commenting on my recent work will say things like, "This painting is very nice, it reminds me of Joseph Stella." Joseph Stella was a 1930s artist who painted industrial American landscapes. People need the past to anchor their opinions, but I'm trying to imagine what the future will be like *without* all the baggage of the past. What I'm trying to do has nothing to do with Joseph Stella or Stuart Davis or anyone else.

I continued to pursue themes of Time, Space, and so on for a show at the Jablonka Gallery in Berlin in September 2008. In dealing with an elusive concept like Time, I've been forced to come up with devices. *Time Stops the Face Continues* has a mirror mounted on it, a motorized mirror that spins. While working on a new series of Time paintings I discovered this bizarre phenomenon: a spinning mirror reflects what's in front of it without distortion, yet if you paint numbers on its surface, they blur and disappear as the mirror turns. The mirror spins, the ground is whirling, energy is coming off it while the numbers on the clock turn into a rainbow of blurred colors. It's so peculiar because the ground (the surface of the mirror) remains the same, yet everything on it physically changes.

As time goes by, memories drift into your head. All the things that are lost and gone. I remember way down on the Lower East Side there used to be these big carved marble dishes for watering the draft horses, put there by the Humane Society. They must have weighed hundreds of pounds, beautiful smooth stone troughs. That's another thing that's gone—along with the horses. The dust of time covers up the memories of everything. In Aripeka there's buried treasure, bones, and Spanish armor; old, archaic things, but nobody knows exactly where they are—those things get lost with time.

I've watched quite a few of my friends depart—Dan Flavin, Donald Judd. It was a great loss to me when Andy Warhol died. Then, ten years later, Roy Lichtenstein went. The poor son of a gun died as the result of a horrible hospital-induced disease, MRSA. That was such a waste. He was only seventy-five, and basically a healthy guy. I could imagine Roy as an old man like Matisse in a wheelchair, still working on his paintings. He had walking pneumonia and checked into Southampton Hospital. When they put him in an oxygen tent, he said to his wife, "Well, here I go." Those were his last words.

Andy, too, died from an unnecessary hospital malfunction. He second-guessed himself. When you hire your own nurse in a hospital that already has assigned a nurse to check on you, they cancel each other out. In Andy's case, each nurse thought the other was monitoring Andy, and in the end neither was on duty when a problem arose.

Many of my old friends are gone now. I have a hard time dealing with the fact that they're just not there to talk to. I can't call them up for a rabbit-skin glue recipe anymore. I think of my old friends as libraries of information that kept my sanity. People a lot younger than me are gone, too. Jean-Michel Basquiat I knew fairly well. He called me and complained about how the critics said his work was terrible. I had an answer for him, but then he killed himself with drugs. When I went to his retrospective at the Whitney, I thought, If he had seen his own retrospective, he would have said, "I'm not that bad, I'm not bad at all, I can keep going." I don't think that artists really see their own work clearly until it's shown to them later because it's all in their head.

Even though I'm always linked with Andy and Roy, that doesn't mean we were all pop artists. Andy and Roy *were* pop. They were pop not only in that their themes were about popular culture, but because they used the techniques and imagery of pop culture. They were magicians of ephemera, bottling something evanescent until they made it visible.

But, like Rauschenberg and Johns, I have never thought of myself as a pop artist. Rauschenberg and Johns, although occasionally thrown into the pop art soufflé, are clearly not pop artists at all. And I am, if anything, more a product of advertising than pop culture. I use pop imagery as a kind of homeopathic device to provoke

the viewer, to confront the viewer, to goad the viewer into questioning his or her own responses to the assault of junk images that numb us.

Andy, I think, was fascinated by the phenomenon of the incessant turnover and disposability of pop culture. He was interested in acceleration in and of itself. He was mesmerized by speed, with the idea of something that at first you see and then you don't—things, images, people appearing and disappearing in quick succession. A fast, preconscious identification and it's over. Like the news, like fads, pop songs, stars; things that run grooves in your synapses and fade.

But the term *pop art* has stuck like the word *cowboy*. Who wants to follow a cow? I'd prefer not to classify myself. They were doing a movie of me last week here and they asked, "What music do you want in the film?" I said, "Nat King Cole Trio, Rusty Bryant, Les Paul and Mary Ford, early rockabilly, and especially jazz." In the 1950s jazz musicians were heroes, and I met a lot of them working in Times Square.

With Roy Lichtenstein at a showing of *Time Dust* (1992), Gagosian Gallery, New York, 1993.

In the same way that a group of scientists drifts farther and farther apart while progressing in their various fields, what was once seen as a group of artists can also drift apart. Critics and art historians establish a theme for a group of artists who emerge at a certain point in time and give them a name. They're called X, say. Then, as time passes, they split off in all directions, and you can no longer classify them with the original group because they've become so different. They are now seen as X, Y, and Z. That's the situation with Andy, Roy, and me. Take the abstract expressionists. The differences between Mark Rothko, Jackson Pollock, Bill de Kooning, and Barney Newman are so big that these people might have been from different schools entirely, but they were all grouped together as abstract expressionists. The diversity in these situations was often more important than the supposed similarities. Same thing with pop artists.

If an artist is allowed to live long enough, he gets to see a great change. George Segal, for instance—is he still considered a pop artist? Even back in the 1960s, he was hardly ever included in shows of pop art. He had something in common with pop, but essentially he was quite different.

When I come back to New York from Florida, I often tell myself

that I'll stop by Andy's Factory or go and see Roy, to check out what mischief they're up to—and then I remember. I feel like an old boxer who no longer has any sparring partners. After Andy and Roy went, I was left shadowboxing with myself.

May 13, 2008. Bob Rauschenberg died last night in Captiva, Florida. He'd been there about forty-four years. He was the inspiration for me to come down here. So many things come to mind after Bob's death. In his work he shot from the hip. He liked to encounter things without planning, the images just collide accidentally. That was Bob's modus operandi. It was at the point of doing it that he discovered whether he was making art or not. For him it was a kind of magical encounter, it's a John Cage idea, too: chance.

Around the time he moved to Florida he also bought a building in New York for about $65,000. It was an old Catholic children's home that he got from Jack Klein. Jack was a tough real estate guy, a wild guy who once got so stoned he fell into a cactus plant wearing only his bathrobe and had to have hundreds of cactus spines pulled out of him with a pair of pliers. All these great characters were constantly crossing paths in the old days of the art world in New York. Early on in his life in New York, Bob lived in rough places, cold-water loft buildings where it was really spare. He didn't mind any of that; he devoted his life to his art. He was used to getting paint all over him, having a few drinks, and going to bed with the paint still on his clothes. I think it must have been then that it dawned on him that his lifestyle—working, drinking, painting, and flopping down flat on a mattress on the floor (which he did!)—was indistinguishable from his art. That's the way he lived—rough. He probably got up in the morning, saw his bed with paint all over it from his clothes, from the night before, and he decided to make a connection from his bed to his art! I can't answer how and why he splashed paint on that bed, but I'll tell you one thing, it became one of his most emblematic works of art because it perfectly illustrates his famous saying: "Painting relates to both *art* and *life*. Neither can be made. I try to act in that gap between the two."

Where did all this wild energy and invention come from? I know that when Bob served in the U.S. Navy he worked in the psychiatric ward of a navy hospital. I don't exactly know what that did for

him, but it could have sparked his genius in some way because crazy people aren't stupid, in fact most are brilliant.

He was one of the most generous artists. I'd known him since he was thirty-three years old, when we both used to do window displays for Tiffany and Bonwit Teller. One time, I had to make a plaster cast of a tree trunk in Central Park, and I asked him, "Where do I get that plaster for broken arms?" And he told me. Another example of Bob's generosity: when I was in jail for protesting the war in Vietnam with another artist who had phlebitis in his leg, Bob gave him $500 or $600 from his foundation, Change Inc., to have his leg looked at. Before that, they were going to amputate it, but because of Bob it didn't happen. Artists have a hard time getting credit cards, getting any credit. Bob had done that kind of thing many times, giving small immediate grants, which were especially appreciated because the artists didn't have to wait for them.

Bob could make art out of any damn thing, anything at all! And he could make money out of nothing, too. You look at the stuff he found on the street that went into the combines. He made incredible assemblages out of utter junk, just stuff. Bob was inexhaustible. He could do a whole show in one week; he could do things like that not because he had things worked out, but because he'd developed a method for making images. He would take photographs—he'd never edit them—have them blown up into four-color-process silk screens, and then screen them on big canvases in a collagelike style. The process became so smelly and so toxic he had to work out a way of doing it using vegetable dyes in the four-color process, and because they were water based he could change them by wetting them and washing them. When I was in his studio in Captiva in early 2008, he had just installed a new, sophisticated printer so he could juxtapose disparate images from his catalogs of photos. Once they got on the canvas, it was wide open—he always pursued the accidental, qualifying nothing, just *doing* it.

One time I was flying from Florida to New York and he happened to be on the plane. I said, "Hey, baby, how're ya doin'?" And he says, "Well, I'm bringing seven drawings to Ileana Sonnabend to sell at a thousand a piece. I have to pay my mortgage, I have to pay for my houses." Well, Ileana sold them later for forty, fifty g's a pop. He could take anything and make art out of it.

He would say there was no such thing as art, or everything is art—in other words, if you talked to him, you talked about all the stuff that *could be* art; he was one of the brightest inventors around. Ideas and concepts that would just blow you away would flow out of him. He taught me that one shouldn't try to second-guess things, just *do* them and see what happens, be surprised or not. When he'd have an exhibition, he'd show *everything* that he'd done recently. Sometimes because you wouldn't quite know where he was going with it. Then there'd be other stuff he'd do which was just genius, incredible things.

He would have turned eighty-three in October. One of his problems was he drank a quart of Jack Daniel's every day of his life for sixty years or more, but oddly enough, his liver turned out to be in pretty good shape, considering. He was in Betty Ford for a while, drying out. I had dinner with him the night he got out—and almost immediately after that Bob was back with a vengeance.

When I saw him last I really thought he'd make a comeback, because I'd seen him at such a low point a few years ago. He'd caught that hospital infection, and I was afraid he was going to die then, but he came back as strong as ever.

It's strange to think of him gone, he hated even the idea of death. He wouldn't go to his best friends' funerals: he wouldn't go to John Cage's funeral, he wouldn't go to Andy's. He was very stubborn. His hand was contorted and it didn't need to be that way. His old doctor said, "What's the matter with his hand? It shouldn't be like that. It should be working." If he had done a little therapy, he could have gotten some use out of it, but he was so stubborn, you know, he lived his own life, drank his own drink. Within the last two months of his life he hired Ricky Martin's jet and flew to Portugal, had a cardiac arrest on the plane, and two nights later he was drinking wine at a party there. His doctors were stunned: "How did you do that?" Then he hired Ricky Martin's jet again and flew to Valencia, Spain, and back to the States again. More cardiac arrests, but he went to Washington for a dinner where he choked. They threw him on the floor to resuscitate him and broke his shoulder. All kinds of things were wrong with him and they finally all hit him at once.

I went down to see him the Saturday before he died; I hardly recognized him. I stayed with him for quite a while, I held his hand, I

didn't say much. When I left, I said, "Bobby, I'll come back in the morning before I go home." I went back the next morning and he'd improved! In one day. He was a little more lively, even though he was heavily drugged. He saw me and three of his other best friends there: Billy Goldston, Don Saff, and Bennet Grutman, so he perked up. Then he whispered, "I want to go home." I heard that when he went over the bridge to Captiva, he said, "This is the best day of my life."

One time I was going to Captiva to visit Bob. I'd brought him a case of Jack Daniel's, but then I thought, No, I don't think I should do that, he's drinking too much already. So I put the booze in my trunk and I bought him a roll of diaphanous material, and soon thereafter he started printing images on it and made many shows using it—it was like making art on air.

Bob's birthdays were always a lot of fun. One time I didn't have any money, and I thought, What can I give him? I found a discarded ladder on the street and I got a candle and put it on the ladder and I brought it to him and I said, "Happy Birthday!" A ladder so that he could go *up*! He took John Chamberlain's kid and put him on his shoulders and he blew out the candle. At the party were all the midgets from the movie *Mondo Cane*. A typically wild and strange party.

Another birthday was in a restaurant, but this time Bob was in a bad mood. He looked at his glass and said, "Well, I hope you all got what you came for!" Something like that. So I ran out into the parking lot, picked up this stone (it weighed about a hundred pounds), put a candle on it, ran into the restaurant, put the stone in the middle of the floor, and I said, "Hooray for Jackson Pollock!" That broke him up, he started to laugh, it broke his mood! He was always raucous, he was a party guy, he would show up at a party at the drop of a hat. When I had my retrospective in Bilbao, Spain, he showed up in his wheelchair! I couldn't believe it. I said, "Bobby, what are you doing?" He says, "I came for the party."

I'll tell you one more Bob story. We were at the de Menils' for a black-tie party. Bob, Andy Warhol, Marisol, Henry Geldzahler, and me. So was a guy named Thom Jones, not the singer—a poet. He kept buttonholing everybody and grabbing their collar and reciting his poetry to them. "Bob," I said, "I'm tired of this fucking guy buttonholing me all the time, so I'll get down behind him and

you push him over." Bob says, "Okay." But in the end it didn't come to that. We left and went down to Saint Adrian's Company bar, which had opened up down the street from the Cedar Bar. We walk in and there's the minimalist Carl Andre: "You're no fuckin' good! Both of you stink!" he says to Bob and me. "Your work is shit!" He's going on like that, so Bob gets down behind him, I push him over. Rosemarie Castoro, Carl's wife, comes up fighting, punching me. Carl says, "Rosemarie, it's okay, don't hit him! Don't hit him! It's just a *conceptual* argument."

I'll miss Bob's impish presence, his mental agility, his startling intuitions. He would say the most amazing things. He could transform the whole moment in the blink of an eye. He approached his art as he approached his life, as an accidental encounter. Like the old billboard painters' slogan goes, "We do good work and there's no demand for it and there's only a few of us left." So, here's to Milton—that's his given name, Milton Rauschenberg! Hey, man!

I try to live in the present, try not to dwell in the past. I'm always excited about new projects. They make me feel like I did when I was at the beginning of my career. Aripeka is a place for new things; it's not nostalgic. I want to live like Picasso—you know, simply, with a goat in the living room. When you don't have many trinkets, it's easier to develop new ideas. The looser you are, the further out you go in terms of emotion and feelings, the better it is for your art. Every painting is a projection of yourself, no matter how abstract it is. Every painting is a self-portrait.

I learn from every new painting. When I begin I always think, How the hell am I going to paint *that*? Sometimes I think that it's going to take me forever to do, but I end up doing it in the blink of an eye. Other times I think I'm just gonna knock out that one section and it takes me a day, *an entire day*. I prepare, mix all the paint, get everything ready, go at it with the best Harmony Fitch brushes, and see what happens in about two, three, four hours. And all of a sudden, it starts to come to life.

On April 25, 2009, a forest fire swept through my property in Aripeka, destroying everything in its path. After it burned out, nothing was left of my house, my office, my studio, and sixty-two acres of lush vegetation. That Saturday I'd taken a long drive and

by the time I got home everything was going up in a cloud of thick black smoke. The firemen were already there trying to save the house, but once a propane tank blew up in the studio, the house went with it. A fireman almost lost his life in the blaze, but luckily no one else got hurt.

The heat was so intense it melted outboard motors, cars, and machinery into puddles of metal. A car sitting in a driveway turned into a pile of white ash. The destructive force was just unbelievable. Nothing was left but ashes.

Buildings you can replace, but the worst part is the trees are gone. The whole area looks like a bomb hit it. A few buildings on the property survived the fire. I moved into the little guest cottage on the canal and the stilt house I built at the end of Shine Lane is now a new office. My assistants Beverly Coe and Charlotte Lee like to come to work there, because, unlike the old, dark, cavelike office this one looks out on a primeval forest and a salt marsh where manatees swim up to the dock.

Long after the fire I was in shock, trying to pull the whole thing together in my mind: the things that got burned, the things that got lost. You never know how you are going to react when something like this happens. You try to think about the good things. I don't have to worry about all those possessions anymore: a collection of old cars, paintings, all my prints, maquettes—so many things. I haven't really gotten my mind around it yet. Now and then I miss things I haven't even thought about. My daughter, Lily, was making papier-mâché animal skulls in school, and I said, "Lily! I have a beautiful cow skull with horns I'll send you," and then I realized, "Whoops, no I don't." Or to people who have been helping me repair down there, I say, "Hey, man, I'll send you a print or a poster." And then it dawns on me that I don't have them anymore. Fortunately I have many of my paintings stored in Manhattan, but my print archive is gone.

What it really means I don't know. Is it going to mean a pause, or is it a way of saying: "Don't be complacent, get off your ass, do something else, no matter what that else is—don't just slide into infinity, get going again!" My crew in Florida—Kevin Hemstreet, Daniel Campbell, Beverly Coe, and Charlotte Lee—and my wife, Mimi, have all been very enthusiastic and inspiring, telling me, "Hey, we'll get this back together; we can do it."

We're going to enclose the area underneath the stilt house and make a studio there. I'm going to try to have a show at the Acquavella Gallery in the fall, just as I'd planned before the fire. About seven new pieces got destroyed in the fire, so I'm going to redo them. I'm going to call the show The Hole in the Center of Time—Memory of a Fire.

I'm pressing onward, trying to keep going and rearranging my life. That's the objective, to keep my sanity. Like the jackass with a banana dangling in front of its nose, I keep going for it. All I need is some new fire inspirations. I doubt I'll ever rebuild the place—it will never be the same because the foliage is destroyed. Everywhere you look, it's just white ashes. The Forestry Department warned me to be careful, to stay away because those burned-up trees are going to fall down. We put up a huge sign on the gate that said DANGER: STAY OUT.

But it's been raining in Aripeka. The ash is like a fertilizer that can make things grow again. Just this morning Charlotte called to tell me that leaves are sprouting on the top of the scorched cabbage palms. I don't expect my hair to grow back as well, but at least some things *in* my head are stirring again. Perhaps it's a sign.

There's an old saying, "If you hang around long enough, maybe something'll happen," but strictly speaking that isn't always true either. I feel lucky that I've been able to make a living from painting any idea that comes into my head. When I make those paintings and put them out on that roadside stand, all I hope is that they'll surprise people enough to slow down, take a look, and say, "What in heck is that Rosenquist up to now!"

INDEX

Page numbers in *italics* refer to captions and illustrations

James Rosenquist has had more than fifteen retrospectives, with two at the Whitney Museum of American Art and four at the Guggenheim Museum. He also has had many gallery and museum exhibitions both in the United States and abroad. He divides his time between New York and Florida, where he lives with his wife and daughter.

David Dalton is the author of some fifteen books, including *James Dean: The Mutant King* and the novel *Been Here and Gone*. He lives in upstate New York with his wife, the painter Coco Pekelis.

This book was set in Janson, a typeface long thought to have been made by the Dutchman Anton Janson, a practicing typefounder in Leipzig during the years 1668–1687. However, these types are actually the work of Nicholas Kis (1650–1702), a Hungarian, who most probably learned his trade from the master Dutch typefounder Dirk Voskens. The type is an excellent example of the influential and sturdy Dutch types that prevailed in England.

COMPOSED BY
North Market Street Graphics, Lancaster, Pennsylvania

PRINTED AND BOUND BY
RR Donnelley, Harrisonburg, Virginia

DESIGNED BY
Iris Weinstein